SYMPATHY FOR THE DEVIL: ART AND ROCK AND ROLL SINCE 1967

SYMPATHY FOR THE DEVIL: ART AND ROCK AND ROLL SINCE 1967

DOMINIC MOLON

With
Diedrich Diederichsen
Anthony Elms
Dan Graham
Richard Hell
Mike Kelley
Bob Nickas
Simon Reynolds
Jan Tumlir

Museum of Contemporary Art
Chicago

in association with

Yale University Press
New Haven and London

[handwritten inscription:] December '07 / Rhino! / Here's to our personalities! And here's to what's really important — sex, drugs + rock + roll! / Love ya babe, / Lance →

This catalogue is published in conjunction with *Sympathy for the Devil: Art and Rock and Roll Since 1967*, organized by the Museum of Contemporary Art, Chicago, and curated by Dominic Molon.

The exhibition was presented at:

Museum of Contemporary Art, Chicago
September 29, 2007 to January 6, 2008

Museum of Contemporary Art, North Miami
May 31 to September 8, 2008

Major support for this exhibition is generously provided by
Cari and Michael Sacks.

Additional support is provided by Sara Albrecht, Marilyn and Larry Fields, Brian Herbstritt, Martin and Rebecca Eisenberg, Nancy and David Frej, Adrienne and Stan Green, Dana and Andy Hirt, Curt and Jennifer Conklin, Sam Schwartz, and Debra and Dennis Scholl.

Published in 2007 by the Museum of Contemporary Art, Chicago, in association with Yale University Press, New Haven and London

Museum of Contemporary Art
220 E. Chicago Avenue
Chicago, Ill. 60611-2643
mcachicago.org

Yale University Press
302 Temple Street
P.O. Box 209040
New Haven, Conn. 06520-9040
yalebooks.com

ISBN: 978-0-300-13426-1
Library of Congress Control Number: 2007933202

Produced by the Publications Department
of the Museum of Contemporary Art, Chicago, Hal Kugeler, Director

Edited by Kamilah Foreman and Amy Teschner
Copyedited by Sarah Kramer
Designed by Jonathan Krohn
Printed in Singapore by CS Graphics

The Museum of Contemporary Art, Chicago (MCA) is a private, nonprofit, tax-exempt organization accredited by the American Association of Museums. The MCA is generously supported by its Board of Trustees, individual and corporate members, private and corporate foundations, and government agencies including the Illinois Arts Council, a state agency, and the City of Chicago Department of Cultural Affairs. The Chicago Park District generously supports MCA programs. Air transportation is provided by American Airlines, the Official Airline of the Museum of Contemporary Art.

Editors' note: Rock-and-roll bands that begin with "the" are numerous (The Beatles, The Rolling Stones, the Clash, the Sex Pistols, etc.), and many publications lowercase "the" in all instances. However, in the tradition of contemporary art scholarship, we have endeavored to precisely document the artists' preferences regarding the visual presentation of their names.

"CBGB As a Physical Space" by Richard Hell originally appeared, in a slightly different form, in *CBGB: Decades of Graffiti,* published by Mark Blatty Publisher, 2006. Used by permission.

"Punk as Propaganda" by Dan Graham excerpted from his book *Rock My Religion: Writings and Projects 1965–1990,* edited by Brian Wallis, pages 96–113, including image on page 104. © 1993 Massachusetts Institute of Technology, published by MIT Press. Used by permission.

"Strange Früt: Rock Apocrypha, by the Destroy All Monsters Collective" by Mike Kelley. http://www.mikekelley.com/DAMDIA.html © Mike Kelley, 2007. Used by permission.

COVER
Douglas Gordon
Bootleg (Cramped) (detail), 1995
Video projection
Dimensions variable
Courtesy of Gagosian Gallery, New York
© Douglas Gordon

BACK COVER
Adam Pendleton
Sympathy for the Devil, 2006–07
Acrylic on canvas
Ninety parts, each: 30 x 23 1/4 in. (76.2 x 58.7 cm)
Courtesy of the artist; Yvon Lambert, Paris and New York; and Rhona Hoffman Gallery, Chicago

CONTENTS

LENDERS TO
THE EXHIBITION

The Andy Warhol Museum

The Art Institute of Chicago

Michael and Tracy Blum

Rebecca and Martin Eisenberg

Gregory and Elisabeth Fowler

Glenn Fuhrman

Megan Green

Holzer Family Collection

Darwin Honore

I. A. S. Icon Art Services

Steven Johnson and Walter Sudol

Andrew Leslie

Lucy Liu

Adam McEwen

Migros Museum für
 Gegenwartskunst, Zurich

Jennifer Moore

Andrew Ong

The Parrino Family Collection

John Rubeli

Dennis and Debra Scholl

Hiroshi Taguchi

FOREWORD
ROBERT FITZPATRICK

Sympathy for the Devil: Art and Rock and Roll Since 1967 is an ambitious exhibition that examines the contemporaneous history of the dynamic relationship between avant-garde art and rock music. Beginning with Andy Warhol's legendary involvement with The Velvet Underground and culminating in new works for the MCA space by artists working today such as Rita Ackermann, Jim Lambie, and Adam Pendleton, *Sympathy for the Devil* provides the most serious and comprehensive presentation of work arising from the intersection of these two cultural entities.

Since its emergence in the 1950s, rock and roll has come to shape and define society, fashion, politics, and so many other aspects of the world we live in, making it an irresistible and inevitable source of inspiration for the artists of our time. Whether it reverberates throughout their studio or plays a central role in their artistic practice (or even provides another creative outlet as evidenced by the many artist-bands that have flourished over the years), rock music has had an undeniably profound impact on the way contemporary art has been made and understood over the past forty years. Conversely, much of rock music created over this period has borrowed from the kind of avant-garde style and sensibility developed within contemporary art, and *Sympathy for the Devil* reflects an acute understanding of how the exchange between the two cultural forms has been mutually productive and stimulating.

As one of the key cities for the blues music that inspired rock musicians—including The Rolling Stones, whose notorious song provides the title for the exhibition—as well as numerous cel-ebrated rock musicians, critics, record labels, and events, Chicago is the ideal place for such an exhibition to be developed and presented. This year also marks the MCA's fortieth anniversary, a fortuitous coincidence, as the museum first opened its doors in 1967, the very year of Warhol's famous foray with The Velvet Underground and the year when rock became recognized as a mature art form with the appearance of other ground-breaking albums such as The Beatles' *Sgt. Pepper's Lonely Hearts Club Band* and *Are You Experienced* by The Jimi Hendrix Experience.

Sympathy for the Devil joins other recent MCA exhibitions such as *Escultura Social: A New Generation of Art from Mexico City* (2007), *Tropicália: A Revolution in Brazilian Culture* (2005), and *Universal Experience: Art, Life, and the Tourist's Eye* (2005) as evidence of the institution's dedication to ambitious exhibitions that combine exhaustive scholarship, geographical and historical breadth, and the active engagement of the art of the moment.

I wish to thank Dominic Molon, Curator, for his conceptualization of and passionate devotion to the project and for his exhaustive texts throughout this exhibition catalogue.

We are profoundly grateful to Cari and Michael Sacks for their wonderful support of this exhibition. We also thank trustees Sara Albrecht and Marilyn and Larry Fields for their continued support of MCA exhibitions as well as the other generous individuals who have made the exhibition possible. This catalogue is another in a series of recent books that we have copublished with Yale University Press, an association that we are proud and honored to have. Finally, I extend warm appreciation to all the artists whose dynamic interactions produced the provocative and important work included in this exhibition.

Robert Fitzpatrick is Pritzker Director of the Museum of Contemporary Art, Chicago.

INTRODUCTION
DOMINIC MOLON

So if you meet me
Have some courtesy
Have some sympathy, and some taste
Use all your well-learned politesse
Or I'll lay your soul to waste

—The Rolling Stones,
 "Sympathy for the Devil"

The relationship between avant-garde art and rock and roll over the past forty years demands a Faustian bargain for both parties. Rock music's cultivation of avant-garde tendencies, tropes, and processes elevates it in terms of its aesthetics and ability to express ideas or explore new sounds in a more sophisticated manner, while running the risk of courting catastrophic pretentiousness in an art form that at its best operates with a primal sense of irreverence. Contemporary art's admission of rock and roll into its realm has the benefit of presenting styles and sensibilities that are immediately readable and accessible to an audience from which it increasingly feels alienated, while simultaneously offering the potential for such corruptions as regressive juvenilia or, worse, the perception of pandering. In spite of the vicissitudes of engagement on both sides, the resulting works of art and music function best when, to borrow from Bennett Simpson, they "[enable] contradictions specific to art itself, rather than simply providing art with a new palatability, theme, or style."[1]

This catalogue has been produced on the occasion of the exhibition *Sympathy for the Devil: Art and Rock and Roll Since 1967,* representing the most comprehensive attempt to both examine the complicated historical relationship between these two cultural phenomena and celebrate the most extraordinary and compelling achievements that have resulted from their interactions.

Such an enterprise is necessarily fraught from the outset with the challenges of what and whom to include (and exclude) and to what degree the curator's own biases (in this case, admittedly, punk rock and its pre- and post-histories) shape and define the final content of the exhibition. In recent years there has been an increasingly self-aware historicizing of the key moments and phenomena defining the relationship between art and rock and roll, including documentary films such as *Kill Yr Idols* (2004); exhibitions surveying the punk eras or the New York and London underground scenes of the late '70s / early '80s, such as the Kunstverein Munich's *Secret Public* exhibition (2006) or *The Downtown Show* at the Grey Art Gallery in New York (2005); and the popularity of bands Franz Ferdinand, Interpol, and the Yeah Yeah Yeahs (among others), who make unapologetic and unabashed references to predecessors that developed out of the crossover of art and rock music. This cultural context makes the attempt at a broader history of that relationship seem that much more urgent and necessary. Covering such an expansive subject, however, requires some degree of structure. Rather than organize the exhibition and catalogue according to the kind of belabored and precious subheadings that plague most major surveys of this ilk, attending to the more authentic way that scenes in particular locations have interrelated and overlapped (or in some cases, not) emerged as a more effective strategy by which to provide a framework for both the exhibition and the accompanying text. This book thus features general histories of the relationship between art and rock music in New York, the United Kingdom, Europe, Los Angeles / the

1. Bennett Simpson, "From Noise to Beuys," *Artforum* 42, no. 6, February 2004, 59.

West Coast, the Broader United States, and the world (including Japan, Mexico, and Brazil) as well as detailed descriptions of works in the exhibition (and important artists).

These texts are followed by more focused essays that address particular aspects of some of these scenes. Bob Nickas provides a highly personal account of the development of coexistent and often codependent art and music scenes in New York City. Simon Reynolds's essay deals with the art school influence on rock in the broader historical sense, particularly how it affected developments in British music. Intensity as a shared quality of punk music and painterly practice in Germany in the '70s and '80s is the subject of critic Diedrich Diederichsen's text. Jan Tumlir identifies Los Angeles's Sunset Strip as a key site for the development of both art and rock sensibilities within the city. Other texts featured here include Anthony Elms's assessment of heavy-metal band AC/DC through conceptual art–style observations and statements; artist Dan Graham's discussion of the differing politics of punk rock's New York and London manifestations; Richard Hell's appreciation of the aesthetic qualities of legendary rock club CBGB; and Mike Kelley's autobiography of noise-rock phenomenon Destroy All Monsters, which he cofounded with Jim Shaw, Cary Loren, and Niagara in the mid '70s, and The Destroy All Monsters Collective.

As much as possible, the exhibition reflected in and documented by this text strives to demonstrate the mutual influence of avant-garde art and rock-and-roll music upon one another solely through the presentation of works of art. With notable and considered exceptions, the exhibition emphasizes the importance of the works themselves (including the music and, in some cases, music videos) rather than addressing the aesthetics of album cover design, posters, documentary photographs and videos, and other such ephemera. It also privileges work that was either created as a direct circumstance of the two cultural genres coming together or that rejects more literal representations of rock icons or phenomena. In doing so, *Sympathy for the Devil: Art and Rock and Roll Since 1967*—rather than adopting the Sisyphean task of representing the comprehensive history of the rock "aesthetic" in all of its manifestations—attempts to present a clearer picture of how the merger of art and rock and roll over the past forty years has produced singular and significant works of art in various formats and media by approaching both cultural realms with courtesy, sympathy, and taste.

Dominic Molon is Curator at the Museum of Contemporary Art, Chicago. He is the editor of *Wolfgang Tillmans, Paul Pfeiffer,* and *Gillian Wearing: Mass Observation.*

NEW
YORK

The insistently social nature of the convergence of art and rock music is best exemplified by its development in New York City from the mid 1960s to the present. It is hardly surprising that the city in which cultural intersections and hybrids occur with the greatest frequency and intensity should be the one where, by and large, the history of rock music and the avant-garde had its most auspicious beginning and arguably its most consistently sustained relationship. In stark contrast to other cities—where the divisions between the performing and visual arts and their attendant social subcultures are more definitively established and maintained—the constantly shifting nature of New York's centers of cultural gravity have led to correspondingly recurrent cross-disciplinary interactions throughout the postwar era. What made the intermingling of the art and rock music scenes unique here was the breaching of the more-or-less imaginary

but still present divide between so-called high / avant-garde art and low / popular culture. The relationship between art and rock and roll in New York has thus steadily progressed from Andy Warhol's active involvement with The Velvet Underground in the late '60s, to the more widespread exchange between downtown artists and No-Wave musicians in the late '70s and early '80s, to interpretations by a current group of artists whose work is characterized by a multidisciplinary approach or by a rigorous and layered understanding of the history of both cultural genres and their intersection.

EXPERIMENTAL JET SET:
THE NEW YORK SCENE
DOMINIC MOLON

The approximately two-year relationship between Andy Warhol and The Velvet Underground meaningfully established the relationship between avant-garde art and rock music. By the mid 1960s, the artist's studio—known as The Factory—had become an epicenter for New York's underground culture. As rock critic turned filmmaker Mary Harron astutely observed in 1980, "So many worlds converged at The Factory . . . that it was probably inevitable that he [Warhol] should meet The Velvet Underground."[1] Warhol was friendly with avant-garde musicians such as La Monte Young and Marian Zazeela, who subsequently worked with future Velvet John Cale, as well as the conceptual artist Walter De Maria, who played in an early incarnation of The Velvet Underground with Cale and Lou Reed called The Primitives. (It is also worth noting that experimental musician Tony Conrad, who was also a part of this circle and continues to be an inspiration to more avant-rock figures, gave The Velvet Underground its name.) It was, however, Warhol's personal assistant, Gerard Malanga, who eventually led the artist to The Velvet Underground, whose music already featured a ready-made vanguard combination of Cale's tendencies toward experimental instrumentation and Reed's poète maudit reflections on the seedier aspects of the urban demimonde. Malanga's extravagant and impromptu dance performances with a bullwhip at The Velvets' gigs led Warhol to contemplate further the use of the band in mixed-media spectacles that were dubbed "Andy Warhol's Exploding Plastic Inevitable." Ronald Nameth's now-classic 1966 film documenting one such performance captures the dazzlingly psychedelic combination of colored lights and film projections, the intensely physical writhing bodies on the dance floor, and the fluctuating sounds of The Velvet Under-

ground—ranging from the sweetly melodic and poetic "Femme Fatale" to the malevolently droning meditation on sadomasochism "Venus in Furs." Significantly, Warhol produced and provided the distinctive cover art for the group's first album, *The Velvet Underground & Nico* (1967), widely considered one of the most influential rock-and-roll albums of all time. Conversely, members of The Velvet Underground—Cale, Reed, Nico, Sterling Morrison, and Maureen Tucker—joined other rock musicians frequenting The Factory in sitting for Warhol's distinctive Screen Tests films in 1966. It is critical to note that Warhol collaborated with a rock-and-roll phenomenon that was hardly part of a pop music mainstream at the time (Velvet's influence would be recognized only much later). Regardless, he provided the band with the initial added visibility and impetus that would lead its foremost figures, Cale and Reed, to bring sophisticated avant-garde strategies into the more widely distributed cultural context of rock music.

While Cale and Reed continued to participate significantly in various rock phenomena of the '70s (the former producing early-punk icons The Stooges' first albums and the latter joining the New York Dolls in establishing glam rock's American roots and later recording the experimental rock masterpiece *Metal Machine Music*), their impact on the overlap between the avant-garde and rock music scenes were superseded in New York by figures such as Patti Smith, Television, Richard Hell and The Voidoids, and the Ramones. Smith, Hell, and Television brought art and literary backgrounds and approaches to music that served to define the early punk music scene in the city, while the speed and aggression of the Ramones brought the intense aesthetic of the musical genre into brutally sharp focus. (Renowned

1. Mary Harron, "Pop Art / Art Pop: The Andy Warhol Connection," in *The Sound and the Fury: A Rock's Backpages Reader, 40 Years of Classic Rock Journalism,* ed. Barney Hoskyns (New York and London: Bloomsbury Publishing, 2003), 364.

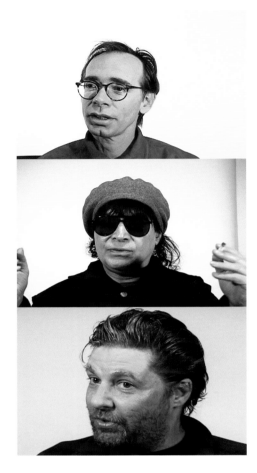

Tony Oursler
Synesthesia, 1997–2001
Color video with sound
Courtesy of the artist

ABOVE, TOP TO BOTTOM
Arto Lindsay
Alan Vega
Glenn Branca

photographer Robert Mapplethorpe provided the cover imagery for both Smith's and Television's early album covers.) Subsequent acts emerging in New York included Blondie as well as Talking Heads, the latter a quartet of former art students from the Rhode Island School of Design with a performance style, cover art, and lyrics that belied their art school training. All these bands and acts performed in a now-legendary network of downtown nightclubs including CBGB, The Mudd Club, and Max's Kansas City. The scene shifted once again toward more art-oriented spaces with the emergence of the No-Wave phenomenon, which would come to represent perhaps the most rigorously and comprehensive engagement of art and rock music in the forty-year history of their direct interaction.

No Wave is primarily associated with a diverse group of performers and composers ranging from the almost primal aggression of Lydia Lunch's Teenage Jesus and the Jerks and the confrontational performativity of James Chance's Contortions to classically trained musicians such as Glenn Branca and Rhys Chatham, whose respective bands Theoretical Girls and The Gynecologists were a critical part of the scene. Along with other key acts such as DNA and Mars, they took inspiration from such avantrock figures as Suicide (New York–based artists / musicians whose work radically incorporated electronics), Brian Eno (who would produce the seminal *No New York* compilation that defined the moment), Yoko Ono, and Captain Beefheart, as well as the experimental composer Philip Glass, in their campaign to tear rock music from its rhythm-and-blues roots. With their harshly atonal and dissonant music, deliberately angular, bilious, or nonexistent lyrics, and rigorously unconventional performance techniques, the No-Wave acts

often found alternative art institutions such as Artists Space, The Kitchen, and White Columns, or even commercial art galleries, to be more accommodating venues than punk-oriented nightclubs. Unsurprisingly, numerous visual artists based in the downtown and East Village areas actively participated in this scene, most significantly Jean-Michel Basquiat (in the group Gray), Barbara Ess, Robert Longo (in the band Menthol Wars), and Richard Prince (also in Menthol Wars). Longo created his iconic *Men in the Cities* drawings at this time (1980), and one can visualize the contorted men and women he depicts either in the audience or on the stage as part of the No-Wave scene. Prince's innovation of using appropriative techniques in photography occurred concurrently with this moment in music, similarly divesting that medium of its soul by depersonalizing the photographic process. This overlap is interestingly evident in his 1984 portraits of appropriated photographs of other members of the downtown scene, including filmmaker Amos Poe, David Byrne and Tina Weymouth of Talking Heads, artist Dike Blair, and Kate Pierson of the B-52's, among others.

Although No Wave is largely understood to have expired in the early '80s (followed by *Mutant Disco* / punk-funk phenomena such as Defunkt, ESG, and Material), various artists extended its energy and spirit throughout the decade. Photographer Richard Kern's films of the early to mid '80s featured Lydia Lunch and other members of the New York underground art and music scene, as did his *New York Girls* series of photographs. The latter, with their lurid neon lighting schemes and young goth- and punk-type women in provocative poses and situations, translates the sinister and transgressive attitude and subject matter of No-Wave and post–No Wave rock into a visual style and sensibility. Swiss-

born sonic and visual artist Christian Marclay was another figure to emerge from the No Wave during the '80s. He performed in acts such as Bachelors, Even, and Mon Ton Son but is perhaps best known for work created throughout his career that takes the physical material of sonic culture and transforms it into new sculptural objects and experiences. He combines various album covers into collages, for example, to highlight the often-strange representations of the human body in rock-and-roll graphic design. In another work, Marclay shifts the use value of a vinyl record by tiling a floor with thousands of them, thus changing the object from a transmitter of musical information to a visually dynamic entity.

This fusion of the auditory and visual qualities of rock music achieved a sort of apotheosis in the rock group Sonic Youth, which emerged from the No-Wave scene in the early '80s. Sonic Youth has, perhaps more than any other entity in the history of rock and roll, successfully bridged the gap between the artistic avant-garde and the musical mainstream both in their application of experimental sonic strategies and in their sustained use of recognized contemporary artists (including the aforementioned Kern and Prince, as well as Mike Kelley, Raymond Pettibon, Gerhard Richter, James Welling, and Marnie Weber) to create their visual identity through album covers and music videos. This is hardly surprising given Thurston Moore's general immersion in the No-Wave scene, Lee Ranaldo's participation in Glenn Branca's performing ensemble, and Kim Gordon's beginnings as both an artist and as a critic for *Artforum.* Conceptual artist Dan Graham is a key friend of the band, and his writings on art and rock music are an essential part of the dialogue, as is his landmark video *Rock My Religion* (1980). Graham's video

Tony Oursler
Synesthesia, 1997–2001
Color video with sound
Courtesy of the artist

ABOVE
Tony Conrad

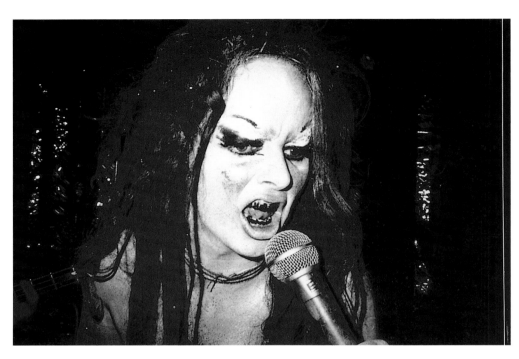

Kembra Pfahler
Kembra Singing in Karen Black Makeup, 2001
Digital print
37 x 45 in. (94 x 114.3 cm)
Edition of 6
Courtesy of American Fine Arts @ PHAG Inc., New York
Photo by Laure Leber

provides intriguing insights into the relationship between punk rock's creation of a physically felt sense of community in a manner that is hardly dissimilar from the ways and means of American religious sects such as the Shakers. One of the key figures to work on *Rock My Religion* (and a director for one of Sonic Youth's first videos) was Tony Oursler. A member of the on-again / off-again band the Poetics, which he formed with Mike Kelley while in art school in California in the '70s and '80s, Oursler has since become celebrated for video installations that feature surreal projections of disembodied human faces, eyes, and mouths onto sculptural substructures. One of his most recent works, *Sound Digressions in Seven Colors* (2006), features seven life-size projections of avant-garde / rock musicians including Tony Conrad, Ikue Mori, Zeena Parkins, James Thirlwell, and Steven Vitiello, as well as Gordon and Ranaldo from Sonic Youth. The performers were each asked to improvise with the knowledge that six other musicians would be performing, thus introducing an element of chance into both the ad hoc group performance arranged by Oursler and the viewer's experience of the installation.

Phyllis Baldino's video *19 Universes / my brother* (2004) operates in an inverse fashion, splitting footage of her rock-musician brother playing guitar into nineteen parts and reintegrating them into one single visual presentation.

Jack Pierson's work embodies much of the style, spirit, and attitude of rock and pop music in its photographic and sculptural evocation of the romanticized American postwar land- and cityscape. He often uses titles and lyrics from songs by Roxy Music and Joni Mitchell, among others, to set a particular mood, while the word sculptures that he has created since 1991 in particular are strongly reminiscent of the ransom

note–like graphic style of '70s punk rock. *Phil Spector* (2007) alludes simultaneously to the famous rock producer's glorious past of recording the Righteous Brothers, the Ronettes, and Ike and Tina Turner and defining the "wall of sound" in the '60s, as well as to Spector's checkered present of being on trial for allegedly murdering his girlfriend in 2003.

Pierson emerged in New York in the early '90s with other artists such as Karen Kilimnik and Rita Ackermann, who were similarly invested in bringing an intensively personal and often theatrical approach to the combination of everyday objects and images, as well as motifs and symbols drawn from the world of rock music. Ackermann herself has been involved with a number of different bands and music projects, most notably the heavy metal–inspired combo Angelblood (also featuring artist Lizzie Bougatsos, now a member of the band Gang Gang Dance with fellow artist Brian DeGraw). Ackermann's paintings, drawings, and collages convey much of the attitude and energy of the genre in her stylized approach to rendering figures and aggressive combinations of various media.

The work of Steven Parrino has only recently come into focus (in small measure a result of his untimely death in 2006). Like Ackermann, he directly participated in musical performance—the high volume bass-guitar noise project Electrophilia with Jutta Koether—as well as actions, such as his sledgehammering of thirteen black-enamel-painted sheetrock pieces at New York's Team Gallery in 2001, that exude the dark aggression of heavy-metal and punk music. His strangely touching video *Mirror* (2003) features the dark-haired and bearded artist (clad in black and wearing sunglasses) holding up a mirror to reveal an off-screen image of Charles Manson and shakily melds his face with

the notorious '60s mass murderer. This scene is atmospherically tempered by The Velvet Underground & Nico's "I'll Be Your Mirror" playing in the background, a somewhat incongruously sweet and affecting foil for Parrino's identification with the evil part of himself (personified, of course, by Manson).

Kembra Pfahler also played a significant role in the art and rock relationship in New York in the '90s. A member of the band The Voluptuous Horror of Karen Black, her work comprises images and props heavily influenced by early horror films rendered in a surf-goth style redolent of her upbringing within the California surfing and punk subcultures.

The rock-inspired or -related art (and art-inspired rock) created by artists and musicians who have emerged in New York in recent years unsurprisingly possesses an acute awareness of both art and rock history and the history of the relationships between the two genres. Aïda Ruilova's videos combine the brutal pacing and editing of music videos with physical actions and intensity characteristic of both horror films and much of the body / endurance-oriented performance art of the '70s. Her 2002 *Untitled* video installation features a re-creation of an element from the final scene in Jean-Luc Godard's 1968 film *Sympathy for the Devil,* in which a young woman is laid prone on a film crane on the beach (one of numerous scenes involving women as foils for political speeches by Black Panther–type figures). Ruilova's video features only the woman on the crane, moving malevolently back and forth to the sound of heavy breathing (rather than the iconic Rolling Stones song that the group is seen rehearsing throughout the film), suggesting a sinister fusion of human and machine. A recent art installation by New Humans, an art and rock collaborative comprising Mika Taji-

Charlie White
Video still from Interpol's "Evil," 2004
Color video with sound
3 minutes, 35 seconds
Courtesy of the artist and Biscuit
Filmworks, Los Angeles

2. Katie Stone Sonnenborn, "New Humans,"
frieze, June / July / August 2007, 259.

ma and Howie Chen, also draws on elements of this Godard film. *Disassociate* (2007) features double-sided silk-screen paintings featuring "decorative tessellations of champagne glass bases and Charles Eames shell chairs, obfuscated at times by bold, thick stripes and expressive swaths of paint"[2] or used as supports for work by other artists (such as Vito Acconci and José León Cerrillo) as all of which are set within wheeled platforms alluding to the partition walls separating various members of The Stones in the studio in Godard's film. The work can be variously performed in numerous ways—the platforms may be moved and the installation may be used (as it was at the Elizabeth Dee Gallery in February 2007) as a performance space—thus echoing the way the film captures The Stones' structuring and restructuring of the title song over various takes.

Slater Bradley's *The Year of the Doppelganger* (2005) similarly draws on an

element from the history of so-called classic rock, staging a situation in which the gaunt male figure he has identified as his "doppelganger" enters the empty University of California football stadium and begins to play the drum riff from Led Zeppelin's "When the Levee Breaks." The work initially functions as a parody of Zeppelin and other massively popular rock groups that require sporting arenas for their concerts, yet the sudden appearance of the football team practicing around the drummer brings an intriguing comparison of male types into play (and further, meditations on different understandings of masculine identity).

Sealing the gap between Sonic Youth and their relationship to art, Jay Heikes's video *Daydream Nation* (2000) restores the Gerhard Richter painting that graces the cover of the Sonic Youth's 1989 album of the same name back to the space of art, constructing a static video equivalent of an off-center lit candle while the music from the album plays in the background. What begins as a sort of rock in-joke sight-gag achieves a sense of grace as the candle slowly burns down and the experience shifts from icon recognition to serene vigil.

Proceeding from work that transplanted African American historical images and motifs into the graphic structures of jazz and pop album covers, Adam Pendleton's multipaneled *Sympathy for the Devil* (commissioned for this exhibition) extends his interest in how a work of art can function as a new form of archive. He conducted rigorous research of imagery throughout the history of rock and roll and selected pictorial icons, motifs, and fragments from the punk and post-punk era of the '70s and '80s that seemed to define the sensibility of that period, if not the style and attitude of rock music itself. Pendleton's grid of silk-screened images echoes fig-

ures such as Warhol and Prince in their emphasis on appropriative techniques yet adds a critical dimension of historicism to his practice.

Cory Arcangel's videos also feature material culled from pre-existing sources. In *Sans Simon* (2004) he creates a witty disturbance of concert footage of '60s and '70s folk rockers Simon and Garfunkel by repeatedly obscuring Paul Simon's face with his hand. In doing so, Arcangel subtly comments on the interpersonal dynamics of a performing duo in rock and pop music, underscored in this case by the fact that Simon has arguably become the more successful, celebrated, and recognizable of the two.

That some of the most recent visual art being made in the space between art and rock and roll should be so heavily informed by elements of art and rock's history is fitting in the context of much of the music now being made by internationally recognized New York–based bands such as the Interpol, the Liars, and Yeah Yeah Yeahs, with little attempt to disguise the influence of No Wave–era bands, particularly in their music. Bjorn Copeland's band Black Dice is similarly informed by the history of experimental tendencies in rock with its combinations of abrasive and dissonant sounds and textures. His graphic works grace the covers of their records yet stand alone in their presentation of jarring juxtaposed images or repeated abstract forms to create a sense of distortion and interference, providing an electric update on a collage aesthetic whose lineage includes such diverse figures as German dadaists from the '20s and '30s John Heartfield and Hannah Hoch, and artists associated with British punk of the '70s such as Jamie Reid, Linder, and Gee Voucher. The engagement of historical avant-gardist visual and sonic forms by Copeland and Black Dice, re-

spectively, in the interest of creating radically new pictures and sounds is thus representative of the New York art and music scenes' engaged use of the past to activate their combined expressions in the present—and future.

The title "Experimental Jet Set" refers to the Sonic Youth album *Experimental Jet Set, Trash & No Star,* 1994, DGC.

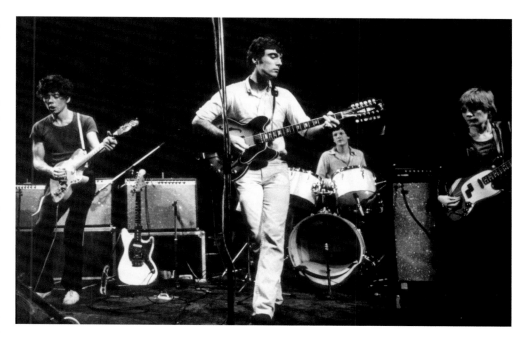

Talking Heads on stage at Roundhouse in the late 1970s
© Adrian Boot / Retna UK

NO NEW YORK: A PERSONAL ACCOUNT OF THE DOWNTOWN SCENE, LATE '70S / EARLY '80S (TO THE BEST OF MY RECOLLECTION)

BOB NICKAS

My very first concert was Black Sabbath in 1971. They played, believe it or not, a benefit for a Boy Scout troop, of which I was a scrawny, half-hearted troop member, sponsored by the Arcola Methodist Church. Bands never ever came to the little New Jersey town where I grew up, so the fact that Black Sabbath was playing a show at a local movie theater seemed totally unbelievable; all these years later, I can't help but wonder if it really happened. And yet my recollection of being in school the next day, ears ringing from their massive volume, hearing not a single word spoken in any of my classes, remains vivid to this day. It was thrilling to hear them play live versions of the songs I knew by heart: "Paranoid," "War Pigs," and "Iron Man." Even at the tender age of thirteen, I knew that a band called Black Sabbath playing a church benefit was an unholy alliance. Like most kids' first concert experiences, mine necessitated the presence of an older brother, who I think had a bad time. Darkness, it seems, was not meant to be his friend.

In high school, there was a record player in art class, and I was among a number of kids who regularly brought in records to listen to while we drew or worked on projects. This was 1972, so you can probably guess what was in heavy rotation: the Allman Brothers and the very unheavy Cat Stevens. Try to imagine the looks of shock and confusion when, one day, I went over to the stereo and put on a new record, the first by a group called Roxy Music. Near-instant rebellion by the southern rock fans (the boys) and curious attention from the girls, who opened the gatefold to reveal individual portraits of a group that didn't look like any we'd ever seen before. I can't recall exactly what it was that got me to buy the album, but it was probably a picture of the band and a mention by Lisa Robinson in a maga-

zine called *Rock Scene*. Roxy's image was oddly contradictory but somehow meshed: Bryan Ferry and Andy Mackay, with leather and tiger-patterned jackets and greased hair, appeared to have stepped out of the '50s; Phil Manzanera, with his silver wraparound sunglasses, looked like a human fly; and then there was Brian Eno, with giant feathered plumes all about his neck that positively screamed camp glamour from the '30s. What I didn't understand then that's crystal clear now is that this was Art rock—art with a capital A. The band's image and sound were so highly stylized, so considered in terms of every detail and nuance, you just knew that bearded guys in jeans were a thing of the past. Records by the New York Dolls, Lou Reed, and David Bowie soon followed, and art class was never quite the same. Almost overnight there were glitter and silver markers in class, for better and mostly for worse.

Around 1978 I became good friends with a band from Haledon, New Jersey called The Feelies. By then my musical taste had shifted yet again, at this point turning back in time to records made in the late '60s / early '70s by The Velvet Underground, Modern Lovers, and The Stooges—all major touchstones for The Feelies—and we bonded musically. (They did eventually turn me on to the MC5, and, if memory serves, Feelie Bill Million actually knew people in the White Panther Party.) Like a lot of friends and fans, I inevitably began to help the band move amps into small clubs and went to every one of their shows. The early Feelies are still revered. With two guitarists and two drummers, they played mostly fast, propulsive songs that lived up to titles like "Crazy Rhythms" and "The Boy With the Perpetual Nervousness." They were very aware of their image and how it stood in contrast to most

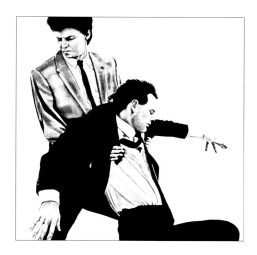

Robert Longo
Untitled, 1981
Charcoal and graphite on paper
5 x 5 ft. (1.5 x 1.5 m)
Courtesy of the artist and Metro Pictures, New York

THEORE
TICA L
GIRLS

Theoretical Girls
"You Got Me / U.S. Millie" (single), 1978
Courtesy of Glenn Branca and Jeffrey Lohn

everyone else. Back then there were a lot of different looks: street urchin, hustler, beat punk, escapee from the mental hospital—all seen against plenty of people who looked, well, perfectly normal. The Feelies, by design, were clean-cut, wore button-down shirts, and would not (at first glance) make parents worry about who their kids were hanging out with or whether their daughters were dating a member of the band. (The chorus of one song declares: "You call it original love / I call it original sin.") They were also clever with press clippings, which were almost nonexistent in the beginning, so they'd make them up from time to time. Their best tagline: "Kraftwerk at a Maytag convention." Thinking back, in particular to the song "The Forces at Work," I find it's truer than you would think. The Feelies were particular about the graphics and images used for fliers and had a habit of playing on or as close to national holidays as often as possible. I recall one show where, at the end, Glenn Mercer called out, "Happy Flag Day!" By taking into account every aspect of the band, particularly visual appearance and presentation, The Feelies, as I would come to realize, were operating as much like artists as a band.

The Feelies began to play shows in New York, which I eagerly went along to. This was the beginning of a new musical education as well as my first brush with the downtown art scene. I still lived in New Jersey, and New York wasn't the clean, corporate, suburban-friendly shopping mall that it is today. Back then, the city bore the traces and lived texture of its distant past. Downtown at night, desolate streets felt eerily dangerous; there were cheap bars on the Bowery where we went for drinks before shows, sitting alongside passed-out bums; trash-can fires on a cold winter's night were a sight to behold. Those bars re-

ally did put you in the mind of Weegee photos from the '40s, and the palpable, noirish feeling of dark alleyways would have been the perfect stage setting for an episode of *Naked City.* No wonder so much of the music then felt like the soundtrack to nocturnal New York. In the song "Venus," when Tom Verlaine sang "Broadway looked so medieval," it rang true.

In the beginning, The Feelies played Max's Kansas City, CBGB, the Lower Manhattan Ocean Club. The downstairs back room at Max's had, of course, famously been the hangout for Andy Warhol and his Factory hangers-on back in the '60s, but bands played upstairs and we always went straight up to the club proper and the pinball machine by the front windows. Max's, quite conveniently, was on Park Avenue directly across from Union Square. The park used to be so dense with bushes and trees that at night you couldn't see inside from the street: the perfect place to score drugs of almost any kind. At CBGB, the big sepia-toned photo blowups of old-time Vaudeville performers were visible alongside the stage, providing a time-warp backdrop to performers like the Ramones and Patti Smith—the Bowery's raunchy past haunting this explosive moment. The obliteration of these pictures by band and fan graffiti seems to me one of the great crimes perpetuated in the name of punk—or, dare I say, art?

The Feelies played the Mudd Club on White Street on numerous occasions. The club featured monthly programs of performances and readings, as well as film screenings by local artists such as Eric Mitchell and Beth and Scott B. People still grouse about the attitude at the door. I found out many years later that the artist Chuck Nanney often manned the door, disappointing and pissing off a lot of people in the process. I didn't know

him at the time, but thanks to my near-invisibility back then I never had trouble getting in, and we're friends today.

I got to see The Feelies as an opening act on bills with bands like Television (to whom they were occasionally compared) and Richard Hell and The Voidoids, with the late great Robert Quine, one of the most distinctive guitar players of all time. The Feelies once opened for Patti Smith at the Village Gate, a show primarily imprinted on my brain for her rendition of "You Light Up My Life" sung with not the slightest hint of irony. (The cover photographs for debut records by Television and Patti Smith were taken by Robert Mapplethorpe.) When The Feelies started to headline shows, they preferred to have opening bands whose music was more difficult, or at least was perceived that way by rock-oriented audiences. This is how I was introduced to two of my favorite bands, Mars and DNA, which would appear on the Eno-produced *No New York* record. (I would later discover oddly beautiful hanging sculptures by Nancy Arlen, who had been the drummer in Mars. Almost thirty years later, they look as strange and fresh as they did back then.) The Feelies had a reason for asking more crowd-testing bands to play before them. It didn't occur to me until later, but for many in the audience, certainly for those who fled to the bar when The Feelies came on, with their soaring guitars and driving rhythms, the mood in the club had to be one of general relief. The Feelies genuinely admired these bands for their energy and adventure, and well understood the degree to which their own music would be offset by that of a demanding opener. This strategy benefited me as well.

Before long I was going out to see bands like Teenage Jesus and the Jerks, the Contortions, and Theoretical Girls. Teenage Jesus, led by Lydia Lunch, and

the Contortions, with wound-up front man James Chance, specialized in their own distinctive Theaters of Cruelty. (Lunch's "I Twist, You Shout" comes readily to mind.) I also went to see The Cramps, with their swampy garage stomp, and Pere Ubu, who spookily conjured up a postindustrial wasteland, (both were from Cleveland), and the haunting, electric blues-punk of The Gun Club, from Los Angeles. At Tier 3 on West Broadway, next to El Teddy's (now gone, like just about everything else from that time), I saw the all-girl Raincoats, from London, and the all-girl Y Pants, who included the photographer Barbara Ess. Y Pants often played toy instruments and once covered The Stones' song "Off the Hook." I can't remember where I saw The Pop Group (one more blown-out weekend), but I still have a single that Gareth Sager autographed one afternoon at 99 Records on McDougal Street. When I looked at the sleeve, he hadn't signed his name but had written a single word: "Jihad!" In the early '80s I had no idea what the word even meant. Ed Bahlman at 99 released records on his own label, including Glenn Branca's first (with cover art by Robert Longo). Ed was responsible, and influential, for introducing something new to the scene: music that was propelled by Latin rhythms and was heavily percussion-based. He put out records by bands I often saw sharing the same bill: Liquid Liquid, KONK, and ESG—the Scoggins sisters from the South Bronx. Drunk and totally wired, quite possibly after that Y Pants show, I said, "It's two in the morning and now I'm in the mood to go see some art." A friend replied: "Galleries and museums aren't open at two am." "I know," I said, "that's the problem." (Go to the location of Tier 3 today and you won't find a club, but a Sufi bookstore founded by Heiner Friedrich of the Dia Art Foundation.) One lazy after-

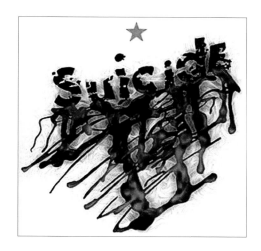

Suicide
Suicide, 1977
Cover illustration by Alan Vega and Timothy Jackson
Reproduced with kind permission of
Suicide / Mute Records / Blast First

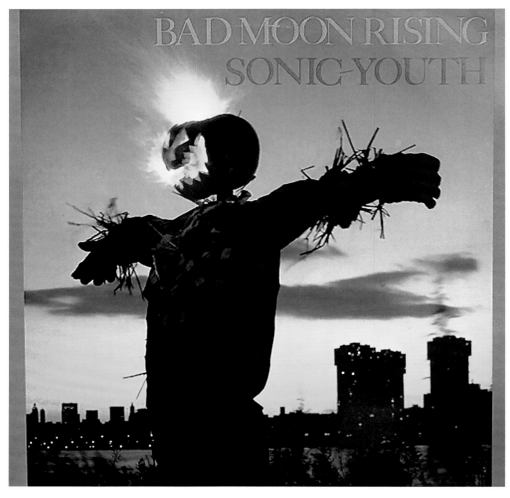

James Welling
Album cover for Sonic Youth's *Bad Moon Rising,* 1985
Color slide film
4 x 5 in. (10.2 x 12.7 cm)
Courtesy of Donald Young Gallery, Chicago

noon at a summer barbecue, The Feelies suggested we all go into the city to see a band with a surf guitar sound that they'd heard about, who had just driven up from Athens, Georgia. So we went to Max's and got to see the first-ever New York show of the B-52's. All these years later, I still wonder: what if I'd never met and befriended The Feelies?

All this time I'd been buying records and 'zines and going to shows. As much as I was interested in art, I went to see bands play more frequently than I went to galleries. The music scene of the late '70s was simply more interesting to me than the art scene. When I went to The Kitchen, I was more likely to be there to see Suicide or Boris Policeband than to see an art exhibition. Policeband was unique: one guy with a police squawk box that he used as a microphone, making calls like: "21 Mary, this is 21 Charlie [jittery radio crackle] pick up two burgers [more crackle] at the IHOP." Another number, set at a policeman's funeral complete with bagpipes keening softly in the background, was my favorite. One of the greatest band names ever was lifted from a *New York Post* headline: 3 Teens Kill 4 No Motive. (The band's best-known visual artist member was David Wojnarowicz.) Art wouldn't get this interesting until the '80s when the East Village scene was well under way—eventually to be co-opted by the established gallery system and implode under the weight of its own reckless abandon.

Before it starts to sound as if I saw every great show ever played, keep in mind that for every great band there were a dozen who've either been forgotten or didn't even make a dent. How many people remember U.S. Ape or Sic Fux or Dark Day? And then there are all the shows I flat-out missed. Flipping through a calendar from 1981, I had written on Thursday, July 2 "Fire Engines"— a Scottish band that played with a spare,

jumpy style and lots of nervous energy, but a show that for whatever reason I didn't go to. I remember getting a call from a friend who told me that there was a band from California called The Minutemen, who played short, fast songs that reminded him of Wire. He said they were playing that night. I kick myself for not going and can only dream of what I missed. And then there's Wire, one of the bands I listened to the most back then. They came to the US for the first time and played just one show—in New York. It was July 1978 and where was I? On vacation.

By the mid '80s I also frequented the Squat Theater, founded by a Polish theater group in a long, narrow space on West 14th Street. To help pay the rent, it had bands play fairly regularly and it's there that I saw shows by the Sun Ra Arkestra, Lounge Lizards, and DNA, who recorded original music for Squat's best work, "Mr. Dead and Mrs. Free." In 1981, the alternative art space White Columns hosted over a week of shows under the banner Noise Fest, organized by Josh Baer and featuring performances by Glenn Branca, Rhys Chatham, Sonic Youth, and Y Pants, among dozens more. All shows I missed! That summer, Sun Ra played an outdoor show as part of the Art on the Beach series sponsored by Creative Time. (If you know where to look and try to find the "Art on the Beach" location, you'll be in Battery Park City with its high-rise apartment blocks and the World Financial Center.) Two years after Noise Fest, White Columns struck again, this time with Speed Trials, five nights of new music organized by Tom Solomon. The title was especially appropriate for the opening night's headliners, The Fall, led by an amphetamine-fueled Mark E. Smith. I still have a tape, since converted to CD, made that night by an old friend, Alan Neill, and despite some nagging PA prob-

lems (about which Smith laughingly mocked: "It's just like 1977!"), this was the band at one of its peaks. Also on the bill was Sonic Youth, and a few nights later, Swans and a still-hardcore Beastie Boys took the stage. ("Egg Raid on Mojo! I've had enough!") Truth be told, these were the first times that I set foot in White Columns, but I couldn't have been the only one. As I've always said, a lot of the people I met in the early '80s art world looked somehow familiar to me when we first met. And why? Because it wasn't really the first time: I'd seen them years before at Max's or the Mudd Club or Tier 3 in the early hours of a day that became yet another in a long line of morning-afters.

Spring 2007

Bob Nickas is a New York–based critic and curator. Since 1984 he has organized more than sixty exhibitions for galleries and museums worldwide.

CBGB AS A PHYSICAL SPACE

RICHARD HELL

First of all, CBGB's is located on the Bowery,[1] a street the very name of which has signified drunkenness, dereliction, and failure for as long as anyone can remember. Such is the mental space of its physical place. Now, though, that particular urban strip has become prime real estate. The most famous rock-and-roll club of all time, which has unquestionably done more than any other establishment to modernize the locale, has been priced out by bidders eager to install designer boutiques, upscale restaurants, and luxury apartments. When the dump opened its doors in December of 1973, it was typical of the rows of flophouses, low-rent restaurant supply corps, a sprinkling of struggling avant-garde theater ventures, and, most abundantly and notoriously, countless ultra-cheap alky dives that, like backwater tidal washup, littered the Bowery, keeping it disreputable, dirty, dangerous, poor, and interesting. Now the club is unique. Very soon it will no longer exist, except perhaps in whatever unlikely form can be transported to Las Vegas, where, it's been announced, tentatively, it will reopen in 2007.

I remember the joint at the beginning. I was in the first band that brought the club attention and in two others that played there steadily in the place's earliest years as a rock-and-roll (cum "punk") club, 1974–77. Pretty much every weekend in that period you could see one or more of the following groups on CBGB's stage (here listed in chronological order): Television, the Ramones, Patti Smith, Blondie, The Heartbreakers, Talking Heads, Richard Hell and The Voidoids, and the Dead Boys. Its physical space, which holds about 350, has stayed amazingly unchanged since it opened. The front two-thirds—entranceway and bar area—of the single long room of the club proper, and the toilet areas downstairs at the

rear, are the same as they always have been. In the venue's first year or two there were a few minor rearrangements made in back, enlarging the stage and dressing rooms and for the purpose of installing a first-class sound system, but the basic layout and construction, as well as the furniture, lighting, and overall atmosphere, have not changed at all since 1974, except that the graffiti has gotten thicker.

The graffiti has gotten thicker, but that happened quickly, too. It took only three or four years for the place to acquire the garish veneer within that's become its distinguishing mark. From the beginning, when Hilly Kristal acquired what was then called the Palace Bar (adjunct booze hole to the Palace Hotel flophouse next door), it's been his stunning, stunningly effective, inertia that determined the styleless club's stylistic elements—its deathless overall wino-dive griminess; the long row of compact neon beer signs dangling like corrupt flags or coats of nauseous arms above the narrow public walkway behind the bar stools; the blunt, ribbed, white tunnel-roof of canvas overhead outside with its innocuously ugly CBGB and OMFUG logo—but the one major shift in the physical appearance of the place also followed from Hilly's free-form apathy, namely his lack of interest in removing any defacement of the club's interior.

The extreme outcome of that ultra-passivity regarding decor is the fantastic, ghostly, jewel-smear-for-walls of a palace-for-fun-seeking-children that the club's physical space has become. Analytically, all those spectra of marker scrawls, blurred spray-paint swaths, and Day-Glo stickers making up the interior planes of a shimmering temple of impulse-to-assert, can't truly be seen as self-assertion. They're more like mob behavior, like what goes on in a mosh pit,

1. I am writing in the late summer of 2006. By the time this appears, CBGB's will no longer exist in the form and location it has held since it opened. It's still there now, though, so I'm using the present tense to describe it.

or like blank genetic reflexes, than anything to do with anyone's self. They're just about leaving a mark, any mark. The specific words scrawled on the walls are irrelevant. Granted, a viewer almost can't help going in for closeups and deciphering statements here and there, but the literal messages are unworthy of the overall effect, and interfere with it, like hearing Lindsay Lohan's words on a talk show. (Maybe the way the great '70s graffiti kids quickly evolved tags that were pure style, almost impossible to read, had something to do with a similar concept. They wanted fame, but fame for simply existing, capable of making a notable mark, not for being anyone outside their tags. Fame as anonymity by another name, or maybe not even fame, but merely the capacity to capture a stranger's attention.)

Above all, though, the effect of the surfaces of CBGB's dark, crazed insides is eerie, haunting. It's like a dead-quiet, chillingly colorful cemetary. Or autopsy: all of compacted history sliced open to view. It's not so much that the graffiti evokes the endless procession of individual kids who've attended the club, but that it evokes their absence, their faceless selves buried under the next pretty layer of pointless assertion. The walls are an onslaught of death and futility as much as they are of life and vitality. The kids believed themselves to be unique individuals; the walls they covered with that claim are the proof that it's a delusion. Or is this what we knew all along, and the walls are sites of reveling in it, reveling in undifferentiation? Because it does seem sweet and innocent and loveable too.

Naturally, the graffiti in CBGB also has a lot in common with the style of music that made the club famous. It's not about an intellectual argument, it's not about opinions, it's about a condition, about being young and hungry;

about energy, anger, and sex; pure formless assertion. Or not: It's about boredom and frustration. But boredom iterated and reiterated, becoming drunk, passing out unconscious, and then beginning again. Funnily. It's horrible, but beautifully horrible, like modern ghostly Japanese horror movies with their derelict, peeling, void-riddled spaces; or like the abandoned West-Side docks of '70s New York where illicit, if somewhat defiantly public, sex was taking place everywhere among the filth and scribbled-on rotting wood. It's about abandon and abandonment made visible, and become the environment for where it's made audible as well. It's about ennui and inertia and their perfect realization in violence and sex. It's so good-looking it hurts.

Summer 2006

Richard Hell is a musician. He is also the author of the novels *Go Now* and *Godlike* and the collection of "essay poems lyrics notebooks pictures fiction," *Hot and Cold*.

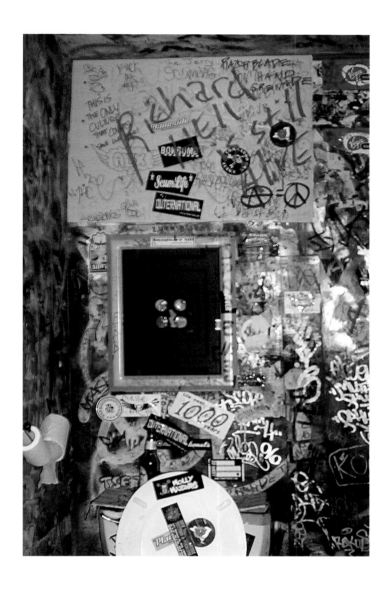 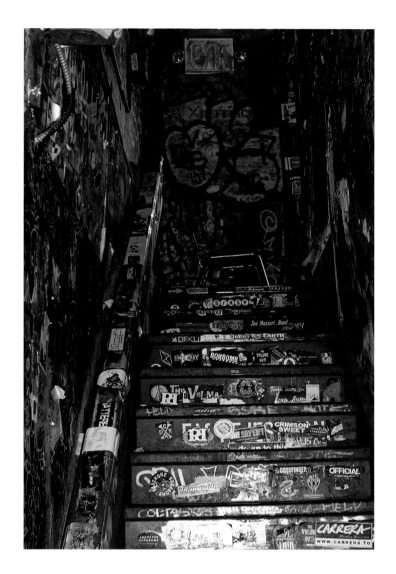

Photos by Justin Kramer

NEW YORK: PLATES

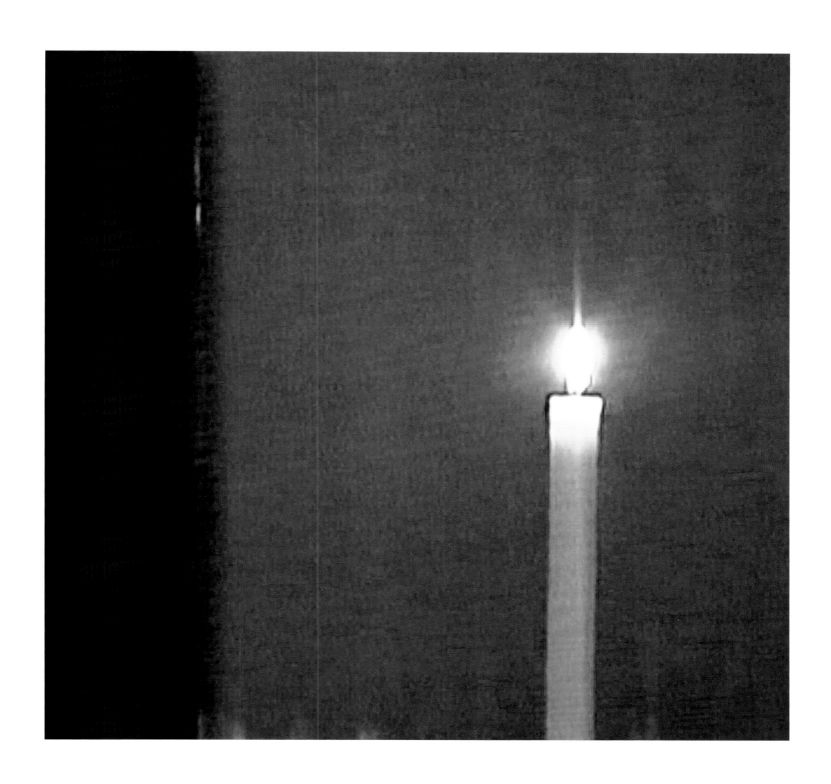

Jay Heikes
Daydream Nation, 2000
Single-channel color video with sound
40 minutes
Courtesy of Shane Campbell Gallery,
Chicago, and Marianne Boesky Gallery,
New York

```
RE _____

(here)(          )(     )
(      )(there)(                              )
(    )  (                                            )
(                    )(here and there -- I say here)
(I do not say it now)(                )(I do not say now)(
(                              )(              )(                )
(                    )(then and there -- I say there)(          )
(        )(I do not say then)(                    )(say there)
(I do not say, then, this)(                    )
(                              )(          )(            )
(        )(          )(then I say)(                )
(        )(          )(here and there)(            )
(              )(first here)(                )
(I said here second)(          )(          )
(                      )(I do not talk first)(        )
(                )(        )(there then)
(        )(here goes)(                    )
(I do not say what goes)(          )(
(                    )(I do not go on saying)(        )
(            )(          )(there is)
(        )(that is not to say)(                )(there is)
(I do not say that)(                    )
(                    )(here below)(          )(            )
(      )(          )(I do not talk down)
(                  )(under my words)(
(under discussion)(          )(          )
(              )(all there)(               )
(      )(      )(I do not say all            )
(              )(all I say)(     )
```

Mika Tajima / New Humans and Vito Acconci
Pattern disturbance, 2007
Silk screen on paper, ink-jet print, wood, and wheels
90 ³/₈ x 47 ³/₄ x 31 ³/₄ in. (229.6 x 121.3 x 80.6 cm)
Installation view, *Disassociate,* Elizabeth Dee Gallery,
New York, February 17 – March 31, 2007
Courtesy of the artists and Elizabeth Dee Gallery,
New York

Mika Tajima / New Humans with José León Cerrillo
Us in the background, 2007
Silk screen on cotton, wood, wheels, and paper
90 ³/₈ x 47 ³/₄ x 31 ³/₄ in. (229.6 x 121.3 x 80.6 cm)
Installation view, *Disassociate,* Elizabeth Dee Gallery,
New York, February 17 – March 31, 2007
Collection of Elizabeth Dee Gallery, New York

Mika Tajima / New Humans
Annulment complex, 2007
Silk screen on cotton, wood, and wheels
54 ¹/₈ x 47 ³/₄ x 31 ³/₄ in. (137.5 x 121.3 x 80.6 cm)
Installation view, *Disassociate,* Elizabeth Dee Gallery,
New York, February 17 – March 31, 2007
Collection of Jenny Moore, New York
Courtesy of Elizabeth Dee Gallery, New York

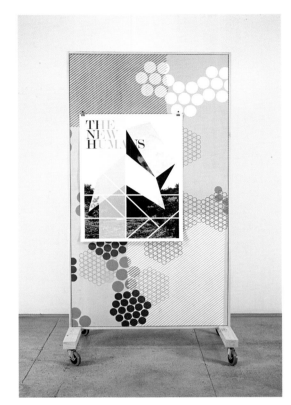
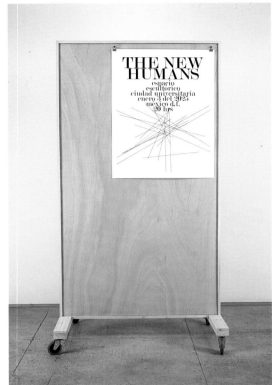
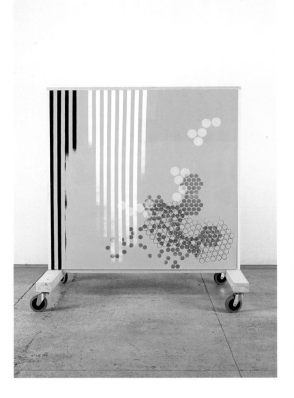

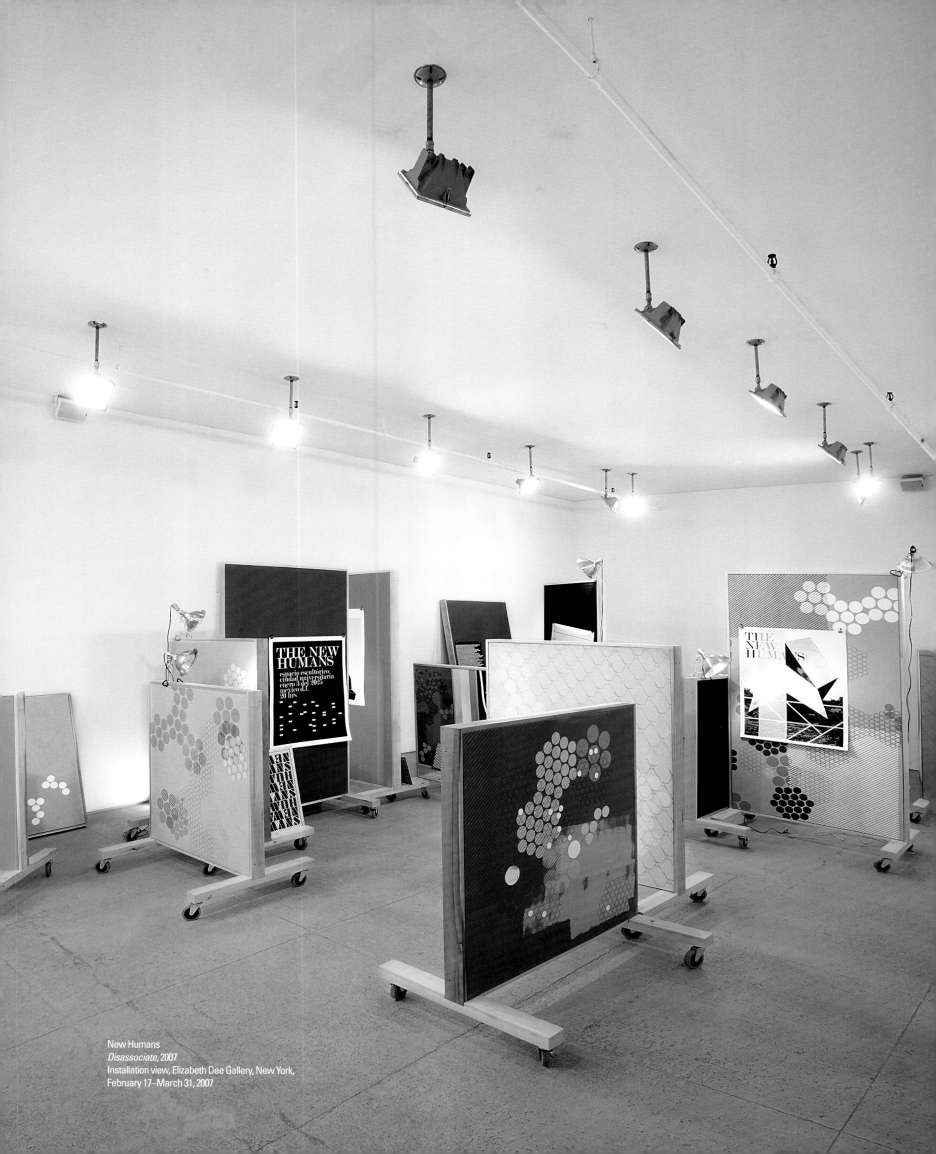

New Humans
Disassociate, 2007
Installation view, Elizabeth Dee Gallery, New York,
February 17–March 31, 2007

Christian Marclay
David Bowie from the series *Body Mix,*
1991
Record covers and cotton thread
29 ¹/₂ x 13 ¹/₄ in. (74.9 x 33.7 cm)
Courtesy of the artist and Paula Cooper
Gallery, New York
© Christian Marclay

OPPOSITE
Christian Marclay
1476 Records (Louisiana Floor), 1993
1,476 vinyl record albums
Installation view, At the Edge of Chaos—
New Images of the World, Louisiana
Museum of Modern Art, Humblebaeck,
Denmark, February 5–May 9, 1993
Courtesy of the artist and Paula Cooper
Gallery, New York

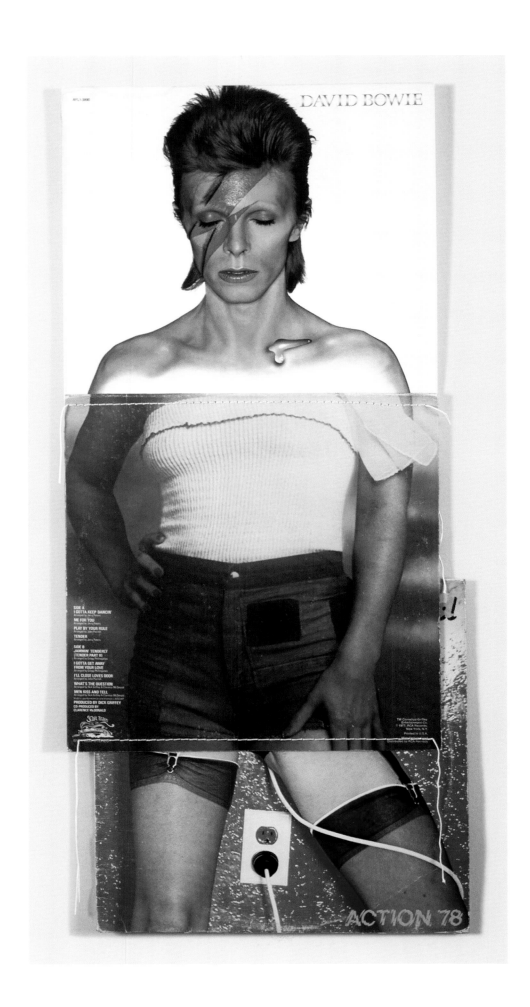

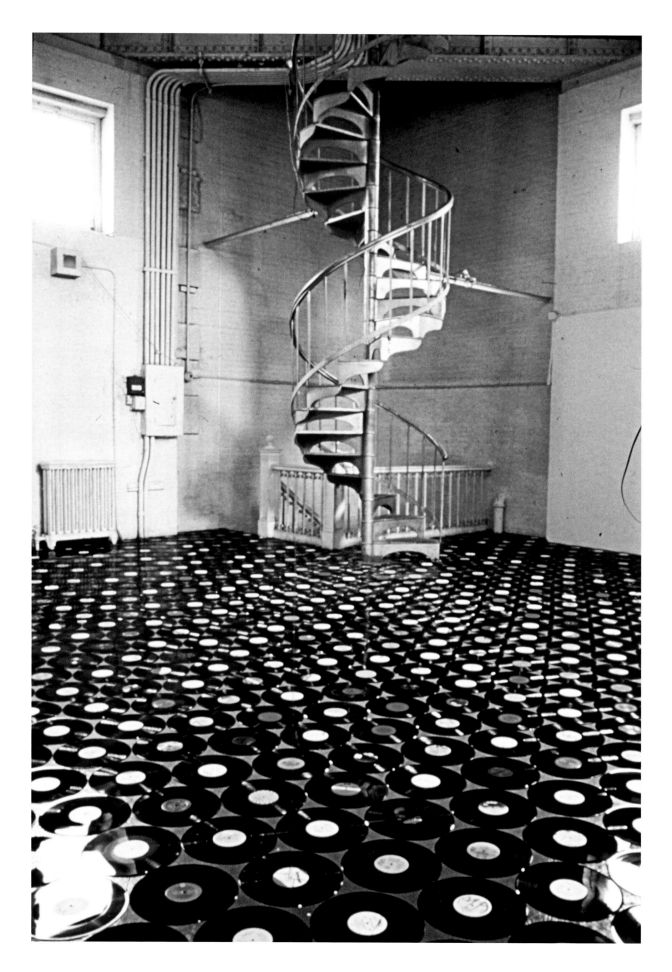

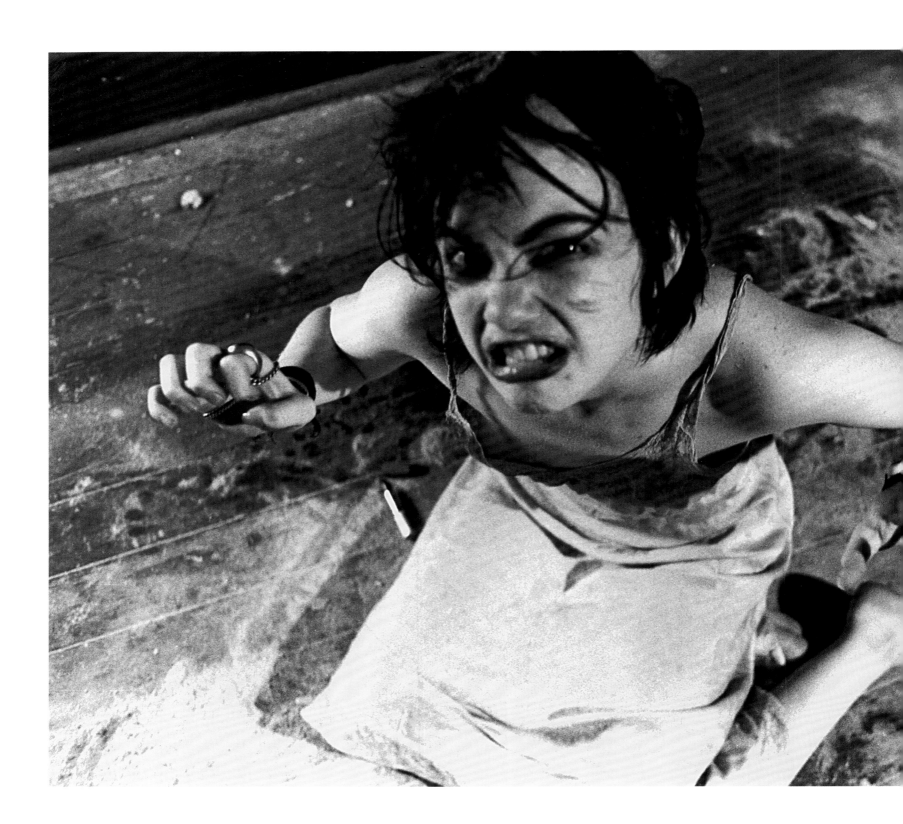

Richard Kern
Lung as brat, 1986
Black-and-white print
30 x 40 in. (76.2 x 101.6 cm)
Courtesy of the artist and Feature Inc, New York

FOLLOWING PAGES

Richard Kern
Anna with Cigarette, 1993
Cibachrome print
40 x 30 in. (101.6 x 76.2 cm)
Courtesy of the artist and Feature Inc, New York

Richard Kern
Kim Gordon with gun, 1985
Black-and-white print
40 x 30 in. (101.6 x 76.2 cm)
Courtesy of the artist and Feature Inc, New York

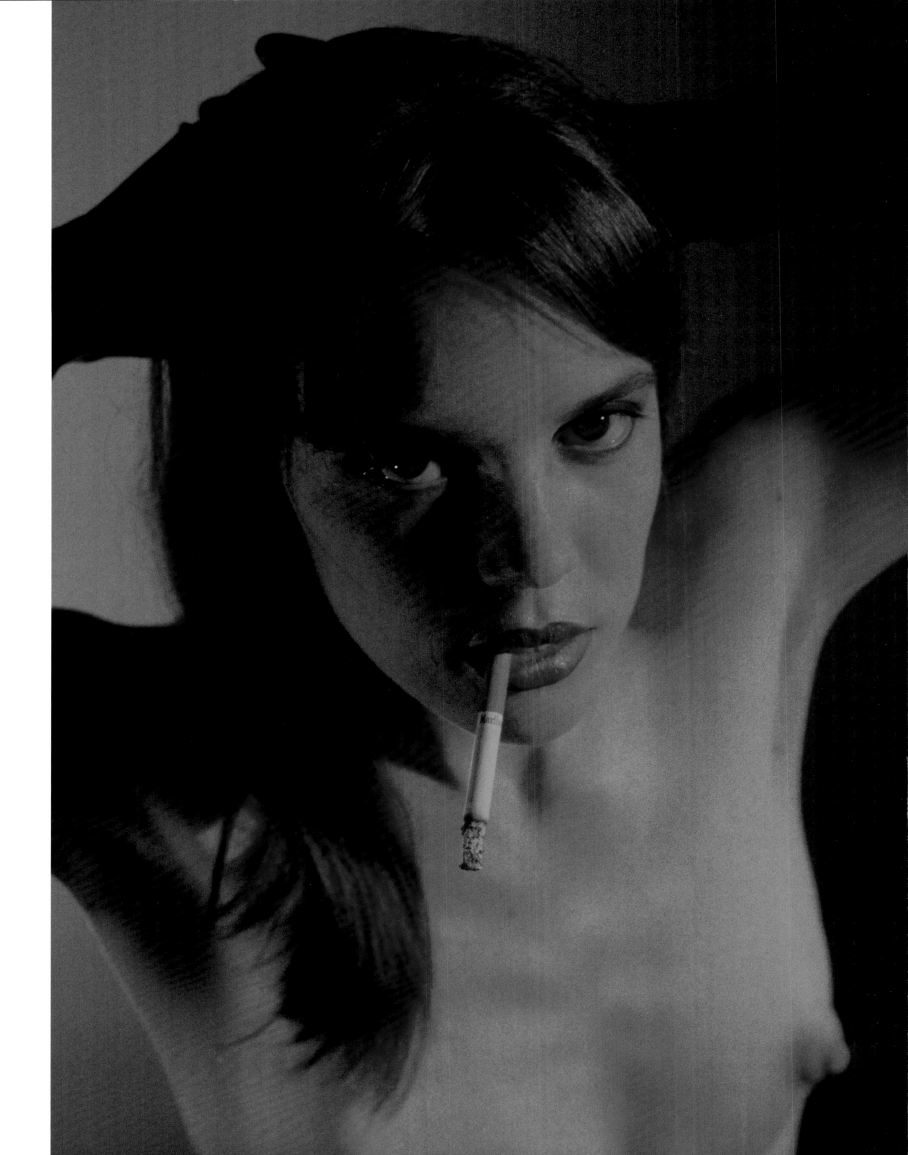

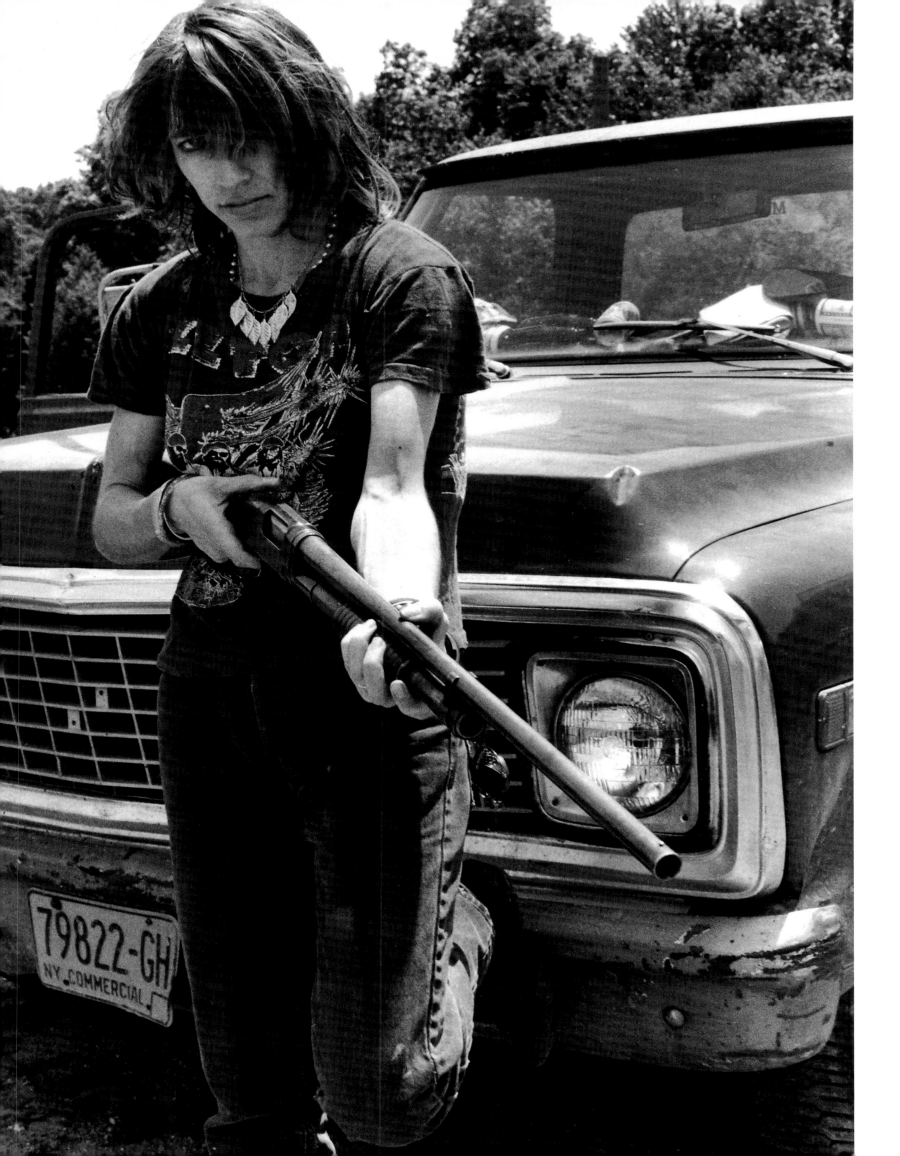

Robert Longo
Untitled (Men in the Cities), 1980
Charcoal and graphite on paper
96 x 60 in. (244 x 152 cm)
Holzer Family Collection, New York
Photo courtesy of the artist and Metro Pictures, New York

FOLLOWING PAGES

Robert Longo
Untitled, 1981
Charcoal, graphite, and dye on paper
96 x 48 in. (244 x 121.9 cm)
Courtesy of the artist and Metro Pictures, New York

Robert Longo
Untitled, 1981
Charcoal and graphite on paper
96 x 60 in. (244 x 152 cm)
Courtesy of the artist and Metro Pictures, New York

43

Robert Longo
Video stills from the Golden Palominos'
"Boy (Go)," 1985
Color video with sound
5 minutes, 30 seconds
Courtesy of the artist

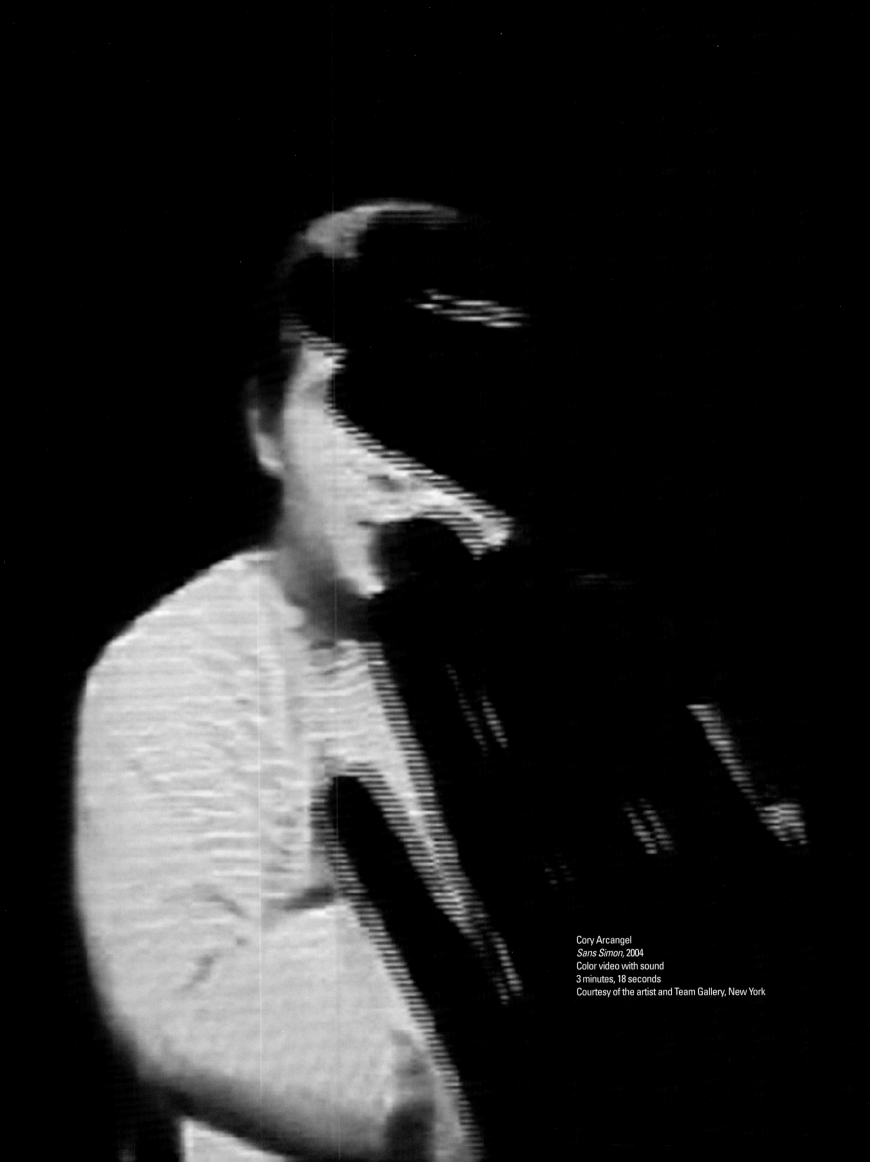

Cory Arcangel
Sans Simon, 2004
Color video with sound
3 minutes, 18 seconds
Courtesy of the artist and Team Gallery, New York

Dan Graham
Rock My Religion, 1982–84
Black-and-white and color video with sound
55 minutes, 27 seconds
Courtesy of the artist

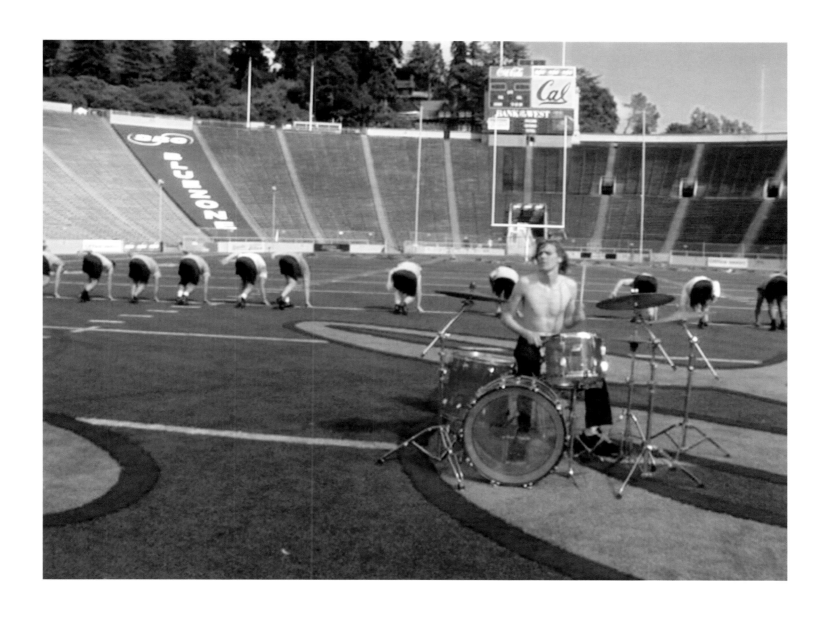

Slater Bradley
The Year of the Doppelganger, 2004
Single-channel color video with sound
4 minutes, 50 seconds
Courtesy of the artist and Team Gallery, New York

Tony Oursler
Sound Digressions in Seven Colors, 2006
Seven-channel video installation with sound
Seven Plexiglas and aluminum projection panels
Each: 72 x 48 x 2 in. (182.9 x 121. 9 x 5.1 cm)
Courtesy of the artist and Metro Pictures, New York
Photo by Tom Powell

Tony Oursler
Sound Digressions in Seven Colors, 2006
Seven-channel video installation with sound
Seven Plexiglas and aluminum projection panels
Each: 72 x 48 x 2 in. (182.9 x 121. 9 x 5.1 cm)
Courtesy of the artist and Metro Pictures, New York
Photo by Tom Powell

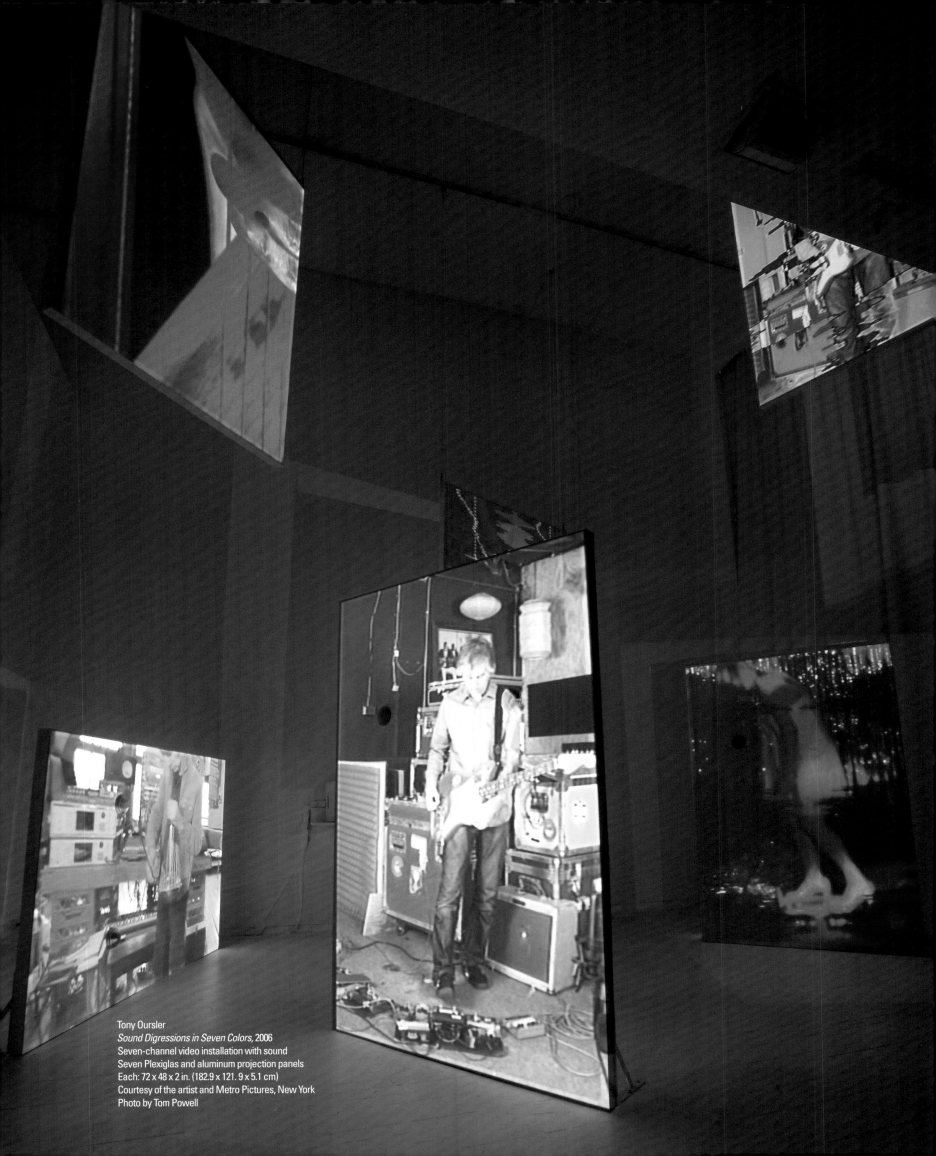

Tony Oursler
Sound Digressions in Seven Colors, 2006
Seven-channel video installation with sound
Seven Plexiglas and aluminum projection panels
Each: 72 x 48 x 2 in. (182.9 x 121. 9 x 5.1 cm)
Courtesy of the artist and Metro Pictures, New York
Photo by Tom Powell

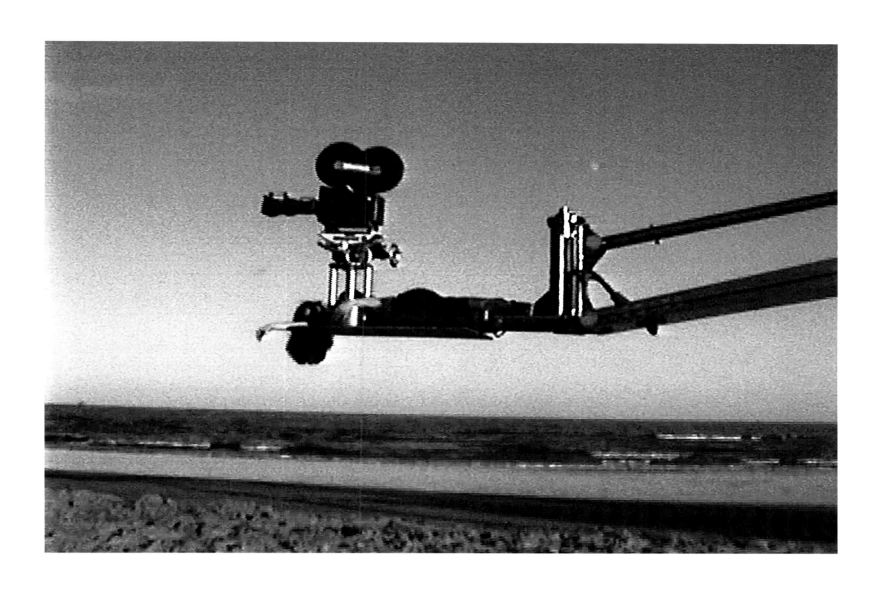

Aïda Ruilova
Untitled, 2002
DVD with sound
58 seconds
Commissioned by ArtPace, A Foundation for Contemporary
Art, San Antonio
Courtesy of the artist; Salon 94, New York; and Greenberg
Van Doren Gallery, New York

Tony Oursler
Storyboard for Sonic Youth's "Tunic (Song for Karen)," 1990
Color video with sound
6 minutes, 17 seconds
Courtesy of the artist

Richard Prince
Portraits, 1984–85
Ektacolor photographs
Each: 24 x 20 in. (61 x 50.8 cm)
Courtesy of the artist and Barbara Gladstone Gallery,
New York
© Richard Prince

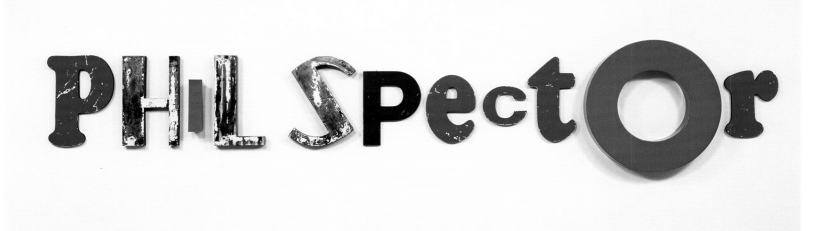

Jack Pierson
Phil Spector, 2007
Metal, plastic, and aluminium
120 x 21⅛ x 3⅞ in. (304.8 x 53.7 x 9.8 cm)
Courtesy of Regen Projects, Los Angeles

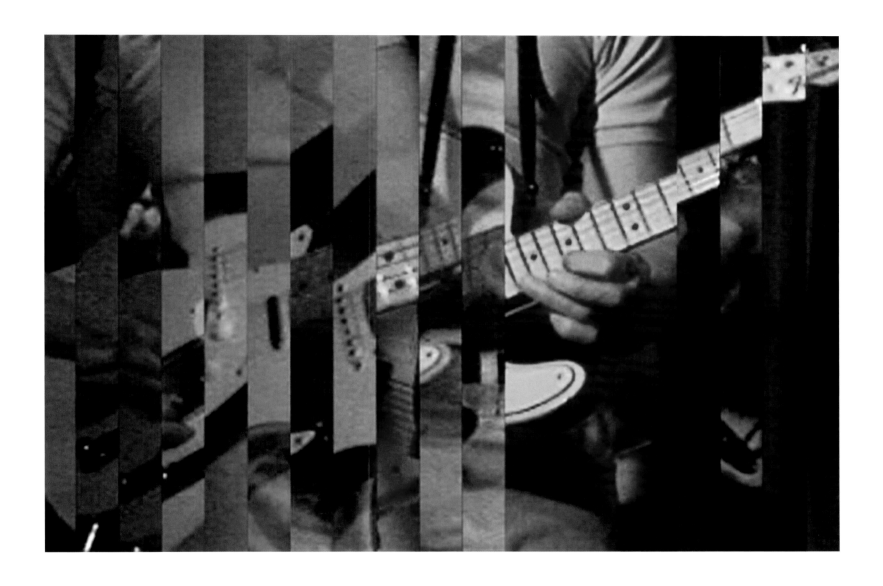

Phyllis Baldino
19 Universes / my brother, 2004
Color video with sound
9 minutes, 2 seconds
Courtesy of the artist

Rita Ackermann
We will skate on shiny shit . . ., 2004
Site-specific wall painting
Installation view, Kunsthaus Baselland, Muttenz / Basel,
Switzerland
Courtesy of Andrea Rosen Gallery, New York

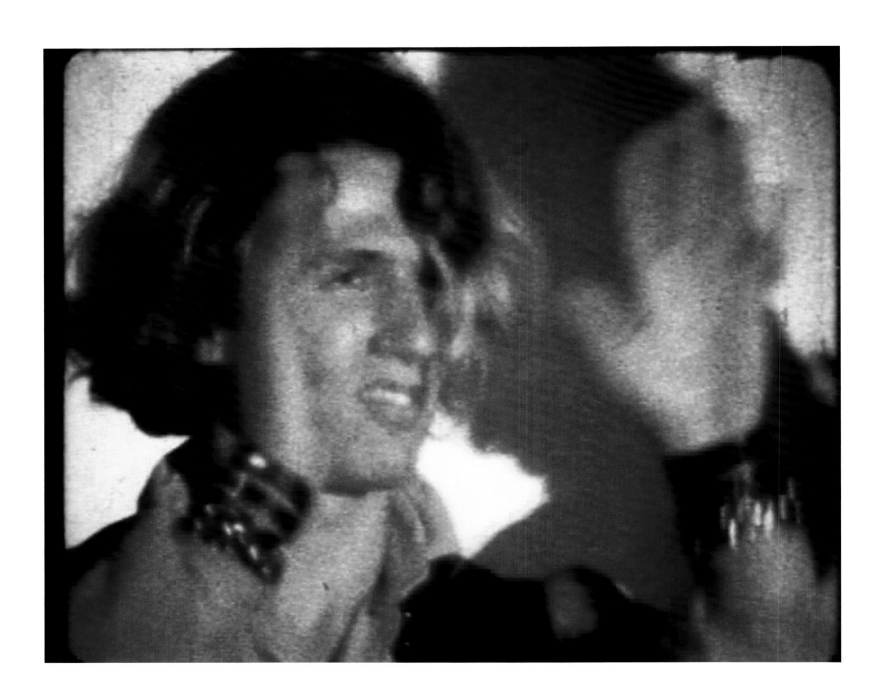

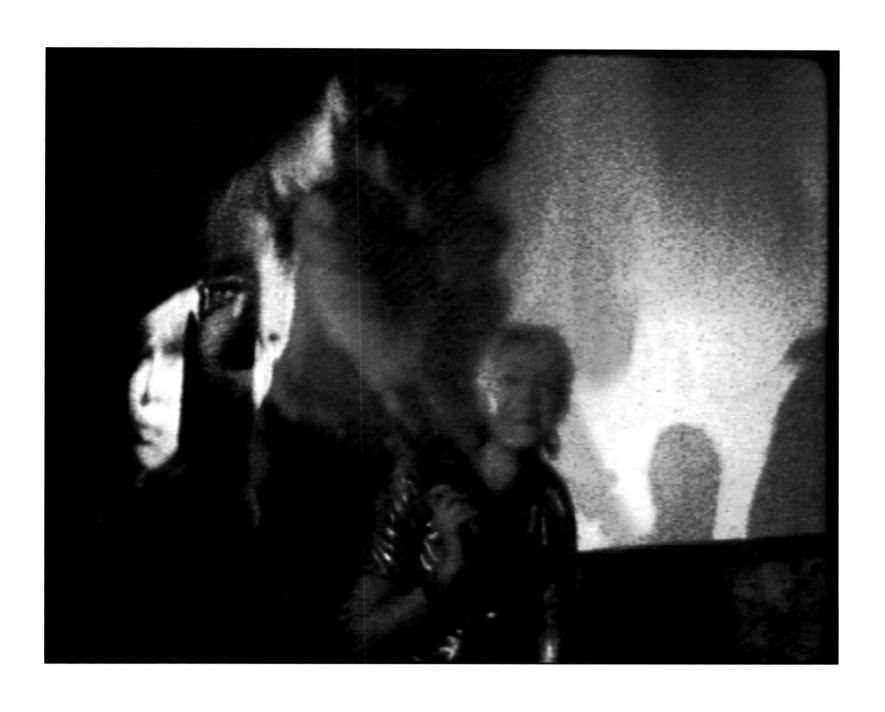

Ronald Nameth
*Andy Warhol's Exploding Plastic Inevitable
with The Velvet Underground,* 1966
Color film
22 minutes
© 1966–2007 Ronald Nameth

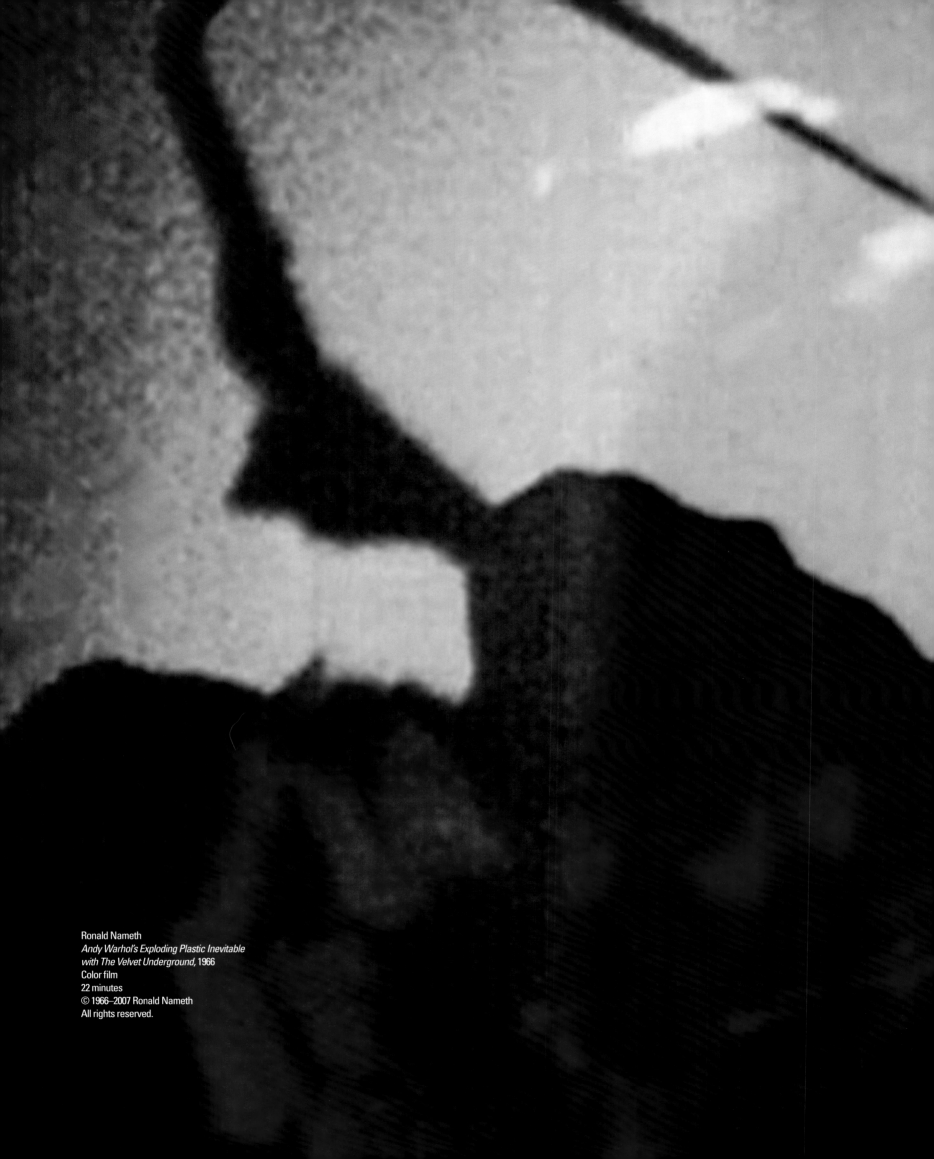

Ronald Nameth
*Andy Warhol's Exploding Plastic Inevitable
with The Velvet Underground,* 1966
Color film
22 minutes
© 1966–2007 Ronald Nameth
All rights reserved.

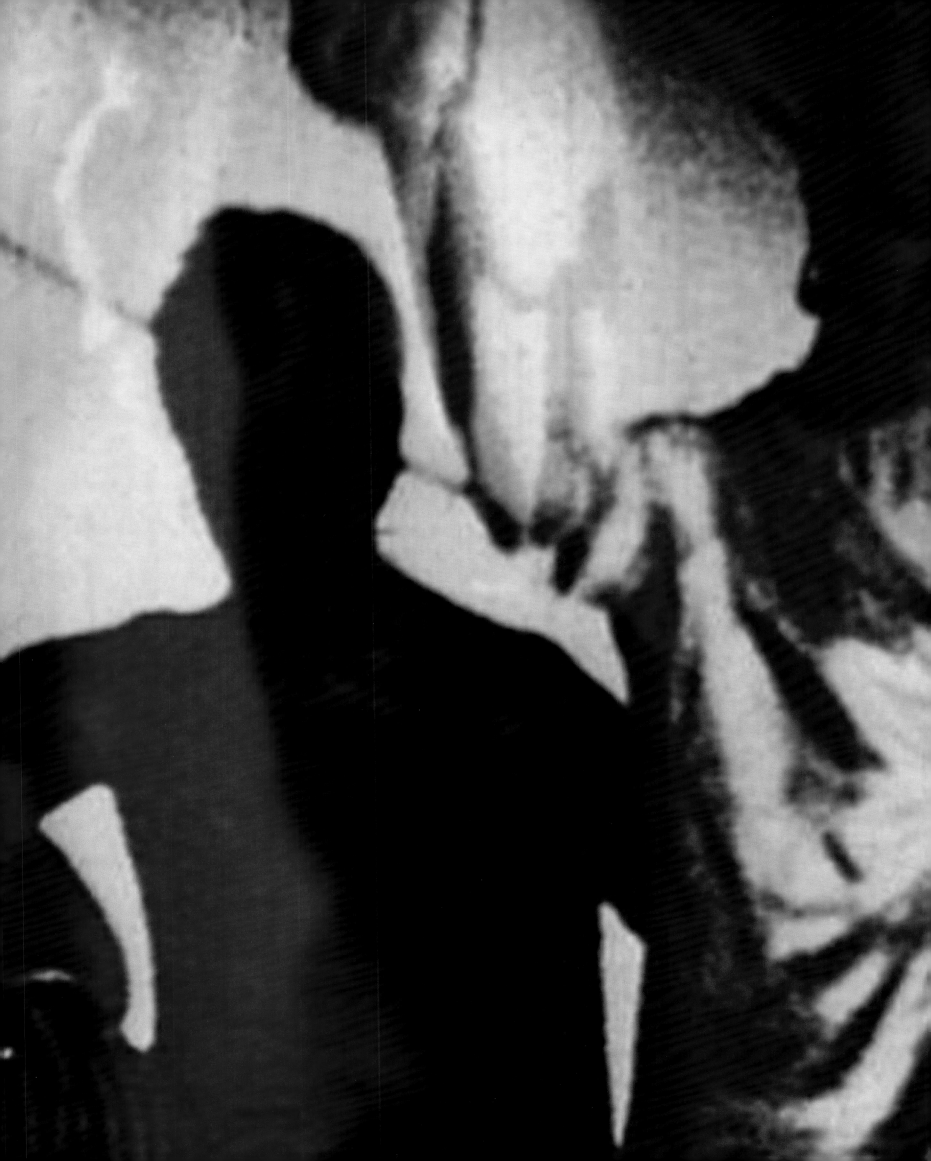

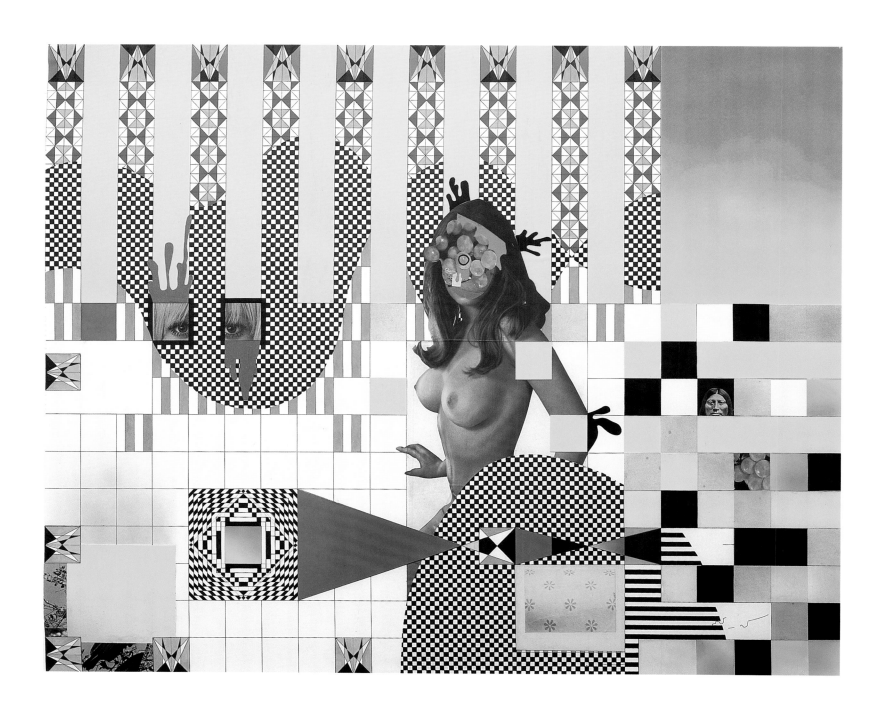

Bjorn Copeland
Money Shot, 2006
Gel pen and mixed media on paper
37 x 49 in. (94 x 124.5 cm)
Courtesy of I. A. S. Icon Art Services

Bjorn Copeland
Vertical Change, 2007
Gel pen and mixed media on paper
49 x 37 in. (124.5 x 94 cm)
Courtesy of China Art Objects, Los Angeles

FOLLOWING PAGES
Adam Pendleton
Sympathy for the Devil, 2006–07
Acrylic on canvas
Ninety parts, each: 30 x 23 ⅛ in. (76.2 x 58.7 cm)
Courtesy the artist; Yvon Lambert, Paris and New York;
and Rhona Hoffman Gallery, Chicago

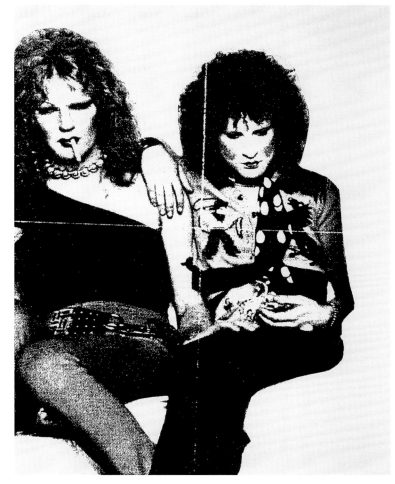

THE UK

In their still unparalleled book on the connections between art and popular music, *Art into Pop*, Simon Frith and Howard Horne stated that the inspiration for the book began with "the observation . . . that a significant number of British pop musicians from the 1960s to the present were educated and first started performing in art schools." They continue, "art school connections explain the extraordinary international impact of British music since The Beatles."[1] Indeed, the fact that The Who's Pete Townshend witnessed artist Gustav Metzger's destruction of a bass guitar while Metzger was guest lecturing at Ealing Art College in the early '60s demonstrates the direct influence that the art school experience had on future rock stars from Britain (other notable figures who attended UK art schools include Eric Clapton, John Lennon, and Keith Richards). Though the influence of British art schools continues to define much of the relationship between art and rock and roll today—Pulp front man Jarvis Cocker recently hosted a three-part BBC radio series discussing the ongoing phenomenon—some of the most interesting and

1. Simon Frith and Howard Horne, *Art into Pop* (London and New York: Methuen, 1987), 1.

influential contributions to this dialogue arose from other circumstances. Britain's status as the other center of the popular music business (besides the United States) prompted the rise of independent movements in the late '70s and into the '80s that were formed in resistance to the economic, geographic, and aesthetically hegemonic nature of the London-based rock music scene. In the early '90s, the mutual explosion of both young British visual artists and rock and pop bands within their respective international spheres of influence was enhanced by the fact that many members from both camps attended the same art schools, and some even collaborated on projects once they achieved levels of fame and recognition. Perhaps the more interesting work, however, continues to be done at present by artists whose relationship with rock music is critical, ambivalent, and iconoclastic.

MADE WITH THE HIGHEST BRITISH ATTENTION TO THE WRONG DETAIL: THE UK

DOMINIC MOLON

The history of the relationship between art and rock and roll in the United Kingdom does, by and large, begin in London with the convergence of artists and rock musicians as part of the Swinging London phenomenon of the mid to late 1960s (memorably represented in Michelangelo Antonioni's 1966 film *Blow Up,* featuring an electrifying performance by the Yardbirds). Pop art and rock music overlapped in a much different manner than they did contemporaneously in New York—whereas Andy Warhol intersected with the already avant-garde–savvy Velvet Underground, his British counterparts Peter Blake and Richard Hamilton both worked with perhaps the most mainstream of all groups, The Beatles. While Blake's cover design for their 1967 *Sgt. Pepper's Lonely Hearts Club Band* album is now legendary (and provides a visual identity for an album that many consider the first to confirm rock music as a serious art form), Hamilton's work on their self-titled 1968 double album pushed the boundary between art and design. Approaching it in his conversations with Paul McCartney as a "limited edition" art project (albeit a limited edition of eight million copies), Hamilton suggested a totally white cover (as the diametric opposite of the Blake cover). Though a concession was eventually made to the record company to emboss THE BEATLES on the cover, the album still featured a poster designed by Hamilton as a collage of personal photographs collected from The Beatles. Another work, *Swingeing London 67 (f)* (1968–69), appropriating a newspaper photograph of lead singer Mick Jagger and art dealer Robert Fraser having just been arrested on drug charges, documents London's intense cultural scene of the time and the commingling of the art and rock music worlds.

The extent of Hamilton's influence beyond his direct involvement with (or citation of) rock phenomena can be seen in the cover art and concept of The Who's 1967 album, *The Who Sell Out.* Complete with fake jingles and commercials linking the tracks, the album featured mock ads for various products with the members of the band as models. More important, one of Hamilton's students in the late '60s, Bryan Ferry, would channel his art school instincts into the formation of Roxy Music, a band that joined David Bowie in defining glam rock in the early '70s. With its emphasis on outlandish costumes, theatrical performances, garishly heavy guitars, and allusions to throwaway pop cultural phenomena, glam was one of the most deliberately visual phenomena to emerge in rock music and produced figures such as photographer Mick Rock and Brian Eno, a member of Roxy Music until 1973 and one of the key popularizers of more experimental sonic pursuits within rock music.

In stark contrast to glam, Mayo Thompson's former Texas-psychedelic band The Red Krayola's collaborations with the Marxist-oriented conceptual art duo Art & Language (comprising Mel Ramsden and Charles Harrison) featured rudimentary instrumentation and flat, off-key vocalizations that espoused interpretations of political theory. Together they produced three LPs: *Corrected Slogans* (1976); *Kangaroo?* (1981), also featuring The Raincoats' Gina Birch, Lora Logic, and Swell Maps' Epic Soundtracks; and *Black Snakes* (1983), as well as two short performance videos—*And Now for Something Completely Different* and *Nine Gross and Conspicuous Errors* (both 1976). Thompson was simultaneously involved with Geoff Travis's Rough Trade independent record label founded in the late '70s, producing early records by Cabaret Voltaire, The Fall, Kleenex, The Raincoats, Stiff Little Fingers, and many other seminal

1. Simon Reynolds, *Rip It Up and Start Again: Postpunk 1978–1984,* (London: Faber & Faber, 2005; repr., New York: Penguin Books, 2006), 171. Unlike Talking Heads, whose quirky accessibility managed to resonate with a broader audience, Wire's resolute singularity consigned them to cult status. Though revered by some of rock music's critically acclaimed elite— Big Black, Fugazi, The Minutemen, to name a few—they are routinely written out of most popular histories of punk, which tend to focus on either the spectacularly controversial Sex Pistols or the overtly political Clash.

2. Ibid., 159.

Contact sheet from Wire, "People in a Room," performance at Jeanetta Cochrane Theatre, London, November 9–12, 1979
Courtesy of EMI and Wire
Photo by Annette Green

groups. Another Art & Language associate made his own contribution to rock history by joining fellow art historian T. J. Clark at Leeds University, where their teachings had a profound influence on avant-punks Gang of Four and The Mekons. Though closely linked at their beginning, the two bands would form distinctive styles, Gang of Four developing an aggressively jagged punk / funk and The Mekons providing a shambling riposte to punk's toothless antisocial posturing.

One of the most critical and influential coalescences of art and music to emerge from England in the '70s was Throbbing Gristle, which formed in 1975. Comprising former members of the transgressive performance art collective COUM Transmissions, Cosey Fanni Tutti, Genesis P-Orridge, and Peter "Sleazy" Christopherson, and later joined by Chris Carter, the band combined aggressive electronic and industrial sounds with subversive lyrical content and a sense of provocation and confrontation that informed both their live performances and overall visual identity. (The name itself is derived from Yorkshire slang for an erection.) Throbbing Gristle pushed social, aesthetic, and musical standards to their limits, with sonic and visual assaults on the audience that evoked Antonin Artaud's "Theater of Cruelty" and the circulation of other forms of communication such as posters, announcement cards, and albums (released on their own label, Industrial Records) that strove to undermine and critique the dominant social structure in a highly sophisticated manner. Their rigorous sonic experimentation and exploration of the more complicated and compromised aspects of humanity made them an influence both on music (with their founding of industrial music, which has now become an accepted genre) and

on visual artists such as Mike Kelley and Lucy McKenzie.

Linder's photocollages of the mid '70s possess a similar sense of intense visuality in their brutal juxtapositions of household objects and situations clipped from magazine advertisements. Her pictorially subversive use of mainstream imagery recalls the work of early-20th-century dadaists such as John Heartfield and Hannah Hoch, or her contemporary Martha Rosler, yet her works are decidedly less politically overt in their intent and affect. One of her most startling images, an athletic nude female torso—with mouths replacing the nipples and a clothing iron for a face—that is diagonally positioned against a white background, was used by the Manchester-based punk band the Buzzcocks for their "Orgasm Addict" single (1977). Linder's images share the energetic and frenetically acidic understanding of mundane life and interpersonal relationships that characterizes much of the punk music that emerged from Britain in the mid '70s. One of the most aesthetically sophisticated groups to emerge from this milieu was Wire, whose members (save for drummer Robert Gotobed) possessed art school credentials. Simon Reynolds has observed that "like Talking Heads, Wire were right at the heart of the punk scene, yet never quite belonged there. They were misfits whose distanced artiness made them distinctive but also rubbed some people the wrong way."[1] With their enigmatically minimalist album covers and often oblique lyrics and song structures, the group played with punk's volume and intensity but replaced its overt politics and posturing with a more cerebrally avant-garde approach. As band member Colin Newman once stated, Wire "wasn't 'arty,' we were doing fucking *art*. Punk *was* art. It was all art."[2] Nothing exemplified this

3. Malcolm McLaren quoted in "Punk and History," in *Discourses: Conversations in Post-modern Art and Culture,* eds. Russell Ferguson, William Olander, Marcia Tucker, and Karen Fiss (Cambridge, Mass. and New York: MIT Press and the New Museum of Contemporary Art, 1990), 225.

4. Greil Marcus, *Lipstick Traces: A Secret History of the Twentieth Century* (Cambridge, Mass.: Harvard University Press, 1989); and Robert Garnett, "Too Low to Be Low," in *Punk Rock: The Culture Legacy of Punk,* ed. Roger Sabin (London and New York: Routledge, 1999), 17–30.

more than their 1979 performance at the Jeanetta Cochrane Theatre in London, featuring mini-performance-art segments by each member of the band and experimentations in their sound that left their audience perplexed.

The still-dominant visual identity of punk is based on the phenomenon that was the Sex Pistols. In many ways the result of impresario Malcolm McLaren's situationist-inspired exercise in creating an aesthetic expression through spectacular social intervention, this more or less musically conventional rock band provided punk with its fashion, graphic design (the now-legendary use of ransom note–like cut-out letters by Jamie Reid), and attitudes. In McLaren's own words the name and concept of the band "came about from the idea of a pistol, a pin-up, a young thing, a better-looking assassin, a Sex Pistol. [I] launched the idea in the form of a band of kids who could be perceived as being bad."[3] McLaren's engagement of the *idea* of a rock band that would function as a work of art in its own right extends from both Warhol and Hamilton, though the band itself would not, arguably, pursue more artistically adventurous terrain until front man Johnny Rotten reverted to John Lydon and formed the more musically daring Public Image Ltd in the wake of the Sex Pistols demise in 1978. Nonetheless, the effect of the Sex Pistols as an aesthetic entity is still felt in the way they have dominated the popular concept of what punk entails and how it is understood visually and intellectually.[4]

In almost absolute opposition to the extravagantly shambling spectacle of the Sex Pistols, was the soberly ascetic visual and sonic identity of the bands and other figures that coalesced around Manchester's Factory Records scene. The label, founded in now-legendary and improbable fashion by talk-show host Tony Wilson, distinguished itself for its radical sense of economic independence and dedication to the supremacy of the artists' vision. This was defined musically by sounds as diverse as Joy Division's intense gothic austerity, A Certain Ratio's funk-laden punk, and Durutti Column's guitar-based explorations, to name a few. Equally important was the graphic design of Peter Saville that provided Factory with its initial image. Drawing on modernist or even classical styles and sensibilities, his posters and album covers exuded a sense of minimalist elegance and grace as an almost jarring riposte to the more impertinently chaotic visuals associated with punk. The ethos of creative freedom and independence that pervaded Factory allowed the self-described "applied artist" Saville to pursue compositional strategies and materials in a manner more in keeping with the fine arts. His two most distinctive and iconic efforts for the label were both for New Order, the new wave band comprising the members of Joy Division after the suicide of their charismatic lead singer Ian Curtis. The cover for the group's international smash single "Blue Monday" was patterned after a floppy disk (and its die-cut design ensured that the label *lost* money on every one sold), while the cover for their album *Power, Corruption, and Lies* (1983) featured the improbable pairing of a classical 19th-century still life by Henri Fantin-Latour and the title of the album and band's name in a futuristic alphabetical color code. Saville's work has been embraced by many figures in the art world whose aesthetic sensibilities were developed in their formative years by his mass-produced minimalism.

A quite different graphic sensibility was developed by Savage Pencil, the nom de plume of illustrator Edwin Pouncey. His wildly stylized drawings for album covers and posters evoke the

provocative physicality of R. Crumb or Chicago imagist painters Jim Nutt and Ed Paschke, as well as the biomorphic nature of abstract expressionist painting. Pouncey's designs for the 1989 Blast First compilation album *Nothing Short of Total War* complemented the gratingly acidic post-punk on the album (by bands such as Big Black, Scratch Acid, and Sonic Youth) with an extravagant black-and-white representation of a postapocalyptic scenario that borrows from the distinctive style of Japanese manga comics. One could consider his graphic design (like the critical writings of Lester Bangs) as moving from design *for* rock and roll to design *as* rock and roll.

The early '90s in the UK were culturally significant for the meteoric rise of young artists in both popular music and the fine arts. Bands such as Blur, Oasis, and Pulp became worldwide sensations with music that wore its Britishness on its sleeve, while artists Douglas Gordon, Damien Hirst, Gavin Turk, and Gillian Wearing (among others) fused the seemingly incompatible strategies of conceptualism and pop art into highly distinctive and memorable works. Hirst has directed a music video for Blur, cut a record with the band's bassist Alex James (as the band Fat Les), and collaborated on paintings with David Bowie, while Gordon, Turk, and Wearing have incorporated rock content to add another dimension to ideas and approaches already operative in their work. Gordon's interdependent trio of video projection works based on illicit concert footage of The Smiths, *Bootleg (Bigmouth)* (1995); The Cramps, *Bootleg (Cramped)* (1995); and The Rolling Stones, *Bootleg (Stoned)* (1995) prompts consideration of a widely, if covertly, distributed visual format that is simultaneously a rare document of a particular event and a testament to the kind of dedication and adulation that

rock stars inspire in their fans. The three video projections are staged in relation to one another to underscore the strikingly different relationship between performer and audience in The Cramps' and The Smiths' footage—the former's lead singer Lux Interior's lewdly profane behavior versus the latter's Morrissey's more beatified and almost sacred presence—and with the split screen footage of the audience from The Stones' notorious 1970 Altamont concert (where four people were killed) as a sort of schizoid limbo in between. Wearing's video displaces the visceral effect of rock music from the arena into the private space in *Slight Reprise* (1995), depicting various people in domestic settings playing air guitar or otherwise physically emoting to their favorite music. *Pop* (1993) by Turk is a life-size wax sculpture of the artist as '70s punk rocker Sid Vicious in a pose that refers simultaneously to Warhol's signature 1963 paintings of Elvis Presley and Vicious's performance in the Sex Pistols' 1980 film *The Great Rock 'n' Roll Swindle.* The artist assumes the role of the doomed punk icon, presumably to suggest that we all possess some degree of Vicious's all-too-human frailty, which he embodied in spectacularly slovenly and tragic fashion, dying drug-addled after possibly murdering girlfriend Nancy Spungen in their hotel room in New York. Encased in glass like a precious museum object, Turk's sculpture is a tribute of sorts to this antihero of rock.

Jeremy Deller's work has consistently explored the ways that everyday people receive mass-distributed pop and rock music and culture and makes them personally meaningful and significant. His *The Uses of Literacy* project from 1997 presented works made by devoted fans of the band Manic Street Preachers, while the more recent *What Would Neil Young Do?* (2006) is a stack

Art & Language and The Red Krayola
Corrected Slogans, 1976
Courtesy of Drag City Records

5. Mark Leckey, *7 Windmill Street W1* (Zürich and London: Migros Museum für Gegenwartskunst and JRP / Ringier and Koening Books, 2003), 19.

of large glossy posters boasting the phrase of the title that functions like Felix Gonzalez-Torres's similar stacked works that exist both as a sculptural mass and a freely distributed takeaway. The work not only seems to answer its own question—suggesting that Young would support the democratic politics of the work's function—but also riffs the popular American bumper stickers "What Would Jesus Do?" by offering the Canadian-born rock star as a more realistic and appropriate figure for one to identify with.

Scott King's collaboration with Kevin Cummins, *Futurama* (2004), combines the design instincts of the former, the definitive rock photography of the latter, and the enduring cult status of the aforementioned Joy Division lead singer Ian Curtis. King, who alternates between graphic design and fine art practices, was working on a yet-to-be published book of Cummins's photographs of Joy Division and was compelled to make a work that reflected his feelings of connectedness and identification with Curtis through the images. In the work, three images from Joy Division's 1979 performance at the Futurama rock festival in Leeds are blown up to monumental size with bold white strokes emphasizing the wild movements of the singer (thought by many to be a side effect of his epileptic condition). *Futurama* evokes the often larger-than-life role of rock stars in many people's lives while celebrating Curtis as one of the first figures to champion sounds and subjects in rock and roll representing darker and more existentially bleak aspects of the human condition.

Jim Lambie's works occasionally refer to Joy Division in their titles yet also celebrate the broader range of rock and roll in their translation of the intangible energy, style, and emotional and physical intensity of the music into sculptural form. His signature *Zobop* installations activate the floor of a given space through the use of colored electrical tape, while other works repurpose everyday objects such as doors, sneakers, mirrors, spray paint cans, beds, and items of clothing (along with virtually anything else within reach) into new material experiences that often allude to the sensibilities of punk, glitter and glam, funk, and psychedelic rock, as well as disco. Lambie's abstract intimations of rock subcultures appeared concurrently with Mark Leckey's more pointed and specific explorations of these sociocultural phenomena, particularly in Leckey's renowned 1999 video *Fiorucci Made Me Hardcore,* a visual history of the changing clothing and dance styles of the various subcultures that had emerged throughout London over the previous two decades. While the footage ranges from scenes in northern soul clubs of the early '70s to hardcore raves in the early '90s, it is the style of The Casuals that Leckey singles out in a related text on the work. A phenomenon of the late '70s and early '80s, The Casuals were part of a football hooligan subculture "dressed in luxurious sportswear, such as Ellesse, Cerrutti, Head, and in Lacoste and expensive golf wear, like Pringle and Lyle and Scott." Their sense of style "was designed to dazzle—both with its luxury and its displacement—and in the glare the casuals could move freely and unhindered, like models shoplifting."[5] Leckey's intense, pulsating soundtrack combines various musical styles and sensibilities and reflects his active role performing in the bands donAteller and Jack Too Jack.

Steven Claydon is another member of Jack Too Jack—and formerly the electronic rock band Add N to (X)—who has distinguished himself as a visual artist. His visual work draws on the often overlooked historical moments when

art and politics merged, such as the early 20th-century British movement Vorticism led by Wyndham Lewis, as well as other moments when music entered the equation. Claydon's *Extinction* (2005) is characteristic of his deliberately antiquated-looking work, depicting what appears to be an extinct bird in the lower-right-hand corner and celestial forms such as the planet Jupiter and the moon the size of an LP, a 7-inch record, and a compact disc. His painting is a witting take on how recorded music formats periodically become obsolescent, comparing their fate to either birds of yesteryear such as the dodo or the inevitable (though only in the almost inconceivably far future) "extinction" of the planets and moons of our solar system.

The title "Made with the highest British attention to the wrong detail" is from The Fall song "The Classical" on the album *Hex Enduction Hour,* 1982, Resurgent.

ONO, ENO, ARTO: NONMUSICIANS AND THE EMERGENCE OF CONCEPT ROCK

SIMON REYNOLDS

Art school bands were legion in the 1960s, especially in the UK. But what's striking is the minimal extent to which art ideas affected the actual practice of music. The artiness in '60s rock tended to have more to do with the way groups presented themselves or packaged their records, along with a generalized bohemian and romantic sensibility that enfolded the music. So while Pete Townshend borrowed the idea of guitar-smashing from Gustav Metzger's auto-destructive art, and the influence of the British school of pop art suffused *The Who Sell Out,* the actual substance of The Who's music remained amped-up rhythm and blues. Dilettantism was frowned upon; '60s rockers struggled to attain virtuosity and showed great reverence for the craft of R&B, folk, and so forth. When '60s rock did go progressive, the catalyst came not from modern art but from other forms of music—the post-Coltrane directions in jazz, Indian raga, musique concrète, and avant-classical electronic composers like Karlheinz Stockhausen. Often, the "innovations" in rock actually came from going back to the pre-rock era, whether it was music hall with The Beatles or, increasingly, pre-20th-century classical music (rock opera, as with The Who's *Tommy*). As for the concept album, it owed nothing to conceptual art and everything to literature.

The first figures to bring art ideas right into the heart of their music-making were Yoko Ono and Brian Eno. Although both made their ground-breaking work in the late '60s and early '70s, their actual influence came through most strongly during the post-punk period of the late '70s (not coincidentally the single greatest phase of art school students forming

bands). Ono was generally scorned at the time. Eno was widely interviewed on account of being the most flamboyant, eloquent, and intellectually engaging member of Roxy Music, but the ideas he aired went against the grain of the early '70s, the age of progressive rock, and only achieved wider fruition after punk.

Ono's first interventions in rock were a series of records with John Lennon that were basically concept art wrought with sound: *Unfinished Music #1: Two Virgins* (1968), *Unfinished Music #2: Life With The Lions* (1969), and *Wedding Album* (1969). The opening track on *Life With The Lions,* "Cambridge 1969" is a live performance at Cambridge University, nearly half an hour of Ono screaming over Lennon's feedback guitar; the second side of the album includes "Two Minute Silence," the first of several art-rock homages to John Cage's "4:33," and "No Bed For Beatle John," on which Ono recites, Gregorian chant–style, various newspaper articles about the couple. *Wedding Album* continued this ploy of using Ono and Lennon's celebrity as its raw material: "Amsterdam," which takes up the entire second side, comprises interviews, conversation, and found sounds taped during the couple's "bed-in" honeymoon / peace protest.

Ono's next forays into recording, *Yoko Ono / Plastic Ono Band* (1970) and *Fly* (1971), were closer to (finished) music, but still highly conceptual. At a time when rock was becoming ever more obsessed with sophistication (subtle playing, ornate arrangements, densely overdubbed production), Ono and partner Lennon staged a self-conscious return to the primitivism of early rock and roll. Ono declared her goal to be a com-

1. Yoko Ono, interview by Joy Press, *The Wire*, no. 146, April 1996, http://www.thewire.co.uk/archive/interviews/yoko_ono.html.

2. Lester Bangs, *Psychotic Reactions and Carburetor Dung*, ed. Greil Marcus (New York: Knopf, 1987; repr., New York: Anchor Books, 1988).

3. Brian Eno, interview by Lester Bangs, *Musician*, November 1979, http://music.hyperreal.org/artists/brian_eno/interviews/musn79.html.

4. Eno, profile by Ian MacDonald, *New Musical Express*, November 26, 1977, http://music.hyperreal.org/artists/brian_eno/interviews/nme77a.html; and Axel Gros, *East Village Eye*, summer 1981.

5. See note 3.

bination of the "strong heavy beat"[1] of rock at its most repetitive and mind-evacuating, with abstract vocalization influenced equally by free jazz and the primal scream therapy that the couple were exploring. Similar ideas of "going back" and stripping down were being mooted by critics like Lester Bangs,[2] who was then starting to espouse the heresy that the crude garage punk of bands like the Troggs and Count Five was superior to *Sgt. Pepper's* and *Disraeli Gears*. Unlike the mid '60s garage bands, who were unable to play anything beyond rudimentary rock, Ono got superbly skilled musicians (Eric Clapton, Ringo Starr, Lennon himself) to play like brain-dead gorillas wearing oven mitts. As an example of conscious regression, *Plastic Ono Band* has as strong a claim as The Stooges' debut album to be the seminal proto-punk record. Ono's contribution to the racket was her abstract vocalese, a searing shriek that anticipated and influenced post-punk women singers like Lydia Lunch, Siouxsie Sioux, The Slits' Ari Up, China Burg of Mars, and Linder of Ludus.

Eno's own brand of proto-punk primitivism was equally conceptual. Proudly describing himself as a "nonmusician"[3] in the countless interviews he did for Roxy and then as a solo artist, Eno espoused a defiantly dilettante approach to rock that ran counter to the reigning valorization of instrumental technique in progressive rock. Eno's approach was markedly different from Ono's, however; he had neither her political and feminist commitments nor her belief in expressionism (which in the spirit of the '60s tended to equate "truth" with the presocialized, the childlike or animalistic). Ideas, Eno argued, counted for far

more than craft. But they also counted for more than passion, emotional content, and expressive intent.[4] If Ono was a proto-punk, angry and anguished, Eno was proto-postpunk: his critique of rock's fixation with authenticity and passion anticipated the postpunk interrogation of "rockism." But in another sense, Eno's impulse wasn't anti-rock so much as an attempt to liberate certain potentials in the music. Eno aimed to bypass rock's ego drama, its adolescent (as he saw it) theater of rebellion, and to focus instead on its noise and its mechanistic insistence ("idiot energy,"[5] he called it), along with its infringements of taste, logic, and proportion (the insanity, clumsiness, and grotesqueness he valued in Roxy Music, and which faded away after he was expelled from the group). Eno's atonal blurts of synth-noise and tape experiments on the first two Roxy albums inspired a generation of post-punk musicians who wanted to explore electronics but bypass the pianistic strictures of the keyboard synthesizer.

Where Ono was a well-known artist before she entered pop music, Eno achieved fame only through music. But his whole approach to music was shaped by his late '60s stint at Ipswich Art College, where he assimilated a sensibility that merged playfulness and detachment. One of his teachers, Roy Ascott, put the students through a disorientation process in order to knock all the romanticism out of them. "Process not product" was the slogan of the day, with the artwork seen merely as the residue of the procedure. What came out of these ideas was a validation of dilettantism, in the sense that people conceived of themselves as artists first in an almost abstract or intransitive sense, and the

choice of a specific medium to work in was secondary, provisional, and usually temporary. Attitude and concepts mattered more than technique or commitment. "Everybody thought they could do anything," Eno recalled of the Ipswich ferment. "Painters could compose music, bricklayers could do happenings, prostitutes could write operas. . . . Most of all what it said to me . . . is that 'At this moment of time there isn't a received container for what you want to do, there isn't a category into which you automatically fit. So though we are called a painting college, part of your job here is to find out what medium you want to work in.' . . . We had one student there who was knitting, that was her work, and another who did performances with a violin on a tightrope."[6]

Later, in the early '70s, as a frequent visitor to a similarly free-form art college, Watford, Eno collaborated with the painter-tutor Peter Schmidt to create the Oblique Strategies,[7] a pack of cards that offered koanlike instructions and lateral-thinking suggestions and were carefully worded to help artists by jolting them through impasses or loosening creative blocks: "Honour thy error as a hidden intention," "Turn it upside down," "Into the impossible," "Is it finished?," etc. Some of the oblique strategies emerged first as functioning principles within Eno's own music-making: the tape-delay systems used to create his solo album *Discreet Music* and the Robert Fripp–Eno collaborations like *No Pussyfooting,* for instance, were incarnations of the Oblique maxim "Repetition is a form of change." One of the instructions, "Change instrument roles," would actually be adopted (or, more likely, independently discovered) by postpunk musicians, with certain bands keeping things fresh by having members swap instruments onstage.

As well as being a conduit for a certain '60s British art school sensibility into rock, Eno was also a key figure in the emergence of a painterly approach to recording. Along with Robert Wyatt and Pink Floyd, he was in the vanguard of exploring the textural and spatial possibilities opened up by the recording studio. In his interviews and writings, there is a consistent impulse to translate sound into the visual register, whether talking about tape as a kind of canvas onto which you can daub layer after layer of sound, or characterizing his productions of groups like U2 as the creation of a landscape in which the songs happen. The essence of record production, for Eno, was its departure from real time: instead of recording a musical event, one builds up a phantasmagorical pseudo-event that could never have happened as a discrete performance in time. Sound-tinting effects and treatments opened up a fantastical palette of timbres; stereo placement, panning, and reverb created the audio equivalent of perspective and allowed for all kinds of fictional or Escher-like spatialities; cutting and splicing and tape loops achieved effects midway between collage and time travel. Briefly out of favor during the convulsion of punk (where his Zen-infused detachment went against the fire and ire of the day), Eno became a central figure again during post-punk, when the music grew more open-ended and experimental. He became one of the major producers of the era, working with Devo and Talking Heads and convening the four principal No-Wave bands in 1978 for the scene-defining compilation *No New York.*

6. Eno, conversation with David Toop, *Sonic Boom: The Art of Sound,* Hayward Gallery, London, May 2, 2000, http://home.iprimus.com. au/dcitizen/index.html?eno_int_sonicboom-may00.html~frameHOME.

7. See Oblique Strategies, http://www.rtqe. net/ObliqueStrategies/OSintro.html; and http:// www.apple.com/downloads/dashboard/reference/oblique.html.

8. Mark Cunningham, interview with the author, 2004.

What follows are case studies of four postpunk artists (or in the first case, a scene) exhibiting the influence of art schools on rock music to a striking—and strikingly different—degree.

1. NO WAVE

A couple of years prior to *No New York,* Eno briefly worked with Television, one of the principal first-wave New York punk bands. The demos turned out disastrously, though. It was a clash of sensibility: the original CBGB punk groups—Television, Patti Smith Group, Richard Hell and The Voidoids—were fundamentally literary, pursuing a vision of poetry fused with rock and roll (Smith called her style "Rimbaud and Roll"; Television's front man–lead guitarist named himself Tom Verlaine). Eno's sensibility came from the plastic arts rather than literature; indeed he rejected rockist ideas of expression torn from the heart and soul, often forming his lyrics out of nonsense babble.

Eno got on infinitely better with the No-Wave groups. The scene was crammed with art school polymaths, Eno-like dilettantes happily dividing their energies among art, filmmaking, being in bands, you name it. DNA's Arto Lindsay and Mars's Mark Cunningham and China Burg had all studied at Eckerd College in Florida, a liberal arts school with a similar free-form atmosphere to Ipswich. Mars drummer Nancy Arlen was a plastic resins sculptor, while guitarist Sumner Crane was a Renaissance man equally interested in experimental music, abstract painting, and philosophy. The group's approach to making rock was stringently conceptual, "a countdown from 10 to 1"[8] where each step involved shedding one of the conventions of rock

and roll, such as unified tempo or tonality. Years before Sonic Youth (massively influenced by Mars) coined the term "reinvention of the guitar," Mars experimented with detuning the instruments, retuning within songs, and using the guitar percussively. Toward the end of Mars's brief but ultra-intense existence, Crane (an accomplished blues guitarist who chose to mutilate his own talent) was generating noise by manipulating the guitar jack. The twin screaming of Burg and Crane massacred melody, while the lyrics explored various states of psychosis and disassociation.

DNA was partly defined by leader Arto Lindsay's desire to sound as little like his friends Mars as possible. Instead of the latter band's wall of noise, DNA devised a skeletal sound full of stops and starts. Later, when a more conventionally skilled musician—bassist Tim Wright, formerly of Pere Ubu—joined, DNA developed a groove aesthetic, albeit still fitful and fractured. But the outfit was at its most radically arty and antimusical in its earliest incarnation, featuring Robin Crutchfield on keyboards. Crutchfield was a performance artist recruited by Lindsay not for any musical ability but rather because of a widely circulated photograph of one of his theater pieces. An image of Crutchfield—garishly made-up, with dozens of miniature genderless plastic baby dolls attached by adhesive tape to his bare flesh—appeared in Toronto's *File* magazine and was included in a box of artists' postcards put out by Vancouver's Image Bank. Crutchfield's approach to playing the keyboard involved virtually transposing a visual arts logic to music: "I relate to the piano sculpturally, pretty much in patterns of black and white,

in groups of two or three keys, and I see these symmetrical patterns on the piano and I work a lot with that!" he explained in a 1978 interview. "Sometimes it doesn't sound good to the ear but it's a real nice geometrical pattern I'm using."[9] Lindsay himself uses visual metaphors to describe his approach to guitar-playing: "It was sculptural as opposed to painterly, shapes that poked out at you, rather than a surface."[10] His singing split the difference between Ono-esque voice-jazz freak-outs and Eno's syllable-rhythm gibberish. Completing the trio, Ikue Mori was a novice at the drums, teaching herself to play by listening to Brazilian percussion records and drawing on her memories of the bombastic rhythms of Japanese court music, resulting in drum patterns that utterly scrambled rock's rhythmic logic.

2. THROBBING GRISTLE
No Wave was influenced by the extremist artists of the late '60s and early '70s, figures like Fluxus, the Living Theatre, the Viennese Aktionists, and Vito Acconci, whose work involved audience confrontation and artist suffering. Before Throbbing Gristle, three members of the group—Genesis P-Orridge, Cosey Fanni Tutti, and Peter "Sleazy" Christopherson—had been exponents of this sort of taboo-busting "total art" under the name COUM Transmissions. A sort of post-hippie commune / performance art troupe, the outfit made a name for itself on the European art circuit, becoming adept at securing British Arts Council grants and invitations to galleries and festivals. Performances involved live sex, various vile fluids and gross substances (used tampons, urine, chicken heads), and disturbing ritualis-

tic acts (injecting blood into a black egg, for instance). When they started to feel stifled by tolerance (art audiences were increasingly unshockable), COUM decided to infiltrate the popular music arena and named itself Throbbing Gristle after a Yorkshire expression for the male erection.

Inspired by the The Velvet Underground and '60s freak acts like the The Fugs, Throbbing Gristle exhibited an Eno-like contempt for technique. Singer Genesis P-Orridge declared, "The future of music lies in non-musicians."[11] Although they started at the same time as the Sex Pistols and the Clash, Throbbing Gristle argued that punk rock wasn't radical enough. "Here's three chords, now start a band," the do-it-yourself clarion call of *Sniffin' Glue* fanzine, already conceded too much to tradition, said P-Orridge in 1977. "You can start with no chords. Why not just say 'form a band and it doesn't matter what it sounds like or whether you even make a noise, if you just stand there silent for an hour, just do what you want.'"[12] In a later interview he recalled how the band at its inception consciously reversed rock's value system: "'Let's not have a drummer because rock bands have drummers. Let's not learn how to play music. Let's put in a lot of content—in terms of the words and the ideas.' So normally a band would be music, skill, style, and all those other things—we threw away all the usual parameters for a band and said, 'Let's have content, authenticity, and energy. Let's refuse to look like or play like anything that's acceptable as a band and see what happens.'"[13]

Probably influenced by ex–Velvet Underground main man Lou Reed's 1975 feedback opus *Metal Machine Music,*

9. Robin Crutchfield, interview, *Search & Destroy,* no. 7, 1978, reprinted in *Search & Destroy, 7–11, the Complete Reprint: The Authoritative Guide to Punk Culture,* ed. V. Vale (San Francisco: V / Search, 1997), 9.

10. Arto Lindsay, interview with the author, quoted in Simon Reynolds, *Rip It Up and Start Again: Postpunk 1978–1984* (London: Faber & Faber, 2005; repr., New York: Penguin Books, 2006), 65.

11. Genesis P-Orridge, letter to *Frendz* magazine, no. 28, 1971, quoted in Simon Ford, *Wreckers of Civilisation: The Story of COUM Transmissions & Throbbing Gristle* (London: Black Dog Publishing, 1999); cf. Throbbing Gristle, interview, *The Wire,* July 2007.

12. Throbbing Gristle, interview by Sandy Robertson, *Sounds,* November 26, 1977.

13. P-Orridge, interview by Johnny Victory, *Voltage* fanzine, date unknown.

14. Green Gartside, interview with the author (February 2005), *Uncut,* April 2005.

15. Gartside, interview by Michael Bracewell, *Guardian,* July 1999, http://www.aggressiveart. org/sp_uk/interviews/spuk_1999_2.htm.

16. See note 14.

Throbbing Gristle's antirock emphasized noise (the band used guitars and basses as tools to generate atonal glissandos or percussive detonations) and the mechanistic (simple programmed rhythms pitter-pattered under the cacophony). Everything—instruments, voices, found sounds—was fed through a battery of effects, treatments, and self-built sound-mangling devices such as the Gristleizer. Live, the noise hit the audience as an assaultive barrage, and early on provoked genuinely aghast and riotous responses, but inevitably fell foul of the shock art trap, whereby the artist ends up screeching at the pre-converted.

Although the rhetoric of nonmusicianship and the interest in sound manipulation recalled Eno, TG's sensibility and intent were very different. The sick humor (macabre and morally deadpan songs about murder, burn victims, and so forth) and punitive sound were a world away from Eno's playful gentleness and gentility. Above all, Eno was a formalist, whereas Throbbing Gristle was obsessed with content. P-Orridge repeatedly stressed that he was a writer and a thinker, not a musician, and that TG members weren't primarily concerned with music or musical technique. It just happened that "organized recorded sound" was what they had chosen as the medium for their "propaganda." Music was relegated to a delivery system for ideas.

3. SCRITTI POLITTI
When Scritti's singer-guitarist-songwriter Green Gartside checked out UK art colleges in the mid '70s to see which one to apply for, he was most impressed by Leeds Polytechnic's Fine Art department. COUM Transmissions–style perfor-

mance art was all the rage, and wandering around the college he saw students exhibiting for their degree show: "There was one room where a chap was making himself vomit, and the next room someone was shooting budgerigars."[14] Arriving at Leeds the next autumn, he looked forward to learning about the reasoning behind the radicalism, only to be brutally disappointed. "Called upon to explain or defend themselves, they couldn't. They were just fucking around, basically—which I thought was a waste of time."[15] In response, Gartside started a kind of counter-curriculum, putting on a lecture series that often involved members of Art & Language, a collective who had given up making artworks and generated instead an intimidating torrent of text, much of it devoted to tearing apart other artists. "I was encouraging all these people to come and basically say what was going on in our faculty was a crock of shit and everybody was wasting their time."[16] Art & Language's gambit of abandoning praxis for pure theory was the logical development of conceptualism: ditch the art-making, keep the concepts—the idea being that before you did anything you ought to work out what was valid. Gartside followed suit, ceasing to paint and presenting his tutors only with writing.

This argumentative and ultra-conceptual approach carried through to Scritti Politti, a band inspired by the Clash and other first wave punk bands but soon to develop a stern and unsparing critique of punk rock and rockism. After moving from Leeds to London's squatland, the three-man core of the band gathered around itself a sprawling collective of like minds who were considered part of Scritti even though they didn't contrib-

ute musically. The group held regular meetings in which the twenty-strong think tank discussed ideas with feverish intensity. Some of these associate members formed their own post-punk outfits, such as the Janet and Johns and Methodishca Tune, but many contributed purely through adding to the ferment of debate and dissension.

Do-it-yourself and demystification were the buzzwords of the era, and Scritti signaled their commitment to the anyone-can-do-it ethos by including detailed information about their means of production on their record artwork: the costs of recording, mastering, labels, sleeves, and addresses and phone numbers for companies that provided those services at budget prices. Another demystifying gesture was Scritti's practice of making up songs on the spot during live performances, an exercise that Gartside later described as "very draining . . . because I would be nervous enough about playing live anyway. To do that and to foolishly set yourself the task of making songs up as you went along was pretty unnerving, and it took its toll."[17] At one gig, every second tune was totally improvised.

In its simplest form, DIY privileged content over form: the idea being that punk was a time of great urgency and those who had something to say didn't need to pay their dues or develop their skills to a certain level before seeking an audience. Scritti certainly valorized the idea of content (one of Gartside's deadliest insults was "formalist," used to denounce art-for-art's-sake experimentalism of the Eno sort). But their idea of do-it-yourself was highly sophisticated, going well beyond the message-over-medium attitude that saw punk as pro-

test with a beat. Scritti's was a kind of antiformalist formalism. If, as Theodor Adorno argued, form is "sedimented content," Scritti's music—with its dismantled and exposed structures, its gaps and failings, loose ends and stray noises—constituted a kind of de-sedimentation process. At a primary level, this "scratching, collapsing, irritated, dissatisfied"[18] sound served to dramatize the idea of musical democracy and stage a rejection of professionalism and song craft. But the fragmentation also paralleled the lyrical content, riddled with political doubts and alert to contradictions as it was. "We were anti-rock, because rock was too solid, too strong, and too sure a sound," Gartside recalled. "We wanted a music that wasn't strong, solid, and sure, because we weren't strong, solid, or sure."[19] Before playing the song suite "Windows" at a gig in 1978, Gartside explained to the audience, "This one falls to pieces on purpose."

In Scritti Politti's early music there is a fascinating struggle between Gartside's gifts as a pop melodist and his ideologically driven suspicion of beauty itself as counterrevolutionary, bourgeois in its analgesic and soul-soothing effects. On the song "PAs," from 1979's *4 A Sides* EP, one line asserts "Good tunes are no better than bad tunes." "Bibbly-O-Tek," on the same EP, features Gartside's multitracked voice, but instead of dovetailing harmonically as in classic rock multitracking, the voices compete for your attention with different melodies and lyrics running simultaneously; meanwhile, the funk groove periodically collapses, then reconstitutes itself. "Messthetics" was how the group dubbed the sound, although by the time they wrote the song of the same name,

17. Gartside, interview by Tony Horkins, *International Musician and Recording World*, July 1984, http://www.aggressiveart.org/sp_uk/interviews/spuk_1985_12.htm.

18. See note 14.

19. Ibid.

20. Fred Vermorel, *Vivienne Westwood: Fashion, Perversity, and the Sixties Laid Bare* (New York: Overlook Press, 1996), 183.

21. Ibid.

22. See *Leaving the 20th Century: Incomplete Work of the Situationist International,* trans. and ed. Christopher Gray (London: Free Fall Publications, 1974; repr., London: Rebel Press, 1998).

23. Malcolm McLaren, interview on *The South Bank Show,* Thames TV, London, 1984, quoted in *Impresario: Malcolm McLaren and The British New Wave,* exh. cat. (New York: New Museum of Contemporary Art; Cambridge, Mass.: MIT Press, 1988), 21.

the willfully fractured DIY sound had already become a highly conventionalized subgenre of post-punk, and the song is ambiguously pitched between anthem and witheringly sardonic parody. After an illness-enforced hiatus and a period of intense theoretical reflection, Gartside renounced the early Scritti messthetic as a misconceived and self-defeating strategy and remodeled Scritti as a pop outfit. He was convinced that the perfection of mass music commodities contained its own utopian potential, while also believing that he could write songs that simultaneously worked as love songs and surreptitiously deconstructed the lover's discourse. The singer who had once decried the whole pop system of competition between bands became a pop star obsessed with scoring hit singles.

4. MALCOLM McLAREN

Where Scritti's Gartside approached music-making in a wary, ideologically vigilant, and deeply conflicted manner, and TG's P-Orridge treated music as mere vehicle for content and intent, Malcolm McLaren's involvement in pop is characterized by an indifference verging on contempt for music qua music. According to his old friend and fellow art student, the writer and pop biographer Fred Vermorel, this attitude was acquired during McLaren's stints in the British art school system (he attended three different art colleges over the course of eight years). In the bohemian milieu in which he and Vermorel moved, music in general and pop music in particular were held in low regard. One of their tutors, the art historian Theodore Ramous, counseled his students that "musicianship was for the more stupid kinds of artist."[20] Vermorel asserts that

"before he resigned himself to the fact that the music industry represented a fertile playground for subsidizing his mischief, McLaren was not the slightest bit interested in rock or any sort of popular music. Indeed we all had a disdain for such music and particularly for the culture surrounding it, which seemed obese and abject."[21]

The notion of pop as a suitable avenue for mischief-making is said to have first entered McLaren's consciousness during his brief period of association with King Mob, a UK affiliate of Situationiste Internationale. One member of King Mob, Christopher Gray, broached the idea of creating a "totally unpleasant" and utterly antimusical pop band. Situationism was dedicated to the abolition of art as a realm of existence separate from everyday life. Instead of the passively contemplated artwork, the goal was to create participatory events or "situations," an open-ended concept that could refer to anything from total art happenings to yippie-style pranks to wild eruptions of festivity to inner-city riots.[22]

McLaren began to see rock as an arena in which he could operate as the catalyst for chaos, as a cultural terrorist. His first stab was with the New York Dolls, cross-dressing proto-punks associated with the Mercer Arts Center in New York. He was attracted to the group because of their musical ineptitude: "I thought it was the worst record I'd ever heard . . . what mattered was that they were so good at being bad."[23] When he took over as the group's manager, it was the dying days of the Vietnam War, and McLaren's provocation was to give the Dolls a treasonous, Communist image makeover, devising a Maoist look of red

patent leather and convincing the band to perform in front of gigantic hammer-and-sickle flags.

When the band disintegrated, McLaren returned to London and set about finding a UK equivalent to the Dolls. He took on a bunch of hungry but directionless youths, gave them their name (the Sex Pistols), and found them a lead singer. Again, his attitude towards music was contemptuous. He insisted, and has continued to insist, despite considerable evidence to the contrary, that the Pistols couldn't play and that punk had never been about the music. "Christ, if people bought the records for the music, this thing would have died a death long ago," he quipped to *The Sunday Times* in 1977.[24] He often talked of initially seeing the Pistols in large part as a vehicle for selling the clothes he and partner Vivienne Westwood made and sold via their Kings Road boutique, Sex (the group's very name was a kind of an advert for the shop). Throughout the Pistols' brief career, McLaren was impatient to leave behind mere music. He put a huge amount of time and energy (and the bulk of the group's earnings) into a Sex Pistols movie. Initially it was to be directed by soft-porn maven Russ Meyer and scripted by Roger Ebert (based on ideas supplied by McLaren) and have the title *Who Killed Bambi*. When that fell through owing to personality clashes between the director and the band, who had minimal interest in making movies and were more concerned with recording and touring, the project mutated into *The Great Rock 'n' Roll Swindle.*

Swindle was an outrageous rewrite of recent history that not only presented McLaren as a Svengali mastermind who cynically planned every step in the Pis-

tols' rise, but also barefacedly nominated the manager as the author of punk rock itself. "I have brought you many things in my time . . . but the most successful of all was an invention of mine they called punk rock," McLaren hisses from beneath a black leather hood (part of Sex's fetish-wear line) at the start of the movie. In an interview some years later, McLaren talked of the Sex Pistols and the sociocultural furor that swirled around their name as a gigantic art piece whose components included publicity, hype, tabloid shock-horror headlines, persecution by the authorities, and, only incidentally, a bunch of human beings and their music: "Rather than just while away my time painting, I decided to use people, just the way a sculptor uses clay," he mused.[25]

Although McLaren's account of his role in the Sex Pistols severely distorted the group's creative period (when melody-writer Glen Matlock, an alumnus of St. Martins College of Art and Design, and singer-lyricist Johnny Rotten were still in the band), it does fairly describe McLaren's contribution in the later stages of the group's existence. The first true flourish of McLaren as auteur was his recruitment into the Sex Pistols as lead vocalist the infamous Great Train Robber, Ronnie Biggs. The Sex Pistols single "No One Is Innocent" (also known as "Cosh the Driver," a deliberately provocative reference to the brutal treatment meted out to one British Rail employee during the robbery) took this bête noire of the UK establishment into the Top Ten. Biggs, who had escaped from prison and lived a playboy's life in Brazil, symbolized the subversive idea that "crime does pay." One verse in "No One Is Innocent" referred face-

24. McLaren, quoted in *The Sunday Times* (London), 1977, quoted in Robert Sandall, *The Sunday Times,* January 14, 2007, http://entertainment.timesonline.co.uk/tol/arts_and_entertainment/article1291539.ece.

25. McLaren, quoted in Paul Taylor, "The Impresario of Do-It-Yourself," in *Impresario: Malcolm McLaren and The British New Wave,* exh. cat. (New York: New Museum of Contemporary Art; Cambridge, Mass.: MIT Press, 1988), 28.

26. McLaren, interview, *Sounds,* July 26, 1980.

tiously to Martin Bormann, another Latin American exile; he too was supposed to have joined the Pistols. At a time of rising lawlessness in the UK, and in a country where the Second World War was a vivid memory, the recruitment of these two enemies of the nation into the Pistols was a crude attempt to double the treasonous impact of "God Save the Queen" the previous summer. But it was also meant to stick in the craw of the liberals and lefties who had gradually embraced punk as the authentic voice of disenfranchised youth on the streets and were attempting to firmly align its rebellion with the struggles of the Anti-Nazi League and its sister organization, Rock Against Racism.

After losing control of the Pistols, McLaren's next intervention in pop, Bow Wow Wow, was an attempt to replay the Sex Pistols farrago as if it really had been a meticulously executed master plan. Deliberately picking more malleable musicians, including a fifteen-year-old Anglo-Burmese girl as lead vocalist, McLaren concocted an inspired ragbag of subversive ideas: cassette piracy (then the record industry's greatest fear), underage sexuality, back-to-nature savagery, a gleefully against-the-grain celebration of mass unemployment as liberating for youth, and more. The group's sound, with its fetching African Burundi rhythms, funk bass, and dashing Duane Eddy guitar, was hitched to a new clothing line designed by Westwood and McLaren, a swashbuckling wardrobe inspired by pirates, American Indians, and other romantic heroes. Bow Wow Wow's music was great, but almost incidental to McLaren's scheme. Along with the record industry and respectable teen sex–fearing grown-ups, his target was the postpunk drift toward musicality. As far as he was concerned this was the return of art-rock in all its studenty reverence and cerebral sexlessness. He was particularly scornful of Johnny Rotten's new venture Public Image Ltd: "He's asking you to take a course in music before you understand it." Rock and roll, in McLaren's view, was "only a bloody Mickey Mouse medium really."[26] And as with the Sex Pistols, McLaren was impatient to get out of music and into other media: there were plans for a Bow Wow Wow movie (the group had originally been hatched from a soft-porn film script) and a magazine called *Chicken* (although this *"Playboy"* for teens" may have been designed purely to cause a child-porn scandal and embarrass its backers, EMI Records).

During punk, McLaren had pioneered an almost-entirely new phenomenon: the manager as star. Figures like himself and Clash manager Bernie Rhodes were as prominent in the music paper interviews as the bands themselves. With Bow Wow Wow, the journalists spoke only to McLaren, and the interview became his true art form. McLaren now seemed to believe that all he needed to do was unfurl his ideas, the blueprint of a new youth subculture, and the kids out there in readerland would simply step into their assigned roles. Reversing the sequence of the Sex Pistols, where genuine chaos and improvised mayhem was followed by McLaren's retro-active rewrite (it's a swindle), McLaren now presented his master plan in advance, prior to its realization as a pop event, the actual process of creating situations seemingly redundant next to giving people ideas.

A series of projects—Bow Wow Wow, with its confusing clutter of subversions; a McLaren solo career that rapidly ran through hip-hop scratching, ethnic world rhythms, and opera, across the albums *Duck Rock* and *Fans*—barely extended beyond their elaboration in interviews. He boasted of his indifference to music, which in the case of the recordings issued under his own name was pulled together by producers, sampling technicians, and session musicians. Hip-hop attracted him precisely because it was an art form based on collage and sonic readymades. *Duck Rock* involved the "borrowing" of Appalachian square-dance tunes, Soweto pop songs, and New York schoolgirl jump-rope rhymes; *Fans* was based on Puccini's *Madama Butterfly.* McLaren laughed off accusations of appropriation and plagiarism. "If people don't want me to plagiarize I'll have to stop work. . . . I can't sit down and write a tune. I'm not interested. I can't write a tune as good as Puccini, so why bother?"[27]

Like Genesis P-Orridge, McLaren conceived of himself as an artist in an absolute and general sense, as opposed to a practitioner of a specific art form. Being an artist was an existential state or characterological disposition, and pop music merely served as a handy medium, an entry-level arena that he abandoned as soon as he could for Hollywood and a fruitless (if financially rewarding) sojourn at the major studio CBS where he was hired to generate edgy treatments. Not long after projects like *Heavy Metal Surf Nazis* entered the cryogenic death zone of development limbo, McLaren received a rare honor, becoming the first and most likely only rock manager to enjoy a retrospective at a museum.

Titled *Impresario: Malcolm McLaren and the British New Wave,* the exhibition was presented by the New Museum of Contemporary Art in New York in the fall of 1988. The work consisted not of paintings or sculptures but rather posters, promo videos, text-daubed T-shirts, and other garments made during McLaren's partnership with Westwood; record covers (including the art historical gag of the cover for Bow Wow Wow's debut album, which featured a photographic remake of Édouard Manet's once infamously indecent 1863 *Dejeuner Sur L' Herbe,* with the underage Annabella posing nude); and slides emblazoned with McLaren's choicest bon mots and slogans. History does not record whether the exhibition also included framed record contracts from deals McLaren struck for the Sex Pistols with major labels EMI and A&M only to be lucratively "let go" when the horrified companies changed their minds. There was, however, just one small relic of McLaren's eight years in the British art school system: a painting covered with the scrawled promise / threat: "I will be so bad."

Spring 2007

Simon Reynolds is a critic. He is the author of *Rip It Up and Start Again: Postpunk 1978–1984* and *Bring the Noise: 20 Years of Writing about Hip Rock and Hip Hop.*

27. McLaren, quoted in "The Phantom of the Opera," *Melody Maker,* August 25, 1984.

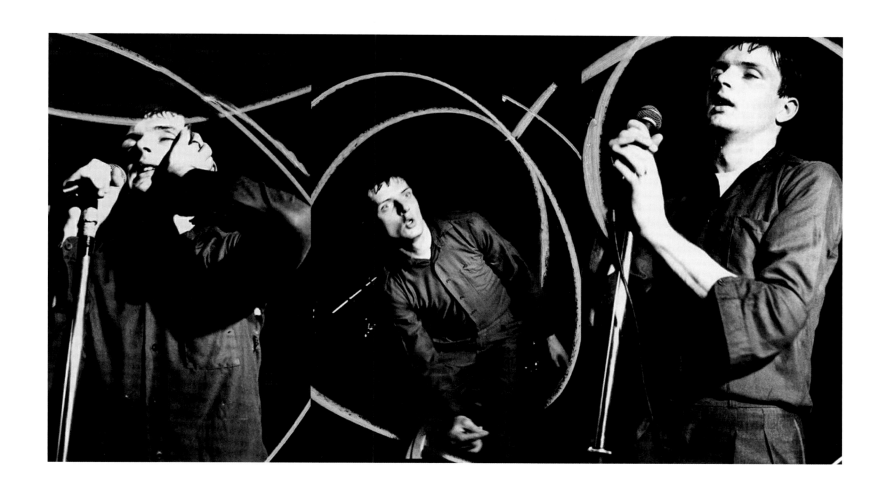

Scott King (with Kevin Cummins)
Futurama, 2004
Digital prints
Approx. 19 3/4 x 9 7/8 ft. (6 x 3 m)
Courtesy of the artist;
Herald St, London; and
Galleria Sonia Rosso, Turin

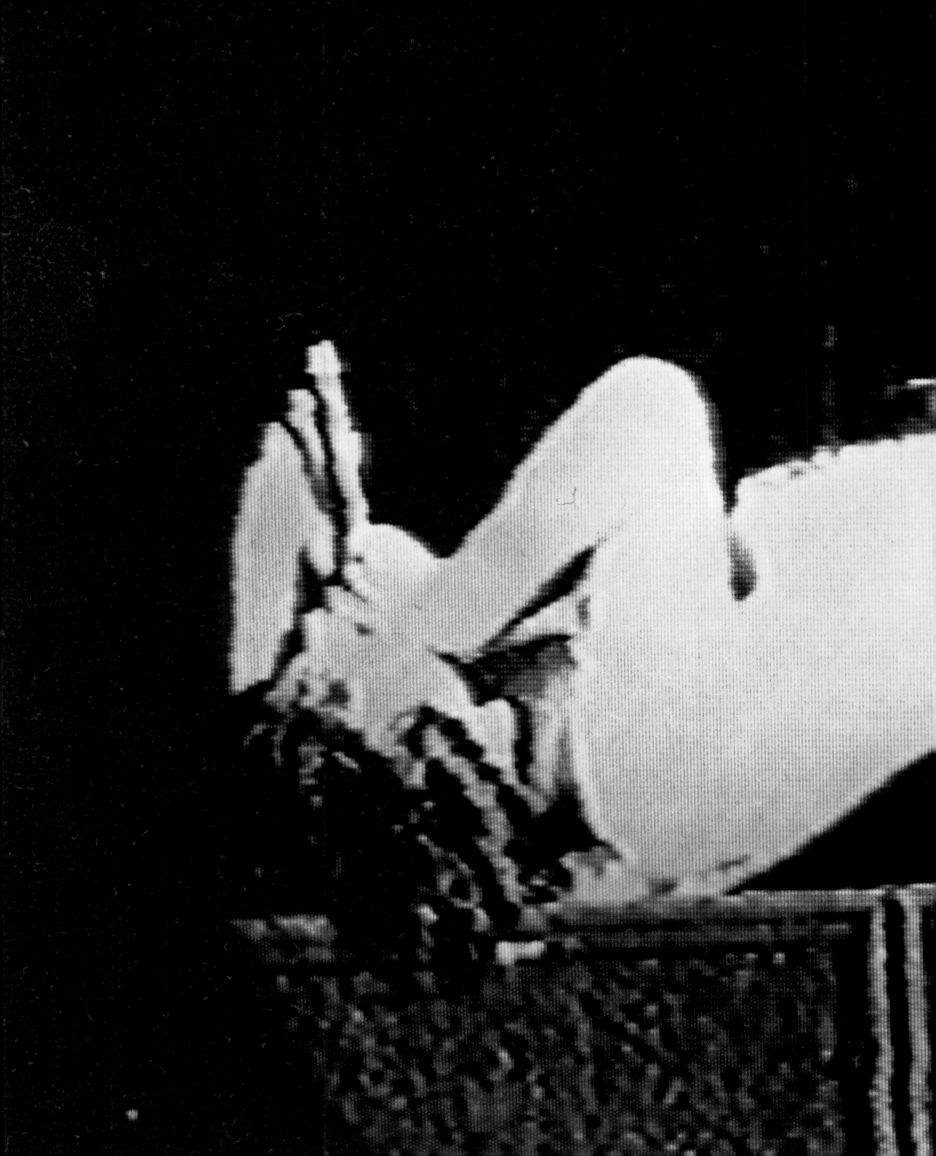

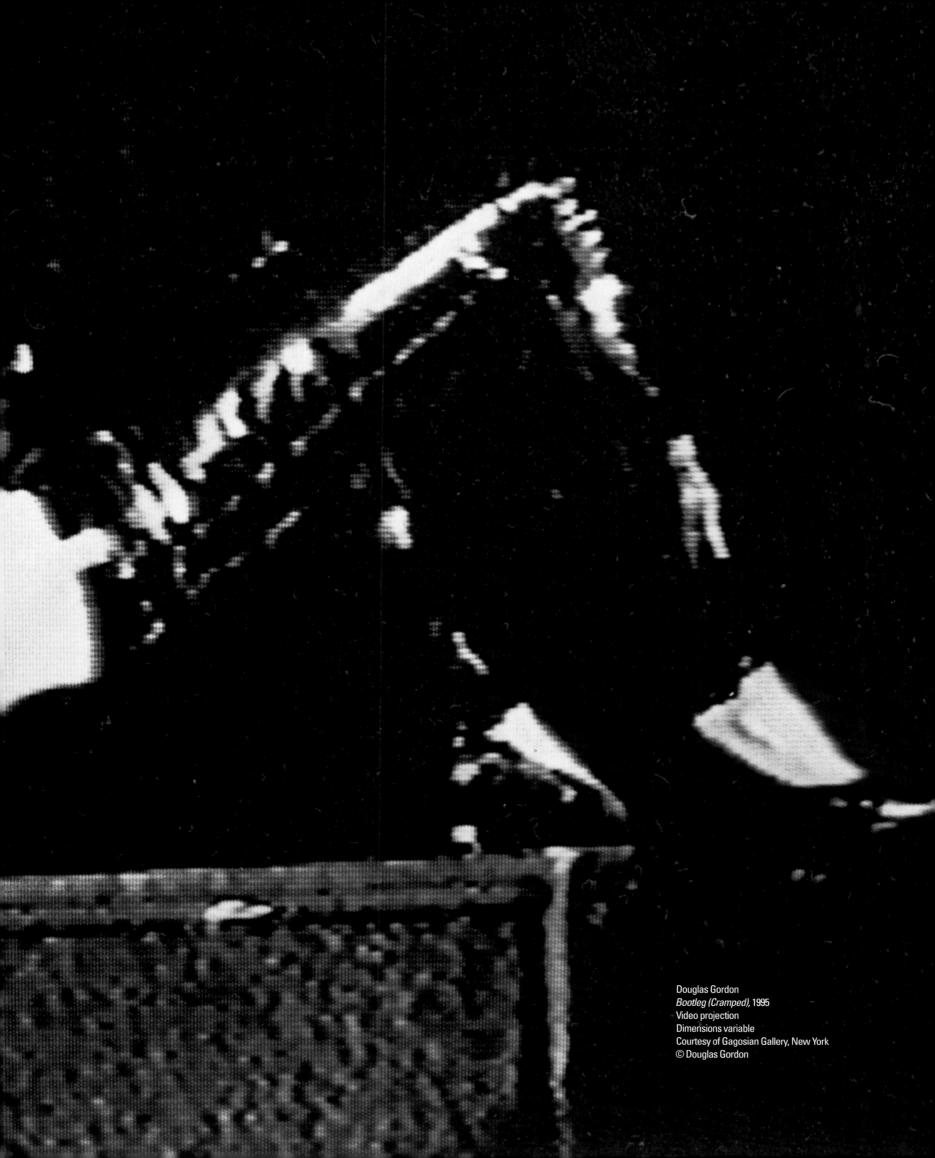

Douglas Gordon
Bootleg (Cramped), 1995
Video projection
Dimensions variable
Courtesy of Gagosian Gallery, New York
© Douglas Gordon

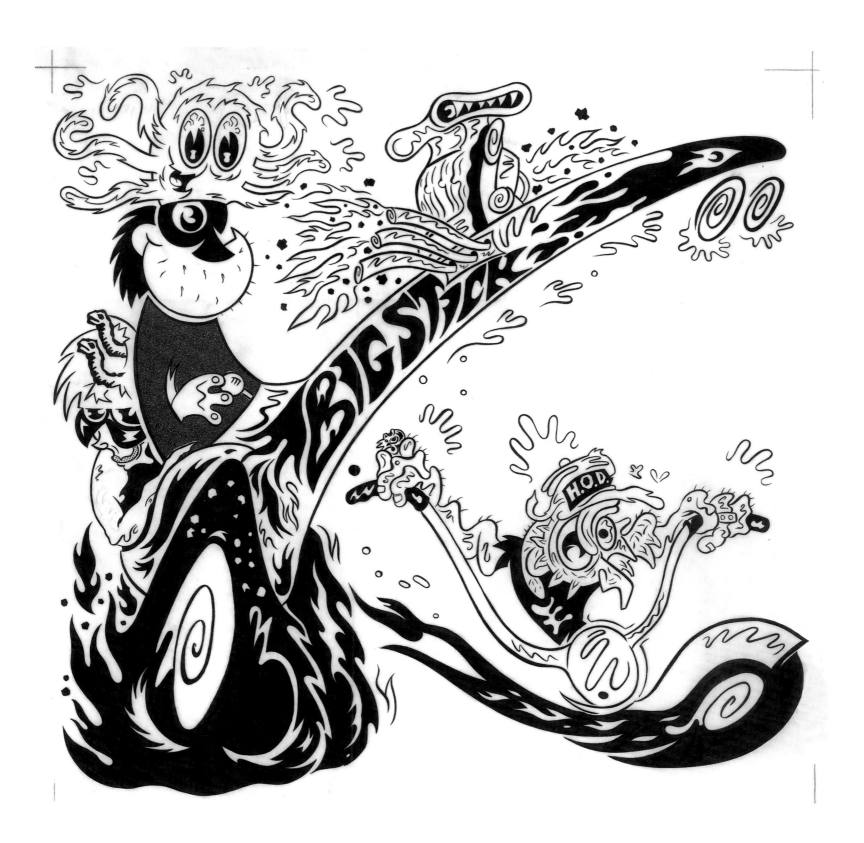

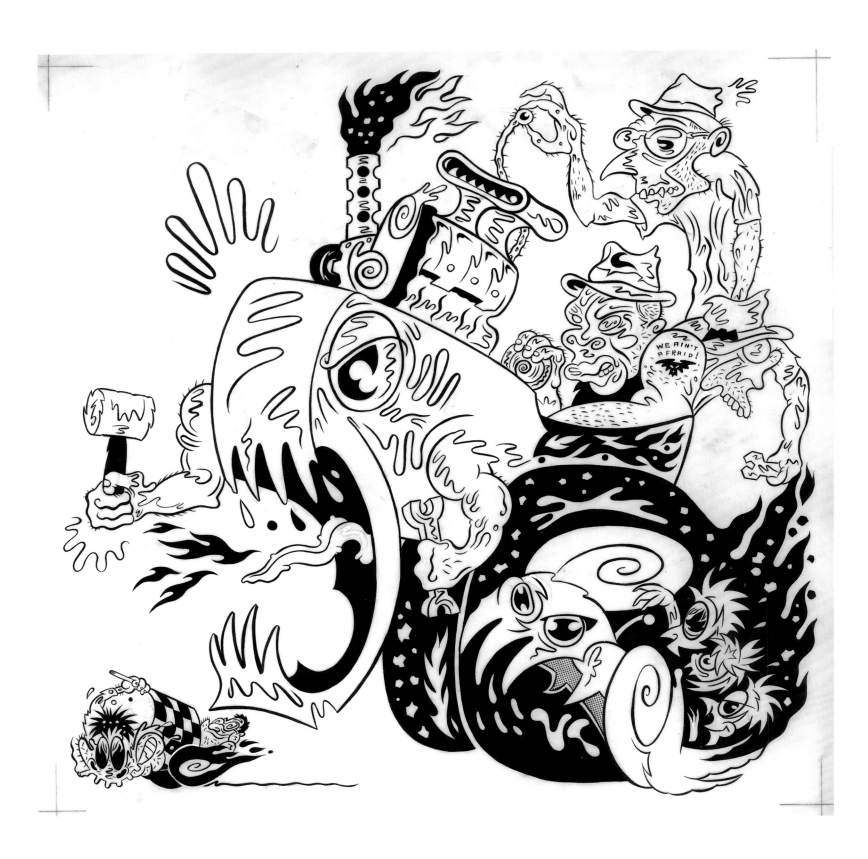

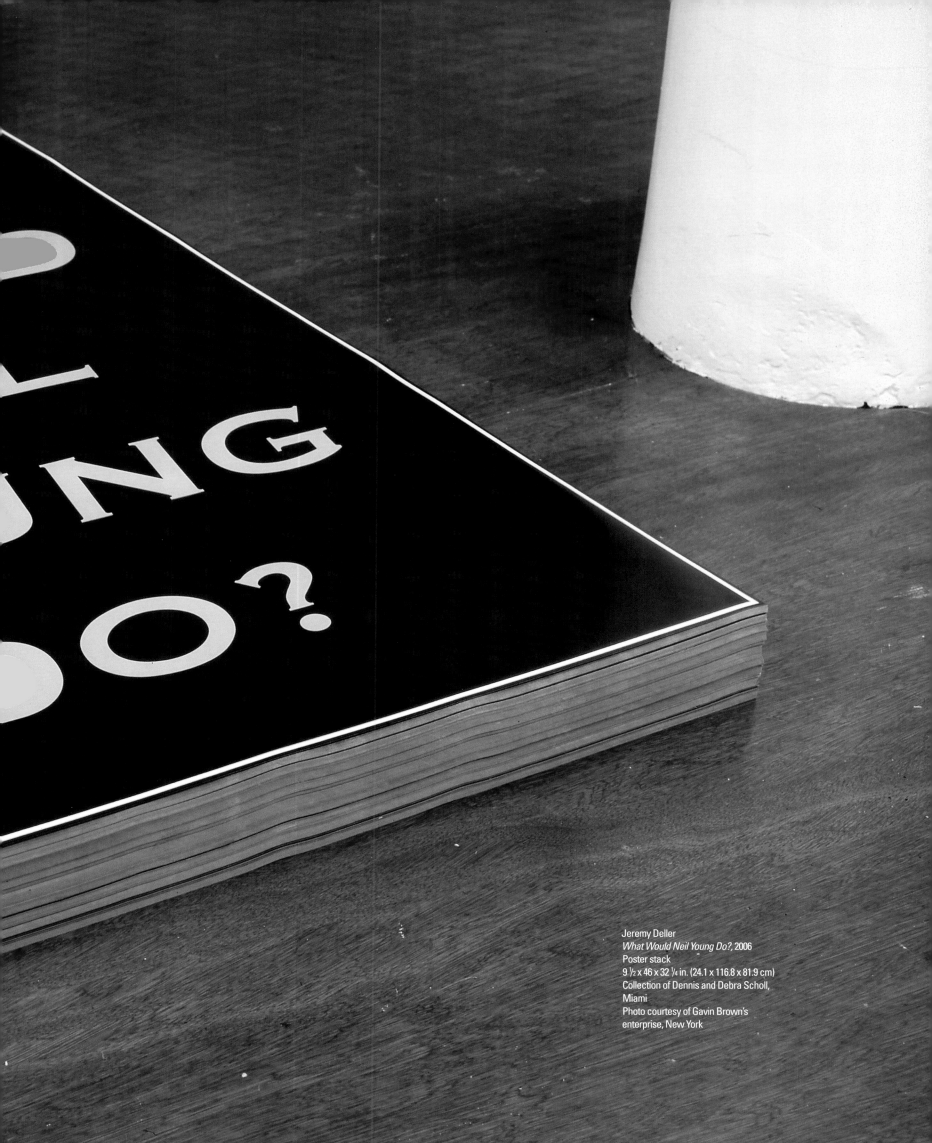

Jeremy Deller
What Would Neil Young Do?, 2006
Poster stack
9 ½ x 46 x 32 ¼ in. (24.1 x 116.8 x 81.9 cm)
Collection of Dennis and Debra Scholl,
Miami
Photo courtesy of Gavin Brown's
enterprise, New York

MUSIC FROM THE DEATH FACTORY

BY THROBBING GRISTLE

MUSIC FROM THE DEATH FACTORY

BY THROBBING GRISTLE

"These seemingly restrained images of social polarized industry serve to bracket Throbbing Gristle from the beginning to the present, one dedicated to annihilation and the other to consumption."

OPPOSITE
1977 Death Factory poster that uses as graphic motif an image of Auschwitz concentration camp. Printed in 1977 as a TG dispatch in its own right or as an accompaniment to gig promotions.

ABOVE
2007 Tate poster that uses the image of the power station, repossessed by Tate Modern. Printed on the occasion of Throbbing Gristle's performance in the Turbine Hall, May 26, 2007.

Peter Saville
Album cover for New Order's *Power, Corruption & Lies* LP,
related notes, and production materials, 1983
Courtesy of Peter Saville Graphic Design, London

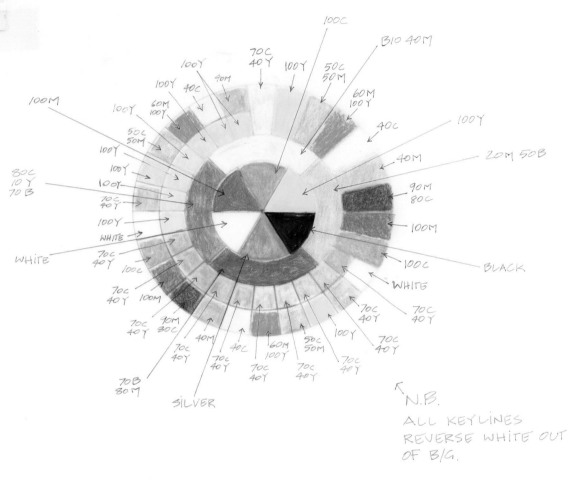

PMS 538 B/G + SPINE

PANTONE
538C

100C
B10 40M
70C
40Y
100Y
50C
50M
100Y
90M
60M
100Y
60M
100Y
40M
100M
100Y
50C
50M
100Y
40C
100Y
100Y
80C
10Y
70B
70C
40Y
100Y
WHITE
70C
40Y
100C
WHITE
70B
80M
SILVER
70C
40Y
100M
90M
80C
70C
40Y
70C
40Y
40M
40C
60M
100Y
50C
50M
100Y
70C
40Y
70C
40Y
70C
40Y
100Y
70C
40Y
70C
40Y
100C
WHITE
70C
40Y
70C
40Y
100M
100Y
40M
40C
90M
80C
20M 50B
BLACK

N.B.
ALL KEYLINES
REVERSE WHITE OUT
OF B/G.

Peter Saville
Album cover for New Order's *Power, Corruption & Lies* LP,
related notes, and production materials, 1983
Courtesy of Peter Saville Graphic Design, London

Peter Saville
Album cover for New Order's *Power, Corruption & Lies* LP,
related notes, and production materials, 1983
Courtesy of Peter Saville Graphic Design, London

A B C D E F G H I J K L M N O P Q R S T U V U K V Z
1 2 3 4 5 6 7 8 9 10 11 12 13 14 15 16 17 18 19 20 21 22 23 24 25 26

	6	P		F 6		N	14	
		1	T		A 1		E	5
Y	3 W		M V		C 3		N	23
	20	T			T 20			
V	P B	75					O	15
							R	18
							D	4
							E	5
							R	8

COLOURS

1	100 M	✳	MAGENTA	
2	50 M 50 C	✳	MAUVE	
? 3	90 M 90 C	✳	VIOLET	(? against Black)
4	100 C	✳	CYAN	
5	100 Y	✳	YELLOW	
6	50 M 50 Y		PALE ORANGE ✗	
7	100 M 100 Y	·	WARM RED ✗	
8	50 C 50 Y		PALE GREEN	
9	100 C 100 Y		GREEN	
0	- White			

B 2	Y	T MAG
L 12	TY	'B
U 21	YT	Y M V
E 5	B	

M 13	T M V	T B
O 15	T B	T O
N 14	TM	M
D 4	(M)	B
A 1	T	T O
Y 25	YB	

NUMERICAL MIXING.

		? ✳	?				Y	PINK	P B	T
	8		4	T M	ORANGE.	M 60 Y 100	✓	?	✓	✓
2	6	T			PINK	M 40	✓	✓	✓	✓
	5	T			✓ PALE BLUE	C 40	✓	✓	✓	?
	1	T M			✓ TURQUOISE	C 60 Y 30 ?	✓	✓	?	✓
						✓ C 70 Y 40				
	9	S			CYAN	100	✓	✓	✓	?
	4	8 S			MAGENTA	100	?	?	✓	✓
1	2	S			YELLOW	100	✓	✓	✓	✓
	3	T M			MAUVE	50 M 50 C	✓	?	?	✓
	7	T M			VIOLET	90 M 80 C	✓	✓	?	✓
	0				WHITE					

8 - 9 s Order

with all = Y
" - most =

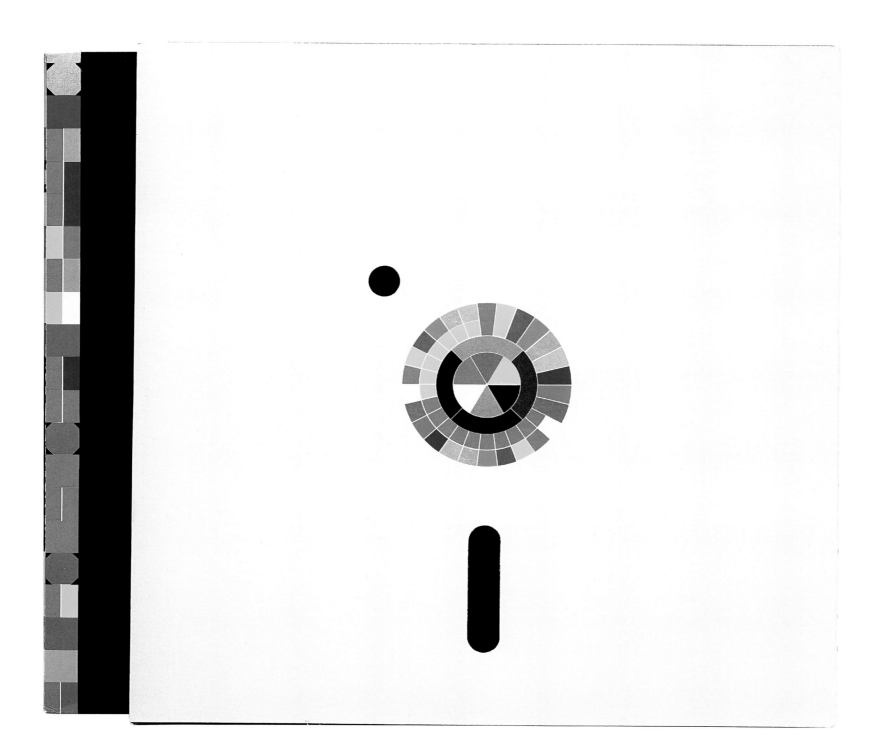

Peter Saville
Album cover for New Order's *Power, Corruption*
& Lies LP, 1983
Courtesy of Peter Saville Graphic Design, London

Peter Saville
Album cover for New Order's *Power, Corruption & Lies* LP, 1983
Courtesy of Peter Saville Graphic Design, London
Reproduction of Henri Fantin-Latour's
A Basket of Roses, 1890
Courtesy of Peter Saville Graphic Design, London

Richard Hamilton
Swingeing London 67 (f), 1968–69
Acrylic, collage, and aluminum on canvas
26 ½ x 33 ½ in. (67.5 x 85.1 cm)
© 2007 Artists Rights Society (ARS), New York /
DACS, London

Linder
Untitled, 1977
Photomontage on paper
Framed: 12 ⁵⁄₈ x 13 in. (32 x 33 cm);
image: 6 ¹⁄₈ x 6 ⁵⁄₈ in. (15.6 x 17 cm)
Courtesy of Stuart Shave / Modern Art

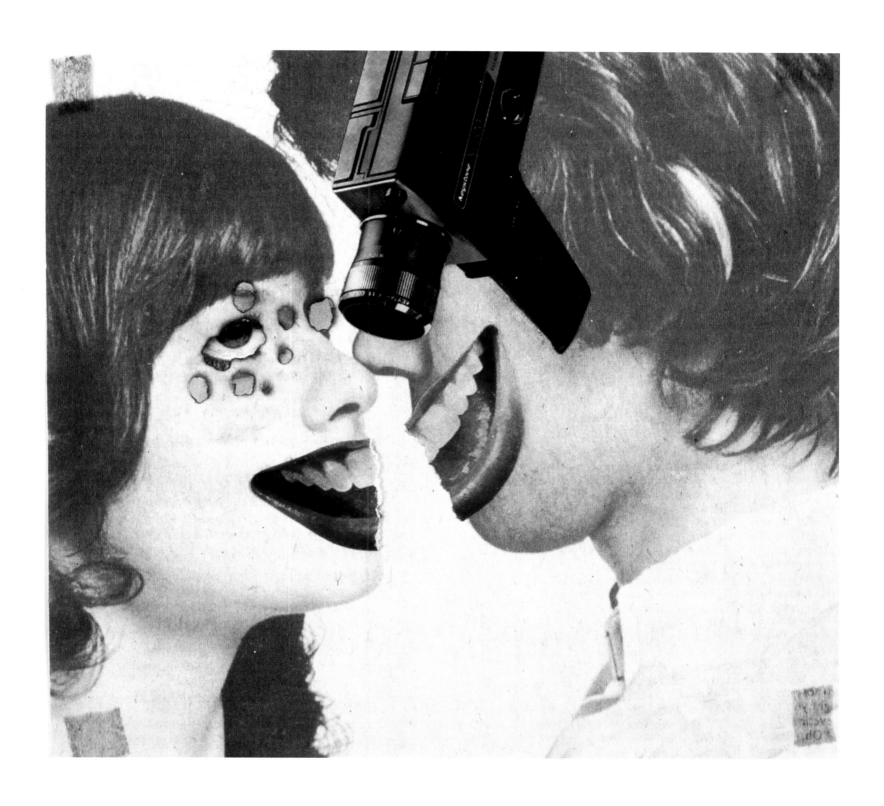

Linder
Untitled, 1977
Photomontage on card
3 $\frac{1}{2}$ x 4 $\frac{1}{8}$ in. (8.8 x 10.5 cm)
Courtesy of Stuart Shave / Modern Art

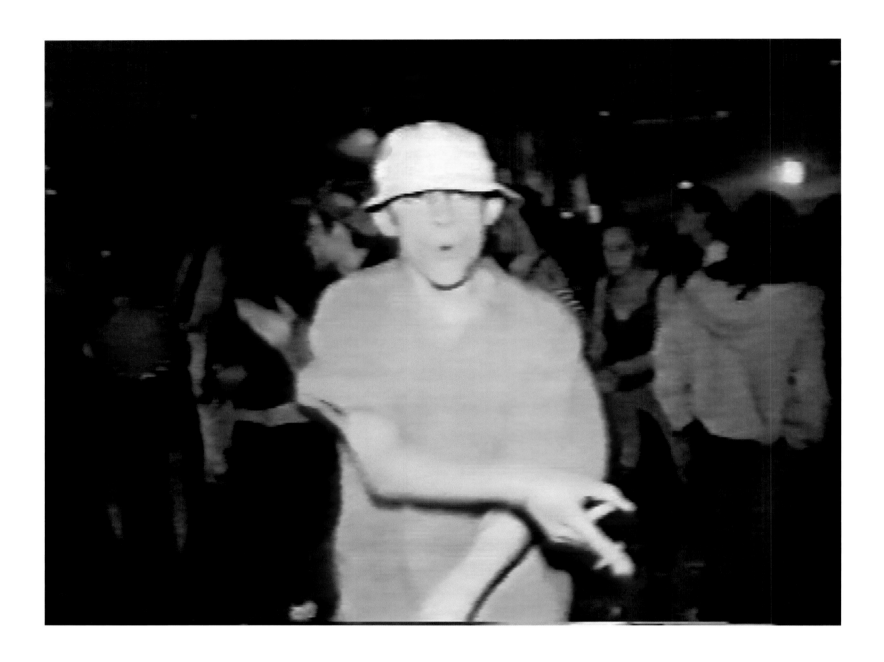

Mark Leckey
Fiorucci Made Me Hardcore, 1999
Color video with sound
15 minutes
Courtesy of Gavin Brown's enterprise, New York

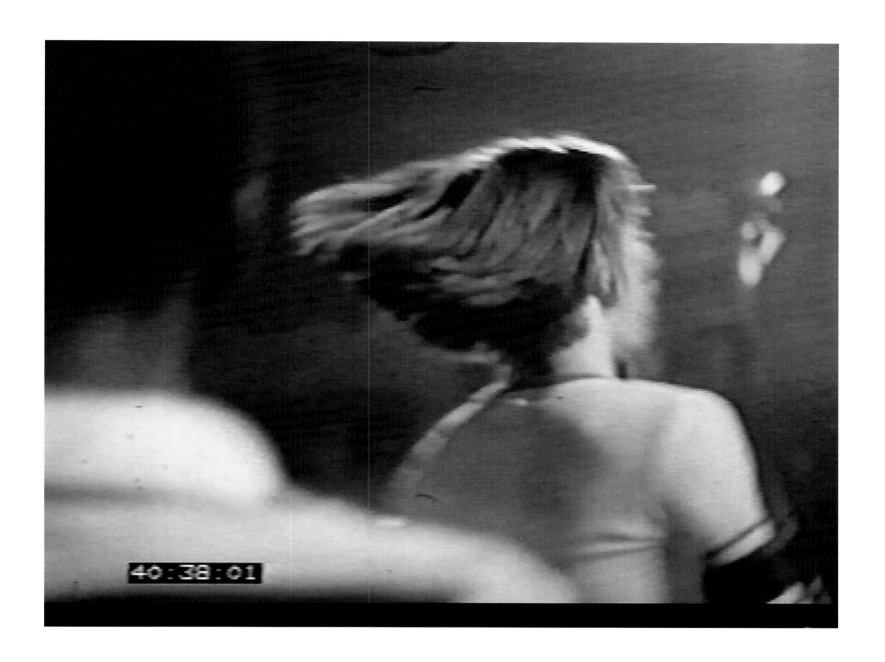

40:38:01

Mark Leckey
Fiorucci Made Me Hardcore, 1999
Color video with sound
15 minutes
Courtesy of Gavin Brown's enterprise, New York

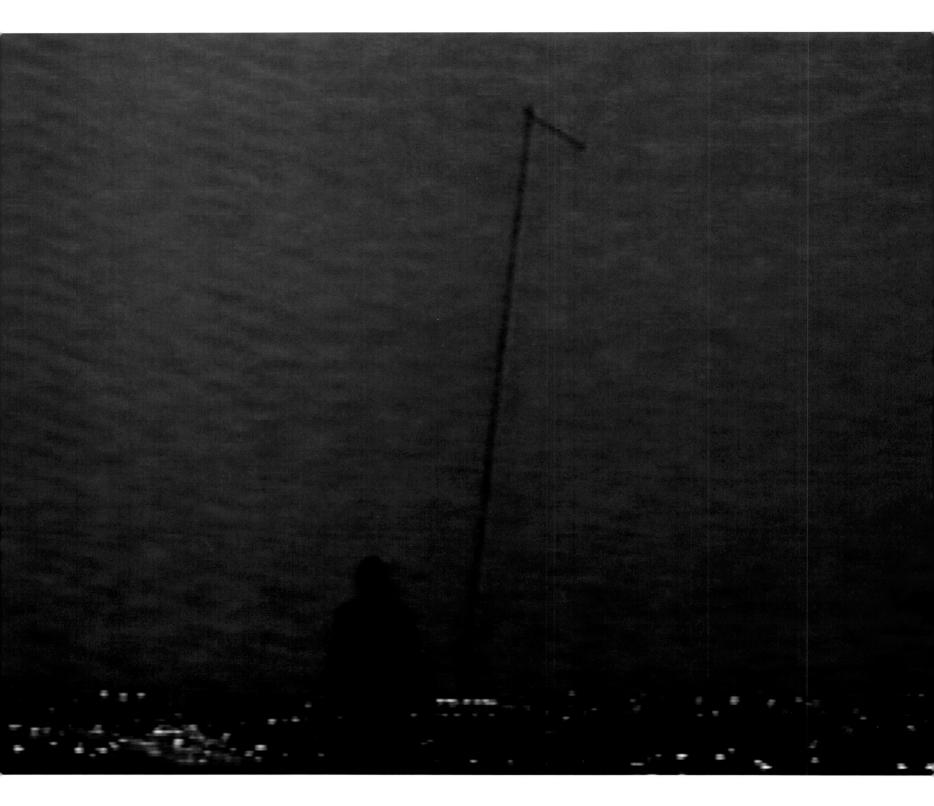

Mark Leckey
Fiorucci Made Me Hardcore, 1999
Color video with sound
15 minutes
Courtesy of Gavin Brown's enterprise, New York

Art & Language and The Red Krayola
And Now For Something Completely Different, 1976
Black-and-white video with sound
9 minutes, 23 seconds
Courtesy of Drag City, Chicago,
and Mayo Thompson, Edinburgh
Photo by Michael David Rose

Steven Claydon
Extinction, 2005
Oil on canvas
40 x 30 in. (101.6 x 76.2 cm)
Courtesy of HOTEL, London

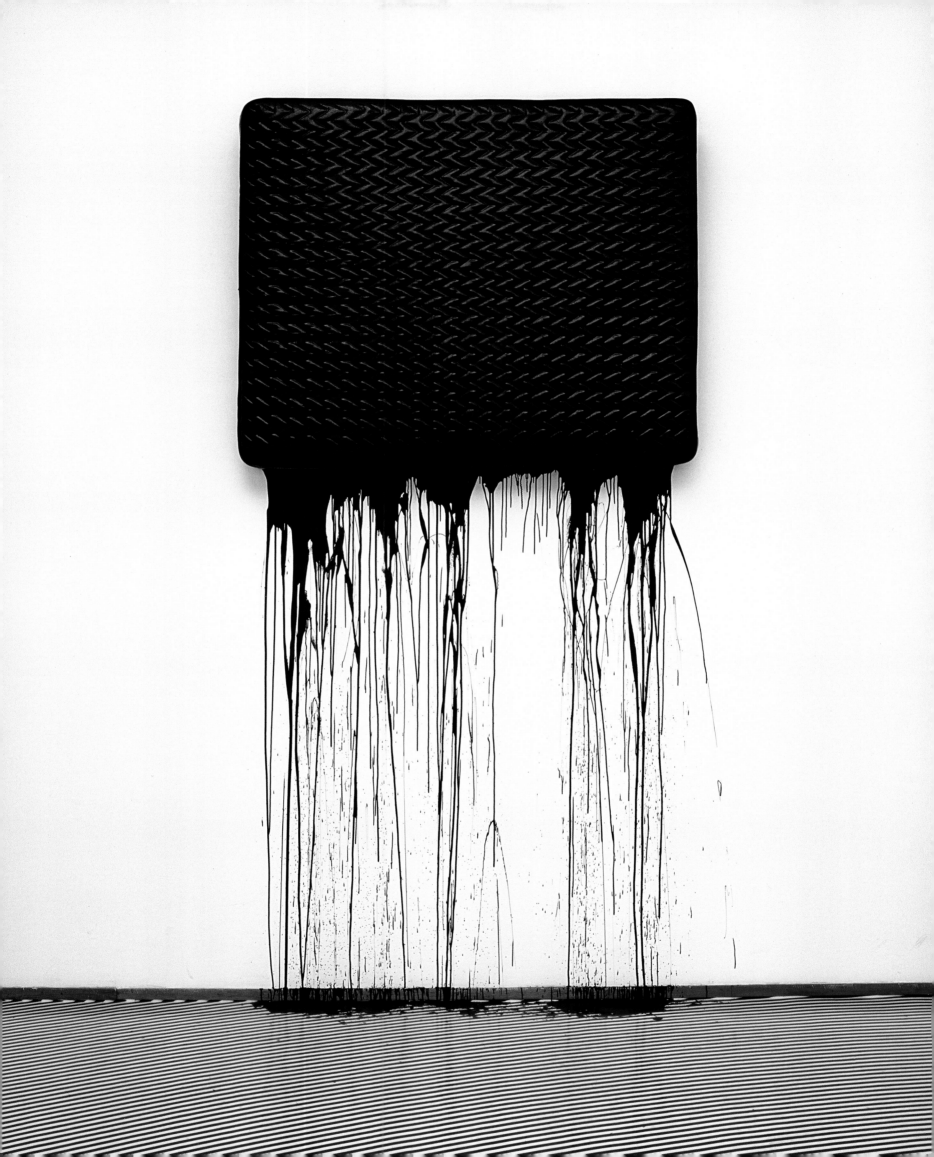

PUNK AS PROPAGANDA
DAN GRAHAM

The Ramones from New York and Devo from Akron, Ohio, model their aesthetic / political strategies after pop artists of the '60s; they prefer to package themselves rather than be packaged by the media or the record industry. Devo suggests that this is necessary in order not to be tricked by the media-dependent and corporate structure of "the business":

> We figured we'd mimic the structure of those who get the greatest rewards out of the upside-down business and become a corporation. . . . Why stop at the music? I really believe that's the mistake groups make. [Most groups] don't understand the total picture that they fit into. They don't see how they interrelate publicly to the culture and the political situation in their work. They are destroyed because they become exploited by the system. Like, take a group, divide them up, pull one person out as the star and make solo albums. . . . We decided that what we hated about rock and roll was STARS. . . . We watched Roxy Music, a band we liked, slowly become Bryan Ferry and Roxy Music. If you get a band that's good, you bust it up and sell three times as many records. Take The Beatles, for example.[1]

Devo broadens this critique of '60s rock and roll to a critique of US corporate capitalism, recognizing the covert function of rock in consumer society as propaganda for the myths of individualism.

> What do you think rock and roll is in America . . . besides Propaganda for Corporate Capitalist Life? Most rock musicians, they're no more than clerks or auto mechanics, you know . . . if they're lucky they'll settle into an Alice Cooper kind of existence. . . . Since pop music is definitely a vulgar art form connected with consumerism, the position of any artist is, in pop entertainment, really self-con-

tempt. Hate what you like, like what you hate. It's a totally schizophrenic position, but that in itself is a principle that most people, both in the business and outside it, don't understand. Therefore, if they don't understand that very idea, they don't even know what they're dealing with. Devo understands its self-contradiction and uses it as the basis for its creativity. . . . The system is totally geared toward profit, obviously. The artist is usually a willing victim because he's a middle-class shit himself.[2]

Devo sees its conceptual role in tearing down the myths and assumptions of the '60s ("All that everybody still thinks is hip or beautiful"). They aim to "remake and remodel" their sources in order to create a new, synthetic, or reconstituted form, analogous to DNA or biological hybrids. By this means they hope to parallel / parody / put into perspective the process by which corporations synthesize new consumable products. "It's taking genetic structures and mutating them, comparing them with other structures . . . like putting a monkey's head on a human baby . . . reordering things and seeing the same things differently. . . . Jumbling up everyone's assumptions, everyone's vested interests, everyone's smug viewpoint."[3]

Their remakes of The Rolling Stones' "Satisfaction" and "Sloppy (I Saw My Baby Getting)" (both 1978) are examples of remodeling Devo's sources. Both songs work by deconstructing and then robotically rebuilding music and lyrical phrasing. To begin with, the latter's title has been altered, putting "Sloppy" before, rather than after, "I Saw My Baby Gettin'." Then, the macho assumptions of the songs (which tend to link male aggression and assertive sexuality to man's connections with primitive ani-

1. Devo, interview, *SoHo Weekly News,* date unknown.

2. Ibid.

3. Ibid.

4. The Rolling Stones, "Satisfaction," *Out of Our Heads,* 1965, Abkco.

5. Roy Lichtenstein, interview by Gene Swenson, "What is Pop Art?," *Art News* 62, no. 7 (November 1963), 25.

mals) have been androgynized by the use of an electronic synthesizer that disembodies the sound. Finally, these hybrids are welded together by a "football half-time drum beat . . . like cheerleaders and marching bands at a football game" in order to instigate group "sing-along" feelings. This breaks down the original song's underlying assumptions: myths of free sexuality and individualism. The message of the typical '60s song, addressed to the self-identity of the listener, served to condition him or her to certain social attitudes, just as advertisements in the media conditioned him or her for a role as a consumer of lifestyles. Devo sees rock and roll as a disciplinary exercise, conditioning the typical American consumer to buy more from big corporations. The group agrees with the lyrics of "Satisfaction" but see the song's stylistic and performative assumptions as supporting both the individualistic mythology and the corporate-induced consumerism that the song's lyrics would undermine:

> When I'm watchin' my TV
> And that man comes on to tell me
> How white my shirts can be
> Well he can't be a man 'cause
> he doesn't smoke
> The same cigarettes as me
> I can't get no satisfaction
> I can't get me no satisfaction . . .[4]

When Devo orchestrates The Stones' numbers to a discolike beat (which owes something to Donna Summer and something to Kraftwerk), the group is deliberately playing on the assumption that punks are against disco and are thus anti-lower-class black / Italian / Hispanic music. The corporate rock industry prefers to divide minority groups into separate markets. This division sets up an ideological opposition between two groups that works in favor of the dominant ideology when it pits one minority group against another. Here,

Devo undermines punk assumptions by its use of disco and upsets disco assumptions by using punk corrosiveness. While media representations place disco and punk in isolated opposition, Devo prefers to broaden its potential audience and to place both attitudes in tension. If a song is both disco and punk at the same time, it can be read both ways; it is equally a parody of both viewpoints. This equivocation enables Devo to locate what punk and disco have in common: the elimination of the spectator's passivity in favor of a "do-it-yourself" production of spectacle. Both disco and punk share a quasi-military beat that forces the audience into collective engagement with the music on the level of its own production. Devo implies that, as mass phenomena, punk and disco dancing resemble Nazi rallies of the '30s and are clearly opposed to the introspective, do-your-own-thing psychedelic trip of hippie music of the late '60s and early '70s, where the individual was the ultimate, self-contained reference point.

In a similar way, the Ramones mock the sincere, confessional "I" of such songwriter-performers as Jackson Browne, Neil Young, or Van Morrison, as well as their introspection and romanticism. The Ramones use a satirical, pop art–like ironic distance and a musical (rock-and-roll) neoclassicism in manipulating their image. Their attitude toward their songs is not unlike Roy Lichtenstein's attitude toward pop art (as stated in 1963): "Art . . . has become extremely romantic and unrealistic . . . it is utopian. It has had less and less to do with the world, it looks inward—neo-Zen and all that. This is not so much a criticism as an obvious observation. Outside is the world; it's there. Pop art looks out into the world; it appears to accept its environment, which is not good or bad, but different—another state of mind."[5]

Pop artists like Lichtenstein were ambivalent about considering their work political. Although Lichtenstein saw the humor in his paintings as political ("The heroes depicted in comic books are fascist types, but I don't take them seriously in these paintings—maybe there is a point in not taking them seriously, a political point."), he was hesitant to admit this. In American culture, to define a cultural work as political automatically categorizes it as academic or high art; mass culture will have little interest in it because it assumes a patronizing attitude. As a category, "the political" is negatively coded; it means "no fun." The Ramones are fun.

Like Lichtenstein's images, the Ramones' songs are comic-strip stereotypes of American pop culture, the post-Vietnam violence repressed by mainstream pop music's mellowed-out, laid-back, higher consciousness, "Made in LA" sound. Placed back in the popular culture, their songs become capable of dual (and ironic) readings: the popular or vernacular reading and a second reading that puts into perspective or quotes the first reading. The Ramones classicize their immediate sources (as does Lichtenstein) by relating them to earlier rock-and-roll lyrics (earlier stereotyped popular culture) and musical conventions. Their first album, *The Ramones* (1976), was constructed from basic '50s musical forms and references. Their second album, *The Ramones Leave Home* (1977), with its remaking of "California Sun," and even more definitively, their next album, *Rocket to Russia* (1977), adopted a '60s California "surfing sound" with its established connotations of "fun." With irony, in "Rockaway Beach" they applied the fun idea both to New York City (generally perceived by the rest of the country to be the opposite of a fun spot), and to punk as a media im-age in "Sheena Is a Punk Rocker" and "Ramona."

The Ramones' neoclassicism is typical of the '70s. The real social confusion of the present is masked by a neatly packaged re-creation of just-past-halcyon times. Recent history—up to ten years ago—is broken into a confusion of delimited, self-contained decades. The public's access to these magic eras is further confused with personal nostalgia: history as memory, memory associated by the media with the time "when we grew up." In media representations, the present is confused with the particular past being revived. The Ramones present the musical forms of this revival but eliminate the nostalgically personalized (social) content. In films, and in TV series such as *Happy Days* (1974–84), *The Waltons* (1972–81), and *Laverne and Shirley* (1976–83), one sees the projection of present-day, largely middle-class problems onto lower-middle-class characters (possibly our family forebears, one generation back) situated in the half-accurately / half-nostalgically depicted decades of the '30s, '40s, '50s, or '60s. The Ramones give us lower-middle-class images of the '70s (albeit in a comic-strip style):

> . . . We're a happy family
> Me mom and daddy
> Sitting here in Queens
> Eating refried beans
> We're in all the magazines
> Gulpin' down thorazines.
> We ain't got no friends
> Our troubles never end
> No Christmas cards to send
> Daddy likes men
> Daddy's telling lies.
> Baby's eating flies
> Mommy's on pills
> Baby's got the chills.
> I'm friends with the president
> I'm friends with the pope

6. The Ramones, "We're a Happy Family," *Rocket to Russia,* 1977, Sire Records.

7. The Sex Pistols, "God Save the Queen" (single), 1977, EMI.

We're all making a fortune
Selling Daddy's dope.[6]

British punk is a product of the class system. In contrast to American punk rock, the British punk movement is suspicious of rock music as an art form and of musical content other than direct, socially realistic propaganda. As the dominant form of representation is an expression of the interests of the ruling class, it is difficult for a minority group to express disagreement with these values and to fairly represent its position in terms of art without its message (and form of expression) being censured, rejected, or questioned. This was made quite apparent to British punk rockers when the Sex Pistols' "God Save the Queen" (1977; originally titled "No Future" and released in the summer of 1977 on the occasion of Queen Elizabeth II's Silver Jubilee) was quickly banned from British radio airplay. It was dropped from production by the Pistols' record company, which was then forced through media intimidation to drop the Sex Pistols as artists. Claiming that the Queen was a "figurehead . . . she ain't no human being," went too far in exposing the British myth in that year of England's extreme trade deficit. Yet the myth of Elizabeth's Jubilee Year had the double function of attracting tourist money and proclaiming that there was a future for England, though this future depended upon preserving status-quo assumptions.

The controversy began when newspaper scare headlines proclaimed (inaccurately) that the song called the Queen "a moron." In fact, the song says that "the fascist regime . . . made you a moron," implying that the cult of personalizing the Queen has no power in reality, so her "humanness" is beside the point—a duplicitous diversion.

 God Save the Queen
 The fascist regime
 It made you a moron
 A potential H-bomb.
 God save the Queen
 She ain't no human being
 There is no future
 And England's dreaming.
 No future
 No future
 No future for you.
 God Save the Queen
 We mean it man
 We love our Queen
 God says:
 God Save the Queen
 Tourists are money
 And our figurehead is not what she seems.
 God save history
 Save your mad parade
 Lord God have mercy
 All crimes are paid
 All crimes are paid
 Where there's no future
 How can there be sin?
 We're the flowers in the dustbin
 We're the poison in your human machine
 We're the future
 God Save the Queen.[7]

Bourgeois cultural forms function to mediate relations between the dominant and lower classes. The predominant form of cultural representation in a capitalist democracy is, like its form of government, a representational form: a fictional, self-contained "world" that stands for reality. Propagandist artwork is, by contrast, an attack on more liberal, realist artwork. Representational work functions as does representational government; various points of view are depicted and mediated in place of direct conflict between the classes or forces in society to which these mediated expressions correspond. The subject or spectator is presumably free to pick and choose among points of view through identification with one char-

acter or another but is distanced from both the fictional world and actual engagement / conflict. Some examples, outside of the pop song, are the novel, fictional films, TV news stories, etc.; in other words, any narrative form that places various characters in conflict. Propaganda, in opposition to this form, aligns the spectator in relation to depicted forces that exist outside and beyond the artwork. Representational realism usually deals with a past situation, whereas propagandist texts use current situations as subject matter. The classical realist text is closed; the conflict exists only within its fictional space. In a narrative work, there is pressure to resolve the contradictions and conflicts through the conclusion. The propagandist text puts the spectator in contact with, and in relation to, social practices existing outside the actual artwork. The propagandist text speaks directly to the audience, addressing it as "you" or "we." It does not, as classical art does, pretend to be disinterested or directed only toward a higher, artistic neutrality. It also does not hide the ego of the spectator. As its subject matter is based on its function, it is ephemeral and not timeless.

The Desperate Bicycles are typical of many amateur, self-recorded, and self-produced British groups, using the medium purely as propaganda. One side of their second self-recorded single, "The Medium Was Tedium" (1978), describes how they made their first self-recorded single for only £125. It suggests that instead of being passive consumer-spectators, listeners go out and produce their own records. The second side, "Don't Back the Front," picks up this refrain and extends it to an essaylike argument, suggesting that listeners refrain from backing the National Front, a neofascist, anti-Asian, anti-black political party with a large skinhead following.[8] It also criti-

cizes, from within, certain self-depictions of the punk movement:

No time for spectating
Tune in, count it
Let it blast
Cut it, press it
Distribute it
Xerox music's here at last. All you
phoney Fascists
Don't Back the Front!
You who trade on racist hate
Better learn some dialectic
Before it gets too late . . .[9]

The song's lyrics are momentary and urgent. They may be paraphrased as follows: first, an appeal to prevent the media from using / defusing / discrediting the punk music scene by fashionably associating it with skinhead and neo-Nazi violence; and second, the audience listening to this record is urged / instructed to make their own records. They are addressed (and constituted by this form of address) as a group considered apart from a general mass audience. Passive record consumption is a trap. Listening to this record is seen as only a preliminary stage for the punk audience; the consumer is encouraged to produce his or her own records and thereby generate further meaning. A third point is that "we," in this specially activated group, are told that "it's (monopolistic) Capital," and not racial minorities (Asians or blacks) who take "our" jobs away. For this reason "we" are advised not to give practical support or encouragement to the National Front, the party blaming unemployment on minority groups in Britain. This allies us with the viewpoint of Rock Against Racism, a collective of new wave musicians and leftists, organized to encourage young, unemployed, working-class whites not to vote for National Front candidates, and to counter the misunderstanding caused by the media's equation of punk music with fascist violence and anarchy.

8. See Dick Hebdige, *Subculture: The Meaning of Style,* London: Metheun, 1979.

9. The Desperate Bicycles, "Don't Back the Front," B-side to "The Medium Was Tedium," 1977, Refill Records.

10. The Clash, "Garageland," The Clash, 1977, CBS Records.

11. The Sex Pistols, "Anarchy in the UK" (single), Virgin Records.

From the perspective of British punk, the notion of the rock star was simply another product of the '60s corporate marketing strategy. This had certain class assumptions as well. Punks were aware that: 1) the '60s superstar was an artificial media myth; 2) this myth and the superstar's position were tenuous; and 3) the superstar artists had failed to perceive their position realistically.

In the '60s, The Beatles had been allowed (symbolically and economically) to rise above their lower-class origins and yet express its communal values. Their rise was accomplished through "normal" opportunities: an art school education and utilization of a market system where rock music had become an important product. As they made money for themselves, and also for the British economy, they achieved not only star status, but upper-middle-class respectability. In fact, with their knighting by the Queen, The Beatles ascended to pseudo-aristocracy.

The mythological ascension of The Beatles was proof for Britain that the class system worked and wasn't as repressive as some critics contended. It also proved that art and the attitudes fostered in British art schools could produce "higher" values, enabling a working-class lad to rise above his common station and the grim reality of his childhood background. By contrast, punk was defiantly anti-art and true to its lower-class origins. Its lyrics offered no escape, no fun, no artlike transcendence of reality. Punk preferred using the local dialect rather than affecting an American cultural accent. It preferred honest amateurism to (corporate) professionalism. It preferred sincere disgust and confusion. Punk asked questions rather than seeking stylistic or spiritual solutions, which were alien to its own social realities and contradictions:

> I don't want to know what the rich are doing
> I don't want to go where the rich are going
> They think they're so clever, they think they're so right
> But the truth is only known by gutter snipes . . .
> We're a garage band and we come from garageland.[10]

On October 8, 1976, after negotiating with a number of record companies, the Sex Pistols signed with EMI, the largest entertainment conglomerate in England. On November 26, 1976, their first single, "Anarchy in the UK," was released:

> Right now! I am the Anti-Christ
> I am an anarchist
> Don't know what I want
> But I know where to get it
> I wanna destroy the passerby
> 'Cos I wanna be Anarchy
> No dog's body![11]

On December 1, 1976, the group appeared on Bill Grundy's Thames TV program, *Today:*

Bill Grundy: I'm told that the group have received £40,000 from a record company. Doesn't that seem . . . er . . . to be slightly opposed to their [*deep breath*] antimaterialistic view of life?

Sex Pistols: No. The more the merrier.

BG: Really?

SP: We fuckin' spent it, ain't we?

BG: Are you serious or are you just making me, trying to make me laugh?

SP: No, it's gone. Gone . . .

Fan: I've always wanted to meet you.

BG: Did you really?

Fan: Yea.

BG: We'll meet afterwards, shall we? **[laughter]**

SP: You dirty sod. You dirty old man.

BG: Well, keep going, chief, keep going. Go on. You've got another five

seconds. Say something outrageous.
SP: You dirty bastard.
BG: Go on, again.
SP: You dirty fucker.
BG: *What* a clever boy.
SP: What a fucking rotter. [*more laughter*]
BG: [*turning to face camera*] Well, that's it for tonight. The other rocker, Eamonn, I'm not saying nothing about him, will be back tomorrow. I'll be seeing you soon. [*To band*]: I hope I'm not seeing *you* again. From me though, goodnight.[12]

As a result of the interview, the Pistols were banned throughout Britain from appearing live on stage, and Thames TV suspended Grundy. It was revealed that Thames was owned by the EMI conglomerate and great pressure was then placed on the company to fire the Sex Pistols. Leslie Hill of EMI recalled:

> The people in EMI and also outside of EMI had different kinds of objections. Some objected to the four-letter words on television; some objected to the supposedly violent [sic] aspects to the whole thing; some objected to the word "antichrist" in the song . . . we couldn't promote the records in that situation. Supposing, for example, they were doing a tour. Now supposing we'd done what we usually do with them on tour, which is to have a press party or a party at the end of the do. . . . You can imagine what would have happened. There would have been a riot. . . . You know, we've got hundreds of groups and hundreds of things to do. It got to a point where it really wasn't worth the trouble . . . I said to them you go to a smaller . . . label.[13]

On March 9, 1977, the Sex Pistols signed with A&M Records. Seven days after signing, after a raucous, press-cov-

ered party at A&M's corporate head-quarters that received alarming publicity, A&M terminated the Sex Pistols' contract at a total profit for the Pistols of £50,000. On their third try, they signed to Virgin Records definitely.

> It's an unlimited supply
> And there is no reason why
> I tell you, it was a frame
> They only did it cause of fame
> Who?
> EMI / EMI / EMI . . . And you thought that we were faking
> That we were always moneymaking
> You do not believe that we're for real
> Or you would lose your cheap appeal
> Don't you judge a book just by the cover
> Unless you cover just another
> And blind acceptance is a sign
> Of stupid fools who stand in line Like:
> EMI / EMI / EMI . . .[14]

The Sex Pistols and their manager Malcolm McLaren promoted the group by focusing the inherent destructiveness symbolized by rock and roll onto rock's real relation to the media. They used the media to become famous in order to then destroy the media and media-created fame. In other words, the Sex Pistols' ultimate goal was to expose it for what it was by forcing the media's contradictions (and their own contradictions as a rock act) into the open. When the Sex Pistols arrived in New York for their US tour in 1978, reporters demanded permission to take photos of Johnny Rotten. He refused unless he was paid $5.00 per photo. The reporters were taken aback; they naturally assumed that all rock stars wanted publicity, any kind of publicity, and that he would relinquish control of his public image and allow himself to be freely manipulated by the press.

12. The Sex Pistols, interview by Bill Grundy, *Today,* Thames TV, December 1, 1976.

13. Fred Vermorel and Judy Vermorel, eds., *The Sex Pistols: The Inside Story,* London: Tandem Publishing Ltd., 1978, 56-58.

14. The Sex Pistols, "EMI," *Never Mind the Bollocks Here's the Sex Pistols,* 1977, Virgin Records.

15. The Clash, "I'm So Bored With the USA," *The Clash,* 1977, CBS Records.

The story was reported in the press without photos.

Many British punk songs attack television as an institution. As the Clash put it in "London Burning," "everybody's drowning in a sea of television." The song "I'm So Bored With the USA" (1977) sees television as a conditioner of working-class acquiescence through its escapist mythology and, more menacingly, as a vehicle for American cultural domination:

> Yankee soldier, he wanted to attack
> The men in Cambodia
> But now he's fallen back.
> Yankee automaton
> He's the dictator of the world
> And they can't afford to miss a word.
> I'm so bored with the USA
> I'm so bored with the USA
> But what can I do.
> Yankee detectives are always on the TV
> 'Cause killers in America
> Work seven days a week
> Never mind the Stars and Stripes
> Let's read the Watergate Tapes . . .[15]

The group Alternative TV evolved in 1977 from the editorial staff of the first punk rock fanzine, *Sniffin' Glue.* In their performances they attempted to question the notion of "giving the audience what it wants." They encouraged viewers to use the band as a framework for collective political expression / questioning. Their live set featured a "soap-box" section, where members of the audience could come on stage and speak their minds. Their intention was to break down the usually passive, powerless position of spectators in relation to the musical spectacle (to their performing "heroes" on stage). Part of the ideal of British punk rock was that no one, not even groups, could dictate the ideas or behavioral norms of anyone else.

Alternative TV's first album, *The Image Has Cracked* (1978), includes an extract from a less-than-successful soap-box session, in which Mark Perry (vocals / guitar) chastises those who have spoken but have had nothing to say. Intercut with this session is a recording taken from a conventional television program of a spokesman extolling the Other Cinema (an alternative cinema-house that featured, in addition to new films, open political discussions on Sunday nights by new wave musicians, writers, and audience members).

Mark Perry: This is the period in the show where we ask members of the audience to come up on stage and say what they would about particular subjects. Anybody who wants to come up, come up now. . . . There must be one of you who wishes to use this particular soap-box we've been standing on. . . . You can have three minutes.
First Person: You're thick, right?
Audience: No!
First Person: What do you mean, "No?" Some of you know nothing . . . OK mate, seeing as though you know nothing, all right, all right. . . . How many of you are over eighteen? . . . Now a lot of you people have been influenced by the Prime Minister, right?
Audience: No!
First Person: You fucking listen, fucking listen to me, right. Shut up!
Second Voice: Let him speak!
First Person: Right. What's your fucking favorite TV program, then?
Audience: [babble of different replies]
First Person: See, all you people watch fucking "Coronation Street." It's your favorite TV program, right? . . . If you really took action . . . see the people running the country . . .
Second Person: My name is Ivan Johnson. One of our group was killed two weeks ago. We are looking for a singer. Anybody who

wishes to audition, just leave your name at the desk. May the dead rise. You want to go? Well, fucking leave your name . . .

Perry: Right. You stupid bastards get off the stage. Right. One of you people gets a chance to say something and what happens, there's a fight. It's not very cool. That's something you can do is fight. I just wanted to make a point. I love all you people, but I hate you when you act like stupid idiots. Because that's how they grind you down. [*Cut to TV program*]

Spokesman: In this space, films have been seen by over eight thousand people in its first years of existence. Films, that but for this cinema, would well have remained in their cans. Here also battles are fought, imaginations are expressed, differences confronted—and it also is space where all kinds of movement can develop . . . [*Cut back to soapbox session*]

Perry: Even rock and roll. A lot of people think it's good that the Buzzcocks and Sex Pistols and the Tridents and all that lot, I love those bands and I'm not putting 'em down, everybody thinks it's great that they are on TV, but it's not, is it? Because what you're getting is diluted, diluted shit. Everybody is so pleased, oh fine, we've got punk on TV. Oh, we've won. No way have you won . . . Someone said, "We know the problem, what is the answer?" This is really depressing, because I have no fucking answer.[16]

The problem for punk was how to present its critique of the corporate system in the form of a product that is, by definition, part of the system. It had to discover how to represent its political stance from inside media representations controlled by liberals. Tom Rob-

inson, lead singer and main songwriter of The Tom Robinson Band (generally known as TRB) is both a Marxist and a gay activist. The Tom Robinson Band was heavily promoted and packaged by EMI, the company that dropped the Pistols, perhaps because TRB's commitment to a specific cause was acceptable from a liberal viewpoint: the group would have a definite market appeal to gays as a large minority group. Rather than be defined by the media as anarchist or punk, Tom Robinson wanted to use his leverage with EMI to further his and TRB's extramusical political aims. For example, printed on the back of their record's cover was this statement:

Politics isn't party broadcasts and general elections, it's your kid sister who can't get an abortion, your best mate getting paki-bashed, or sent down for processing one joint of marijuana . . . it's everyday life for rock fans, for everyone who hasn't got a cushy job or rich parents. I got no illusions about the political left any more than the right; just a shrewd idea of which of the two die's gonna stomp on us first. All of us—you, me, rock and rollers, punks, jobless, dope smokers, squatters, unmarried mothers, gays, the jobless immigrants, gypsies . . . And if we fail, if we get swallowed up by big business before we achieve a thing, then we'll haveta face the scorn of tomorrow's generation. But we're gonna have a good try. Fancy joining us?[17]

On the back cover there are also appeals to join specific political organizations, giving addresses to write for further information.

In an interview, Robinson explained how he would present TRB's song "Sing If You're Glad To Be Gay" (1978) to the general audience:

If you walk straight on and sing "Glad To Be Gay," you get all sorts of limp-wrist gestures and take-the-piss-

16. From Alternative TV, *The Image Has Cracked,* 1978, Anagram Punk UK.

17. From Tom Robinson Band, *Rising Free* (EP), 1978, EMI.

18. Tom Robinson, interview, *New Musical Express,* date unknown.

19. Ibid.

20. Tom Robinson Band, "Glad To Be Gay," *Rising Free* (EP), 1978, EMI.

21. The Clash, "White Riot," *The Clash,* 1977, CBS Records.

out-of-fags business. . . . The words "gay lib" are enough to bring a snicker to every locker room. People don't respond rationally to the subject. Women sense rivalry in it and men sense a threat to their masculinity. At small gigs, where we played most of our working life, these self-same macho drunks, the rowdy element in every audience, are the ones that are gonna cause trouble.[18]

Instead, the band would usually begin the set with "Martin" (1978), a song about male bonding,

delivered in the person of a working-class hoodlum swilling a bit of beer, meself, talking about beating up kids at school, getting nicked by the police. . . . They think it's great, raising their beer glasses and cheering. They're in there with you. Then you start "Glad To Be Gay" with "The British police are the best in the world" . . . and they say "Yeah, right, mate! Bloody right! I've been drunk and disorderly on a Saturday night!" And then you hit them with the chorus, and by then they're already involved. And that way you don't get beaten up as you walk out the stage door.[19]

The British police are the best in
the world
I don't believe one of those stories
I've heard
About them raiding our pubs for no
reason at all
Lining up customers by the wall
Pickin' out people, knocking them
down
Resisting arrest as they're kicked on
the ground
Searching their houses
Calling them queer
I don't believe that sort of thing happens here.
Sing if you're glad to be gay
Sing if you're happy to be that way

Hey, sing if you're glad to be gay
Sing if you're happy that way.[20]

Black men have got a lotta
problems
But they don't mind throwing
a brick.
But white men have got too
much school
Where they teach you to be thick.
So we're content, we don't resent,
We go reading papers and wearing
slippers!
WHITE RIOT!
I WANNA RIOT!
WHITE RIOT!
A RIOT OF MY OWN![21]

The Clash's "White Riot" was written early in 1977, after troubles broke out at London's annual Notting Hill Carnival, an event organized by the neighborhood's black immigrants. Although newspaper reports implied that it was the blacks who rioted against the police who were protecting innocent tourists, the events were more complex. In addition to merrymaking, the event had become an occasion for various leftist groups to propagandize to both black and white celebrants. That year the right-wing National Front counterdemonstrated against the leftists at the carnival and was attacked by both leftists and blacks. The police interceded to separate the two groups, but seemed to do this in the Front's favor and to bully black people. Some blacks counterattacked and a police riot ensued. In a sense, the police represented (to the blacks) all the under-the-surface hatred and anger that lower-middle-class whites have harbored against black immigrants for years. Two years of successive and serious riots helped make evident that beneath the facade of the Silver Jubilee, Britain was having difficulty accepting its new position as a poor and multiracial society. Among its working class, the Pakistani

and Jamaican Commonwealth arrivals were rising toward middle-class status faster than native whites were.

"White Riot" was partly an answer to white hate directed toward blacks. Historically, in the evolution of rock music, young white singers had always appropriated black music and slanted it toward a white, teenage audience (and market). But black music (representing black ideology) and white music (representing white ideology) are never precisely compatible. In dealing with blacks, white music either sentimentalizes the blacks' plight or seeks a transcendental synthesis of both realities. A classic example is Elvis Presley's "In the Ghetto." While its subject matter focuses on poor urban blacks, the point of view is clearly white, Christian, guilt-assuaging, and subtly patronizing; it reveals more about white, middle-class ideology than about how blacks live.

The Clash's "White Riot" is not an apology, nor is it a fascist defense of poor white youths' distrust of black immigrants. It sees the problem (not from a universal human perspective) only from a white perspective (as the song is written and performed by a white group for white audiences), a viewpoint usually masked by the liberal projections at work in a song like "In the Ghetto." By comparing the white and black situations (they argue), working-class whites can acquire a clearer view of their own dilemma. "White Riot" states the problem as honestly as possible—but, it is not a personal confession, or polemic (as Bob Dylan might have written). A later song by the Clash, "White Man in Hammersmith Palais" (1978), continued this meditation on the problem of two cultures and two musics coexisting in Britain.

In "Repetition," recorded in late 1977 by The Fall, a young Manchester group, the issue was extended to the form of rock music / punk itself. While the content of punk music was politically progressive, its form generally seeks to eliminate progressive qualities in favor of basic rock-and-roll repetitions. Musical form (which then inevitably drifts back toward the "artistic" after its initial purge of these qualities) and the political content expressed by the lyrics often contradict each other:

White noise
Look at them speeding
You don't wear a black and white tie
You're gonna make it on your own
'Cause we dig you
'Cause we dig you
Ah we dig you
Ah repetition of the drums and
we're never gonna lose it.
This is the 3 R's:
Repetition
Repetition
Repetition . . .
Oh repetition in the music and
we're never gonna lose it.
President Carter loves repetition
Ah Chairman Mao he dug repetition
Oh repetition in China
Repetition in America
Repetition in West Germany
Simultaneous suicides
We dig it
We dig it . . .[22]

Spring 1979

Dan Graham is a New York–based artist and critic. He is the author of Rock My Religion: Writings and Projects 1965–1990.

22. The Fall, "Repetition," B-side to "Bingo-Master's Break Out!," 1978, Step Forward.

Notes
This essay was first published as "Punk: Political Pop" in Journal / Southern California Art Magazine, no. 22, March–April 1979, 27–33. Originally a slide lecture that Graham presented with appropriate audio clips, the text was transcribed at the suggestion of Deborah Berchett-Lere, guest editor for a special issue of the Journal on "the interface between the visual arts and music." In addition to "Punk: Political Pop," the issue featured interviews with Judy Nylon and Iggy Pop and texts by David Byrne, Rhys Chatham, and others. Graham's writing was accompanied by photographs by Melanie Nissen of local punk stars. The Journal was the quarterly publication of the Los Angeles Institute of Contemporary Art (LAICA), a now-defunct alternative space.

This essay also appears in Dan Graham, Rock My Religon: Writings and Art Projects, 1965–1990, ed. Brian Wallis (Cambridge, Mass.: MIT Press, 1993), 96–113.

EUROPE

Avant-garde artists and musicians in the United States and the United Kingdom had a developed and concentrated commercial music system they could respond to (or react against), but their European counterparts faced a more challenging situation: the absence of a dominant pop culture to galvanize them.

Discussing this lack of a centralized and sophisticated network of pop cultural production in Germany and elsewhere on the continent, artist Jutta Koether states that "this second-order pop culture is the only pop culture around, so either you work with it or have nothing. So there is a kind of ambivalent feeling if you want to enter it."[1] While this perhaps accounts for the striking absence of significant crossovers between art and rock and roll in countries like France or Italy, it is important to note that the intersection of the two cultural genres largely developed, as it had in other places, through socially driven circumstances. In Germany, the first meaningful instances of art and rock's relationship appear to have occurred courtesy of "krautrock" bands such as Can or Faust in the early 1970s, which

1. Jutta Koether quoted in "Jutta Koether," in Mike Kelley, *Mike Kelley: Interviews, Conversations, and Chit-Chat (1986–2004),* ed. John C. Welchman (Zurich and Dijon: JRP / Ringier and les presses du reél, 2005), 98.

were soon followed by the international phenomenon Kraftwerk, which brought a Warholian sensibility to electronic-based music. The intense exchange between art and rock that occurred in the late '70s and early '80s in Cologne and Düsseldorf owed much to clubs like the Ratinger Hof and to publications such as *Spex*. This spirit lives on through artists such as Kai Althoff and the aforementioned Koether. In more recent years, artists and musicians as diverse as Laibach, Aleksandra Mir, and Pipilotti Rist have explored political issues such as the lingering influence of fascism or contemporary understandings of feminism through their use of rock music.

EUROPE ENDLESS: ART AND ROCK ON THE CONTINENT DOMINIC MOLON

In Cologne and Düsseldorf, groups such as Can, Faust, Kraftwerk, and Neu! developed sound structures and sound scapes that incorporated such experimental tropes as atonality, repetition, and the use of unorthodox instrumentation more familiar to radical composers like Karlheinz Stockhausen or the free jazz emerging from Chicago's AACM (Association for the Advancement of Creative Musicians). Kraftwerk in particular developed a Warholian approach to creating a factory-like sensibility in relationship to their musical production and the construction of their image. As Lester Bangs reported in 1975, "Kraftwerk, whose name means 'power plant,' have a word for this ecstatic congress [of humanity and technology]: *Menschmachine,* which translates as 'man-machine,'" adding that "they also referred to their studio as a 'laboratory.'"[1] The group, which began in "the art student bohemia of Düsseldorf" and acknowledges the influence of Fluxus and happenings, would go on to have an incalculable influence on what would become techno music, as well as on hip-hop through the sampling of their "Trans-Europe Express" on Afrika Bambaataa's seminal dance single "Planet Rock."[2]

Düsseldorf's Ratinger Hof club became a central fixture for the crossover between the art and rock music scenes. In April 1974, for example, students of the legendary artist Joseph Beuys organized a rock-and-roll festival. These organizers included Johannes Stüttgen, who decorated the bar with panthers and leopards, and Walter Dahn, who installed a life-size figure of Elvis Presley at the entrance. Dahn especially figured as one of a number of artists who frequented the nightclub in its days as one of Germany's primary punk hang-

outs. The club, under the direction of Carmen Knoebel, eventually hosted the elite avant-rock acts of the '70s and '80s, including Wire, XTC, The Red Krayola, The Pop Group, Scritti Politti, and Gang of Four from the UK; Pere Ubu from the United States; and Mittagspause (featuring painter Markus Oehlen), S.Y.P.H., and Einstürzende Neubaten from Germany. It also played host to the musical component of the 1980 *Finger für Deutschland* exhibition held at Jörg Immendorff's studio in Düsseldorf, which included Werner Büttner, Martin Kippenberger, and Albert and Markus Oehlen. Various bands affiliated with the scene played the concert, which was documented on video. Knoebel also ran the record label Pure Freude with Harry Rag from 1978 to 1984, releasing music by bands such as S.Y.P.H., The Mekons, The Raincoats, Mittagspause, and Can.

Kippenberger's life and work often touched on rock music. He was one of the members of the band Luxus—which also featured Christine Hahn (who also played with Glenn Branca in Theoretical Girls) and Eric Mitchell (best known, perhaps, for his 1980 film *Underground U.S.A.*)—and made recordings (as the Alma Band) with Albert Oehlen as well as solo recordings. The artist also co-owned the SO 36 club in Berlin, before settling in Cologne in 1983. Finally, paintings such as *Flotter Dreier, Motörheads Rom 1941* (1981) and *Motörhead (Lemmy)* (1982), as well as projects such as *Brasilien Aktuell* (1986) and the drawing series *Heavy Maedel* (1991), demonstrate the ongoing importance rock music has played in Kippenberger's oeuvre throughout his career.

Another key element that straddled the art and music scenes in Germany in the early '80s was the Cologne-based music and art magazine *Spex,* featuring

1. Lester Bangs, *Psychotic Reactions and Carburetor Dung* (New York: Knopf Books, 1987; repr., New York: Anchor Books, 1988), 156–57.

2. Michael Bracewell, "Wired for Sound," *frieze,* no. 98, April 2006, 132.

Slim Smith
Album cover art for Laibach's
Sympathy for the Devil, 1988
Courtesy of Mute Records
© EMI Group and Affiliates

3. Bennett Simpson, *Make Your Own Life: Artists In and Out of Cologne,* exh. cat. (Philadelphia Penn.: Institute of Contemporary Art, 2006), 23.

4. Isabelle Graw, "Peripheral Vision," *Artforum* 44, no. 7, March 2006, 260.

contributions by artists and art critics such as Peter Bommels, Diedrich Diederichsen, and Jutta Koether (in her regular "Mrs. Benway" column). Not only was the coverage of both art and music within the same context of critical importance in this regard, but so too was the fact that the publication introduced then-emerging artists from the United States such as Mike Kelley and Richard Prince. This and the general atmosphere of multidisciplinarity fostered by the general crossovers between the art and music scenes in Cologne cre-

ated a situation described by Bennett Simpson in which "artists' bands and musical projects were not merely life-style but a source of group experimentation where social energies, personal auratics, and non-visual energies could be channeled and vetted within a small community of one's peers."[3] Koether's early book-oriented efforts comprised "texts, with a very punk aesthetic, statements and magazine cutouts . . . placed in record stores for [her] peer group." Her subsequent paintings challenged the hegemony of the styles emerging from the male-dominated neue wilde and Mulheimer Freiheit groups of German painters of the early '80s, with their "relentless pressure on the formal implications of 'bad' (untrained, punk, DIY) painting."[4] In more recent years, Koether has collaborated with other artists on such sound and art-related projects as playing in the duo Electrophilia (with artist Steven Parrino), working with Rita Ackermann on the double album *Diadal* (1998), and the installation project *Club in the Shadow* (2003) with Sonic Youth's Kim Gordon at the Kenny Schachter Gallery in New York. Koether's *Music* (2006), from the series *structural necessity of multiple inconsistent fantasies* combines a large black canvas backdrop with a silver tinsel curtain and densely tactile black paintings suspended from the ceiling on chains to create a visual presentation highly suggestive of the kind of layered intensity and complexity of the musical sensibilities of Koether's music-based projects.

Though Koether eventually moved to New York in the early '90s, the crossover between the visual arts and rock music have continued from the '80s into the present, through the efforts of entities like Albert and Markus Oehlen's band Van Oehlen (a witting take on American

rock stars Van Halen), the Oehlens' and painter Werner Büttner's involvement with Mayo Thompson's Red Krayola, and other figures such as Cosima von Bonin and especially Kai Althoff. The latter has been particularly involved in this area, through both his internationally known electronic-rock outfit Workshop and works that allude to fictional rock bands (his foldout album cover *Ashleys*, 1989) and figures such as former X-Ray Spex and Essential Logic front woman Lora Logic. Althoff's involvement with Workshop, whose album covers boast various examples of his visual art work and whose sound is indebted to krautrock bands such as Neu! and Can, is but one part of an artistic practice that eliminates hierarchical boundaries between craft, format, genre, and medium, instead seeing all manner of expression as an interconnected whole.

One of the more curious aesthetic phenomena to emerge from the politically unstable environment of the former Yugoslavia during the '80s was the Slovenian fascistic industrial band Laibach. Like Kraftwerk, the group placed an emphasis on a collective identity rather than on individual contributions, replacing their German counterparts' elegant techno-futurist style with a more aggressive nouveau-totalitarian aesthetic. Laibach took its name from the Nazis' name for the city of Ljubljana, establishing a tendency for controversy and provocation from the outset. In the mid '80s, the group joined forces with the like-minded artists' collective Irwin and the theater group Scipion Nasice Sisters to create the organization Neue Slowenische Kunst (NSK), thereby uniting rock music, experimental theater, and high art to provide a late-century reflection on (and of) fascism that swung ambivalently and ambiguously between

nostalgic celebration and critical irony. In addition to its own self-penned songs, Laibach often performed classic rock standards such as The Rolling Stones' "Sympathy for the Devil" or The Beatles album *Let It Be* (in its entirety, sans the title song), with a humorous sense of dirgelike authoritarianism.

A radically different synthesis of politics, music, and art is found in Aleksandra Mir's 1996 project *New Rock Feminism*. Born in Poland and a citizen of Sweden living in both Palermo and New York City, Mir consistently examines how the creation and presentation of art may function socially or politically. *New Rock Feminism* is the result of her compiling over one thousand signatures at Denmark's Roskilde Festival for a petition demanding more female rock bands and performers and submitting the petition to the festival's organizers. Her monumental presentation of the work comprises both photographs documenting her activity and reproductions of the petitions, emphasizing the alternately disturbing and comical nature of the audience's comments and underscoring Mir's intent of bringing a structured form of political protest into

Martin Kippenberger
*Veranstaltungsplakat SO 36
Berlin.8.5. – 23.5.1979,* 1979
Offset print
11³/₄ x 11³/₄ in. (30 x 30 cm)
Courtesy of the Martin Kippenberger Estate, and Galerie Gisela Capitain, Cologne

5. Robert Garnett, "Too Low to Be Low: Art Pop and the Sex Pistols," in *Punk Rock: So What?: The Cultural Legacy of Punk,* ed. Roger Sabin (London and New York: Routledge, 1999), 25.

the chaotic social situation of a rock concert. *New Rock Feminism's* disruptive gesture echoes critic Robert Garnett's observation that "there are few places within which the contradictions of late-capitalist power relations are more palpably evident than at a rock festival" by heightening awareness of political inconsistencies in the utopian and communal rhetoric often espoused at such events.[5]

Polish artist Paulina Olowska and Scottish artist Lucy McKenzie presented an inverse combination of social space, rock music, and avant-garde strategy with their *Nova Popularna* project in Warsaw in 2003. Facilitated by the Foundation Gallery Foksal, it functioned as a working illegal bar fashioned after the salons and cafe concerts of the European modernist era and featured concerts by various performers, including artist Mark Leckey's band donAteller. Rather than Mir's injection of a rational political critique into an unstable social situation based on an experience of rock music and alcohol (and probably other substances), Olowska and McKenzie used the premise of an art installation to organize a clublike atmosphere that prompted considerations of the continuing historical tradition of an urban avant-garde communal experience—from the cafes of fin-de-siècle France and Vienna to the punk clubs of the '70s and '80s.

Swiss video artist Pipilotti Rist was a member of the rock band / performance group Les Reines Prochaines from 1988 to 1994 and has frequently incorporated elements of rock and pop music into her work. Early single-channel videos such as *I'm Not the Girl Who Misses Much* (1986) and *You Called Me Jacky* (1990) typify her use of performance, arch humor, and sonic and visual distortion to create works that are intensely personal

while reflecting on the deeper psychological issues of feminine social roles. *I'm Not the Girl Who Misses Much* features a blurry image of the artist in a revealing outfit hysterically repeating the title of the work, an alteration of the first line from The Beatles' song "Happiness Is a Warm Gun" (the original lyrics are "*She's* not *a* girl who misses much"). Rist's manic articulation of the changed lyric creates a tension between the sense of self-assurance that the phrase implies and the sense of psychological dementia that one sees on screen (a sensibility made that much more disturbing by the diminished visual quality of the image). *Jacky* features the bespectacled artist lip-synching obscure British folk rocker Kevin Coyne's nostalgic song "Jack and Edna," subtly meditating on gender roles by mimicking a male voice singing about a male-female relationship. This video also possesses a complicated visual field, the images of Rist's performance competing with images of trains and railroads that underscore the melancholy undertone of the music. Both works, made during the ascendance of MTV and music-video culture, function as critical counterparts to the music video in their emphasis on willfully crude visuals and presentations of persona and identity that defy the "star-glorification" more characteristic of this format.

In recent years, artists and collectives such as Akademie Isotrop and Thomas Zipp have continued to keep the crossover between art and rock music alive in Germany. The former was founded in 1996 by a group of twenty artists, authors, and musicians and was based in Hamburg until 2000. The Akademie had their own exhibition space in the famous Pudel Club punk venue, called Nomadenoase (Oasis of the Nomads)

and published their own magazine, *Isotrop*. Though mostly recognized now for a distinctive painting approach, the Akademie nevertheless demonstrates the multidisciplinary spirit that continues to exist in German art. Much of the Berlin-based Zipp's work is inspired by rock music and the psychedelic drug culture associated with the genre without making overt references to either. With its multiple layers of historical allusions and dense materiality, his work creates a visual analogue for the kind of sonic dissonance and distortion characteristic of avant-rock icons such as The Velvet Underground, The Stooges, and Lou Reed. An organ that he created from almost seventy different noise-makers (horns, bells, whistles)—many of which came from the former East Germany for a 2006 exhibition at Harris Lieberman Gallery in New York—seems to bring the German fascination with combining art, industrial technology, and rock music found in Kraftwerk and Einstürzende Neubaten full circle into the 21st century.

The title "Europe Endless" refers to the Kraftwerk song "Europe Endless" on the album *Trans-Europe Express*, 1977, Capitol Records.

INTENSITY, NEGATION, PLAIN LANGUAGE: WILDE MALER, PUNK, AND THEORY IN GERMANY IN THE '80S

DIEDRICH DIEDERICHSEN

Today it is common to relate punk's break with pop music, as well as new wave and its stylistic spin-off Neue Deutsche Welle (German new wave), to parallels in the visual arts: wilde maler (new savages) and the incorporation of theory and political orientation. But what did they really have in common?

One of the most widely read and cited authors in subcultural circles in those days in the old Federal Republic of Germany was Jean François Lyotard. His most popular book was the compilation by Merve Publishers titled *Intensities*. Published in 1978, the formative year of the reception of punk, the book includes a brief text on its back cover that ends with the sentence: "I hope my discourse has some of this intense lack of reputability."[1] Intense lack of reputability—the phrase seemed to hit the nail on the head better than any one of the songs that had come out until then. Yet what did Lyotard, or his youthful readers, mean?

What corresponded to this intense lack of reputability on Lyotard's part? When one pages through the book that offers this back-cover propagandistic pearl, one finds, among other things, the claim that Cage and Nietzsche raised the challenge for a "politics of intensities." Lyotard explains: "These are the 'people of intensification,' the 'masters' of today: outsiders, experimental painters, pop artists, hippies and yippies, parasites, the insane, inmates. An hour of their lives contains more intensity (and less intention) than a thousand words from a professional philosopher."[2] It is not unimportant that already in 1972, these "Comments on the Return of Capital," which Lyotard delivered in a lecture, repeatedly and explicitly refer to music as the place where the fight between good intensity and bad representation most pointedly

plays out—as the fight between the musical note and sound.

The note had already lost sound for some time, not only in serial and post-serial modern composition, whose electronic Cologne contingent (including Eimert and Stockhausen, among others) had only replaced the notes with even more exact descriptions of the overdetermined intentions of composers—not only in the work of Cage, aleatoric and indeterminate artists, and others who freed sound from the prison of the musical note and its aesthetic considerations. No, in free jazz the note had also had its day: the new sounds of free jazz could no longer be transcribed, but for those musicians the escape of sound was primarily social rather than aesthetic. It was an index of the revolt against white suprematism. Punk had a social index as well: the note as part of the musical order and its regime of technical abilities had become obsolete through aggressive dilettantism and other nonconformities expressed by the anarchy, the chaotic otherness, of sound.

What role did punk have in this theory—beyond the presumed unified front in the fight of sound with the note? Why did it attract people like me, who lived at the time in the milieu of punk and New Painting? Didn't it call our enemy, namely the hippie, a hero, and wasn't it exactly the opposite of a theory from 1978, actually the typical theory of 1972, as the fight shifted from college campuses and the street to psychiatry and art. As a youth in 1972, I was, in any case, a full-fledged fan of intensity. Fully unclear, wide-open adventures lay before me, to be determined by nothing, aside from the lasting impression that they should make on me and the impression I wanted to make on all who would accompany me on my adventures: sustained, intense living was the only alternative

1. Jean François Lyotard, *Intensitäten,* Berlin: Merve, 1978.

2. Jean François Lyotard, "Bemerkungen über die Wiederkehr des Kapitals," in *Intensitäten,* Berlin, Germany: Merve, 1978, 32.

Markus Oehlen
Mittagspause, 2004
Oil lacquer on canvas
31 1/2 x 39 3/8 in. (80 x 100 cm)
Courtesy of Galerie Hammelehe und Ahrens, Cologne

to not being dead. In 1978 intensity was an irritating and kitschy cliché, a purely nominal claim in a discursive routine, an eternal element of older people's conversation and a vehicle of ideological anti-intellectualism, something hippies and the average right winger had in common. It was a discursive tool directed against any possibility that a political life, an aggressive counterculture could regenerate itself. On the other hand, in 1978 "lack of reputability" still sounded very interesting.

The talk about intensity was therefore not purely philosophical. It was present in the everyday language with which everyone who turned twenty in the '70s grew up. The argument about intensity was stronger than any political one; it was the meaning of life to live intensely—on that, religious fanatics and revolutionary anarchists could agree. Indeed the realization of punk's break with this culture took on two forms: on one hand, rejection of the so-called hippie culture because for all its intensity, it had become silly, thus harmless, and above all, stupid. This oppositional standpoint was decidedly intellectual. One must once again discuss, employ concepts, express things, read books, be explicit. From this standpoint one looked to books published by Merve, only to read in them once again that it is better to exist on the other side of representation—like the hippies who had just been overcome—to exist as an outsider, without concepts. But it was still better to at least read this than—as for so long already—to experience the ideology of hippies and feelings and outsiders as social pressure. If the outsider were registered within a theory, one could see if he were right.

Punk's second break with this culture was, however, formulated as exactly the opposite. Intensity as a value was not the problem; the once-intense lives of the outsiders were not hopeless, rather they were hardly intense any more—not because they had become weak-minded, but because they had long ago become only representatives of intensity, portrayers of intensity. The discourse of their legitimization was possibly damaged through this shift, so that intensity was no longer discussed from this side either, but its goal and value were not yet canceled out. One strived to give new legs to intense living, in new lifestyles, new ways of being an outsider. In this version the hippies weren't so guilty of being hippies, but the opposite: their guilt lay in not being hippies anymore—in having betrayed the ideals of the "people of intensification." These two readings of punk's break with the culture agreed only on this: that which was praised without risk in 1978–79 as "hippie," "outsider," and "experimenter"—once essentially state art and state culture—was to be rejected today.

The reasons for the rejection were diametrically opposed: negation of the principle of intensity as critique of representation on the one hand, negation of contemporary means and forms of intensity and its empirical representatives on the other. Among the ranks of punk, this led to followers and opponents of intensity finding themselves in the same bars, the same concerts, and the same clothing. Because they drank, smoked, took drugs, and listened to music together, but did not discuss concepts, this difference was not dealt with in concepts that could have articulated it, but through aesthetic battles of substitutes. Even I swung between the two positions: I loved text-oriented, manifesto-like, quotational, denotative punk songs because they proceeded anti-intensely (in that, certainly very intensely); I also loved the aesthetics of subjuga-

tion, electronic, loud, heavy punk and the industrial impudence because they rescued intensity. People who were well versed in representation and its criticism, such as Malcolm McLaren, seemed worthy of admiration to me, but they also quickly became boring and predictable. Single-minded artist types bored me, but at the same time they were also the only people who could be surprising.

Corresponding to the three musical centers of West German punk culture (West Berlin, Hamburg, Düsseldorf), there were three centers of new savages—in West Berlin, Hamburg, and Cologne.[3] As the visual artists were closer to a conceptual universe than the punk musicians were—not in the least because they had experienced the conceptual in earlier debates in art—for example, at actual, conceptually based academies such as Düsseldorf or the Cooper Union in New York—here there were the beginnings of explicit confrontations that in music or in everyday life were relegated to differences in taste or to fighting. The Moritzplatz-painters from Berlin, painters like Middendorf or Salome were accused of representing only the lifestyles they found attractive, but not transferring them into their own form of painting or art. Images of rock-and-roll singers or transvestites or strong women were considered by many to be tautological duplications of already intensely expressive gestures.

On the other hand the Hamburg Group around Werner Büttner and Albert Oehlen pursued a more anti-intense program (in the sense described above) and accused the Berlin artists of being intensity players and prompters of mistakes, which the outsider kitsch of the official, liberal Social Democrat culture also made. Conversely, the Cologne artists around the Gruppe Mül-

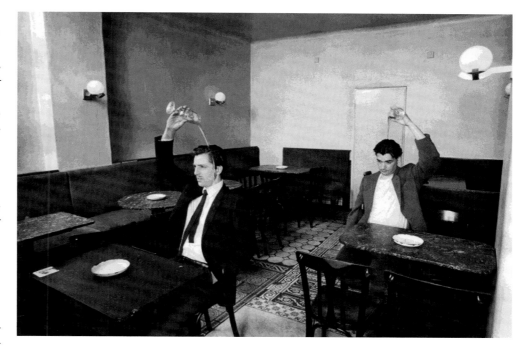

Albert Oehlen and Werner Büttner
Biertaufe, 1982
Gelatin silver print
Courtesy of the artists
Photo by Rainer Fichel

lheimer Freiheit (Müllheimer Freiheit Group)—including Walter Dahn, Jiri Georg Dokoupil, Peter Bömmels, Hans Peter Adamski, Gerhard Naschberger, and Gerard Kever—were more representatives of the other philosophy, that intensity is only betrayed but still can be rescued if only its contextual conditions could be newly constructed. The references to blues and Beuys in Dahn's work and to an ideal Africa in Dahn and Dokoupil's work point to the reconstruction of an intense life as life in art. Later Dokoupil in particular transferred this idea into a rather distanced, smirking postmodern disposition, whereas Bömmels continued painting as an heuristic exploration of individual as well as sociopathic conditions. The group even lost one member to the sect led by Bhagwan Shree Raj-neesh. The Hamburg artists reproached them: "Six young Cologners present a synthesis of Antes and Schröder-Sonnenstern."[4] The Cologne artists accused the Ham-

3. The Düsseldorf bands' relationship to the visual arts represents a complicated exception: Carmen Knoebel, the owner of the influential label Pure Freude (Pure Joy) and for a time owner of Ratinger Hof, had a close relationship to the visual arts as the wife of Imi Knoebel, considered to be of an earlier artist generation. The painter Markus Oehlen played drums for the most important German band at the time, Mittagspause, but soon moved to Hamburg. It was not until that time that he decided to work primarily as a visual artist. Moritz Reichelt (Moritz Rrrr) of Plan was and is a visual artist but did not belong to the controversial trend of New Painting at the time, rather he owed his ironical style to the Gruppe Normal and Milan Kunc, who were rather singular phenomena.

4. "Facharbeiterficken," in: Markus Oehlen, Ina Barfuß, Werner Büttner, Georg Herold, Albert Oehlen, Thomas Wachweger, Martin Kippenberger, *Über sieben Brücken mußt Du gehen—mußten wir auch,* Stuttgart, Germany: Galerie Max Hetzler, 1982.

5. Alfred Nemeczek, "Malerei '81: Die Sache mit den Wilden," in *art* (Germany), October 1981.

6. *Rockpalast,* which exclusively featured live performances, was a very popular TV program in the '70s. Bands like Little Feat and The Who appeared frequently, but punk was excluded because of its lack of technical skill.

burgers once again of pure caricature, of an art completely caught up in humor—without any intensity.

The first reporters to investigate the movement worked for the established magazine *art*, and for them the whole movement in all of the cities was caught up in the concepts of the "wild," the "painterly," and, above all, "unbridled subjectivity."[5] The last term was illustrated, among others, in Werner Büttner's painting *Selbstbildnis im Kino onanierend* (Self-portrait Masturbating at the Cinema) (1980), which presented the helpless (self) criticism of painterly subjectivity as much laconically as allegorically (instead of celebrating it). But also in a funny way he finds a correspondence in a paradox of this historical art text, which namely derives the worldliness and curiosity of new savages painting from the interest in cinema repeatedly expressed by the painters questioned. That this paradox was not felt to be a paradox is stated in ironically intended, aphoristic classics of the period, such as this line from the Fehlfarben: "Ich kenned as Leben / Ich bin im Kino gewesen" ("I know life, I've been to the movies"). In the lyrics of the new Hamburg poets like Christoph Derschau and Kiev Stingl and pseudo hard-boiled, trenchcoat-wearing authors from Schwabing such as Jörg Fauser, the cinema was also a wild yet sentimentally atmospheric bar, whose culture of representation was somehow more true than the intensity of past trips to India and improvisational experiences.

The central, negative concept of legitimization in all punk iterations was boredom. The song "Boredom" by the Buzzcocks and the 1978 film *Brennende Langeweile* (literally "Burning Boredom," known in English as *Bored Teenagers*) by Wolfgang Büld with Ian Moorse and Gaye Advert from the Adverts (and the rest of their band) identified expressively what united the different factions and practices: a feeling of oppressive existential hopelessness that was headed not for catastrophe but rather for a secure yet worthless life. Already as in various Situationist statements, boredom meant something other than the absence of variation and entertainment. It was, rather, the result of too much of it. Neither the remainder of a politicized culture whose representatives had been indistinguishable from the power figures for a long time, nor the completely industrial entertainment-oriented youth and counterculture, could give one the feeling that life decisions in politics or culture would proceed other than without consequences in the production of ordinariness. The consensus of the democrats and their similarly consensual rock culture in state-owned TV programs appeared to be provoked only through consistent negation. It quickly became clear, however, that this negation of boredom could not only be expressive and dramatic, as that was exactly the mode of Rockpalast (Rock Palace)[6] rock, that is: the other side. The problem of nothing happening, as seen in Büld's film, could not be distinguished from the other problem, namely the fact that something happening is always somehow ugly.

Such a criticism of boredom could have been politically driven, as seen in the Situationists and the beginnings of the leftist (at first in the minority) punk school in the direction of Gang of Four and The Mekons, who in Germany corresponded most closely to S.Y.P.H. and Fehlfarben. This approach could, however, also take an existential and anthropological tack, as the search for the essential: representatives of this vein also soon took shape. In the ever more

elaborate and artistic fanzines such as *Die 80er Jahre* (The '80s) by Jürgen Kramer, suddenly authors such as Heidegger and an orientation on Bataille's anthropology and the recently fashionable *Critique of Reason* played an ever-greater role.

An even more central, unifying figure, due to the various subscenes, was Nietzsche: the philosopher was newly read by the French, such as Lyotard, Deleuze, and Foucault, who in an affirmative discourse and in the previously mentioned intensification also actually reconciled the formerly differing positions on intensity: even those who accused the hippies of betraying intensity, like those who wanted to obliterate the idea of intensity, could agree on the apodictic, antidemocratic, and aggressive tone that one could learn from Nietzsche. This could be learned completely independently from reading his philosophy from one or the other perspective, completely independently from any positions at all.

I have already pointed out that the varying negative references to intensity played a decisive role in the development of an implicit self-understanding of the different punk cultures—of course, implemented without explicit concepts. In fact nearly all elements of such self-understanding had come into being from the negative—and cannot be translated automatically into the affirmation of its opposite. Indeed one was not truly against everything, and one's oppositions were not random. But it was very important not to transfer one (often very specific) negation into a position through only a simple act of applied logic. The experience that is suspected to be limited by all as tragic, stopping history in a state of negation, should be drawn out as long as possible, just for this reason. For a few individuals, as

Jürgen Teipel reports at times in macabre detail in his book *Verschwende Deine Jugend* (Squander Your Youth),[7] this moment lasts for a very long time, to this day. However, it is a mistake to deduce from this wish that one should make the moment of negation last as an actual expression of a nihilistic stance.

Rather, the state of negation is much more a state of the greatest control possible: he who rejects everything is not responsible for anything that exists and at the same time has everything else that does not exist open to him in an endless realm of future possibilities. He must only attenuate the moment at which this future will begin. That is the reason for the unbelievable moment of stubborn persistence in all styles of punk (and other movements of negation), expressed aptly in the appropriate self-criticism "Punk makes [your] ass fat" (by, I believe, Peter Hein).

In spite of this, punks also stated what they didn't want: they could not always remain general. And theoreticians did this, too. Visual artists, although at the time truly in the middle of the two forms of expression—privileged with contact to each—showed this more readily than stating it did. They often expunged methods that one knew and could identify only if one were on the inside of the artists' circle or knew the artistic context. If one looked at them from the outside, one could only recognize the exactitude with which this expunging went against something, against something specific, without knowing what. That was very impressive.

Today one can once again observe a strategy of artistic production that was common at that time, the avoidance. One has two premises: 1) to deliver material with no similarities at all, no recognizability, legibility; and 2) to produce unconditionally, to produce objects that

Albert Oehlen
Als Gott Den Rock erschuf Mußer geil gewesen (Rockmusic III), 1984
Oil on canvas
78 3/4 x 78 3/4 in. (200 x 200 cm)
Private collection, Berlin
Courtesy of Galerie Max Hetzler

7. A kind of oral history of German punk history. Jürgen Teipel, Verschwende Deine Jugend, Frankfurt, Germany: Suhrkamp, 2003.

are materially at hand. What at that time was tested out as impossible subjects and combinations of themes, illegibility attempts to conquer today through formal and material strategies—as one could see, for example, in several works of the so-called new formalism, as presented in the exhibition by the same name (Formalismus) by the Hamburger Kunstverein in 2004.

In prominent places as well, punks proclaimed above all what they did not want: "No (more) Heroes" (The Stranglers), "No Values" (Black Flag), "No Future" (Sex Pistols). Less prominently: "keine alte Bewegungen" (no old movements) (Fehlfarben), no nature (S.Y.P.H.), no political pretensions, no bourgeois. Of course, there are infinitely more statements that above and beyond these often differ greatly in status: in interviews, song lyrics (ironic), song lyrics (as a manifesto), etc.—but put together, they are very precise and can therefore be discussed in the sense that they permit the positive derivation avoided by their originators. They were, above all, also successful; that is, they were frequently copied. It is interesting that nearly all of these statements were not so clearly intended as they sound.

"No heroes," as mentioned in The Stranglers' song "No More Heroes," is often considered the central punk statement. It reaches into the even more concrete rejection of "No Beatles and Stones," to which the Clash could agree. Not only songwriters' explanations—as in my conversation with Hugh Cornwell—but the list of questionable heroes in the song also states that this was not simply a demand, but even more an expression of regret: Leon Trotsky and Sancho Panza, whom the narrator misses in "No (more) Heroes," were not the heroes of their historical or fictitious contexts; they were each second

in line. They are already antiheroes. Yet they have also disappeared—possibly sacrificed to the heroes, destroyed by the heroes. The chorus of "No (more) Heroes" permits an interpretation of regret as well as demand. The identification with heroes in the punk culture was for a while much stronger than in previous youth and countercultures based on music. Precisely because all possible rules and institutions of cultural production and reception, such as record companies, large concerts, hit parades, and high-tech industry, including the highly visible cult of pop stars, were called into question; figures on a human scale were established as heroes, as a last consistent unity of the culture. A few individuals became completely overtaxed representatives of a lifestyle believed to be held together by nothing material, fixed, or constant (Sid Vicious) or moral (Joe Strummer). This produced not only a disgusting culture of persecution of traitors, but also connected or contributed to the general trend of works of art becoming more defined as agents of an act.

In "No Values," Black Flag communicates a rejection of all, even leftist, values and confesses, of course, inconsequently to a value, namely to the values of anarchism, which is cleaner and without historical flaws. It could neither be held responsible for GULAGs like the historical Communists nor for bureaucracy like Social Democracy. Still the values of anarchism clearly derive from leftist antibourgeois thought. To this day punks all over the world adopt the reverence for anarchy expressed (and at times doubted) relatively elaborately by BF and others, above all by the California bands. The derivation of anarchy from the rejection of values—all values—which one can follow (under the circumstances), if one equates the normative

instrumentalization of values through authorities with the values themselves, is generally clear and causes difficulties only for those individuals who want to derive an enduring practice from that. For example, Black Flag, like many others, established a company, namely the SST label, as a first step to control-free space—a classic paradox of the independent culture.

Yet aside from this often discussed problem, the pro-intensity and traitor-persecuting side of punk culture wanted, above all, an especially intimate and intense relationship with their own morality and the values on which it was based. Their sensitivity toward every possible de-intensifying medium between pure morality and behavior refers absolutely to an obsession with morality. And the types of people depicted in that manner could be nothing other than heroes. Punk history, as shown also in Teipel's *Verschwende Deine Jugend,* is full of types who collapsed under this pressure or under this contradiction: organization of total negation as total terror of morality.

That punks did not want or foresee a future for themselves doesn't really add up to the world-famous line by the Sex Pistols, "There is no future in England's dreaming." The decided lack of a future in the chorus "for you and me," only refers to our lack of inclusion in a monarchistically transfigured dream of England—which we actually already knew to be so. The current and binding translation of "No Future" in the everyday sociofolklore of the '80s was: the end of utopia. Punk was the break with that— and let's call it by its most common name—socialistic utopia. All of its early formulations, as long as they were not cynical nor radically to the right, were cautious to describe how one could remain (radically) left, without kidding one-self. For that reason, all of us who were young at the time never understood the contortions of all of those who in 1989 for the first time said good-bye to socialism as a concrete hope—neither its value as novelty nor the panicky, hectic pace with which so many "'68ers" absolutely wanted to go to the other side (i.e., the status quo, capitalism) and believed they had to give up criticism with concrete utopia.

Thus the three German examples of negation given above make concrete applications of the common findings in German circumstances: no nature, as in "Zurück zum Beton" ("Back to the Concrete"), by S.Y.P.H., was directed against the Green Party, which was just getting established. Punks also already knew at the time that nature cannot rescue us if we give up on society. Fehlfarben directed "keine alten Bewegungen" (No old movements) ambivalently at the '68ers, but also at the rigid punks and also possibly against those who waited to join all the revivals of the rediscovered old movements of mod, ska, and many others, which started around 1980. The phrase "Was heute zählt ist Sauberkeit" ("What counts today is cleanliness"), perhaps the best line in all of German punk culture, also has three interpretations that do not agree: 1) Cleanliness is the repressive norm of the Federal Republic of Germany, against which punk rebelled like earlier anti-repression youth cultures. We note this with sarcastic regret. 2) Cleanliness as individual integrity is the only chance of surviving politically / socially. Moralistic rigor remained the last possibility for staying political, if there were no prospects of organizations, recognized truths, and party lines. At the same time one sought out, of all things, the normative pressure on the individual as the medium—for which the lamented cleanliness of the

continually predominant German disciplinary culture still stands. We stand in a kind of ambivalent half-solidarity with this position. 3) Cleanliness as provocation of the likewise empty antibourgeois sentiment of the punks. We are there.

Because punk so often referred to its internally directed terror of morality (and its opposite, which it logically always dragged around) and to an ethic of existence as an anticlean, continually drunk, or otherwise radical person but having no external and generally valid representational (e.g., political, socialistic) reasoning for that ethic, punk needed a figure as an enemy whom one could accuse of something other than political or otherwise controversial failure, namely only individual, mistaken living: bourgeois existence and ridiculousness. An infinite number of songs agree on this. It should be about something (also political and especially moral, not to be a traitor) that at the same time could no longer be generally justified. The consequence: hate ad personam. Worse: hate toward losers as another side of hate toward traitors. This problem was also anticipated in a song by Fehlfarben: "Gottseidank nicht in England" (Thank God not in England), in which the world of a person "overtaken by reality" collapses.

Theory—see above—had departed from Marxism (or better, the German translations and their publishers had done so) at the same moment as punk had, in its own implicit way, but now the intensity of existence in an earlier sense was introduced as an antidote, in a sense that must have been recognized by discerning punks as actually hippielike. For this reason (and for many others, for which there is no room here) in the next ten years a synthesis often occurred among the lifestyles shaped by punk and aesthetics (and practices) shaped by intensity-based hippie philosophy (in the forms of industrial music, the music on the 4AD label, etc.). The visual artists had yet another material, another encoded history of negation: the negative reference to the history of the avant-garde, which did not yet exist in the memory of pop music.

In this connection there is also a consensus—the dominant artistic direction to be negated was conceptual art of the '70s, but there was no consensus about which element or which part of conceptual art was to be negated. If there were one direction that rejected anti-sensualist or anti-retinalist intellectual aspects according to a deeply bourgeois normative ideology of immediacy, there was also another, for which Büttner, Kippenberger, and Oehlen, among others, stand. These artists attained the achievement of abstraction in concept art but did not wish to apply an aesthetic that also exhibited their intellectuality as a mode of representation; they preferred to try out the capacity of artistic work to conceptualize at the apparently most natural opposite pole to conceptual art—in painting.

The problem that presents itself in the context of this latter approach is once again one that painting shares with pop music of the punk period: the longing for a nonmedial medium, the wish to step out of the discussion of mediality and, through a kind of metaphysics of plain language, to grasp something like the artwork itself. Just as anarchism represented a value system that at the same time could be understood as the rejection of all values, media and artistic means that no longer seemed to be media at all were needed. Painting was therefore not considered the medium with which one could express oneself particularly well—it was considered to

be the medium that should stand for art itself, in the most unburdened sense in contemporary discussion, and owing to its historical burden in the most encumbered sense. Only in this manner could one realize the intellectual challenge of the demystification of art in material that at first glance sensually concealed the intellectual and conceptual aspects hidden within it.

This (unstated) idea corresponds to the punk rock concept of the famous "three chords," the simplest form of song and the most traditional musical structures, which do not distract from the essential. It was implicit in the cult of energy, intensity, and an uncorrupted sense of community. But, just as for the painters, the most conventional and most historically laden form was felt to be the most appropriate. It is of course easy to accuse such a naive antiformalism of believing in a so-to-speak reactionary manner that they could ignore the avant-garde's knowledge of forms and media and their history and legitimacy.

That would be wrong not only because it is too easy but also because it would overlook the aesthetic discovery punk rock and a particular kind of painting made in the late '70s and early '80s: that one can employ and display symbols in a new way only when one allows them to function within the most conventional framework possible. The central knowledge of punk rock that, on the one hand, rock and pop music were always about attitude and behavior (cool, speech-analogous, and anti-intense) and, on the other hand, noise and energy (intense) sound freed from notes, called for a simple and recognizable form that was adopted as a support from the history of music only in order to be able to communicate its new discoveries. In painting, nonessential work corresponded to this, using all of the elements of painting considered to be essential and inherent to painting. The work with strokes and methods of application was not based on artistic and aesthetic means but, as symptoms of ways of life, was based on character, psychology, ideology, and politics. This was understood as a radicalization, not as a retraction of the realizations of concept art.

One could of course interpret this decision against advanced form as well as against medial advancement in different ways. For one, it went against the kitsch of self-satisfying skill, against the pseudo-artistry and pomposity of progressive rock, and thus against the belief in the ability to implement artistic forms in general as an untainted means of self-expression. In this respect punk rock and New Painting were also analogous formats as they wanted to accept their artistic means only as damaged or, as it was called then, as "miserable" (elend means such that they are always symptoms of their social and political genealogy, on the most molecular level, in the elements of their artistic expression). For another, there was an aesthetic of simple, democratic language: by implementing the most simple and accessible means with form and medium, one believed to have completely removed an undemocratic barrier to production as well as to reception.

As much as that held true for a certain time and the desired effects of a democratization entered, bands and labels shot up all over. Many groups that had not been allowed entry until then (including women, who were continually excluded in rock, but many musically uneducated, more conceptually oriented artists, working-class youth, and intellectuals) took up the empowering format of punk rock (and a form of painting freed from traditional barriers).

In the long term, the overlooked and ignored mediality, the laws of genre, tradition took revenge. Only those who worked on it carefully in their damaged "misery" could, in the long run, keep their work immune from the revenge of the unheeded ones. In other cases, this anti-mediality provided that innumerable painters actually believed, in a reactionary sense, in painting as an unfettered and available historical medium and genre. Consequently, forms of punk rock were reshaped by raucousness and its history and finally used by the ones who really believed in raucous screaming, experienced as an appropriate expression, and who heard in it not only a symptomatic noise of history that one can bring—paradoxically—to speak about its genesis by mobilizing it as a recognizably dead form of expression.

Related to the tradition of plain language there was also the access that the punk generation found to electronic music: synthesizers became desirable as nonhistorical or forgotten nonmedia that were simply there to serve, not, as in the hippie period, as an ideal means to producing "outrageous" or new sounds. In this respect the cheap, tonally crude Casio keyboards that set the scene were employed more functionally as metronomes. A lot of the Acid House aesthetic from 1988 referred once again to this simplicity and reduction.

But this reevaluation of the synthesizer from an elaborative to a simplifying machine, as it came to be used in work by the early Cabaret Voltaire to Plan, from Human League to DAF, brought forth a new, constructive aesthetic that—as happens so often when a new machine is available—for various reasons wanted to have nothing more to do with history—whether for good or bad futuristic reasons will not be discussed here. Electronic futurism, unlike punk, did not want to connect with history—not even through the negative contact that occurred in working off and producing the energy of noise from junk and breakage, which, however, became fruitful through analysis and insights due to the historicity of the material in punk rock. The great treatments of soul (Dexys Midnight Runners, Scritti Politti—or ska or reggae in the punk generation) were to thank for punk's sensibility toward the historical—aesthetics built on failure and loss, to which early '80s synth-pop liked to refer.

Indeed the rededication of the synthesizer into a simple and accessible medium and into something that should primarily serve the production of social energy (and not artistic form) also had a parallel in the German visual arts—in the work of all the artists interested in media art at that time who were still students at the academies, who freed work on and with video and other emerging electronic media from the roles of self-searching introspection, social documentary, or visual novelty. Similar to the means of punk rock and synth-punk, they wanted to employ it in the production of situations and actions. In Hamburg at the time, artist groups such as M. Raskin Stichting Ens. or Minus Delta t, derived attempts at media art—and also many ideas that later became fruitful in Net art as well—from a punk-specific low regard for the autonomy of media. In a dialectic manner they always found the ideal new medium in that which pushed its mediality in front of its perceptibility and ability to mobilize social energy. With the same right (and with a friendly nod to Walter Benjamin) one can attribute exactly this effect to the old, outmoded medium.

Intensities will continue to be mobilized against representations. And

one will always ask oneself what one should mobilize against the representation of intensity. This will then remain one good reason to interrupt intensity; the second reason is that the friends of asociality repeatedly land on the right if the context of the left has used itself up socially. These interruptions, reconstructions, and transgressions of parallel projects of emancipation and critique of representation that are mutually friendly only in a limited manner have found in punk a historical focus, a counterpoint to which one can well describe their legitimacy. Punk's explosive nature exists in that punk—under other, vastly depoliticized contextual conditions—still represents the image of the greatest power that acts of radical cultural self-empowerment could seize in recent decades—and the dangers of this power.

Spring 2007

This essay was translated from German by Tawney Becker.

Diedrich Diederichsen is a Berlin-based art and music critic. He is Professor of Theory at Merz Akademie School of Design, Stuttgart, and Professor at the Institute of Art Theory and Cultural Studies at the Academy of Fine Arts, Vienna.

THIS FELLOW IS PLAYING ON LUXUS

ERIC MITCHELL

S.O.36 RECORDS

THIS GUY IS PLAYING ON LUXUS

AKIM SCHAECHTELE

S.O.36 RECORDS

THIS WOMAN IS PLAYING ON LUXUS

CHRISTINE HAHN

S.O.36 RECORDS

THIS MAN IS PLAYING ON LUXUS

KIPPENBERGER

S.O.36 RECORDS

Martin Kippenberger
This Man is playing on Luxus;
This Fellow is playing on Luxus;
This Guy is playing on Luxus;
This Woman is playing on Luxus, 1979
Four offset prints
Each: 14 x 12 ¹/₂ in. (35.5 x 31.6 cm)
Courtesy of the Martin Kippenberger Estate, and Galerie
Gisela Capitain, Cologne

WE WANT MORE FEMALE BANDS!

NAME	SEX	NATIONALITY
SO FUCKIN START ONE!		
[signature]	M	USA
[signature]	M	USA
Emy. K	♀	S.
Mici mus		
[signature]	♀	Z
[signature]	♀	S
[signature]	♀	S
[signature]	♀	DS
TRISH HATLER	M	S
[signature]	♂	S
[signature]	M	N
Richard Sazen	M	N
SAMAN NAKHOJAVANI	M	IRAN
[signature]	M	*[signature]*
MORE JAZZ	FEMALE	YEAH

NEW ROCK FEMINISM

Formed at Roskilde festival '96

Aleksandra Mir
New Rock Feminism, 1996 / 2007
Digital prints
Dimensions variable
Courtesy of the artist and Gavlak Projects,
West Palm Beach

Thomas Zipp
Geist Ueber Materie (Future Organ), 2006
Mixed media, wall text, and framed mixed-media drawings
on paper
Dimensions variable
Courtesy of Harris Lieberman, New York, and Galerie Guido
W. Baudach, Berlin
Photo courtesy of Tom Powell Imaging

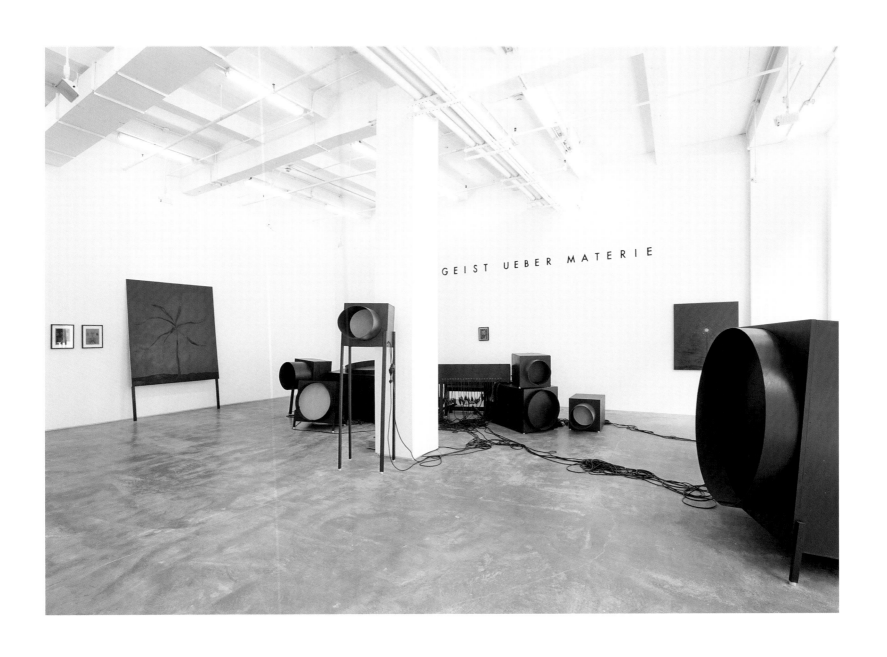

GEIST UEBER MATERIE

Thomas Zipp
Geist Ueber Materie (Future Organ), 2006
Mixed media, wall text, and framed mixed-media drawings
on paper
Dimensions variable
Courtesy of Harris Lieberman, New York,
and Galerie Guido W. Baudach, Berlin
Photo courtesy of Tom Powell Imaging

Thomas Zipp
Uranlicht, 2006
Acrylic and oil on muslin and mixed media on paper
98 x 134 in. (249 cm x 340.4 cm)
and 16 $\frac{1}{2}$ x 12 $\frac{1}{2}$ in. (41.9 x 31.8 cm)
Courtesy of Harris Lieberman, New York,
and Galerie Guido W. Baudach, Berlin
Photo courtesy of Tom Powell Imaging

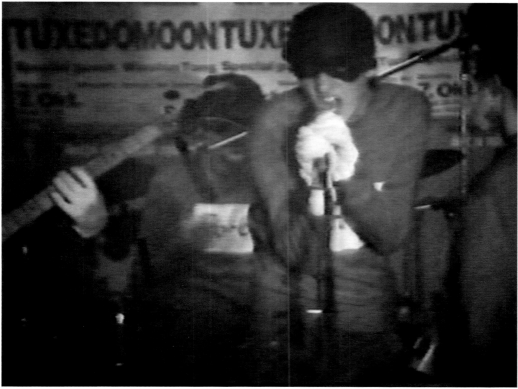

Carmen Knoebel
Documentation of *Finger für Deutschland*,
Ratinger Hof, Düsseldorf, Germany, 1982
Courtesy of Carmen Knoebel
Photo by Michael David Rose

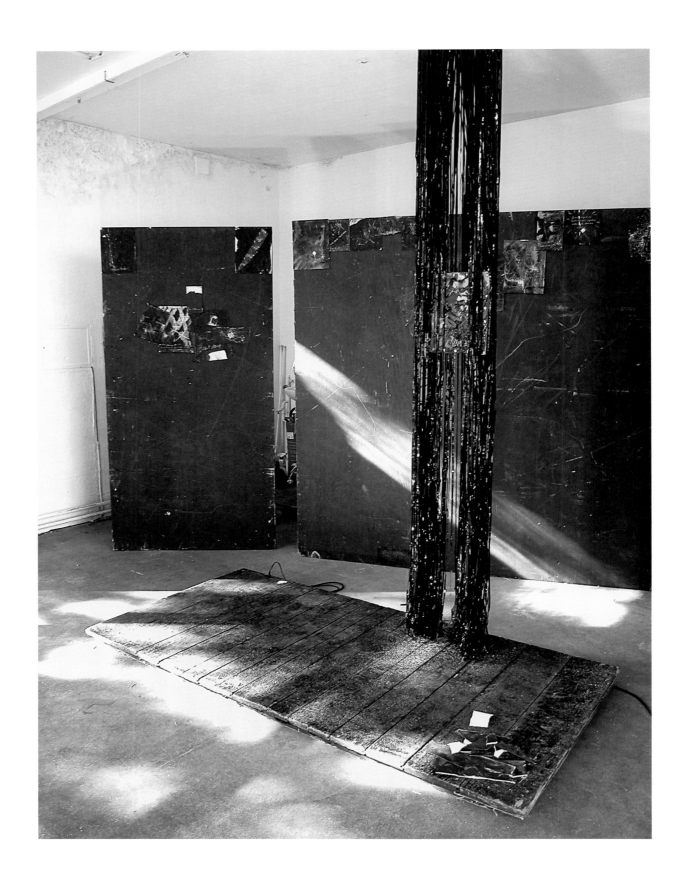

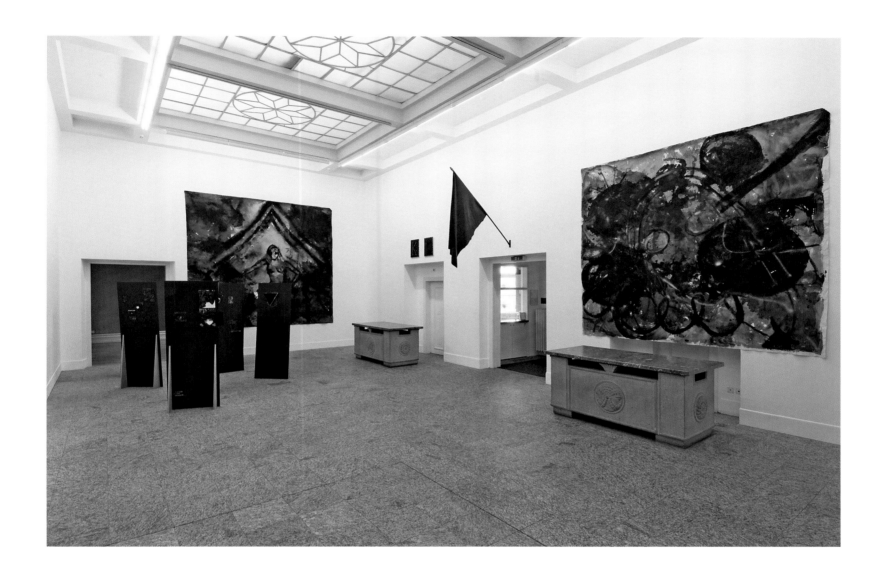

Pipilotti Rist
I'm Not the Girl Who Misses Much, 1986
Video
7 minutes, 46 seconds
Courtesy of the artist; Hauser & Wirth,
Zurich and London; and Luhring Augustine,
New York

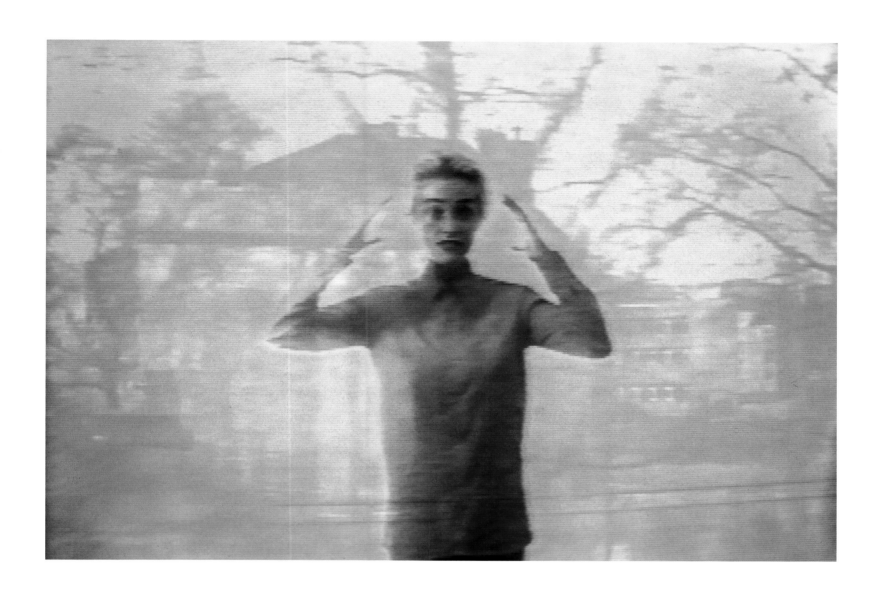

Pipilotti Rist
You Called Me Jacky, 1990
Video
4 minutes, 6 seconds
Courtesy of the artist; Hauser & Wirth,
Zurich and London; and Luhring Augustine,
New York

Workshop
Image 1: "Early photograph ca. 1983, showing Workshop
members. Among these is Edwin Kroll, far left, who was
with the group from its very beginning. His effortless
performance on stage consisted of show dancing.
Otherwise many ideas musically derived from his mind.
Furthermore, Pamela Meyer-Arndt, second from right,
who was a great influential force, starring in videos, [and
a] filmmaker herself, brought her sister, Xenia, to play
transverse flute in the band."
Photo by S. Jagenburg

Image 2: "The presentation of the fourth album, titled
Meiguiweisheng Xiang, 1997, at a club in Cologne. It would
merely be an endless set of playing music, our own but
also [by] many others, from both records and tapes with all
kinds of additional treatment, including playing instruments,
and occasionally singing one of the songs from the album,
live, titled *Schlehe,* in duet with Stefan Mohr, who is
amongst the most important of all participating people in
Workshop as his visions of the music and of the rest of
us, he would manage to engineer, record, and produce in
unmatched beauty. The other person who does this equally
well is to be mentioned in awe too, Christoph Rath.
From left to right: Kai Althoff, Mathias Köchling,
Stefan Mohr, Stephan Abry.
Photo by K. Sistig

Image 3: Stephan Abry and Kai Althoff at a river in Scotland,
date unknown
Photo by D. Althoff

Image 4: Photo taken on occasion of an early tape release,
Boing-Klirr, in 1982
Photo by D. Alker

Image 5: Photo taken on almost similar occasion, *L' arrivée
au grand tam-tam,* 1984
Photo by J. Krings

Images courtesy of Kai Althoff

LOS ANGELES/ THE WEST COAST

The relationship between avant-garde art and rock music on the US West Coast is far less well documented and cohesive than it is in New York or the United Kingdom, yet in many ways it has been characterized by a looser, freakier (yet no less intellectually intense) scene. While Andy Warhol and The Velvet Underground were striving for an ideal state of uptightness in their infusion of avant-garde noise and existential urban realism into rock and roll, musicians such as Captain Beefheart and

Frank Zappa in southern California and the psychedeli ight-show impresarios of San Francisco were explor ng more intangible, weird, and psychologically expan sive sounds and visions in the late 1960s. This spiri was carried through in various ways along the Pacifi coast into the '70s and '80s by art and rock phenomena from the experimental efforts of the Los Angeles Free Music Society (LAFMS), to the theatrical antics of San Francisco's Survival Research Laboratories and The Residents, among others, and further northward with Vancouver's first conceptual artist band, the UJ3RK5 (pronounced "you jerks"). The emergence of punk in the late '70s brought with it an independent, do-it-your self approach toward cultural production and distribu ion (much in keeping with the individualist spirit of the avant-garde) as well as an aesthetic geared toward the antiauthoritarian content and demeanor of the music Numerous figures involved with (or influenced by) the LA punk scene have become an integral part of the city's rapid development into one of the most important inter national centers for contemporary art.

THIS AIN'T NO PICNIC: LOS ANGELES AND THE WEST COAST

DOMINIC MOLON

Late 1960s visual phenomena such as Bill Ham's *Light Sound Dimension* light shows and the wildly stylized poster designs for rock shows occurring primarily in San Francisco's Haight-Ashbury district provided an aesthetic that was adopted by many visual artists and graphic designers; yet it is debatable whether this material was ever consciously considered to be part of an avant-garde context or understanding. Regardless, the combination of vibrant Day-Glo colors and abstracted forms with the so-called acid rock that formed the soundtrack for LSD trips provided a profoundly distinctive visual style and an aesthetically totalizing experience. The music of Frank Zappa and especially Captain Beefheart and the Magic Band (fronted by Don Van Vliet), however, seemed a deliberate attempt to infuse rock and roll with sonic elements drawn from experimental music sources as a way to subvert the hegemonic forces of the music industry (very much a presence in Los Angeles) from within. The graphic sensibility cultivated by these two figures also demonstrated an acute understanding of a particularly modernist understanding of parody and the surreal. The cover of Zappa's Mothers of Invention band's 1968 album *We're Only In It for The Money* directly mimicked (and critically sabotaged) the cover art of The Beatles' immediately revered concept album *Sgt. Pepper's Lonely Hearts Club Band* from the previous year. Beefheart's promotional video for the 1970 *Lick My Decals Off Baby* album has more in common with experimental filmmaking than anything resembling an advertisement. In the '80s, Van Vliet would turn to a career in painting, yet the music and aesthetics of Beefheart would have a lasting influence, both on more radical rock music and on artists Mike Kelley, Jim Shaw, and countless others.

Inspired by Beefheart and Zappa, the Los Angeles Free Music Society (LAFMS) was formed in the early '70s by Chip Chapman, Joe Potts, Rick Potts, and Tom Recchion and has continued to exist since then as a loose collective of musicians and groups inclined toward exploring more experimental sonic concepts and approaches. Among the bands that have been associated with the society throughout the years are rock critic Richard Meltzer's Smegma, The Doo-Dooettes, and Le Forte Four. In addition to producing records, LAFMS organized Fluxus-style concerts and published a magazine titled *Light Bulb*. The group represents a significant bridge in the avant-garde music scene in LA between the Beefheart and Zappa productions of the late '60s and the earliest rumblings of punk and art-school bands (such as Mike Kelley and Tony Oursler's Poetics, discussed below). A similar organization (often featuring members associated with the LAFMS) called SASSAS (the Society for the Activation of Social Space through Art and Sound), spearheaded by artist Cindy Bernard, has in recent years presented numerous performances and events that extend the spirit of the LAFMS into the present day.

Kenneth Anger's films of the '60s and '70s eventually provided much of the inspiration for the style and sensibility of what has become familiar to us through music videos. Having created a stir with his tell-all book *Hollywood Babylon* in 1959, Anger then turned to filmmaking, creating avant-garde classics such as *Fireworks* (1947), *Inauguration of the Pleasure Dome* (1954), and *Scorpio Rising* (1964). In the mid '60s he began work on the film *Lucifer Rising* (1972), shooting in locations as disparate as Egypt, England, and Germany and creating images and scenarios heavily informed by the occult. He had

Poetics performance, 1977
Photo courtesy of Tony Oursler

1. Kristine McKenna, "Remembrance of Things Fast," in *Forming: The Early Days of L.A. Punk,* ed. Exene Cervenka and others (Santa Monica, Calif.: Smart Art Press, 1999; repr., 2000), 31.

The Residents
Courtesy of The Cryptic Corporation

originally wanted Mick Jagger of The Rolling Stones to play Lucifer, but Bobby Beausoleil played the part. Beausoleil also wrote the soundtrack for the film from prison (for his participation in the Charles Manson murders). Beausoleil is also rumored to have stolen the print of the film and hidden it in the desert. After moving to London, Anger shot the wildly visual *Invocation of My Demon Brother* in 1969, again drawing heavily on images and symbols from the occult and incorporating a dark and mysterious synthesizer-dominated soundtrack by Mick Jagger.

San Francisco during the '70s featured an intriguing and intense scene featuring orthodox punk bands such as the Dead Kennedys and the Avengers, radical performance artists and collectives such as Monte Cazazza, Johanna Went, and Survival Research Laboratories, and the avant-rock band The Residents. Cazazza was an active participant in the mail-art movement, collaborating frequently with Throbbing Gristle's Genesis P-Orridge. Survival Research Laboratories (spearheaded by Mark Pauline) mounted apocalyptic spectacles involving warring machines that matched (or perhaps even exceeded) the intensity and dynamism of a rock concert. The Residents constructed themselves as an intriguingly autonomous collective, releasing albums through its own record label, Ralph Records, and maintaining its anonymity from beyond the facade of the cleverly titled Cryptic Corporation management company and its signature eyeball heads. Its inspired, concept-oriented albums were matched by videos that functioned like short, experimental films featuring strange computer graphics and stranger props, stagecraft, and performances all set to the warped keyboard-driven sound of their music. The Residents' wry and obliquely satirical observations on ev-

eryday life and culture brought a sense of criticality and focus to the more free-form surrealism inspired by their psychedelic precursors.

While The Residents and others were both extending and dramatically altering the psychedelic legacy in San Francisco, the LA punk movement was insistently taking root. In stark contrast to punk's development in New York, the LA punk scene initially remained more or less estranged from the avant-garde art scene altogether (with occasional exceptions, including COUM Transmissions, whose transgressive performance at the Los Angeles Institute of Contemporary Art in 1976 prompted noted art world figures such as John Baldessari and Chris Burden to walk out). As Kristine McKenna has observed, "In classic dada tradition, punks rejected The Academy and drew instead on 'low' sources: graffiti, underground comics, advertising, car culture, the tarot, blaxploitation, bondage and pornography, surf culture, '50s industrial films, *Mad* magazine, and the universe of American detritus that winds up in thrift stores."[1] Regardless, the short-lived band the Screamers did demonstrate certain avant-gardist tendencies in their performances and boasted a distinctive logo designed by artist Gary Panter (later renowned for his epic comic-saga *Jimbo,* whose young punk-protagonist struggled through a seemingly postapocalyptic American wasteland).

The most significant art-music entities to emerge in LA during the late '70s and early '80s were Raymond Pettibon and the Poetics. Pettibon's drawings formed the visual identity of the album covers and fliers for his brother Greg Ginn's punk band Black Flag and those of other bands on Ginn's SST independent record label such as San Pedro's The Minutemen. In spite of their not having been created explicitly for the purpose of being album cover or

flier art and in any way affected by or made in the spirit of the music of Black Flag or The Minutemen, the images are perfectly complementary to the music in their mutually bleak and jaundiced view of contemporary American culture and society. In a more direct and archly humorous fashion, perhaps, than their New York counterparts, LA punk bands took the more dysfunctional and hypocritical aspects of the government and other institutional representatives of authority as their target, a stance echoed in Pettibon's caption-filled images that meditated on the failure of the utopian visions of the hippie generation and the dystopia they left in its place. The Poetics grew out of Mike Kelley's jamming with fellow art students at Cal Arts such as Bill Stobaugh and Mitchell Syrop, initially known as Polka Dot and the Spots. Having met Tony Oursler and being influenced by visiting artists such as Laurie Anderson and David Askevold, Kelley shifted his efforts toward what would become the Poetics, a group that combined aspects of comedic performance and a wide variety of musical sensibilities—aspects of early electronic and industrial music, Beefheart, disco and funk, and the more theatrically weird elements of rock music.

A sometime collaborator with the Poetics and one of the most fascinating and inscrutable figures from the LA scene is Jim Shaw, who was a founding member of Destroy All Monsters with Kelley, Niagara, and Cary Loren while in Michigan (Ann Arbor and Detroit). In 1985, he started working on his *My Mirage* series (the title culled from an Iron Butterfly song), which read various aspects of his growing up as an adolescent in the '60s through an alter ego named Billy. This multimedia work—comprising drawings, paintings, and videos—draws on various sources, rock music among them, to form a pseudo-narrative about

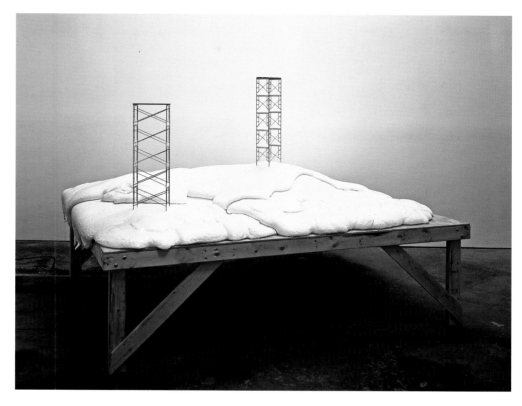

Billy's transition from the typical sex, drugs, and rock and roll–obsessed teenager into a born-again Christian adult. Shaw's work reveals, among other things, the critical role that rock and roll (and the culture around it) has played in the identity formation of successive generations since the mid '60s.

Further north along the Pacific coast in Vancouver, artists Rodney Graham, Jeff Wall, and Ian Wallace were involved with the band UJ3RK5. The band lasted long enough to record an EP for a local label and was eventually picked up by a major label looking for new wave bands from Canada in the wake of a successful single by the band Martha and the Muffins. Without support from the record label and with Graham, Wall, and Wallace all actively pursuing more serious careers as artists, UJ3RK5 disbanded. Aside from the occasional work refer-

Sam Durant
Proposal #2 for Monument at Altamont Raceway. Tracey, CA, 2003
Polyurethane foam, acrylic, wood, ABS pipe, audio system, and miscellaneous hardware
96 x 71 x 28 in. (243.8 x 180.3 x 71.1 cm)
Photo courtesy of Blum & Poe

Barbara Bloom
Album cover art for Stephen Prina's
Push Comes To Love, 1999
Courtesy of Drag City Records, Chicago

Christopher Williams
Album cover art for the Red Krayola's
Amor and Language, 1995
Courtesy of Drag City Records, Chicago

encing rock music (*The Guitar Players,* 1988) or gracing the cover of an album (for Sonic Youth's 2007 *The Destroyed Room,* named for the work on the cover), Wall has focused solely on creating work that has changed the understanding of photographic process and reception altogether. Graham, however, has continued to make, perform, and record music on a regular basis, in addition to creating works directly relating to various musical genres. His most recent body of work touches on the preordained visual associations we have with various forms of music and finds Graham often humorously locating himself within various staged situations. In the diptych *Awakening* (2006), he inserts himself into a group photo of the legendary heavy-metal group Black Sabbath, the lead singer of which, Ozzy Osbourne, appears to gesture toward Graham's prone, street musician–like figure on a bench. Graham's literal, physical separation of the work into two photographs subtly underscores their various differences—psychological, chronological (the band's height occurred in the early '70s), and musical—while rendering the image as a negative further complicates the relationship between group and individual in the picture. Vancouver has continued to produce a younger generation of artists, including Tim Lee, Steven Shearer, Ron Terada, and Althea Thauberger, whose work explores aspects of rock music and cultures.

In '90s LA, the art-rock dialogue seemed to coalesce around more conceptually oriented artists and musicians. Stephen Prina began to incorporate music more insistently into his practice around this time, including the live performance *Sonic Dan*—an intertwining of Steely Dan and Sonic Youth songs with fragments of Anton Webern compositions thrown in for good measure, as well as performing his own low-key

post-rock compositions accompanied by a string quartet in the galleries of the Getty Museum in his 2000 film *Vinyl II.* In 1999 he released the album *Push Comes to Love* on Chicago's Drag City label featuring musical compositions of his own, as well as lyrical contributions by LA literary figures such as Amy Gerstler and Benjamin Weissman, and musical accompaniment by avant-rock figures such as David Grubbs and Jim O'Rourke. Drag City also began releasing albums by Mayo Thompson's legendary art-rock entity The Red Krayola in the mid '90s. The recordings of that period—including *The Red Krayola* (1994), *Amor and Language* (1995), *Hazel* (1996), and *Fingerpainting* (1999)—boast an impressive list of the LA art world's most prominent figures, including artists Tricia Donnelly, Sharon Lockhart, Prina, Alex Slade, and Christopher Williams (and international figures Werner Büttner and Albert Oehlen), as well as art dealer Margo Leavin and premier musicians from the city's underground punk scene such as George Hurley (formerly the drummer for The Minutemen) and guitarist Tom Watson (from the bands Slovenly and Overpass).

While a figure like Thompson (who has since relocated to Edinburgh, Scotland but continues to teach in LA) has maintained a long-standing and direct history with rock music and its industry, artists emerging in LA in the '90s incorporated rock music into their work based on its significant impact on their lives and cultural understanding of recent history. In her essay on the Chinatown area's shift from the city's punk center in the '80s to its emerging art hub in the 2000s, Frances Stark, whose own work and writing often touch on rock phenomena (none more memorably than her letter to Jacob Lowenstein of indie rock band Sebadoh) suggests how the impertinently independent attitude of

young gallery owners and artists implementing that shift developed from the sensibilities of the very punk scene they replaced.[2] Sam Durant, for example, uses references to Nirvana's Kurt Cobain, Neil Young, and The Rolling Stones and their ill-fated 1969 concert at the Altamont Speedway near San Francisco to place historical events and iconic works of art into a more broadly defined cultural context. The expansive, site-specific wall drawings that Dave Muller has been creating in recent years use rock and roll's own history to form an undulating graphic landscape that insinuates itself within the interior architecture of a space, using a representation of a literally organic form to underscore the organic qualities of cultural development. (Muller has also actively performed with Kelley's Poetics project and often DJs as part of his Three-Day Weekend events.) For *Velvet Underground / Perfect World* (2000, 2005), Jason Rhoades folded an element of his conceptually complex *Meccatuna* and *Perfect World* projects— both involving layer upon layer of American vernacular materials and linguistic forms—into the tough, urban sensibility of The Velvet Underground through the use of neon signs and street lingo for female genitalia. Mungo Thomson's work has frequently reached back into the history of rock music, focusing on critical absences, as in *The Collected Live Recordings of Bob Dylan 1963–1995* where one hears only the audience responses or Dylan's lead-ins, or in his *Drum Kit Drawing* of 2005, depicting the empty drum setups of rock drummers including Led Zeppelin's John Bonham and The Who's Keith Moon, who both died prematurely.

Thaddeus Strode's paintings occasionally make reference in their titles to rock phenomena such as drum solos or the Sex Pistols' Johnny Rotten, yet much of his work, including paintings such as *In The Wild With The Ox (Herding the Bodhi Mind)* (2006), exudes the physical intensity of rock and roll in the combinations of anarchic compositions, clashing neon colors, and frenetic overlapping of imagery and symbols. (Strode has also actively participated in the LA music scene, principally through the group The Perfect Me.) The films of Cameron Jamie are presented under the strict conditionality of the sludge-metal group The Melvins performing live in front of them, thus ensuring that the music resists becoming mere background for his vérité meditations on aggressive subcultures such as the Krampus rituals in Austria (*Kranky Klaus,* 2002) and the violent wrestling matches conducted by adolescents in the backyards of America (*BB,* 1998–2000.) A starkly different exploration of masculinity occurs in Mark Flores's complementary drawings of Iggy Pop and Jayne (formerly Wayne) County, intended for presentation in the men's and women's restrooms, respectively. Focusing on two icons of the glam rock era—Pop representing a certain flawed ideal of masculinity, and County, representing a compromised ideal of femininity—he conceptually restages the performative nature of gender inherent in glam rock in a social situation where certain aspects of performance and posturing often come into play.

Marnie Weber's *A Western Song* (2007) extends her ongoing meditation on feminine identity through the staging of strange, multilayered scenarios in films featuring performances of trippy, country-and-western inflected rock music by the group The Spirit Girls—a fictionalized band of womn in white masks who seem to hover between earthly humanity and the ethereal beyond.

The title "This Ain't No Picnic" refers to The Minutemen song "This Ain't No Picnic" from the album *Double Nickels on the Dime,* 1984, SST.

2. See Frances Stark, "A Little Untoward History: On Chinatown's Recent Influx of Art and its Potential," *Recent Pasts: Art in Southern California from the 90s to Now,* ed. John C. Welchman (Zurich: JRP / Ringier, 2005), 41–56.

Jim Shaw
My Mirage Logo #3, 1989
Silk screen on paper
17 1/4 x 14 1/4 in. (43.8 x 36.2 cm)
Courtesy of the artist and Metro Pictures

PLAYING
THE STRIP
JAN TUMLIR

1.

The movement of an observer across the built landscape of the city has supplied American rock with many figures and motifs. The music of The Velvet Underground instantly transports one to New York, and if one is already there, then The Beach Boys or The Doors do the same for Los Angeles. Detroit, Chicago, Washington, etc., have all spawned local variants of dominant idioms such as roots-rock, garage-punk, hardcore, industrial, and so on. These sounds are nurtured on a sense of place, a specific cultural milieu with communities and histories. Rock bands typically evolve out of audiences who go on to exercise a special claim on the band, and vice versa, owing to their common association with the same hometown. Raised together, these two become increasingly estranged, making for songs in which that sense of rootedness is often offset by undercurrents of loss. Thanks to the devotion of hometown fans, the band achieves the requisite notoriety to mount a national tour, thereby leaving the fans behind. The original audience stays put as the band takes to the road.

The experience of betrayal is endemic to the overarching narrative of American rock as an accelerated, concentrated version of the greater American success story, one that rarely ends well. From the first moment, a vague apprehension of the tragic fate begins to take shape in the lyrics. The song forms favored by rock give rise to personae directly inherited from romantic figures such as Charles Baudelaire, Thomas de Quincey, and Edgar Allan Poe, all cosmopolitan wanderers, embodiments of the city's most exalted and squalid quarters, its bright and shining centers and shadowy peripheries. The one who says "I" in the song represents the city's mass public somewhat as a politician does, but with a Baudelarian side that remains ambivalent, supremely noncommittal to the end. Words are chosen carefully to promote a sense of open-ended intimacy, or intimacy without consequences. Increasingly, the poetic gift is curbed in the interest of self-preservation; the lyrical voice becomes strategic, learning from past mistakes even as it resolves to keep "sleeping around."

In his 1975 song "Drive Back," for example, Neil Young coldly orders a groupie to "Drive back to your hometown / I want to wake up with no one around."[1] Followed by the elegiac "Cortez the Killer" on the *Zuma* album (1975), the analogy between touring and imperialist invasion is cemented: bearing gifts and promises of a better life, the band can only pass on its restlessness and anomie, alienating its fans from local traditions, uprooting and displacing everyone in the way. Young has released numerous LA-themed albums—*Time Fades Away* (1973), *On the Beach* (1974), and *Zuma* (with Crazy Horse), among them—that amount to a long-term exorcism of the rock-and-roll spirit. A blur of overheated, unfocused desires pushing the band to such inhumane extremes, this ethos is finally recognized, and categorized, as pathological.

Proximity within distance; distance within proximity. Nowhere is the lyrical sensibility more acutely split along these psycho-geographical axes than in LA where we have no interior to know intimately, only an outwardly sprawling exterior. Here the existential emptiness and anonymity shared by all big cities reaches an apex. Albert Thibaudet's comment that Baudelaire's famous sonnet "A une passante" "could blossom only in the milieu of a great Capital, where human beings live together

1. Neil Young and Crazy Horse, "Drive Back," *Zuma,* 1975, Reprise Records.

177

2. Albert Thibaudet, *Intérieurs* (Paris: Plom-Nourrit et cie, 1924), quoted in Walter Benjamin, *The Arcades Project,* trans. Howard Eiland and Kevin McLaughlin (Cambridge, Mass., and London: The Belknap Press of Harvard University Press, 1999), 252.

3. The Doors, "LA Woman," *LA Woman,* 1971, Elektra Records.

4. Frederic Jameson, "Postmodernism and Consumer Society," in *The Continental Aesthetics Reader,* ed. Clive Cazeaux (London and New York: Routledge, 2000).

as strangers to one another and yet as travelers on the same journey" could apply just as well—perhaps even better—to any of the representative LA songs: "I Get Around" (1964) by The Beach Boys, "Sin City" (1969) by The Flying Burrito Brothers, "LA Woman" (1971) by The Doors, "Hotel California" (1977) by the Eagles, "Babylon Sisters" (1980) by Steely Dan, and "Los Angeles" (1980) by X, among many others.[2] Over and above the fact that these songs are all about LA, they are of it; internal and external landscapes are brought into perfect alignment as an LA state of mind that we have come to understand as a kind of drive-through limbo.

As an urban-industrial offshoot of the medieval *jongleur,* the traveling minstrel, the rock and roller is always just passing through. The LA song, especially, is characterized by a dreamy momentum that is tailor-made for car radio. The trajectory across the urban topos begins at the point of arrival, with the initial border-crossing through the symbolic proscenium that precedes and delimits the city scene. The subject's emergence in this new context is endlessly rehearsed and then replayed, for it is here that one casts off the burden of pre-ordained identity to begin the process of self-reinvention. Wavering on this threshold, the uprooted self relates the loss of former attachments and obligations in words that grow correspondingly blurred, a free-floating verse that converts inner emptiness into ecstatic affirmation, sheer potential. No longer a known quantity, the empty subject merges with the flow of human traffic to become another face in the crowd.

"Well, I just got into town about an hour ago / Took a look around, see which way the wind blow," is how The Doors' "LA Woman" begins. As always, the singer is driven by the promise of romance around every corner, those "little girls in their Hollywood bungalows." This being LA, however, the erotic charge of such words quickly turn sinister, with "Cops in cars, the topless bars," and finally, in the closing line of the song, "Motel Money Murder Madness."[3] The first impressions of a place never before visited but anticipated in dreams that are, for their part, supported on a vast and pervasive foundation of images, are inevitably uncanny. Whether the actual LA conforms to the cliché or not, the lyrical subject is always caught between the Lacanian imaginary and the real. To what extent does LA, the city, measure up to the fantasies that it is in the business of perpetrating and that every one of us is complicit in perpetuating? We experience every big city virtually before we enter in person—via travel brochures as well as books, films, and works of visual art; via the profile or footprint of representative buildings, a distant skyline, a bird's-eye view—but in LA that initial sense of unreality persists. It is clichéd, but not untrue, to claim that everyone here comes from somewhere else. Even those who count themselves authentic natives, Angelenos born and bred, are susceptible to a haunted sense of displacement.

Descending from the night sky into the gently flickering grid is an emblematic LA experience, an establishing shot within which one has miraculously come to occupy a central role. However, once one touches down, this fleeting glimpse of totality gives way to a rapid succession of partial, disparate, and disorienting views. The on-the-ground conditions are characterized by a sense of acute dislocation, according to Frederic Jameson, who pronounced LA the model postmodern city for this reason.[4]

This is where so-called advanced art finally reneges on its promise to submit the space of urban-industrial modernity to a comprehensive cognitive mapping. Abstraction, ideally a means of negotiating the opposed sensibilities of the one and the many, the individual subject and the generic mass, is inadequate to the challenges posed by this city. With a related mandate, popular music fares better because it does not necessarily aim for synthesis. In the LA song, especially, the one and the many—in this case, the band and its audience—eye each other suspiciously across vast distances, or opposing lanes of freeway, in passing.

2.
Ed Ruscha has made numerous paintings overlooking LA at night as if from a plane or even a satellite. This picture-postcard vantage is so familiar that it can be conjured with a few swipes and splatters of black and white pigment, leaving the viewer to fill in the details. Like many artists of his generation, Ruscha might have taken his cue from Marshall McLuhan, who distinguishes between "hot" and "cool" media on the basis of their appeal to the human sensorium.[5] In other words, McLuhan measures the temperature of our subjective response, which tends to rise in direct proportion to its fall within the object itself: the "hottest" media are thereby intrinsically also the "coolest." As in Ruscha's overview of LA, sensory deprivation activates the viewer's imagination.

Pop art (not to be confused with the authentically popular) appropriated these strategies of commercial art and then customized them to suit its more autonomous or oblique ends. As did James Rosenquist or Andy Warhol, Ruscha was trained in graphic design, which gave him an edge in what is possibly the most pressing challenge of the post–abstract expressionist years: to cool down painting in order to "hot up" the viewer. In *Talk Radio* (1988), a representative LA painting, Ruscha accomplishes this task systematically, by degrees. First, he conforms the free-form gestural expression of the New York School painters to the denatured order of the grid; second, he inscribes the eponymous words, in a precise rendering of handwritten script, atop it like a logo. Ironically, the written word, or what Marshall McLuhan termed the "technology of literacy," serves as a visual object that in turn serves as aural experience, the incessant real-time chatter of so-called "secondary orality." These discrepancies are so many cracks and fissures emanating from the larger break at the crux of this artist's work. That which the abstract expressionists sought to integrate into a singular flatness is here divided into two discrete, discontinuous planes: one literal, consistent with the surface of the work, the other representational and drawing away into the perspectival distance.

More to the point, though, one might think about the relation of urban experience, on the one hand, and music, on the other, in determining the look and feel of modernist abstraction from Édouard Manet to Piet Mondrian to Jackson Pollock. As noted, Ruscha strains this legacy through the template of applied art, in which Pollock is known less for his radical reduction of painting to its material essentials than for his jazzy stylings, effectively a graphic identity that he developed for the big-city loner, a widely imitated American character that wrestled with the burden of postwar freedom. Pollock translated existential philosophy into squalling bebop fugues and agitated brushwork. In Ruscha's painting, Pol-

5. Marshall McLuhan, *Understanding Media: The Extensions of Man* (New York: McGraw-Hill, 1964; repr., Cambridge, Mass., and London: MIT Press, 1995).

6. Walter Pater, *The Renaissance: Studies in Art and Poetry,* 1873.

lockian *écriture* becomes plain writing. The words identify the underlying field of the big city at night as an informational apparatus in itself, the electrical ground of an atmosphere now charged with communicative potential—the ether. No longer the outcome of a subjective reprocessing of the public structures of urbanism, abstraction is inherent in the object, the distant cityscape, which is then dutifully represented.

That these works typically take a square format makes perfect sense, as the square is a module of the grid depicted therein and, just like the grid, suggests infinite expansion. The square remains unencumbered by the standard art-historical associations that we bring to a horizontal or vertical canvas, the first favoring the landscape or ground and the second, the figure. Taking neither the measure of nature nor that of man, it announces itself as a manufactured thing first and foremost, an impression that is clinched by this work's breezy mix of bare-bones photorealist imagery and quasi-personalized typography, which resembles nothing so much as the cover of a vinyl LP—and, even more specifically, the sort of scaled-up, hand-painted copies of album covers one still sees outside stores like Tower Records on Sunset Boulevard.

Ruscha's work is symptomatic of the deep reach of the rock-and-roll spirit into the structural core of postmodern art, and as such serves as a model for all that follows. This work evokes a particular sensibility—or, better, an attitude or a voice—that the artist shares with the local music community. And it is pervasive: so much so that one finds it even, or especially, in those works that make no explicit reference to music.

The artist's book *The Sunset Strip* (1967) is one such work. A paradigmatic instance of conceptual literalism, the title says it all, or so it would seem. It lays out the objective parameters: a territory is staked out and subdivided for documentation and then reconstituted as a photographic foldout. With its plain white cover bearing only the title, it announces itself as a book; but once opened it admits a different order of cinematic reference. Our perspective on the street, as glimpsed through the windows of a moving car, automatically becomes cinematic, but this is static, extruded, objective cinema. The book's interior resembles a strip of film, its adopted format allowing us to see one building after another, or all of them at once, over the several blocks that constitute the Strip portion of Sunset. The buildings line up, but only just; Ruscha's rough cut-and-paste joinery never quite obscures the fact that this work is a collection of still-image fragments, individual photographs compiled in the form of an album. Considering the street's rapid-fire succession of garish window displays, shop signs, and billboards, this approach is entirely appropriate: the Strip is both a highly visual and fractured subject.

But the Strip is also a mecca of rock-and-roll and club culture. In the mid '60s especially, when Ruscha's book was made, it was de rigueur for any band worth its salt to play the Strip because it was, and to an extent still is, record industry central. Of course, the experience of music as such remains inaccessible to Ruscha's book, but precisely as a missing part it is insinuated with that much more insistence. Ruscha translates music into visual terms, though not in the manner suggested by Walter Pater's famous quotation, "All art aspires to the condition of music."[6] Similarly, when Clement Greenberg, in his essay

"Toward a Newer Laocoön," notes the central influence of music as a "paragon art" on the development of avant-garde sculpture and painting, he points to "its 'absolute' nature, its remoteness from imitation, its almost complete absorption in the very physical quality of its medium." In other words, its "pure," irreducible abstraction sets it apart from the sort of music that inspired Ruscha.[7] If *The Sunset Strip* is covertly about music, then it is the music played on this street: a popular music that stubbornly resists reduction to operate instead as a model of connection-making between a wide range of word-, image-, and object-based media. In effect, Ruscha, in his quintessentially cool pop manner, locates the Strip as a place where music has already been translated—into signage, advertising copy, architecture, etc.—and then he simply appropriates it photographically.

Since the connection between sound and image, music and art, is here a fait accompli, all that is left for the artist to do is point it out. What is most striking about *The Sunset Strip* is precisely this discrepancy between its rote formal means and its ostensibly expressive ends: Ruscha's camera is limited to pointing and shooting. Per Pater and Greenberg, the abstract expressionists plumbed music's inner structure in search of a grounding for their abstract works, but Ruscha just fires off one image after another. Repetition over time is asserted as a robotic alternative to actually composing the image, to both abstraction and expression. One doubts that Ruscha ever bothered to peek through the view finder, forcibly expunging his work of any sign of technical expertise in order to harness the remote effect of an apparatus left to its own devices. The overexposure, lack of focus, and graininess of the image—elsewhere written off as signs of technical incompetence—are seized as the component parts of a new aesthetic, a more literal sort of flatness. "All I was after was that store-front plane," claimed Ruscha. "It's like a Western town in a way. A store-front plane of a Western town is just paper, and everything behind it is just nothing."[8]

Flatness, a quality that Greenberg found to be synonymous with "frankness" and truth telling in art, is in this way related back to illusionism, but a uniquely forthright illusionism. Clearly, Ruscha is not simply reacting against the modernist order; the urban experience, the example of music, truth to medium, and flatness remain foremost concerns in charting the way forward, only now we are dealing more specifically with LA, rock and roll, and photographs. Flatness is their common element; and Ruscha effectively transposes it from the abstract expressionist canvas to the real space of the storefront plane. Observed from the street, LA greets the mobilized viewer as a sequence of facades, already photographic fronts, and the same can be said for rock music, which is often seen in the form of a promotional image, before it is heard. The point is restated from the opposite end in the photographic book *Records* (1971), where the experience of trawling through the artist's collection of LPs is rendered analogous to a drive down the Strip. On facing pages we are shown squares and circles, a series of album covers alongside their contents, the records themselves. This act of revelation is largely redundant, however—and this is the source of the work's po-faced humor—as all records tend to look alike. Only the most literally superficial part of the equation makes itself known to the camera, which is no doubt always

7. Clement Greenberg, "Toward a Newer Laocoön," in *Clement Greenberg: The Collected Essays & Criticism, Volume 1*, ed. John O'Brian (Chicago and London: University of Chicago Press, 1988), 31.

8. Ed Ruscha, quoted in David Bourdon, "Ruscha as Publisher (or All Booked Up)" (1972), in Ed Ruscha, *Leave Any Information at the Signal* (Cambridge, Mass.: MIT Press, 2002), 23.

9. Theodor Adorno, "The Form of the Phonograph Record" (1934), in *Essays on Music,* ed. Richard Leppert (Berkeley, Calif.; Los Angeles; and London: University of California Press, 2002), 278–79.

10. Ibid.

11. Meg Cranston, interview with the author, March 13, 2007.

the case, but the desire to see deeper is also acknowledged through its repeated thwarting. There is no synaesthetic payoff, just the slapstick collision of the gaze against black plastic.

Records stages a multimedia summit, of sorts, to work out an equitable compromise between the competing interests of photography and phonography. At issue is the perpetuation of a modernist concern with flatness, one that implicates both media equally, but in a manner that deviates sharply from the former test case of painting. On this point, it is worth recalling Theodor Adorno's characterization of both the photographic print and the phonograph record as "herbaria of artificial life."[9] "Records are possessed like photographs," he wrote, both of them designated as *Platte,* or "plates" in German.[10] This term highlights the process of flattening, the squeezing out of a third dimension, whether visual or aural. In fact, the first proper record "album" consisted of eight one-sided, ten-inch discs of Beethoven's *Fifth Symphony* packaged in a luxurious accordion sleeve *(1914).* Whether or not the accordion fold in Ruscha's *The Sunset Strip* refers directly to this artifact, it reminds us that even the straightest street with the flattest scenery may be reconfigured by the mobilized observer into a somewhat more complex proposition—in this case, a zigzag. Moreover, by swiveling our perspective from one side of the street to the other, the camera mimics the movement of a stylus down the groove line of a record. The reproduced street runs right down the length of this work, a long gray furrow that gives way, at its center, to the white of the underlying paper stock, with the buildings rising up on either side like architectonic embankments. Once the trajectory is de-

termined, the image simply follows; it is the visual residue of a lens drawn mindlessly across the built surface of the city, vibrating in tune with the likewise visual messages dispersed along the way.

3.

Ruscha has always practiced a dissident brand of pop; only in the work of his closest contemporaries—figures such as Bas Jan Ader, David Lamelas, and Allan Ruppersberg—do we find anything like it. These artists were all drawn to LA by a powerful mythology at once sinister and sublime, and one that receives its most alluring articulation in the language of music as opposed to that of art proper. All shared the desire for a different sort of community, which they later found on Sunset Boulevard, where they located their respective studios. In spite of the occasional flare-up of interest every decade or so, LA's indifference to its art scene, up until at least the mid '90s, is legendary. The early history of LA art remains largely a secret one because, lacking any credible infrastructure, the city's fledgling art world was absorbed into a range of outlying cultures. The surfers settled in Venice and the rockers on the Strip, in yet another iteration of the city's sunshine-noir dichotomy. Driving in from his native Oklahoma, Ruscha apparently saw this narrow bar and club–lined corridor as "the perfect city," according to Meg Cranston, who recently retraced the trajectory of *The Sunset Strip* with a busload of Getty scholars, narrating every point along the way where the art and rock worlds intersected.[11]

Looking over old photographs of the Mark di Suvero–designed *Peace Tower,* officially titled *The Artist's Protest Tower* (1966), which was mounted at the corner of La Cienega and Sunset boulevards

and then filled with the works of local luminaries as well as a good portion of art flown in from the East Coast, one is struck by the still wild and undeveloped look of the place. The street is bordered by a sharply rising cliff side dotted with shrubs, a few trees, and just one or two overlooking homes, all of which form a naturalistic backdrop to di Suvero's work: a distinctly technological, information-age structure reminiscent of bombs and rockets but also power lines, radio emitters, and the improvised electrical towers then becoming a ubiquitous feature of the outdoor rock festival circuit. One cannot shake the impression that the opening rally on February 26, which was overrun with wild-haired characters from all walks of life, was a trial run for Woodstock—or, closer to home, Monterey Pop and Altamont. Likewise, in November of the same year, those scenes of raucous demonstration that were commemorated in the film *Riot on Sunset Strip* (1967) are remarkable today for their highly mixed, heterogeneous composition. Specifically protesting the practice of carding at clubs (a lightweight teeny-bopper issue), the riot became a matter of greater local concern to those who understood that age discrimination was only the tip of the iceberg in an effort to bring their "perfect city" under municipal control. Up until this point, the Strip had remained effectively unincorporated, a "temporary autonomous zone," to borrow Hakim Bey's felicitous designation, free to interpret the law as it saw fit.[12]

In this way, local "wannabe" Rodney Bingenheimer was initially admitted into rock royalty by supplying underage groupies to visiting acts like The Rolling Stones, Led Zeppelin, and David Bowie at his English Disco, thereby earning the erstwhile title of Mayor of Sunset Strip.

No doubt the riot included a number of his patrons, both young and old, who saw the deployment of LAPD crowd-control squadrons on their free-wheeling street much like the communards in mid 19th-century Paris: harbingers of a new order, morally repressive, and anti-fun. Certainly, the artists—especially those who had fled conservative, Protestant backgrounds and who saw LA as the antidote to all that was uptight in the world—could be counted on to connect the dots historically. An Edenic haven of polymorphous perversity for rock-and-roll desperados, the Strip really was a perfect city, in this sense, a western-town version of Left Bank bohemia.

The influence of the place is evident in works like Bas Jan Ader's *I'm Too Sad to Tell You* (1970). With the eponymous words hand-scrawled across a grainy black-and-white photograph of the handsome, lanky-haired artist sobbing away, it too could easily pass for an album cover: an introspective folk-rock exercise à la Tim Buckley or Harry Nilsson. Likewise in those pictures of a mane-tossing David Lamelas—with eyes closed and head raised and wielding a guitar like an ax, he is set to receive the rock-and-roll spirit as a form of divine or demonic inspiration straight from the spotlight. Titled *Rock Star (Character Appropriation),* this 1974 series that the Argentine artist produced while still in London, bespeaks the literal proximity of the so-called post-studio and rock-and-roll crowds.[13] Whereas figures such as Larry Bell, Billy Al Bengston, Robert Irwin, and Craig Kaufmann—founding fathers of those representative West Coast art movements Finish Fetish and Light and Space—required large-scale quasi-industrial work spaces, the post-studio artists were more suited to modest storefronts or their upstairs Sam

12. Hakim Bey, *TAZ: The Temporary Autonomous Zone* (Brooklyn, Ny.: Autonomedia, 1985).

13. The term *post-studio* is generally attributed to John Baldessari, who exemplified a post-studio attitude when he sent the entirety of his painterly production up in flames in 1970 and who then went on to teach an influential class at CalArts on the topic. For his part, however, Baldessari attributes the term to Carl Andre.

14. Michael Fried, "Art and Objecthood," in *Art and Objecthood, Essays and Reviews* (Chicago and London: University of Chicago Press), 148–72.

15. Bas Jan Ader, quoted in "Rumbles," *Avalanche*, winter 1991, in *Los Angeles: 1955–1985*, ed. Catherine Grenier (Paris: Centre Pompidou, 2006), 221.

Spade–style offices. On the Strip, they spent their days moving around fragments of image and text or editing film, emerging only at night to take in a show at neighboring clubs such as The Roxy, The Troubadour, or The Whiskey.

Following a clearly delineated historical logic, we may observe the incremental tempering of the expressive gestures of the New York School painters in subsequent movements, such as post-painterly abstraction, the color field, minimalism, and pop art. By the time we get to conceptual art, their cool sensibilities turned glacial, and precisely at this point the LA articulation of a post-studio practice took shape as an alternative. On the face of it, the (re)emergence of a lyrical voice in an art form that had been scrupulously purged of authorial signature in pursuit of literal objectivity, what Michael Fried would term "objecthood," or objective "presence," is wantonly retrograde.[14] Whatever expressionist backsliding this work may indulge, however, is held in check by a deeply ingrained sense of the culture as a complex system of relations, one that includes art as opposed to being antithetical, indifferent, or subservient to it. But the discursive cohesion that once enabled artists to take part in great, cultural movements backward or forward, upward or downward, inward or outward, had already given way to the endlessly recombinant field of cross-categorical citation that we are still contemplating today. Inspired by the various subcultures of the Strip, the post-studio crowd gave in to the enraptured postures of rock while simultaneously cultivating their pop art cool to the point of conceptual iciness.

The subtitle of Lamelas's work gives the game away: just as Warhol had appropriated the commodity fetish to serve as an object of art, so does Lamelas, in a context increasingly given to practices of objective dematerialization and de-skilling, appropriate the character of the rock star as a subject, a model lifestyle for the artist. As with any piece of effective theater, this change of context works on at least two levels. On the one hand, it plays up the extraordinary quality of the rock-star pose, which is thrown into high relief when observed against the stringently neutral backdrop of the art of the time. And, on the other, it normalizes this strangeness as a pose, exactly, while suggesting that posing is what we all do. Accordingly, a deeply unsettling mixed-message—with gender-bending fashion cues and ecstatic expression battling the beard and phallic instrument—is rendered nearly commonplace because, as we all know, all the world's a stage.

Moreover, in order to yield a credible pose, the poser has to believe in his or her authenticity. On this point, Ader is unequivocal: *I'm Too Sad to Tell You* is compelled by "extreme grief."[15] Whether crying, falling, or *In Search of the Miraculous* (1975), as per the title of the final three-part work that would take his life, Ader's performance of passion always points back to the Man of Sorrows. The rock-and-roll appropriation of Christian iconography is commonplace at this point—in the films of Ken Russell, including The Who's rock-opera *Tommy* (1969), and the Broadway hit *Jesus Christ Superstar* (1970), among many other examples—but in the context of what is considered advanced art, it remains defiantly off-putting, de trop. Again, this conscious strategy effortlessly plays up all the tensions and oppositions that simply come with the territory of the contemporary culture. Repeatedly alluding to his Dutch countrymen and a supremely ascetic artistic heritage, Ader

acknowledges the crucial link between modernist iconoclasm and the Protestant Reformation, only to break that connection. From Pieter Saenredam's paintings of stripped-down churches, proto-modernist white cubes, to Mondrian's abstract epiphanies before the Westkappelle lighthouse, Ader plots the course of his own production as a historical offshoot, holding fast to the sense of spiritual seeking that characterizes the work of his forefathers while also striking out on a tangent. Ader's post-studio passion plays are very much the product of Catholic tastes.

The rock-and-roll culture of the Strip opens a perverse loophole in the dispassionate edifice of conceptual art, allowing for the resumption of all manner of dramatic, even sentimental, imagery. Of course, outright expression is mitigated by ironic and farcical attitudes but, in the end, the post-studio crowd is obviously as susceptible as anyone else to the romantic clichés that they have reintroduced into contemporary art. In particular, the myth of the outsider, the solitary wanderer, exerts the greatest pull; passed on to popular music from the romantic and symbolist poets, here it is reclaimed by high culture.

An undercurrent of melancholia runs through even the most outwardly comical efforts, such as Allan Ruppersberg's *Where's Al?* (1972). A jumbled assortment of snapshots of young adults engaged in diverse leisure pursuits and typed file cards that both ask and answer the titular question, the work's repetitive structure is slapstick without impairing its philosophical gravitas and core concern with the impossible rift between work and play, observing and being. The simple explanation for the artist's absence from every picture is that he is on the other side of the lens,

the posture of the artist as producer effectively exempting him from the joys of a life authentically lived. One telling excerpt reads, "He: Where's Al? She: He's hibernating on Sunset." No doubt, it is the colloquial call-and-response quality of this work that compelled the critic Alex Farquharson to include it in his recent Beach Boys–themed project, *Brian Wilson: An Art Book.*[16] More specifically, Ruppersberg's work is imbued with the same sense of vaguely manic yearning, at once depressed and ecstatic, that is the hallmark of tracks like Wilson's "In My Room" (1963).[17]

Popular music speaks the language of mass media: it aims to appeal to the greatest number of listeners, while maintaining the illusion of intimate connection. In this way, "In My Room" effectively merges, in verse, the spaces of production and reception with the artist revealing himself to be as alone as the individual listener. The tensions between individual and collective, inherent in modern society, are pushed to the extreme, and it is precisely the impossibility of reconciling the live experience of rock with its intimations of communal utopia and the alienated condition of the solitary record buyer that captured the imagination of the artists on the Strip.

4.

"Many people I know in Los Angeles believe that the '60s ended abruptly on August 9, 1969," wrote Joan Didion in her book *The White Album,* "at the exact moment when word of the murders on Cielo Drive traveled like brushfire through the community."[18] In hindsight, portents of the end of the '60s are found everywhere, but few failed to notice that the most significant among these—Altamont, Charles Manson, the Watts Riots—are geographically linked. The

16. Alex Farquharson, ed., *Brian Wilson: An Art Book* (London: Four Corners Books, 2005).

17. The Beach Boys, "In My Room," B-side to "Be True to Your School," 1963, Capitol Records.

18. Joan Didion, *The White Album* (New York: Simon and Schuster, 1979), 47.

19. Barney Hoskyns, *Waiting for the Sun* (New York: St. Martin's Press, 1996), 149.

20. As in the title of Fred Goodman, *The Mansion on the Hill: Dylan, Young, Geffen, Springsteen, and the Head-on Collision of Rock and Commerce* (New York: Times Books, 1997; repr., New York: Vintage Books, 1998).

21. See footnote 19.

fault lines threatening to fracture a once-unified youth culture run deepest in California. For his part, British rock critic Barney Hoskyns points to the Monterey Pop festival as the beginning of the end: "Nothing was the same after Monterey. That 'international pop festival' signaled not only the birth of the rock industry as we know it today, but the onset of the decadence which characterized the music scene in general—and the Los Angeles scene in particular—through the late '60s and '70s."[19]

Decadence is here equated with the selfish turn that leads from the We generation to the Me generation, a turn encouraged by immense record-industry profits and their accumulated impact on the figure of the rock star who is transformed from pied piper of the revolution to a ghastly shade haunting "The Mansion on the Hill."[20] LA tends to nurture such downer dramas because, although it is the first capital of the communication age, it can foster the same degree of isolation as can the Carpathian Mountains that Count Dracula called home. In his film *Sunset Boulevard* (1950), Billy Wilder cannily applied the conventions of F. W. Murnau–era Gothic horror to a self-reflexive meditation on the psychological costs of working in the film industry. By the late '60s, the rock-and-roll version seemed to write itself.

The Beach Boys' Mike Love famously denounced Brian Wilson's song "In My Room" as "ego music," thereby affirming Love's faith in the band's other, more selfless and public side. Known for anthemic celebrations of California youth, The Beach Boys would endure a difficult process of maturation that saw the gradual bending of its collective voice to the will of the studio auteur. In this sense, "In My Room," initially released as the flip side of the hit single "Be True to Your School," provides an early indication of the band's future direction, both in terms of its greatly expanded artistic ambitions and the subsequent losses in its fan base. Those songs that resonated most profoundly in the hive mind of American adolescence, and throughout those rare spaces where teens may congregate, would face an uncertain fate in the years following graduation. Where else to go but further inward?

Only in the light of its utopian hippie foundations would such an experimental initiative be deemed decadent; yet, decadence is the overwhelming impression we have of LA rock in the late '60s and '70s, and it is one that Wilson's more mature albums, *Pet Sounds* (1966) and *Smiley Smile* (1967), corroborate. The turn inward that leaves out the collective is echoed in a highly manipulated studio sound, refined to the point of corruption, that later became the city's official soundtrack. Whether it is because of the sex, the drugs, or the money, the West Coast music scene in the late '60s and '70s was "invaded by people to whom flower-power ideals of peace and love were of scant concern," according to Hoskyns; that is, "con-men, mobsters, dealers, biker gangs."[21] These are all outsiders to a scene that is attempting against all odds to maintain its innocent outlook, the very thing that renders it vulnerable to a criminal element. Hippiedom is easily infiltrated by its ideological antagonists, as Manson stands to show, but the fall of flower power is not due to simply an overabundance of love betrayed by worldly realities. When, in the 1969 film *Easy Rider,* Peter Fonda's Captain America character listlessly declaims, "We blew it," he means the whole counterculture, which has basi-

cally become a criminalized stranger to itself.

Bearing in mind the avant-garde affinities of The Beach Boys' later albums and the turn they helped to steer from a naturalistic studio sound to one more deliberately constructed and collaged, we may find that Hoskyns's "decadence" is also an inevitable consequence of reversing Walter Pater's famous dictum, for here music aspires to the condition of art. Accordingly, the question of just what side art is on?—is it an agent of anarchy or the law, of progressive or conservative politics, of cultural populism or elitism, and so on—becomes increasingly pressing. Many will see art itself as an infiltrating element, no less ambiguous than Manson, and no less destructive. No surprise then that the gathering clouds of paranoia that darken those years are especially apparent in the work of contemporary artists who are outsiders almost by definition and thereby literally "strangers in a strange land," to borrow the title of Robert Heinlein's 1961 best seller, when they come to LA. Here, again, Ed Ruscha's *The Sunset Strip* offers a case in point: although it was produced the same year that found Sunset Boulevard filled to capacity with agitated, youthful bodies in newspaper photos and television news segments, this book depicts desolation. Under a blazing sun, the street appears vaguely postapocalyptic in its emptiness. Either all are hidden away indoors or else, like the artist, in their cars. That nobody walks in LA is one way to read the evidence, but what if, like so many western towns, this one is being abandoned? What if it were already a ghost town, with nobody to see and nobody seeing? *The Sunset Strip* could then be the product of an automated surveil-lance system still sweeping the streets after everyone has left.

It is certainly a fanciful interpretation but one that is borne out by the increasingly pessimistic work of ensuing generations, artists whose work was later included in such shows as *LA: Hot and Cool: The Eighties* (at the MIT Visual Arts Center, 1987–88); *Sunshine and Noir: Art in L.A., 1960–1997* (at the Louisiana Museum of Modern Art, Denmark, 1997); and, of course, Paul Schimmel's definitive dystopic LA exhibition, *Helter Skelter: L.A. Art in the 1990s* (at The Museum of Contemporary Art, Los Angeles, 1992). Artists like Mike Kelley, Raymond Pettibon, and Jim Shaw remained invested in the '60s as subject matter, though strictly in its downside, the bummer that follows the summer of love. Their shared fascination with Mansonesque master manipulators, sexual hysteria, drug psychosis, and physical deformity, as well as with surface textures that are grubby, wrinkled, hairy, pimply, and pock-marked, points to a too-early intake of the era's late style as reflected in acid rock, exploitation cinema, and especially underground comics. On the whole, the art of *Helter Skelter* is symptomatic of a profound and traumatic temporal dislocation or of growing up within a youth culture that is, for its part, just growing old.

The pared-down pop of the Sunset Strip artists was followed by referential surplus and subject positions that became increasingly schizoid as a consequence of overidentification with too many lifestyle models. In his emblematic *My Mirage* project (1986–91), for instance, Jim Shaw extends an investigation into the origins of his artistic self into a burgeoning archaeological inventory of increasingly specific cultural sources, from Beach Boys LP covers to

Mad magazine comic strips, which he deftly reproduces by hand on a series of regular 17- by 14-inch poster boards. A visual bildungsroman of distinctly postmodern vintage, the trials that this young man—Shaw gives him the utterly unremarkable name of Billy—must encounter en route to becoming a true author are simply too numerous, too perplexing, and too imposing. Accordingly, the cathartic slaughter of the father that would allow for meaningful differentiation is endlessly forestalled. Shaw, who portrays his pseudonymous Billy as an overweight teen, opts instead for a cultural *grande bouffe,* glutting on the output of his hippie forefathers. Tellingly, Shaw reintroduces his hand into the process of pop citation, not necessarily to distort but rather to mimic as accurately as possible, the information. Whereas Lamelas pulled off his *Character Appropriations* as economically as possible, one is astounded at the obsessive extent of Shaw's effort, the sheer quantity of works his oeuvre comprises.

Excess is the common attribute of the *Helter Skelter* artists: walls are hung top to bottom with images, tabletops are covered edge to edge with objects, and, barring the requisite walkways, every square foot of floor space is taken up. The endlessness at the core of these projects reflects the endlessness of consumption: the endless stores on each street, the endless aisles in each store, the endless rows on each aisle, the endless objects.

That the movement of an observer across the built landscape of the city ultimately has to do with consumption is an insight that does not come easily to rock music, which would prefer to imagine that the streets could be used for something else. *The Peace Tower* project answers a call to collective action sounded in songs like Buffalo Springfield's "For What It's Worth" (1967), which roused listeners as though out of a consumerist torpor with its urgent refrain, "Stop, children, What's that sound? / Everybody look what's goin' down." But those lyrics also betray an insidiously self-questioning strain that is more aligned with the alienated postures of local artists, the connoisseurs of pop noir from the late '60s to the present. Further on, the singer's ambivalence gives way to cynicism: "What a field day for the heat / A thousand people in the street / Singin' songs and a-carryin' signs / Mostly say, 'Hooray for our side!'" Insight into the action-reaction dynamics of oppositional expression breeds resignation, as the song's exhausted title suggests. Whether it is better for a crowd to simply fall apart or be broken up by force is a question for cynical reason to decide— and art, at least, has the advantage, as it never expected anything more than social exclusion and anomie in LA.

Subsequent generations will continue to dissect the cultural fallout of the '60s with a forensic acuity that seems to intensify in direct proportion to their distance from the events in question. Meg Cranston on the sad tale of Marvin Gaye, murdered by his own father (*God Love the Tragic Artist,* 1997); Sam Durant on Altamont (in the 1998 installation *Partially Buried 1960s / 70s: Utopia Reflected, Dystopia Revealed);* and Mungo Thomson on the death drive as the active principle of rock and roll (*Drum Kit Drawing,* 2005) are all instances of an acutely scholarly art with all the ironies that this assumes given the antiestablishment biases inherent in the subject. All are historically removed from the cultural milieus they have chosen to mine, which become, accordingly, points of historical

interest. If these artists manage to sum- mon a sense of passionate engagement, it is largely due to their real experience with these historical sites; that is, with the archaeology of the city and street, a rock-and-roll ruin.

Thomson's archival installation *The Collected Live Recordings of Bob Dylan, 1963–1995,* which premiered at Margo Leavin Gallery during his first solo exhi- bition in 1999, draws on a familiar sys- tem of connections between the road and the record, the superstar and the fans. Its centerpiece is an aural collage compiling every extant instance of the on-tour Dylan addressing his live audi- ence and its collective response, with all music dutifully edited out. A work of pop sociology, it separates the rock-and-roll voice into dramatic and documentary registers, extracting the persona of the performer from that of the song-bound character, while at the same time raising a number of fundamental Platonic ques- tions as to the nature of representation, imitation, and mimicry. In *The Republic,* for instance, Plato asks, "whether the poets, in narrating their stories, are to be allowed by us to imitate, and if so, whether in whole or in part, and if the latter, in what parts; or should all imita- tion be prohibited?" And if this question is here resumed as gravely as before, it is because Dylan is not merely an enter- tainer. His voice, that of a generation, is historically significant, which raises it to the status of a poetic voice as Plato de- fines it when he states that "all mythol- ogy and poetry is a narration of events, either past, present, or to come." Inas- much as the poetic voice has the power to influence the course of events in our time, matters of form or style gain a crucial social dimension. Whether we are dealing with "either simple narra- tion, or imitation, or a union of the two"

and whether "the poet is speaking in his own person" or "in the person of another" make all the difference in the world.[22]

Through a process of subtraction, Thomson's installation sensitizes us to the specific grain of the rock-and-roll voice as mixed style, precisely: the aural signature of an enormously volatile iden- tity that is continually renegotiated in the volley of call and response between the one and the many, the full-but-isolated individual and the empty-but-integrated mass. The process of give and take that constitutes every dialogue requires that communicating parties appropriate and internalize each other's utterances. Ac- cordingly, we may assume that Dylan's voice is shaped by his audience to the same extent that their voices are shaped by him, and we hear this exchange in Thomson's work in a way that neither side could possibly have heard at the time the recording took place. And this is because the artist, in his expertise as ultimate outsider, places us right in the communicative breach between them.

Winter 2007

Jan Tumlir is a Los Angeles–based writer. He also teaches art history and theory at the Art Center College of Design and the University of Southern California.

22. Plato, *Republic,* trans. B. Jowett (New York: Modern Library, 1982), 92–95.

LOS ANGELES /
THE WEST COAST: PLATES

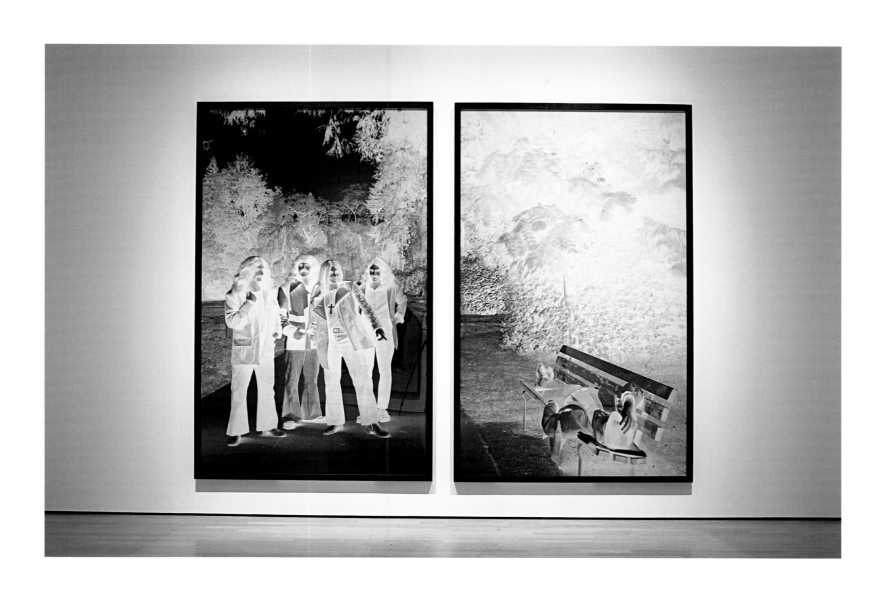

Rodney Graham
Awakening, 2006
Two monochrome color photographs
Each: 94 $\frac{1}{2}$ x 57 $\frac{1}{2}$ in. (239.4 x 146 cm)
Overall: 94 $\frac{1}{2}$ x 121 in. (239.4 x 307.3 cm)
Edition of four aside from artist's proof
Courtesy of Donald Young Gallery, Chicago

Raymond Pettibon
No Title (Fight for Freedom!), 1981
Ink on paper
11 x 8 ¹/₂ in. (27.9 x 21.6 cm)
Courtesy of Regen Projects, Los Angeles

OPPOSITE
Raymond Pettibon
No Title (Angel Dust), 1982
Ink on paper
14 ¹/₂ x 10 in. (36.8 x 25.4 cm)
Courtesy of Regen Projects, Los Angeles

FOLLOWING PAGES

Raymond Pettibon
No Title (Before you die), 1980
Ink on paper
14 ¹/₂ x 12 in. (36.8 x 30.5 cm)
Courtesy of Regen Projects, Los Angeles

Raymond Pettibon
No Title, 1978
Ink on paper
14 x 11 in. (35.6 x 27.9 cm)
Courtesy of Regen Projects, Los Angeles

ANGEL DUST

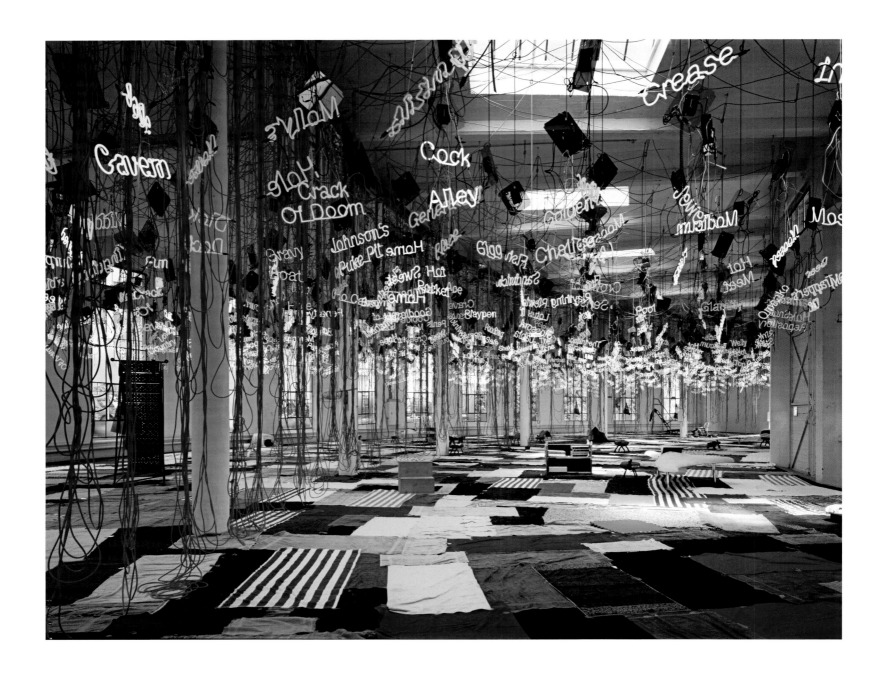

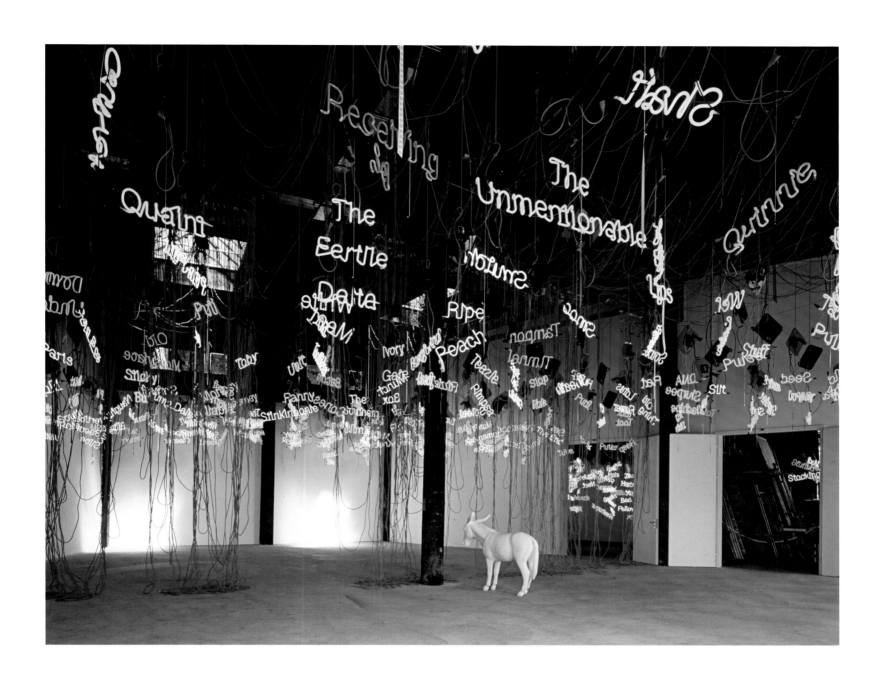

Jason Rhoades
My Madinah. In pursuit of my ermitage . . ., 2004
Installation views, Hauser und Wirth Collection, St. Gallen
June 13 – September 12, 2004
© The Estate of Jason Rhoades.
Courtesy Hauser & Wirth, Zurich and London.
Photo by A. Burger

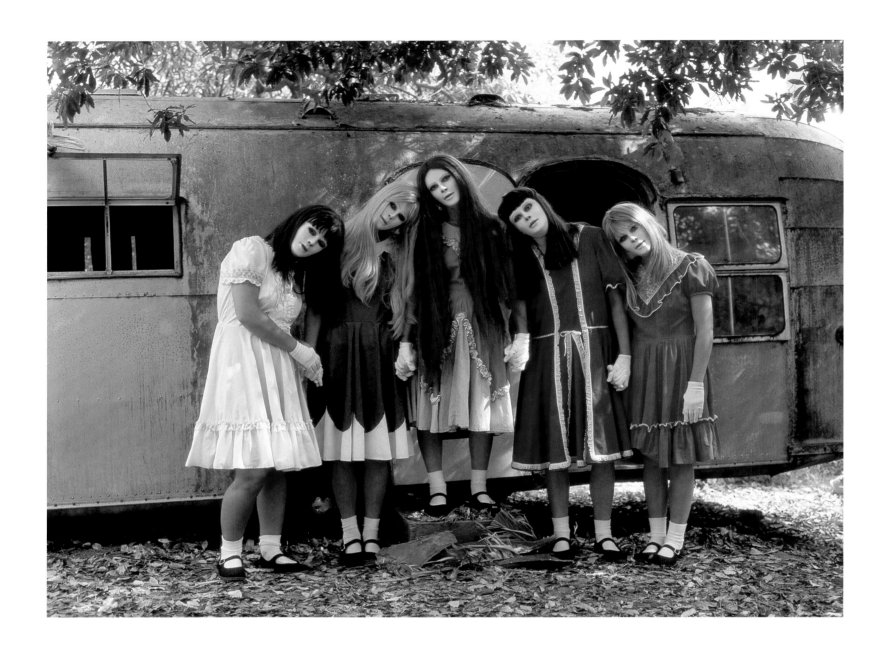

Marnie Weber
The Western Song, 2007
16mm color film transferred to video
24 minutes
Courtesy of Patrick Painter Inc, Santa Monica

Thaddeus Strode
In the Wild with the Ox (Herding the Bodhi Mind), 2006
Mixed media on canvas
107 x 131 in. (272 x 335 cm)
Collection of Hiroshi Taguchi
Courtesy of Galerie Michael Janssen, Cologne

OPPOSITE
Mungo Thomson
Drum Kit Drawing (John Bonham), 2005
Four-color ballpoint pen on Duralene
14 x 17 in. (35.6 x 43.2 cm)
Courtesy of John Connelly Presents, New York

ABOVE
Mungo Thomson
Drum Kit Drawing (Keith Moon 2), 2005
4-color ballpoint pen on Duralene
14 x 17 in. (35.6 x 43.2 cm)
Courtesy of John Connelly Presents, New York

Mark Flores
I Need More, 2005
Colored pencil on paper
Two parts, each: 29 x 22 ½ in. (73.7 x 57.2 cm)
Collection of John Rubeli, Encino, California
Courtesy of David Kodansky Gallery, Los Angeles

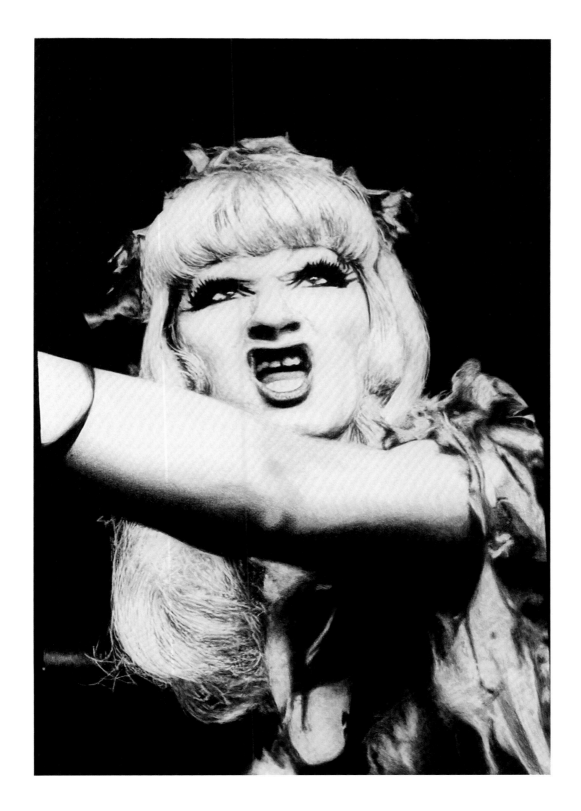

Mark Flores
Jayne County (at the Roxy), 2007
Colored pencil on paper
44 x 30 in. (111.8 x 76.2 cm)
Collection of Martin and Rebecca Eisenberg, New York
Courtesy of David Kordansky Gallery, Los Angeles

The Residents
Third Reich n' Roll, 1976
Black-and-white video with sound
4 minutes, 34 seconds
Courtesy of The Cryptic Corporation, San Francisco

Dave Muller
I Want It Louder, 2006
Installation view, Gladstone Gallery,
February–March 2006
© Dave Muller 2006
Courtesy of Gladstone Gallery, New York
Photo by David Regen

STRANGE FRÜT: ROCK APOCRYPHA BY THE DESTROY ALL MONSTERS COLLECTIVE

MIKE KELLEY

The white man's malady, nostalgia.
—Ze'ev Chafets, *Devil's Night: And Other True Tales of Detroit*

Editors' note: The Destroy All Monsters Collective consists of artists Mike Kelley, Cary Loren, and Jim Shaw. *Strange Früt: Rock Apocrypha* (2000–01) is an installation made up of four mural-sized paintings on canvas flats in the manner of classic freak show banners and videotape projections. The paintings (designed by Kelley and Shaw) are historical in nature and focus on entertainment and subculture personalities associated with the Detroit area in the late '60s and early '70s, the period in which the original members of the noise band Destroy All Monsters grew up (Kelley, Loren, Shaw, and a fourth member, Niagara). This is the time period when Detroit was renowned for its alternative hard rock scene and also the era in which local television fare was eclipsed by syndicated programs.

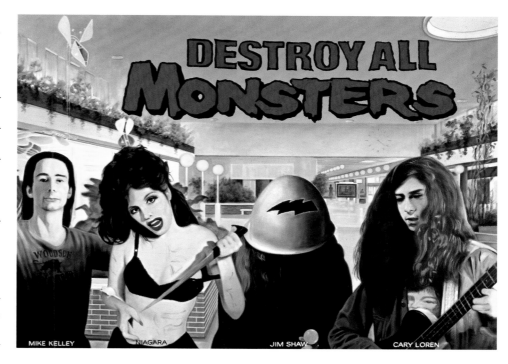

THE PAINTINGS

Mall Culture (96 x 138 in.) shows the original lineup of Destroy All Monsters (Kelley, Loren, Shaw, and artist-singer Niagara) posing in the west court of the Westland Center Mall in Kelley's hometown suburb.

The Heart of Detroit by Moonlight (120 x 240 in.) (10 x 17 ft.) features the radical, White Panther–associated rock band the MC5 (Motor City Five) surrounded by comedian Soupy Sales; children's television program hosts Captain Jolly and Johnny Ginger; wrestler George "The Animal" Steele; horror movie host Morgus "The Magnificent"; the "godfather of soul" James Brown; shock rocker Alice Cooper; the Vernors ginger ale gnome; blues great John Lee Hooker; and rock journalist Lester Bangs, all set against a depiction of the skyline of downtown Detroit.

Greetings from Detroit (120 x 228 in.) (10 x 19 ft.) is a similar composition in which local rock acts The Früt of the Loom, Grand Funk Railroad, The Stooges, The Up, and Scott Richardson of the SRC, along with free jazz great Sun Ra; funkmaster George Clinton; queen of the Ann Arbor freaks Pat Olesko; White Panther Zenta Minister of Religion, Brother J. C. Crawford; and children's television program host Milky the Clown parade in front of Detroit sculptural landmarks the *Spirit of Detroit,* the *Step of the Dance,* and a 1967-period race riot inner-city landscape. The world's largest American flag, which once adorned the front of Hudson's department store on special occasions, has been replaced with the flag of the anarchist White Panthers.

Amazing Freaks of the Motor City (96 x 132 x 6 in.) positions White Panther Party head John Sinclair in front of the giant Uniroyal tire landmark, whose whitewall has been replaced with a "rainbow coalition wall." Surrounding

Sinclair are the visages of Iggy Pop, Question Mark (of ? and the Mysterians), white soul man Mitch Ryder, afternoon movie host Bill Kennedy, Ted Nugent of the Amboy Dukes, and the Funkadelic trademark afro-zombie from the cover of the *Maggot Brain* album (1971). Sinclair sports a sweatshirt with an airbrush painting by famed Detroit hot-rod cartoonist Stanley "Mouse" Miller, who later became one of the most esteemed of the San Francisco psychedelic poster artists and is especially respected for his graphic work for the Grateful Dead.

THE VIDEO

Strange Früt: Rock Apocrypha was directed by Cary Loren. The videotape mixes footage of interviews with rock promoter and Grande Ballroom owner "Uncle" Russ Gibb; R&B musician Andre Williams (famed for his hit "Shake A Tail Feather"); underground radio disc jockeys Dave Dixon and Ben Edmonds; and Motor City wrestling

The Destroy All Monsters Collective
(Mike Kelley, Cary Loren, and Jim Shaw)
Mall Culture, 2000
Acrylic on canvas
96 x 138 in. (243 x 352 cm)
Courtesy of Patrick Painter Inc.,
Santa Monica

The Destroy All Monsters Collective
(Mike Kelley, Cary Loren, and Jim Shaw)
The Heart of Detroit by Moonlight, 2000
Acrylic on canvas
120 x 240 in. (304.8 x 518.2 cm)
Courtesy of Patrick Painter Inc.,
Santa Monica

The Destroy All Monsters Collective
(Mike Kelley, Cary Loren, and Jim Shaw)
Amazing Freaks of the Motor City, 2000
Acrylic on canvas
98 x 138 in. (243 x 350 cm)
Courtesy of Patrick Painter Inc,
Santa Monica

promoter Ron Ruby. It also contains archival television footage of Robin Seymour's *Swinging Time* teen dance show; horror film host The Ghoul; preschool television show *Romper Room;* Bill Kennedy; and children's entertainer Poopdeck Paul, as well as contemporary portrayals of Soupy Sales, Morgus "The Magnificent," Sir Graves Ghastly, and Milky the Clown. The videotape also features reenactments of period rock-oriented urban myths, performed by denizens of a contemporary Detroit-area goth nightclub, and John Sinclair's White Panther pronouncements, rendered by stoned-out participants at the annual Ann Arbor Hash Bash (a mass display of public disobedience protesting the prohibition of marijuana usage). The videotape has a soundtrack by Destroy All Monsters.

Even though *Strange Früt: Rock Apocrypha* is a historical project that focuses on a particular moment in Detroit history, we members of The Destroy All Monsters Collective are updating the project to include current musical developments in Detroit. Thus, a number of famed Detroit techno DJs are re-editing and mixing elements from period rock recordings, as well as Destroy All Monsters material, into a new soundtrack for the installation. Techno, which is considered a musical form indigenous to Detroit, and the noise music of Destroy All Monsters have similar roots in late psychedelic music, especially German bands such as Kraftwerk and Tangerine Dream, as well as the electronic dance music developed in the '70s by Giorgio Moroder.

In a playful commentary on the usurpation of rock music by hip-hop and techno, we are also presenting a new videotape that is a scrambled-until-it-is-unrecognizable mix of the film *Still Crazy* (1998). This comedy about a washed-up '70s rock band, appropriately named Strange Fruit, will be randomly cut up into short bits and re-assembled to produce a feature-length techno-beat track.

The large-scale paintings in *Strange Früt: Rock Apocrypha* refer to the tradition of historical painting in the grand style, with minor local personalities and subcultural figures substituted for the major historical heroes traditionally featured in that genre. The Destroy All Monsters Collective grew out of a specific historical period and cultural milieu; these works point out that fact. They are not meant to be a nostalgic look back to a better time, nor do they claim that the represented period is any more important than other localized cultural scenes, then or now. They are simply a play with historical form, designed, in part, as an ironic comment on our current postmodern period, generally dominated by ahistorical tendencies.

These works also ironically comment on the current popularity of the "art band" phenomenon. Museums and galleries in America and Europe abound

The Destroy All Monsters Collective
(Mike Kelley, Cary Loren,
and Jim Shaw)
Greetings from Detroit, 2000
Acrylic on canvas
120 x 228 in. (304 x 518 cm)
Courtesy of Patrick Painter Inc.,
Santa Monica

with "sound" shows. Most of these exhibitions focus on artists who use tropes associated with the pop musical forms of rock and techno; rarely do these shows attempt to present such works within a historical framework. Instead, in the spirit of much neo-pop art, the focus is on the work's fashionable and timely attributes.

The so-called art-band phenomenon goes back to the mid '60s and was contemporaneous with the pop art movement. Warhol's involvement with The Velvet Underground and the fact that many psychedelic bands had avant-garde pretensions (and were often made up of artists) proves this point. The art bands of the late '70s (Throbbing Gristle, Devo, Talking Heads, the No-Wave bands, etc.) could be understood as sharing certain concerns with the concurrent appropriation art movement; yet they were never accepted within the gallery or museum system. The artists who made up these bands came to be considered as musicians, and their

practices were not considered through art discourse. Only now have such activities begun to find acceptance in the mainstream art world. For example, the band Fischerspooner is sponsored by art-world agencies and presented as an artwork in a manner similar to the promotion of the earlier nonmusical group Art Club 2000. The peddling of a band as an artwork would have been unthinkable until recently.

This fact reveals our current moment in art history, when mass culture and the entertainment industries (MTV for example) have absorbed tropes associated with the historical avant-gardes. Critical aspirations, questions of authorship raised by appropriational strategies, and a countercultural stance (as in punk rock) have been replaced with a general embrace of pop culture as the new standard of beauty. One need only look at the success of the Britpop movement to see the truth of this observation. Destroy All Monsters still embraces the avant-garde position. We started off as an anti-

band, questioning the mindless pap produced by the culture industry for the youth market by adopting the form of the rock band and fucking with it. Even though such a position is no longer tenable in the current environment, where noise music is simply another form of pop music, we still strive, as artists, to examine pop culture through a critical and analytical mind-set—albeit one with a sense of humor.

The project's title, *Strange Früt,* was derived from the name of the lowest of the Detroit psychedelic bands, The Früt of the Loom. This band's aesthetic was so shoddy and anarchist that their singers were often picked at random from the audience and their stage act consisted of inept covers of '50s rock standards and displays of nudity. It is also a reference to the famously dismal Billie Holiday song "Strange Fruit."

Fall 2001

Mike Kelley is a Los Angeles–based artist. He is the author of several volumes of critical writings and interviews.

THE BROADER UNITED STATES

In a manner characteristically distinct from the development of the phenomena on the West and East Coasts, the cultivation of rock culture and iconography in art and the incorporation of sophisticated aesthetic strategies and practices in rock music occurred more or less simultaneously, though in understandably less cohesive fashion, in middle America. Rock and roll was arguably conceived far from the cultural centers of the United States, in Memphis, Tennessee, and many of its great-

est practitioners hail from anywhere but Los Angeles or New York. Much of the crossover between art and rock music in the Midwest and elsewhere in the broader expanse of the United States was determined by social and cultural particularities such as Cleveland's industrial landscape or the development of widely recognized independent record labels in Chicago that ultimately dictated the unique sounds and visuals that emerged from Chicago, Detroit, Cleveland, and elsewhere. These circumstances continue to define the way that record labels, artists' collectives, individual visual and musical artists, and bands have quietly created radical and innovative contributions outside of the more recognized locations of cultural activity.

HOME OF THE BRAVE: THE BROADER UNITED STATES
DOMINIC MOLON

The artists who defined Chicago imagism in the 1960s and '70s, such as Ed Paschke and Karl Wirsum, departed from their fellow pop culture–oriented contemporaries in New York in their celebration of the funkier and more so-called low-brow subjects and in their manic and extreme distortion of the human figure in their work. Thus while Andy Warhol was producing the coolly avant-garde Velvet Underground, Wirsum was depicting maverick blues-rock icon Screamin' Jay Hawkins as a frenzied figure vibrating with much of the same electric intensity found in songs like the ribald howler "I Put a Spell on You" in his 1968 painting *Screamin' J. Hawkins.* Paschke's *Japanese Cowboy* (1969) does not directly allude to specific rock-and-roll phenomena yet features the dynamic color and compositional style of the psychedelic posters used to promote shows at the time. And though his lurid, neon paintings of women from the early '70s, such as *Lucy* (1974), were inspired by the streetwalkers in his neighborhood, their extravagant hairstyles and clothing suggest nothing so much as the wild fashion statements being made by British and American glam rockers of the time such as David Bowie, T. Rex, and the New York Dolls.

Pedro Bell, a Chicago-based African American artist was not associated with the imagist painters yet the work he made for the album covers of George Clinton's funk-rock band Funkadelic possesses similarly bizarre figuration and garish colors. *The Electric Spanking of War Babies* from 1980, for example, demonstrates the band's cultivation of an outlandish Afro-futurist sensibility along with other musicians during the '60s and '70s such as jazz visionary Sun Ra and reggae phenomenon Lee "Scratch" Perry in its evocations of spaceships and other science-fiction iconography. As music critic John Corbett

has observed, "Ra, Clinton, and Perry . . . build their mythologies on an image of disorientation that becomes a metaphor for social marginalization, an experience familiar to many African Americans though alien to most of the terrestrial, dominant white 'center.'"[1] Bell's cover depicts a bound woman being spanked within an overtly phallic spaceship-like structure—an image striking for both its content and its dynamic color and composition. *Electric Spanking* was considered so risqué by Warner Brothers records that they "chose to half-cover the image, replete with peek-holes and the words: 'The cover "they" were too scared to print!'"[2] (Apparently, the decisive factor for the record company was a threat from the feminist antiporn group Women Against Violence.) Regardless, this cover and others by Bell, such as the one for the classic Funkadelic album *One Nation Under a Groove* (1978), have since become a profound if rarely acknowledged influence on many contemporary artists working today.

Though better known for recordings made in the United Kingdom or in Los Angeles, Mayo Thompson's The Red Krayola emerged from the psychedelic scene in Austin, Texas, in the late '60s. Joining bands such as the 13th Floor Elevators on the radical International Artists label, Thompson, with Frederick Barthelme, expanded conventional notions of how music could be made and presented. According to Robot A. Hull, "Like the Pied Piper, the band attracted a cult, fifty-odd followers who accompanied the Krayola on assorted garbage. When 85 of these freaks crammed into a studio one summer's eve to provide background chaos for a Krayola recording session, [their following] the Familiar Ugly was formed."[3] Hull further describes the resulting *The Parable of Arable Land* (1967) stating that "occasionally a song will rise above

1. John Corbett, *Extended Play: Sounding Off from John Cage to Dr. Funkenstein* (Durham, N.C.: Duke University Press, 1994), 18.

2. Ibid., 22.

3. Robot A. Hull, "Sound and Visions: Psychedelia," *The Sound and The Fury: A Rock's Backpages Reader, 40 Years of Classic Rock Journalism,* ed. Barney Hoskyns, (New York and London: Bloomsbury Publishing, 2003), 383–84.

4. Ibid., 384.

5. Simon Reynolds, *Rip It Up and Start Again: Postpunk 1978–1984* (London: Faber & Faber, 2005; repr. New York: Penguin Books, 2006), 80–82.

Roman Signer
Album cover art for Gastr del Sol's *Upgrade and Afterlife*, 1996
Courtesy of Drag City Records, Chicago

the madness only to be smothered by a lamebrain pounding a piano with a banana," and that "despite its obscure artiness, the Krayola's album signifies the undercurrent of the psychedelic era: wholesome dementia."[4] Indeed, this early incarnation of Krayola can be heard in the more irreverent moments of the band's more restrained later efforts while presaging theatrically decadent southwestern bands of the '80s and '90s like Austin's Butthole Surfers and Oklahoma's Flaming Lips.

Other musical phenomena that developed outside the centers of New York and LA with a major impact on both visual artists and experimentally oriented rock musicians include such figures as those associated with Chicago's free-jazz consortium the Association for the Advancement of Creative Musicians (AACM) and Detroit's legendary proto-punk band The Stooges (featuring punk icon Iggy Pop). Both of these entities had an enormous influence on the avant-noise rock band Destroy All Monsters begun by Mike Kelley and Jim Shaw with Cary Loren and Niagara when they were art students at the University of Michigan. Inspired by the extreme performances of Iggy Pop and the avant-gardist strategies of the AACM-related Art Ensemble of Chicago, as well as the transgressive proto-industrial band Throbbing Gristle, Destroy All Monsters' presentations focused on radical musical stylings as well as a sculptural stage presence. In 2000, while continuing to perform in various permutations, Kelley, Loren, Niagara, and Shaw created a multimedia self-documentation project that comprised large, banner-sized paintings of the band and various eccentric and influential cultural figures and icons of Detroit, as well as accompanying video documentation.

Also emerging (purportedly) from Michigan was the duo Half Japanese, founded around 1975 or 1977 by brothers Jad and David Fair. The band's deliberately amateurish sound resulted from their decision to ignore basic musical tenets such as chords, rhythms, and melody. The band would become characteristic of an independent spirit present in much of the more experimental music coming out of the Midwest in the '70s and '80s. Further south in Ohio, for example, both Akron's Devo and Cleveland's Pere Ubu brought avant-garde musical sensibilities and a sense of irreverent theatricality to bear on their radical redefinition of the potential of rock music. Ubu was named after Alfred Jarry's notorious fin-de-siècle play *Ubu Roi* from 1896—a precursor to the artistically eccentric activities of the dadaists of the nineteen-teens, themselves considered spiritual predecessors of the '70s punks—and created angular and abject sounds suggestive of Cleveland's postindustrial dystopia. Devo emerged in the aftermath of the 1970 shooting at Kent State, combining jagged synth-based melodies with warped yet incisive social commentary and a highly developed visual and conceptual identity. Promoting their theory of "devolution"—"a patchwork parody of religion and quack science woven together from motley sources, including the second law of thermodynamics, sociobiology, genetics, the paranoid science fiction of William S. Burroughs and Philip K. Dick, and anthropology"—and dressed uniformly like "maintenance worker geeks," Devo was more like a commercially successful performance-art collective than a rock band.[5]

Emerging about a decade later, Chicago's Big Black added an aggressively grating and abrasive sound and attitude to the American post-punk prospect. Led by rock iconoclast Steve Albini (who has since become one of the most respected and sought-after producers and spokes-

persons in the business) the band distinguished itself for both its unique pairing of a drum machine and brutally metallic guitar and its jaundiced lyrics, recounting stories of American abjection and depravity. Their liner note inserts resembled works of conceptual art, with their simple white Helvetica text against a black background, and were filled with lacerating fragments of prose reflecting on the discontents of contemporary culture. They shared a style and sensibility with other midwestern bands on the independent, Chicago-based Touch and Go record label such as the Didjits, Scratch Acid, and especially Killdozer from Madison, Wisconsin.

A cooler approach to avant-rock was found in Chicago-based acts such as David Grubbs and Jim O'Rourke's Gastr del Sol, Tortoise, and The Sea and Cake (featuring painter Sam Prekop). Their sound was less rock and drew more on the textures of experimental jazz. They marked the emergence of new independent labels in Chicago such as Thrill Jockey and Drag City, the latter especially involved in the art-rock overlap given their presentation of acts such as The Red Krayola, Stephen Prina, Silver Jews, and Will Oldham's Palace and Bonnie "Prince" Billy projects. This mellower and more angular sonic sensibility finds a visual equivalent, perhaps, in the photographs of Chicago-based Melanie Schiff. In works such as *Emergency* and *Neil Young, Neil Young* (both 2006), she combines an almost laconic, matter-of-fact view of nature in relation to culture, with a sense of photographic precision and clarity. Her haunting 2006 collaboration with Tony Tasset, *Hard Rain,* features a close-up of Tasset's teenage son's face in white makeup with red and blue around his eyes—a reconstruction of the album cover image for a Bob Dylan live album from 1976. Stripped of its original context and celebrity presence, Schiff

and Tasset's photograph poignantly captures the mysterious mask of adolescence, though ironically through an image that alludes to the sagacious Dylan well into adulthood.

Another recent example of an art and rock crossover to occur outside of the urban / cultural centers of New York and Los Angeles is the group of artists and musicians that emerged in Rhode Island in the late '90s / early 2000s known collectively as Fort Thunder. Comprising solo artists, noise bands, and performance projects Jim Drain, Brian Chippendale, Forcefield, and Lightning Bolt, among others, their presentations were characterized by wildly imaginative situations and scenarios effected in real time and space. As Sarah Agniel has observed in a text on Fort Thunder, "when trying to establish an alternative reality, imagination and fantasy are powerful tools with which to combat the omnipresence of the everyday world."[6]

This tendency toward a combination of intensely physical sounds, eccentric performances, and outlandish costuming and visual effects is shared by young, Chicago-based artist Josh Mannis. In his video *The Wipe* (2005), for example, performers clad in bizarre outfits dance and move against a densely constructed background of computer graphics to an original heavy-metalesque score. Like the artists from Fort Thunder, Mannis cultivates a sense of irreverence and caprice in his adventurously postmodern layering of styles and motifs from pop cultural history.

The title refers to the song "Home of the Brave" from the Naked Raygun album *All Rise,* 1987, Homestead Records.

6. Sara Agniel, "Only in Lonelyville," in *Wunderground: Providence, 1995 to the Present,* exh. cat. (Providence: Rhode Island School of Design Museum of Art, 2006), 83.

THE BROADER
UNITED STATES: PLATES

Melanie Schiff and Tony Tasset
Hard Rain, 2006
Chromogenic development print
12 x 12 in. (30.5 x 30.5 cm)
Courtesy of the artists; Kavi Gupta Gallery, Chicago;
and Rhona Hoffmann Gallery, Chicago

Pedro Bell
Album cover art for Funkadelic's
The Electric Spanking of War Babies, 1980
Colored marker on poster board
Four parts, each: 40 x 40 in. (101.6 x 101.6 cm)
Courtesy of the artist
Photos by Michael David Rose

ABOVE
Josh Mannis
*The Wipe (Extreme Blackend Grind Version w/ Thorne
Brandt, Vanessa Harris, and Helen Hicks)*, 2005
Video
Courtesy of the artist

OPPOSITE
Karl Wirsum
Screamin'J. Hawkins, 1968
Acrylic on canvas
48 x 36 in. (121.9 x 91.4 cm)
Collection of The Art Institute of Chicago,
Mr. and Mrs. Frank Logan Prize Fund

223

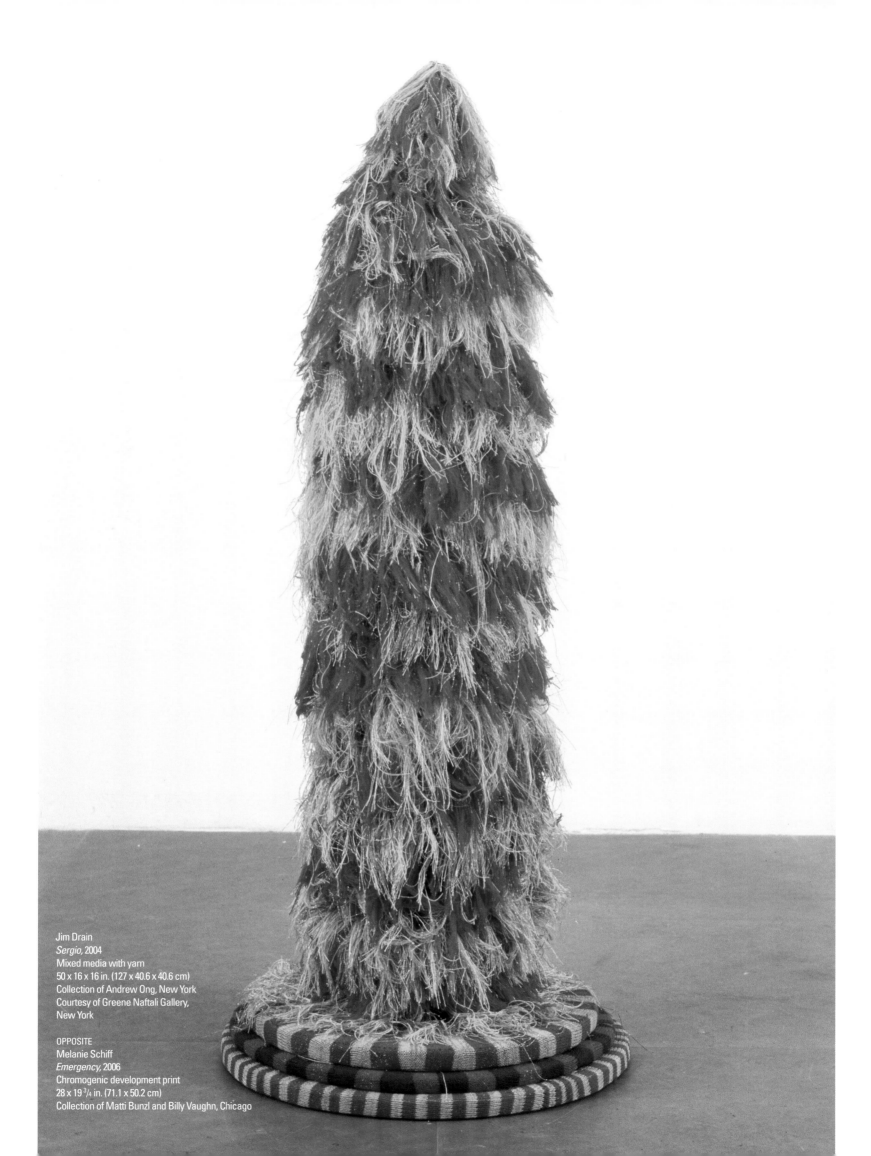

Jim Drain
Sergio, 2004
Mixed media with yarn
50 x 16 x 16 in. (127 x 40.6 x 40.6 cm)
Collection of Andrew Ong, New York
Courtesy of Greene Naftali Gallery,
New York

OPPOSITE
Melanie Schiff
Emergency, 2006
Chromogenic development print
28 x 19 ³/₄ in. (71.1 x 50.2 cm)
Collection of Matti Bunzl and Billy Vaughn, Chicago

Ed Paschke
Japanese Cowboy, 1969
Oil on canvas
14 x 10 in. (35.6 x 25.4 cm)
MCA collection, Susan and Lewis Manilow Collection of
Chicago Artists
Courtesy of the Ed Paschke Foundation

Ed Paschke
Lucy, 1973
Oil on canvas
59 $^7/_8$ x 38 in. (152.1 x 96.5 cm)
MCA collection, gift of Albert J. Bildner
Courtesy of the Ed Paschke Foundation

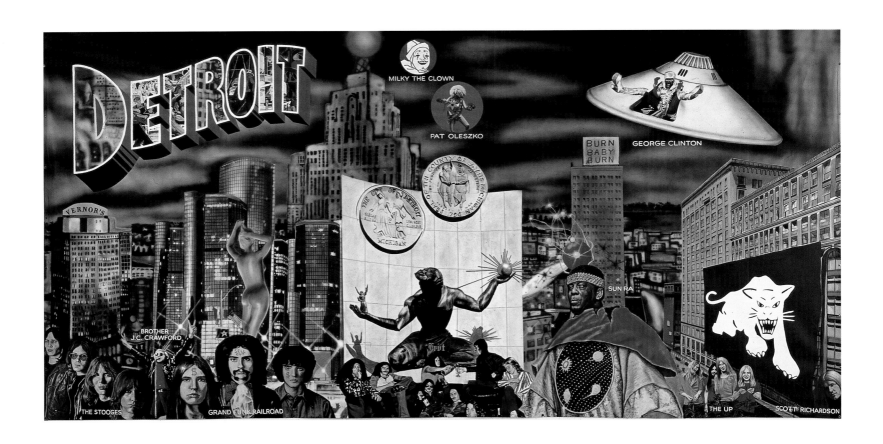

The Destroy All Monsters Collective
(Mike Kelley, Cary Loren, and Jim Shaw)
Greetings from Detroit, 2000
Acrylic on canvas
120 x 228 in. (304 x 518 cm)
Courtesy of Patrick Painter Inc., Santa Monica

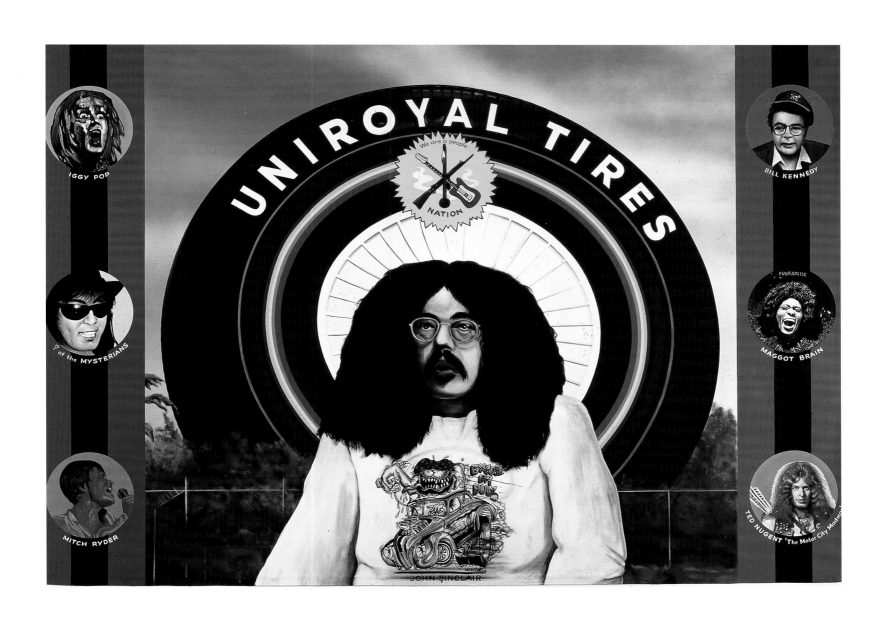

The Destroy All Monsters Collective
(Mike Kelley, Cary Loren, and Jim Shaw)
Amazing Freaks of the Motor City, 2000
Acrylic on canvas
98 x 138 in. (243 x 350 cm)
Courtesy of Patrick Painter Inc., Santa Monica

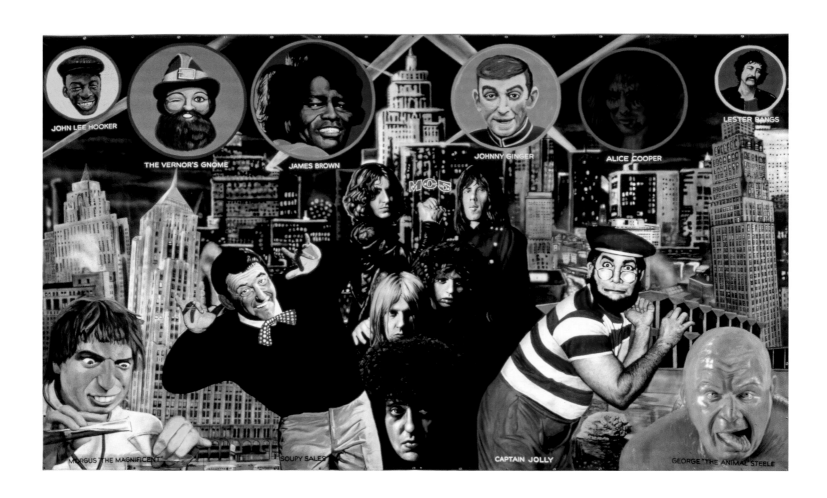

The Destroy All Monsters Collective (Mike Kelley,
Cary Loren, and Jim Shaw)
The Heart of Detroit by Moonlight, 2000
Acrylic on canvas
120 x 240 in. (304.8 x 518.2 cm)
Courtesy of Patrick Painter Inc., Santa Monica

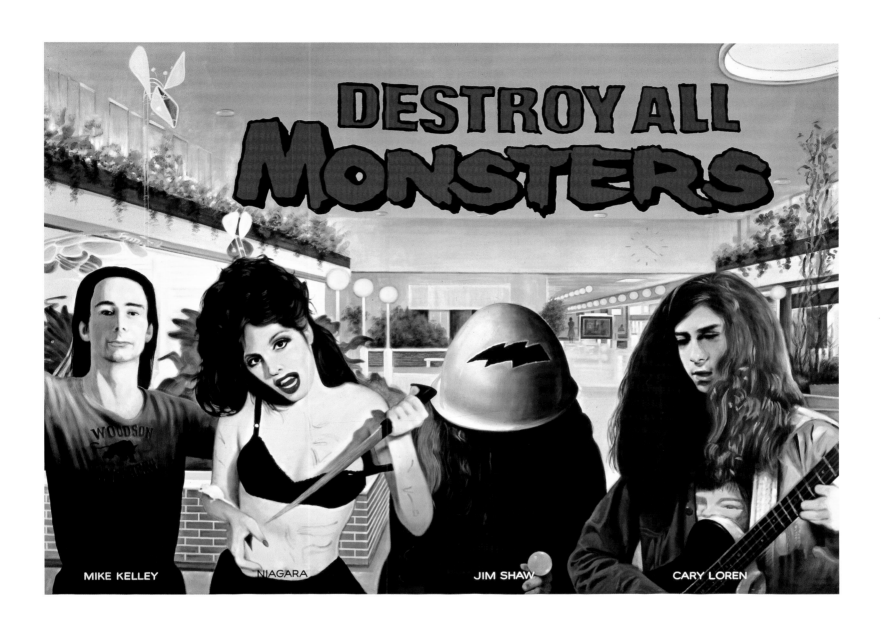

MIKE KELLEY NIAGARA JIM SHAW CARY LOREN

The Destroy All Monsters Collective (Mike Kelley,
Cary Loren, and Jim Shaw)
Mall Culture, 2000
Acrylic on canvas
96 x 138 in. (243 x 352 cm)
Courtesy of Patrick Painter Inc., Santa Monica

SENTENCES ON AC/DC
AC/DC
ANTHONY ELMS

1. The members of AC/DC are mystics rather than rationalists. They leap to conclusions that logic cannot reach.

2. Repetitive choruses repeat repetitive choruses.

3. Irrational urges lead to new experience.

4. Classic rock is essentially repetitive.

5. Irrational urges should be followed absolutely and logically.

6. If Angus Young changes his mind midway through the execution of the verse-chorus-verse, he compromises the result and repeats past results.

7. Angus Young's will is secondary to the process he initiates from riff to song. His willfulness may only be ego.

8. When the words *rhythm, drink, black, satisfaction, love,* or *hell* are used, they connote a whole tradition and imply a consequent acceptance of this tradition, thus placing limitations on AC/DC, which would be reluctant to make rock that goes beyond the limitations.

9. The lyric and the riff are different. The former implies a general direction while the latter is the component. Riffs implement the lyric.

10. Riffs can be works of rock; they are in a chain of development that may eventually find some form. All riffs need not be made physical.

11. Riffs do not necessarily proceed in logical order. They may set one off in unexpected directions, but a riff must necessarily be completed in the mind before the next one is formed.

12. For each work of rock that becomes physical, there are many variations that do not.

13. A work of rock may be understood as a conductor from AC/DC to the listener, but it may never reach the listener, or it may never leave AC/DC's practice space.

14. The words of Bon Scott or Brian Johnson to a "babe" or "honey" or "lady" or "girl" or "mama" or "woman" or "baby" or "squealer" or "Rosie" may induce a rockin' night if they share the same urge.

15. Since no way is intrinsically superior to another, AC/DC may use any way equally, from a long way to the top (if you wanna rock and roll) to a highway to hell.

16. If words are used and they proceed from urges about rock, then they are rock and not literature; numbers are not mathematics.

17. All riffs are rock if they are concerned with rockin' and fall within the conventions of rock.

18. One usually understands the rock of the past by applying the conventions of the present, thus misunderstanding the rock of the past.

19. The conventions of rock are altered by works of rock.

20. Successful rock changes our understanding of the conventions by altering our perceptions.

21. Perception of urges leads to new urges.

22. AC/DC cannot quench its thirst for rock and cannot satisfy it until it is complete.

23. AC/DC may misperceive a work of rock (that is, understand it differently from the artist) but still be thunderstruck and set off on its own chain of headbanging by that misconstrual.

24. Dirty deeds are subjective.

25. AC/DC members may not necessarily understand their rock. Their perception is neither better nor worse than that of Richard Meltzer.

26. AC/DC may perceive the rock of others better than its own.

27. The urge of a work of rock may involve the matter of the chorus or the process in which it is made.

28. Once the tone of the riff is established in Angus Young's mind and the final song structure is decided, the riff is carried out blindly. There are many side effects that Angus Young cannot imagine. These may be used as riffs for new songs.

29. The process is mechanical and should not be tampered with. It should run its course.

30. There are many elements involved in a work of rock. The most important are the most obvious.

31. If AC/DC uses the same riff in a group of songs and changes the tempo, one would assume AC/DC's concept involved the tempo. Similarly, if AC/DC uses the same gender in a group of songs and changes the terminology, one would assume AC/DC's desire involved the terminology.

32. Banal riffs cannot be rescued by beautiful execution.

33. It is difficult to bungle a good riff.

34. When those in AC/DC learn their craft too well, AC/DC makes slick pop.

35. These sentences comment on rock but are not rock and do not rock.

Winter 2007

Anthony Elms is an artist and writer. He is also the editor of *WhiteWalls* and assistant director of Gallery 400 at the University of Illinois at Chicago.

WORLD

For better or worse, rock and roll has become an international phenomenon. Some consider it yet another example of American cultural imperialism (and a threat to indigenous aesthetic forms and traditions), while others admire it as an exciting and socially progressive outlet for self or group expression. Over the past decade, art created beyond the United States, the United Kingdom, and the rest of Europe has received heightened attention, due to an increasingly global consciousness in both art institutions and the art market. Given this condition, determining the true extent and breadth of the commingling of art and rock music scenes in such disparate settings as Japan, Mexico, Brazil, and elsewhere is difficult to ascertain (depending on the place), yet the work of particular artists and musicians has managed to establish itself in a Western context and provides a starting point from which to consider the more global manifestations of this crossover.

EVERYTHING IS POSSIBLE: ART, ROCK AND ROLL, AND THE GLOBAL PERSPECTIVE
DOMINIC MOLON

In Japan there is a long history of particulary experimental manifestations of rock music, beginning with the late 1960s space-rock pioneers Hadaka no Rallizes (also known as Les Rallizes Denudes), "who drew inspiration from The Velvet Underground's Exploding Plastic Inevitable light and sound shows and from Blue Cheer's heavily amplified sound."[1] One of the most significant figures to emerge from Japanese rock, Keiji Haino, began as part of Lost Aaraaff and then formed the psychedelic ensemble Fushitsusha, later distinguishing himself with numerous solo presentations that combined extended guitar chords and haunting vocals. Western visual artists such as Cameron Jamie and Raymond Pettibon have performed with Haino or incorporated his music into their work.

Another internationally recognized Japanese noise phenomenon is Merzbow, which "[was] the brainchild of Masami Akita . . . a theoretician of surrealism in music [who] practiced a form of savage violence that was more akin to suicide bombing on nonmusical works such as *Rainbow Electronics,* 1990, *Music for Bondage Performance,* 1991, . . . and *Tauromachine*, 1998."[2] In the 1990s and 2000s, numerous Japanese rock bands such as Buffalo Daughter, Cibo Matto, Melt Banana, Pizzicato Five, and Shonen Knife (all, interestingly, featuring the strong presence of women) made inroads into the Western music scene. Perhaps the most significant act in art and rock's confluence is the Boredoms. Led by guitarist Seiichi Yamamoto and vocalist Yamatsuka Eye, "a typical track might feature massively distorted guitars, squealing synths, any number of odd found-object noisemakers, or studio-manipulation effects; conventional song structures are thrown out the window in favor of abrupt, whiplash-inducing changes of direction."[3]

Gracing the covers of albums by Shonen Knife and Fantômas, Yoshitomo Nara's drawings also have consistently alluded to rock phenomena or figures such as Kurt Cobain and Neil Young throughout his career. His renderings of impossibly cute children holding guitars or engaged in other rock-and-roll behavior successfully represent the musical genre's combination of childlike exuberance and its more adult-oriented themes and sense of experience. Seemingly innocuous, Nara's drawings use the deceptive sweetness of his figures as a foil for their cultivation of a latent antiauthoritarian, punk sensibility.

The sophisticated drawings of Mexico City–based Daniel Guzmán incorporate the sinister imagery and aggressively stylized logos of heavy-metal music. In series such as *Darkness on the Edge of the Town* and the *Paul McMeats Series, The Violence Around Us* (both 2005), disembodied heads, skulls, and other dark phenomena are surrounded by malevolent swirls of black. This art demonstrates a curious similarity between the willful celebration of mortality in Mexican customs such as Día de los Muertos and in the sensibility of heavy-metal bands primarily from the United States and the United Kingdom such as Black Sabbath, Iron Maiden, and Slayer, as well as punk bands such as The Cramps and The Gun Club.

Rock music held a fraught position within Latin American cultural history, largely seen first as an imperialist phenomenon from the North yet eventually being assimilated and transformed in unique ways in various countries.[4] It was most pronounced, perhaps, in Brazil with Tropicália, a movement in visual art, music, and theater that emerged in the late '60s. Musically, the sensibility was distinguished by a highly original combination of bossa nova, rock and roll, Bahia folk music, African music,

1. Piero Scaruffi, "A Brief Summary of Japanese Rock Music," in *The History of Rock Music,* www.scaruffi.com/history/japanese.

2. Ibid.

3. See Steve Huey, allmusic.com.

4. Much has been written on the subject of the position of rock music in Latin America; see especially "Mapping Rock Music Cultures across the Americas," in *Rockin' Las Americas: The Global Politics of Rock in Latin/o* America, edited by Deborah Pacini Hernandez, and others Hector Fernandez L'Hoeste, and Eric Zolov (Pittsburgh Penn.: University of Pittsburgh Press, 2004),1–21; and Alan O'Connor, "Punk Subculture In Mexico and the Anti-Globalization Movement: A Report from the Front," *New Political Science* 25, no. 1, 2003, 43–53.

5. "Gerald Matt in discussion with assume vivid astro focus," *in assume vivid astro focus: Open Call* (Nuremberg, Germany: Verlag für Moderne Kunst Nurnberg, 2006), 71–72.

and Portuguese fado and spearheaded by figures such as Gilberto Gil, Caetano Veloso, and the avant-garde group Os Mutantes. In visual art, Hélio Oiticica and Lygia Clark's groundbreaking experiments with materials incorporated direct interaction with the works that implicitly represented a form of resistance against Brazil's oppressive military government. Oiticica's collaborations with Neville d'Almeida, a series titled *Cosmococa* (1973), comprise room-size environments featuring slide projected images of pop cultural icons whose features have been decorated with cocaine powder and other materials such as sand, balloons, and hammocks. Perhaps the most affecting of these works incorporates the music and album cover from Jimi Hendrix's 1972 *War Heroes* album, identifying the African American rock legend as a particularly influential figure in their cultural cosmology.

Much of the spirit of Tropicália lives on in the work of the multinational collective assume vivid astro focus. Taking its name from an amalgam of the Throbbing Gristle album *Assume Power Focus* and the British band Ultra Vivid Scene, the collective creates installations featuring programs of music videos, intensely psychedelic wallpaper and decals that consume a given space, and other elements including masks that allow viewers to actively participate in the work. Various forms of music, including rock, inform the sensibility and approach of assume vivid astro focus, and indeed they have themselves stated that "music . . . is the medium that is the closest to perfection in terms of reaching the viewer and transmitting ideas."[5] The comprehensive, multimedia nature of their presentations recalls not only Oiticica's environments but also Andy Warhol's Exploding Plastic Inevitable events with The Velvet Underground.

Rirkrit Tiravanija, a Thailand-born artist who, like assume vivid astro focus, embodies the globalized, internationalist spirit of recent art, also similarly emphasizes the active participation of the individual experiencing his work. In *Untitled 1996 (Rehearsal Studio No. 6 Silent Version)* (1996), he creates a situation in which a functional recording studio is set up within the confines of the museum space whereby a band or individual may use the guitar, drum kit, bass guitar, and microphones to cut a demo tape. The work becomes an active social sculpture both through this interaction and through the ability of other visitors to listen in on the performance of anyone using the space. In doing so, he provides a clear and engaging reminder of how rock music at its best is a primarily shared and communal experience.

The title "Everything Is Possible" refers to the Os Mutantes album *Everything Is Possible: The Best of Os Mutantes,* 1999, Luaka Bop.

THE WORLD: PLATES

Daniel Guzmán
Hand from the *Thieves Like Us Series,* 2004
Ink on paper
38 x 26 $\frac{1}{4}$ in. (96.5 x 66.7 cm)
Courtesy of Harris Lieberman, New York, and kurimanzutto,
Mexico City

Daniel Guzmán
Solicito Chicas from the *Thieves Like Us Series,* 2004
Ink on paper
39 ¹/₂ x 54 ¹/₂ in. (100 x 138cm)
Collection of Andrew Leslie
Courtesy of Harris Lieberman, New York

Daniel Guzmán
New York Dolls from the *Thieves Like Us Series,*
2004
Ink on paper
41 3/8 x 44 1/2 in. (105 x 113 cm)
Collection of Gregory and Elisabeth Fowler
Courtesy of Harris Lieberman, New York

Rirkrit Tiravanija
Untitled 1996 (Rehearsal Studio No. 6 Silent Version), 1996
Plexiglas wall, metal framework, guitar, bass guitar,
electronic drum kit, microphones, recording equipment,
headphones, and carpet
Dimensions variable
Courtesy of Gavin Brown's enterprise, New York

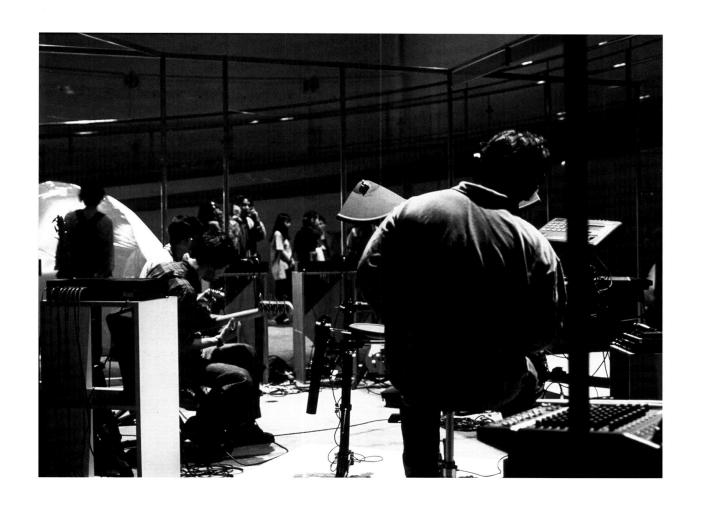

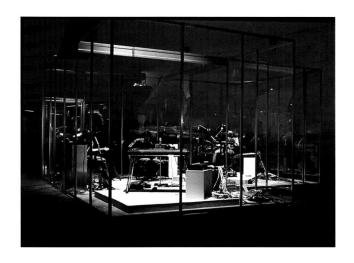

Yoshitomo Nara
One, two, three, four!, 2004
Colored pencil on paper
12 $\frac{1}{2}$ x 9 $\frac{1}{2}$ in. (31.8 x 21 cm)
Private collection, Boston
Photo courtesy of Marianne Boesky Gallery, New York

Yoshitomo Nara
Untitled (Who Snatched the Babies), 2001–02
Colored pencil on paper
11 3/4 x 8 1/4 in. (29.8 x 21 cm)
Private collection, San Francisco
Photo courtesy of Marianne Boesky Gallery, New York

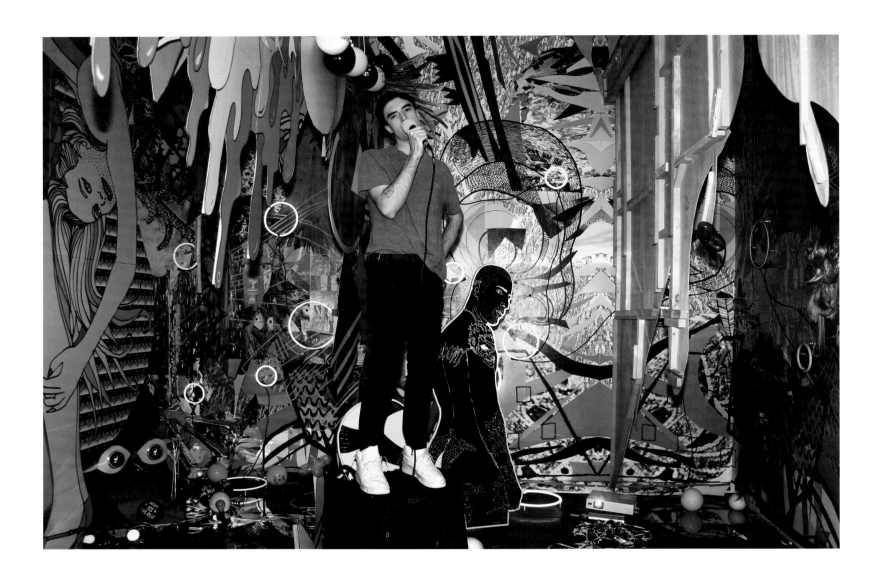

assume vivid astro focus
A very anxious feeling, 2007
Musical performance by Barr
Installation view, John Connelly Presents, New York
Courtesy of John Connelly Presents, New York

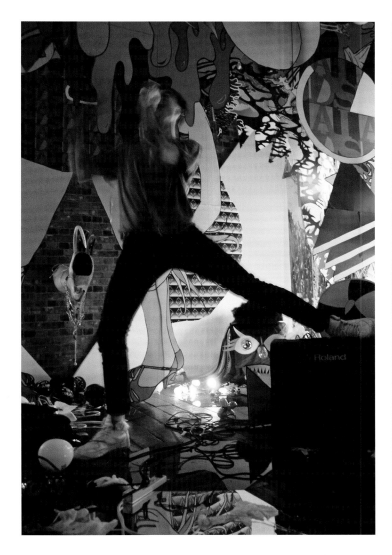
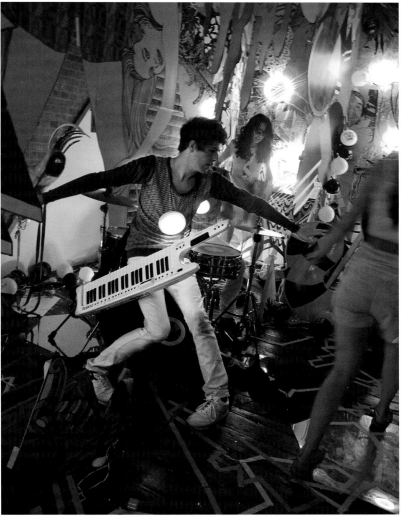

assume vivid astro focus
A very anxious feeling, 2007
Musical performances by Frankie Martin and Tristan Perish
Installation view, John Connelly Presents, New York
Courtesy of John Connelly Presents, New York

A TIMELINE

A TIMELINE
Joe Madura and Dominic Molon

1966

Rick Barthelme, Steve Cunningham, and Mayo Thompson, students at the University of St. Thomas in Houston, Texas, form The Red Krayola.

Andy Warhol meets The Velvet Underground through his personal assistant, artist Gerard Malanga.

Band formed: The Red Krayola

1967

The Summer of Love in San Francisco is preceded by the "Human Be-in," a musical gathering at the Polo Grounds in Golden Gate Park attended by 25,000 people.

California's Monterey Pop Festival features Jimi Hendrix, Janis Joplin, and The Who.

Ralph J. Gleason and Jann Wenner start *Rolling Stone* magazine in San Francisco.

The Tropicália cultural movement begins in Brazil.

DJ Tom Donahue begins playing rock and roll 24 hours a day on the San Francisco radio station KMPX-FM, marking the beginning of FM rock in the US.

Albums released: The Beatles' *Sgt. Pepper's Lonely Hearts Club Band* (cover design by Peter Blake and Jann Haworth), David Bowie's *David Bowie* (debut), Buffalo Springfield's *Buffalo Springfield Again,* The Doors' *The Doors,* The Jimi Hendrix Experience's *Axis: Bold As Love* and *Are You Experienced?,* Mothers of Invention's *Absolutely Free,* Pink Floyd's *The Piper at the Gates of Dawn,* The Velvet Underground's *The Velvet Underground & Nico* (US release; "peelable" banana cover by Andy Warhol), and The Who's *The Who Sell Out*

Bands formed: Hadaka no Rallizes (Japanese psychedelic rock),The Silver Apples (experimental music), and The Stooges (Detroit, proto-punk)

1968

Pink Floyd introduces the "azimuth coordinator," an electronic sound projector, at Royal Albert Hall, London. The band is the first to experiment with quadraphonic sound (the use of 4 sound channels instead of 2) at live shows.

Creem magazine begins publication in Detroit. It will feature writing by Lester Bangs, Robert Christgau, Greil Marcus, Dave Marsh, Richard Meltzer, and Nick Tosches.

The Detroit band Motor City Five (MC5) plays at the Democratic National Convention in Chicago. The Rolling Stones' "Street Fighting Man" is banned following riots at the convention.

The New Yardbirds evolve into Led Zeppelin and debuts with a show at the University of Surrey in the UK.

John Lennon and Yoko Ono release their first collaborative album, *Unfinished Music, No. 1: Two Virgins,* featuring experimental music and a notorious cover with a hazy image of the couple naked.

Cream plays a sold-out farewell gig at Royal Albert Hall, London, after a career of only 2 years and 4 months.

Richard Hamilton creates works in the *Swingeing London 67* series featuring press coverage of the arrests of Mick Jagger and Robert Fraser on drug charges. He also designs the minimalist cover for The Beatles' self-titled double album (now unofficially known as the White Album).

Jean-Luc Godard's film *Sympathy for the Devil* is released. It juxtaposes shots of The Rolling Stones rehearsing the title song with scenes touching on political issues of the day, including civil rights and feminism.

Albums released: Big Brother and the Holding Company's *Cheap Thrills* (cover by R. Crumb), The Byrds' *Sweetheart of the Rodeo,* The Jimi Hendrix Experience's *Electric Ladyland,* John Lennon and Yoko Ono's *Unfinished Music, No. 1: Two Virgins,* Van Morrison's *Astral Weeks,* Mothers of Invention's *We're Only in it for the Money,* Dusty Springfield's *Dusty in Memphis,* and The Velvet Underground's *White Light / White Heat*

Band formed: Can (Cologne, West Germany, krautrock)

1969

Woodstock attracts 400,000 to see Creedence Clearwater Revival, the Grateful Dead, Jefferson Airplane, Janis Joplin, Santana, and The Who. At Altamont Speedway, The Rolling Stones rushes through its set as violence results in 4 deaths.

The Who's rock opera *Tommy* debuts.

Jim Morrison is arrested for indecent exposure during a concert in Miami, Florida.

Kick Out The Jams by MC5 becomes a prototype for punk rock.

Performance art collective COUM Transmissions is founded in Hull, UK.

Kenneth Anger's experimental horror film *Invocation of My Demon Brother,* featuring a score by Mick Jagger, is released.

Albums released: Captain Beefheart and the Magic Band's *Trout Mask Replica,* David Bowie's *Space Oddity,* Bob Dylan's *Nashville Skyline,* Moby Grape's *Truly Fine Citizen,* Nico's *The Marble Index,* Os Mutantes' *Mutantes,* The Rolling Stones' *Let it Bleed,* Santana's *Santana,* The Stooges' *The Stooges,* The Velvet Underground's *The Velvet Underground,* Scott Walker's *Scott 3* and *Scott 4,* and Neil Young's *Everybody Knows This Is Nowhere*

Death: Brian Jones of The Rolling Stones (drowning, age 27, Sussex, UK)

Ronald Nameth
*Andy Warhol's Exploding
Plastic Inevitable with the Velvet
Underground,* 1966

Karl Wirsum
Screamin' J Hawkins, 1968

Ed Paschke
Japanese Cowboy, 1969

1970

The Beatles break up. Its last album is *Let It Be.*

Black Sabbath makes its London concert debut at the Roundhouse. Iggy & The Stooges has its first live concert, at a Halloween party in Ann Arbor, Michigan.

The Doors plays its last live concert, at the Warehouse in New Orleans.

Richard Branson launches Virgin Records in the UK as a mail-order discount retailer by placing advertisements in the newspaper *Melody Maker.*

Mick Jagger appears in Donald Cammell and Nicolas Roeg's cult classic *Performance.*

While an undergraduate at The State University of New York at Stony Brook and a graduate student at Yale University, Richard Meltzer writes and then publishes *The Aesthetics of Rock,* a seminal moment in the development of rock criticism.

Albert and David Maysles's film *Gimme Shelter,* documenting The Rolling Stones' Altamont concert of 1969, is released.

David Bowie appears on the cover of his album *The Man Who Sold the World* in a dress designed by Mr. Fish.

After studying with Richard Hamilton at Newcastle University, Bryan Ferry abandons his formal art education to form Roxy Music.

Kraftwerk is formed in Düsseldorf, West Germany, by Ralf Hütter and Florian Schneider-Esleben.

Albums released: The Beatles' *Let It Be,* Joseph Beuys's *Ja Ja Ja Nee Nee Nee,* Black Sabbath's *Black Sabbath,* David Bowie's *The Man Who Sold the World,* Kraftwerk's *Kraftwerk,* Led Zeppelin's *Led Zeppelin III,* Pink Floyd's *Atom Heart Mother,* The Stooges' *Fun House,* and The Velvet Underground's *Loaded*

Bands formed: Roxy Music and Kraftwerk

Deaths: Jimi Hendrix (sleeping-pill overdose, age 27, London) and Janis Joplin (heroin overdose, age 27, LA)

1971

The FCC instructs FM radio stations not to play songs perceived as encouraging drug use.

Drummer Klaus Dinger and guitarist Michael Rother leave Kraftwerk to form NEU!

Woody and Steina Vasulka form the artists' collective The Kitchen in New York. It later becomes a nonprofit space that hosts No-Wave acts in addition to video and performance art. Robert Longo will hold a position as a curator there in 1978.

In New York, Abbie Hoffman creates the radio station WPAX Hanoi, which transmits tape recordings for US troops in Vietnam. The initial broadcast opens with Jimi Hendrix's "The Star-Spangled Banner."

Eric Clapton, Bob Dylan, and George Harrison take part in The Concert for Bangladesh at Madison Square Garden in New York, the largest benefit concert to date.

David Bowie meets Andy Warhol for the first time, at The Factory, and subsequently releases the song "Andy Warhol."

Writer Dave Marsh uses the term "punk-rock" for the first time, to describe ? & the Mysterians.

Lou Reed leaves The Velvet Underground.

Stanley Kubrick's violent futuristic film *A Clockwork Orange* is released.

Let It Rock clothing shop opens on Kings Road in London.

The Montreux Casino in Switzerland burns down during a Frank Zappa and the Mothers of Invention concert, inspiring Deep Purple's 1972 "Smoke on the Water."

Three members of COUM Transmissions—Genesis P-Orridge, Cosey Fanni Tutti, and Peter "Sleazy" Christopherson—form the industrial-music group Throbbing Gristle with Chris Carter.

Albums released: Black Sabbath's *Paranoid* and *Master of Reality,* David Bowie's *Hunky Dory,* The Doors' *L.A. Woman,* Led Zeppelin's *Led Zeppelin IV,* Joni Mitchell's *Blue,* Harry Nilsson's *Nilsson Schmilsson,* Yoko Ono's *Fly,* The Rolling Stones' *Sticky Fingers* (cover by Andy Warhol), and T. Rex's *Electric Warrior*

Bands formed: Faust (one of the first to sign with Virgin Records), NEU!, Suicide (Martin Rev and Alan Vega), and Throbbing Gristle

Death: Jim Morrison (heart attack, age 27, Paris)

1972

Nuggets: Original Artyfacts from the First Psychedelic Era, 1965–1968, a double album of mid '60s garage-band singles, is released and later inspires punk and revivals of garage.

Roxy Music releases its first album. Bryan Ferry decides to take an advertising approach to the album cover, with a shot of model Kari-Ann taken by American fashion photographer Karl Stoecker. "Virginia Plain," the first single, takes its name from a 1964 painting by Ferry.

David Bowie's first glam-rock hit, "Starman," enters the Top Ten at the same time that London's first Gay Pride march takes place.

The BBC censors Paul McCartney's "Give Ireland Back to the Irish," while US radio bans John Lennon and Yoko Ono's "Woman Is the Nigger of the World."

With wide distribution to stores, UK poster companies like Art Tempo, Art Media, and Permaprints give broader visibility to rock posters.

The reggae film *The Harder They Come,* directed by Perry Henzel and starring Jimmy Cliff, is released.

Eschewing commercial radio music, The Residents releases its debut album, *Santa Dog.*

Albums released: *Nuggets: Original Artyfacts from the First Psychedelic Era, 1965–1968* (Electra Records compilation), David Bowie's *The Rise and Fall of Ziggy Stardust and the Spiders from Mars* (glam rock), John Cale's *The Academy in Peril* (cover by Andy Warhol), Jimi Hendrix's *War Heroes,* Lou Reed's *Transformer* (glam rock), The Residents' *Santa Dog,* and Roxy Music's *Roxy Music*

Bands formed: DEVO (Akron, Ohio; in response to the Kent State University shootings), Los Angeles Free Music Society, and New York Dolls

Death: Billy Murcia of New York Dolls (drowning, age 21, London)

1973

In the largest rock crowd ever assembled, 600,000 people attend a concert in Watkins Glen, New York, featuring the Allman Brothers, The Band, and the Grateful Dead.

David Bowie mixes Iggy & The Stooges' *Raw Power,* a significant inspiration to punk.

Hélio Oiticica and Neville d'Almeida collaborate on *Cosmococas,* "quasi-cinematic" art and sound installations, including one incorporating Jimi Hendrix's 1972 *War Heroes* album.

Albums released: David Bowie's *Aladdin Sane,* Tony Conrad's *Outside the Dream Syndicate* (experimental music), Funkadelic's *Cosmic Slop* (cover by Pedro Bell), Iggy & The Stooges' *Raw Power,* New York Dolls' *New York Dolls,* Mike Oldfield's *Tubular Bells* (first Virgin Records release), Pink Floyd's *Dark Side of the Moon,* Lou Reed's *Berlin,* and Roxy Music's *For Your Pleasure* and *Stranded*

Bands formed: Destroy All Monsters (University of Michigan students Mike Kelley, Jim Shaw, Niagara, and Carey Loren)

1974

Talking Heads forms at the Rhode Island School of Design and opens for the Ramones at CBGB in New York. Television and other punk and new wave groups begin to perform at the club.

Trouser Press magazine, focusing on the British scene, new wave, and punk, launches in New York.

Carmen Knoebel opens Ratinger Hof, providing a venue for the emerging punk scene in Düsseldorf.

Albums released: David Bowie's *Diamond Dogs,* Brian Eno's *Here Come the Warm Jets* and *Taking Tiger Mountain by Strategy,* Nico's *The End,* Lou Reed's *Rock 'n' Roll Animal* and *Sally Can't Dance,* The Residents' *Meet the Residents*, and Roxy Music's *Country Life*

Bands formed: Cabaret Voltaire (industrial rock, Sheffield, UK) and Talking Heads

1975

Led Zeppelin has 6 albums on the US charts simultaneously.

Bruce Springsteen is on the covers of *TIME* and *Newsweek* simultaneously.

Greil Marcus's book *Mystery Train: Images of America in Rock 'n' Roll Music* is published.

Kraftwerk's *Autobahn* hits number 5 on the US charts.

The Sex Pistols plays its first gig, in the common room at the St. Martin's School of Art, London, opening for Bazooka Joe, whose lead singer, Adam Goddard, later changes his name to Adam Ant and forms Adam & the Ants.

Peter Gabriel leaves Genesis.

Talking Heads gives its first performance at CBGB.

New York Dolls disbands.

The first issue of *Punk* magazine is published.

Malcolm McLaren and his partner, clothing designer Vivienne Westwood, change the Let It Rock clothing shop's name to SEX.

Albums released: Brian Eno's *Discreet Music* and *Another Green World,* Kraftwerk's *Radio-Activity,* Led Zeppelin's *Physical Graffiti,* John Lennon's *Shaved Fish,* NEU!'s *NEU '75,* Pink Floyd's *Wish You Were Here,* Queen's *Bohemian Rhapsody,* Lou Reed's *Metal Machine Music,* and Patti Smith's *Horses* (cover by Robert Mapplethorpe)

Bands formed: Motörhead (heavy metal, London) and Pere Ubu (avant-rock, Cleveland, Ohio)

1976

The first European Punk Rock Festival is held at Mont de Marsan, near Bordeaux, France.

Throbbing Gristle first performs, at Air Gallery, London, then, notably, at the Institute of Contemporary Arts, London, for COUM Transmissions' exhibition *Prostitution.*

The Clash performs its first concert, in Chalk Farm, London.

The first official punk rag, *Sniffin' Glue,* founded by Mark Perry, begins production and stops the next year.

The Band is joined by Bob Dylan, Van Morrison, and Neil Young during its last show, which is filmed by Martin Scorsese, at San Francisco's Winterland Ballroom.

The Red Krayola collaborates with the art collective Art & Language to produce the LP *Corrected Slogans* in addition to two short performance videos, *And Now for Something Completely Different* and *Nine Gross and Conspicuous Forms.*

Musician magazine begins publication.

Albums released: AC/DC's *Dirty Deeds Done Dirt Cheap,* Buzzcocks' *Spiral Scratch,* Ramones' *The Ramones,* The Residents' *The Third Reich n' Roll,* and Throbbing Gristle's *Second Annual Report*

Bands formed: The Cramps (psychobilly punk, New York), The Cure (new wave, London), The Fall (avant-rock, Manchester, UK), Half Japanese (brothers Jad and David Fair, Uniontown, Maryland), Joy Division (punk, Manchester, UK), Poetics (avant-rock, with Mike Kelley and Tony Oursler, Los Angeles), Siouxsie & The Banshees (new wave and punk, London), Teenage Jesus and the Jerks (No Wave, New York, featuring Lydia Lunch), U2 (new wave, Dublin), and Wire (punk, London)

Single released: The Damned's "New Rose" (Stiff Records' first widely distributed single)

Ed Paschke
Lucy, 1973

The Residents
Third Reich n' Roll, 1976

1977

The Roxy, London's first all-punk club, opens with a Clash concert.

Chris Searle, the manager of the Virgin Records store in Nottingham, UK, and Virgin Records are tried in a magistrate's court under the 1889 Indecent Advertisements Act for the display of promotional materials for *Never Mind the Bollocks, Here's the Sex Pistols.* They are found not guilty.

The Los Angeles Music Institute, originally for guitarists and later for all rock musicians and recording engineers, is the first music school to standardize training in pop, rock, and jazz music.

Gang of Four and The Mekons study at Leeds University with art historian T. J. Clark and artist Terry Atkinson.

Albums released: David Bowie's *Low* (the first of three Berlin-based collaborations with Brian Eno), Elvis Costello's *My Aim is True* (debut), Eagles' *Hotel California* (classic rock), Brian Eno's *Before and After Science,* Fleetwood Mac's *Rumours* (classic rock), Richard Hell & The Voidoids' *Black Generation,* Sex Pistols' *Never Mind the Bollocks, Here's the Sex Pistols* (with "God Save the Queen"), Suicide's *Suicide,* Talking Heads' *77,* Television's *Marquee Moon,* and Wire's *Pink Flag*

Bands formed: Black Flag (punk, LA), Crass (punk, London), Germs (punk, LA), Screamers (punk, LA), Theoretical Girls (No Wave, featuring Glenn Branca, New York), and Weirdos (punk, LA)

Deaths: Marc Bolan of T. Rex (car crash, age 29, London) and Elvis Presley (heart attack, age 42, Memphis)

Single released: Buzzcocks' *Orgasm Addict* (Linder photo collage on the cover)

1978

The Factory club in Manchester opens with a performance by Joy Division and a poster designed by Peter Saville. Tony Wilson forms Factory Records.

Glenn O'Brien begins hosting the New York public access show *TV Party* with Blondie guitarist Chris Stein.

Sex Pistols bassist Sid Vicious is arrested for the murder of girlfriend Nancy Spungen in New York.

Derek Jarman's film *Jubilee,* featuring Adam Ant, Jordan, and Siouxsie & The Banshees, is released.

Digital synthesizers replace voltage-controlled synthesizers. The Roland MC-4, the first mass-marketed sequencer, is introduced.

Rough Trade Records is founded in London.

Mark Pauline founds Survival Research Laboratories, performing elaborate presentations of technologically innovative machinery.

Greg Ginn's independent record label, SST, forms. His brother, Raymond Pettibon, designs the signature logo and subsequent covers.

Martin Kippenberger becomes managing director of SO 36, a club at the center of Berlin's punk and new wave scene.

Albums released: *No New York* (No-Wave compilation produced by Brian Eno), Blondie's *Parallel Lines* (new wave), David Bowie's *Heroes,* Buzzcocks' *Another Music in a Different Kitchen* and *Love Bites,* Crass's *Stations of the Cross,* Brian Eno's *Ambient #1: Music for Airports,* Funkadelic's *One Nation Under a Groove,* Germs' *(GI),* Pere Ubu's *The Modern Dance,* Public Image Ltd.'s *Public Image,* The Slits' *Cut,* Bruce Springsteen's *Darkness on the Edge of Town,* Talking Heads' *More Songs About Buildings and Food,* Throbbing Gristle's *D.O.A. The Third and Final Report,* and Wire's *Chairs Missing*

EP released: Black Flag's *Nervous Breakdown* (cover art by Raymond Pettibon)

Band formed: DNA (No Wave, New York)

Death: Keith Moon of The Who (prescription-drug overdose, age 31, London)

Singles released: Scritti Politti's "Skank Bloc Bologna" and Siouxsie & The Banshees' "Hong Kong Garden" (debut)

1979

Siouxsie & The Banshees release the single "Mittageisen (Metal Postcard)," inspired by John Heartfield, representing a point where punk (which earlier had used Nazi symbolism) firmly aligns itself with the anti-fascist movement.

David Bowie releases the promotional film for "Boys Keep Swinging."

Goth begins to grow out of punk with the release of Bauhaus's *Bela Lugosi's Dead* 12-inch record. Three of the 4 Bauhaus members attended Nene Art School in Northampton, UK. Singer Peter Murphy turns down an opportunity to become a painter's apprentice.

At the age of 15, Jarvis Cocker forms Pulp in Sheffield, UK.

The No Nukes concert with Tom Petty and Bruce Springsteen is held at Madison Square Garden, New York.

Eleven people are crushed or trampled outside the Riverfront Coliseum in Cincinnati in anticipation of a concert by The Who. Unaware of the tragedy, the band plays a full set after its manager decides not to cancel the show in order to avoid more disturbances.

Disco Demolition Night, a promotional event sponsored by radio station WLUP-FM, takes place at Chicago's Comiskey Park after a White Sox baseball game. Following the mock destruction of disco records, mini-riots ensue on the field.

The Sub Pop record label is founded as the magazine *Subterranean Pop* in Seattle.

Albums released: David Bowie's *The Lodger,* Buzzcocks' *A Different Kind of Tension,* Clash's *London Calling,* The Fall's *Live at the Witch Trials* (debut), Gang of Four's *Entertainment,* James Chance & the Contortions' *Buy,* Pere Ubu's *Dub Housing* and *New Picnic Time,* Pink Floyd's *The Wall,* Public Image Ltd.'s *Metal Box,* The Residents' *Eskimo,* Talking Heads' *Fear of Music,* Throbbing Gristle's *20 Jazz Funk Greats,* and Wire's *154*

Bands formed: Bad Brains (punk, Washington, DC), Hüsker Dü and The Replacements (Minneapolis), Negativland (experimental rock, San Francisco), and Pulp

Death: Sid Vicious of the Sex Pistols (heroin overdose, age 21, New York)

Linder
Untitled, 1977

Raymond Pettibon
No Title, 1978

Raymond Pettibon
No Title, 1978

1980

Pink Floyd performs *The Wall* in 12 concerts at 2 venues in the US.

Eric Mitchell produces, directs, and stars in *Underground U.S.A.*

Led Zeppelin disbands.

Joy Division becomes New Order after Ian Curtis commits suicide.

Richard Hell writes in the *East Village Eye,* "The fact is that London punk was copied from New York punk in 1976," staking claim to the movement's origins.

Penelope Spheeris's documentary *The Decline of Western Civilization,* about the LA punk scene, including Black Flag, Circle Jerks, and X, is released.

The first Monsters of Rock festival at Castle Donington, UK, showcases heavy metal, which is growing in prevalence.

Rude Boy, a narrative film featuring the Clash, is released.

As the band UJ3RK5, Canadian artists Rodney Graham, Jeff Wall, and Ian Wallace release a self-titled EP.

Dan Graham releases his video *Rock My Religion,* exploring the relationship between music and religion largely through the work of Patti Smith.

Painter Jörg Immendorff hosts the exhibition *Finger für Deutschland* along with an accompanying musical festival.

Cologne-based music and popular culture magazine *Spex* is launched.

Albums released: Glenn Branca's *Lesson No. 1,* Captain Beefheart and the Magic Band's *Shiny Beast (Bat Chain Puller)* and *Doc at the Radar Station,* Joy Division's *Closer,* Colin Newman's *A–Z,* Pere Ubu's *The Art of Walking,* The Residents' *Commerical Album* and *Diskomo / Goosebump* (with Snakefinger), Talking Heads' *Remain in Light,* and U2's *Boy* (debut)

Bands formed: Einstürzende Neubaten (industrial, Berlin), Merzbow (noise, brainchild of Masami Akita), New Order, and Workshop (electronic rock)

Deaths: John Bonham of Led Zeppelin (asphyxiation from vomit after a drinking binge, age 32, Windsor, UK), Ian Curtis of Joy Division (suicide by hanging, age 23, Macclesfield, UK), and John Lennon (murder, age 40, New York)

EP released: UJ3RK5's *UJ3RK5* (debut)

1981

MTV debuts with the video for "Video Killed the Radio Star" by The Buggles. The first hour of programming also includes The Who, The Pretenders, and Todd Rundgren.

My Life in the Bush of Ghosts, produced by David Byrne and Brian Eno, distinguishes itself as representative of the use of sampling and tape cutting.

UK new wave label Some Bizarre releases a self-titled compilation featuring Depeche Mode, Soft Cell, and The The.

R.E.M. plays its first show, in Athens, Georgia.

Corey Rusk founds Touch and Go Records in East Lansing, Michigan.

Kim Gordon, Thurston Moore, and Josh Baer organize Noisefest '81 at White Columns, a 9-day festival to promote the downtown New York experimental music scene. The event includes Glenn Branca, Sonic Youth, UT, and Y Pants.

The 10th anniversary of the Glastonbury Festival features New Order.

Henry Rollins becomes the lead singer of Black Flag.

Albums released: *Urgh!: A Music War* (soundtrack to a film documenting live performances by The Au Pairs, The Cramps, Gang of Four, and Pere Ubu, among others), Glenn Branca's *The Ascension* (cover by Robert Longo), Einstürzende Neubaten's *Kollaps,* The Feelies' *Crazy Rhythms,* Keiji Haino's *Watashi Dake* (solo debut), Motörhead's *No Sleep 'til Hammersmith,* Colin Newman's *Provisionally Entitled the Singing Fish,* The Red Krayola and Art & Language's *Kangaroo,* and Wire's *Document and Eyewitness*

Bands formed: Butthole Surfers (bizarre indie rock, Austin) and Slovenly (avant-rock, LA)

Death: Bob Marley (cancer, age 36, Miami, Florida)

Singles released: Laurie Anderson's "O Superman" and Mission of Burma's "Academy Fight Song"

1982

The Smiths plays its first gig, at the Ritz in Manchester. The Hacienda club opens in the same city.

DEVO plays what it calls the first "video synchronized" rock concert, in Minneapolis in front of a rear-projection screen.

The New York club Max's Kansas City closes.

Captain Beefheart and the Magic Band releases its final album, *Ice Cream for Crow,* as singer Don Van Vliet abandons music for painting.

Albums released: Laurie Anderson's *Big Science,* Bad Brains' *Bad Brains,* Captain Beefheart and the Magic Band's *Ice Cream for Crow,* The Cure's *Pornography,* Colin Newman's *Not To,* Pere Ubu's *The Song of the Bailing Man,* and Scritti Politti's *Songs to Remember* (featuring the song "Jacques Derrida")

Bands formed: Big Black (avant-rock, Chicago) and Swans (avant-rock, New York)

Death: Rock critic Lester Bangs (painkiller overdose, age 33, New York)

Carmen Knoebel
Video documentation of *Finger Für Deutschland* performance in Dusseldorf, 1982

Robert Longo
Untitled (Men in the Cities), 1980

Robert Longo
Untitled, 1981

Robert Longo
Untitled, 1981

Pedro Bell
Art for Funkadelic's *The Electric Spanking of War Babies* album, 1981

Raymond Pettibon
No Title (Fight for freedom!), 1981

Raymond Pettibon
No Title (Angel Dust), 1982

1983

R.E.M.'s *Murmur* is released, signaling a shift toward alternative rock.

The Smiths records its first BBC session, for the *John Peel Show* on Radio 1.

Speed Trials, a 5-day festival including the Beastie Boys, The Fall, Lydia Lunch, and Swans takes place at White Columns, New York.

Mick Jones leaves the Clash.

Alan McGee founds Creation Records in London.

Albums released: Laurie Anderson's *Mister Heartbreak* and *United States,* Bad Brains' *Rock for Light,* David Bowie's *Let's Dance,* Glenn Branca's *Symphony Number 1 (Tonal Plexus)* and *Symphony Number 3 (Gloria),* New Order's *Power, Corruption & Lies,* The Red Krayola and Art & Language's *Black Snakes,* Swans' *Filth* (debut), and Talking Heads' *Speaking in Tongues* (featuring a special-edition cover by Robert Rauschenberg and "Burning Down the House")

Bands formed: Dinosaur Jr. and The Flaming Lips (Oklahoma City)

1984

Bob Geldof organizes the recording of "Do They Know It's Christmas," a precursor to Live Aid.

Cult-classic punk movie *Repo Man,* directed by Alex Cox, is released.

Albums released: Giorno Poetry Systems' *Better an Old Demon Than a New God* (featuring Richard Hell, Lydia Lunch, and Psychic TV), Hüsker Dü's *Zen Arcade,* Killdozer's *Intellectuals Are the Shoeshine Boys of the Ruling Elite,* Minor Threat's *Out of Step,* The Minutemen's *Double Nickels on the Dime,* The Offs' *The Offs First Record* (cover by Jean-Michel Basquiat), The Replacements' *Let it Be,* and Run-D.M.C.'s *Run-D.M.C.*

Bands formed: The Jesus and Mary Chain, My Bloody Valentine, and Yo La Tengo

EPs released: Big Black's *Racer X* and *Bulldozer*

1985

The Live Aid charity concert, organized by Bob Geldof and Midge Ure, benefits Ethiopian famine relief and starts a trend for charity festivals and records. Starting at Wembley Stadium, London, the concert continued at JFK Stadium, Philadelphia, and in Belgrade, Cologne, Moscow, and Sydney. Participants include David Bowie, INXS, U2, The Who, and Neil Young. The broadcast is watched by 1.5 billion people.

Farm Aid is held in Champaign, Illinois.

The 11-day Rock in Rio, attended by 1.4 million people, is played by such diverse acts as the B-52's and Iron Maiden as well as Brazilian acts Gilberto Gil and Moraes Moreira.

Michael Eavis buys the adjacent farm to expand the grounds for Glastonbury, this year featuring Joe Cocker and Echo & The Bunnymen.

The Revolution Summer in the punk scene takes place in Washington, DC.

Spin magazine begins publication.

Albums released: Giorno Poetry Systems' *A Diamond in the Mouth of a Corpse* (artwork by Keith Haring and musical contributions from Coil, Hüsker Dü, and Sonic Youth), Golden Palominos' *Visions of Excess,* The Jesus and Mary Chain's *Psychocandy,* Killdozer's *Snake Boy,* Laibach's *Laibach* and *Nova Akropola,* Christian Marclay's *Record without a Cover,* Mission of Burma's *The Horrible Truth About Burma,* Markus Oehlen's *Beer is Enough, Gut und Bosse,* Squirrel Bait's *Squirrel Bait,* and Tom Waits's *Rain Dogs*

Band formed: The Melvins

Death: D. Boon of The Minutemen (car crash, age 27, Tucson, Arizona)

1986

Farm Aid is held in Austin, Texas. Amnesty International launches the 2-week tour A Conspiracy of Hope, in which Peter Gabriel, Lou Reed, and U2 perform, at the Cow Palace in San Francisco.

Bob Dylan performs in Washington, DC, to commemorate the first Martin Luther King Day.

Artforum's summer issue features a Brian Eno flexi-disc.

Jon Moreland climbs on stage at a concert by The Cure in LA and stabs himself repeatedly with a hunting knife; the crowd cheers, thinking it is part of the show.

Neil Young organizes the first Bridge School Benefit Concert at the Shoreline Amphitheater in Mountain View, California. Don Henley, Tom Petty, and Bruce Springsteen perform.

The *New Musical Express (NME)* and the Institute of Contemporary Arts, London, produce the *C86* cassette compilation, later viewed as one of the formative releases of British indie rock. The ICA hosts a week of gigs in conjunction with the release, including a performance by Primal Scream.

Albums released: Laurie Anderson's *Language is a Virus,* Bad Brains' *I Against I,* Beastie Boys' *Licensed to Ill,* Big Black's *Atomizer,* The Melvins' *10 Songs,* Slayer's *Reign in Blood,* Slovenly's *Thinking of Empire,* The Smiths' *The Queen Is Dead,* and XTC's *Skylarking*

Bands formed: The Afghan Whigs, Boredoms (Osaka, Japan), Manic Street Preachers (as Betty Blue), Pixies, and Primus

Single released: The Alma Band's (Martin Kippenberger and Albert Oehlen) "Live in Rio"

Robert Longo
Video for The Golden Palominos'
"Boy (Go)," 1985

Pipilotti Rist
I'm Not the Girl Who Misses Much, 1986

Dan Graham
Rock My Religion, 1982–84

Peter Saville
Album cover for New Order's
Power, Corruption & Lies, 1983

Richard Prince
Portraits, 1984–85

Richard Kern
Kim Gordon with gun, 1985

Richard Kern
Lung as brat, 1986

1987

Peter Gabriel's Claymation video for "Sledgehammer" sets a new standard for music videos. New Order's video for "True Faith," by French choreographer Philippe Decouflé, is also notable.

Jim Lambie helps to form The Boy Hairdressers, which later becomes Teenage Fanclub.

MTV Europe is launched.

Controversy prompts Geffen Records to move Robert Williams's front-cover image for Guns N' Roses' *Appetite for Destruction,* depicting interlocking levels of human-to-robot rape and brutality, to the inside cover.

Albums released: Big Black's *Songs About Fucking,* Butthole Surfers' *Locust Abortion Technician,* Giorno Poetry Systems' *Smack My Crack* (art by Gary Panter and musical contributions from Nick Cave, Einstürzende Neubaten, and Tom Waits), Killdozer's *12 Point Buck* and *Little Baby Buntin',* R.E.M.'s *Document,* Squirrel Bait's *Skag Heaven,* Swans' *Children of God,* and U2's *The Joshua Tree* (produced by Brian Eno and Daniel Lanois)

Band formed: The Boy Hairdressers

1988

Sub Pop begins the Sub Pop Singles Club.

Lester Bangs's anthology, *Psychotic Reactions and Carburetor Dung: The Work of a Legendary Critic,* edited by Greil Marcus, is published.

Kurt Cobain smashes his guitar on stage for the first time at the Evergreen State Dorm Party in Olympia, Washington.

Rolling Stone names R.E.M. "America's Best Rock-and-Roll Band."

The Smiths, minus Johnny Marr, performs its last concert together, at the UK's Wolverhampton Civic Hall.

Artist Pipilotti Rist begins performing with Les Reines Prochaines.

The book *Art into Pop* by Simon Firth and *Lipstick Traces* by Greil Marcus are published.

Penelope Spheeris's film *The Decline of Western Civilization Part II: The Metal Years* is released.

Jethro Tull wins the first Best Hard Rock / Metal Group Grammy Award.

Albums released: Blissed Out Fatalists' *Blissed Out Fatalists* (featuring future gallery dealer Jeff Poe), Christian Marclay's *More Encores,* Pixies' *Surfer Rosa* (produced by Steve Albini), and Sonic Youth's *Daydream Nation* (cover by Gerhard Richter)

Bands formed: Green Day, Nine Inch Nails, and The Smashing Pumpkins

Death: Hillel Slovak of Red Hot Chili Peppers (heroin overdose, age 26, LA)

EP released: Fugazi's *Fugazi*

Singles released: Laibach's "Sympathy for the Devil" and Nirvana's "Love Buzz / Big Cheese" (Sub Pop Records)

1989

Izzy Stradlin of Guns N' Roses is arrested for urinating on the floor, verbally abusing a flight attendant, and smoking in the nonsmoking section of a US Airways flight from LA to Indianapolis, after having to wait to use the restroom.

Matador Records in New York and Chicago's Drag City label are founded.

Albums released: *Nothing Short of Total War* (Blast First compilation featuring Big Black, Dinosaur Jr., and Sonic Youth with cover art by Savage Pencil), Beastie Boys' *Paul's Boutique,* Glenn Branca's *Symphony No. 6 (Devil Choirs at the Gates of Heaven),* The Cure's *Disintegration,* Nirvana's *Bleach,* Pixies' *Doolittle,* Rapeman's *Two Nuns and a Pack Mule,* Slint's *Tweez,* The Stone Roses' *The Stone Roses,* and Urge Overkill's *Jesus Urge Superstar*

Bands formed: Blur, Mazzy Star, Pavement, and Radiohead

Death: Pete de Freitas of Echo & The Bunnymen (motorcycle accident, age 27, London)

EP released: Fugazi's *Margin Walker*

1990

Grant proposals for performance artists Karen Finley, John Fleck, Holly Hughes, and Tim Miller are vetoed by John E. Frohnmayer of the US National Endowment for the Arts (NEA), inspiring vigorous debate over arts funding and issues of censorship.

The original members of The Velvet Underground perform at an Andy Warhol retrospective at the Cartier Foundation in Jouy-en-Josas, outside Paris, playing a 15-minute version of "Heroin."

The 20th anniversary of the Glastonbury Festival takes place in Pilton, Somerset, UK, with The Cure and Sinead O'Connor.

Albums: Fugazi's *Repeater,* Happy Mondays' *Pills, Thrills, and Bellyaches,* Raymond Pettibon with Super Session's *Torches and Standards,* Psychic TV's *Towards Thee Infinite Beat,* and Sonic Youth's *Goo* (cover by Raymond Pettibon)

Savage Pencil (Edwin Pouncey)
Cover art for *Nothing Short Of Total War* LP (details), 1989

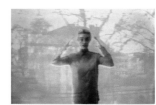

Pipilotti Rist
You Called Me Jacky, 1990

1991

The first Lollapalooza tour features Jane's Addiction, Nine Inch Nails, Henry Rollins, and Siouxsie & The Banshees. The International Pop Underground Convention in Olympia, Washington, features 6 days of mostly female acts, including Bikini Kill, Riot Grrrls, and Seven Year Bitch.

Oliver Stone's movie *The Doors,* is released.

MTV Asia is launched.

During an *NME* interview with Steve Lamacq, Manic Street Preachers' lyricist Richey James Edwards carves "4 Real" into his arm with a razor blade to attest to the band's sincerity.

The books *Rock and the Pop Narcotic* by Joe Carducci and *England's Dreaming* by Jon Savage are published.

Avant-rock band Negativland courts controversy with the single "U2," featuring recut versions of U2 songs mixed with recorded tirades by disc jockey Casey Kasem, resulting in a lawsuit from U2's label, Island Records.

Albums released: Fugazi's *Steady Diet of Nothing,* My Bloody Valentine's *Loveless,* Nirvana's *Nevermind,* Slint's *Spiderland,* and U2's *Achtung Baby*

Bands formed: Gastr del Sol (post-rock) and The Voluptuous Horror of Karen Black (with Kembra Pfahler)

Deaths: Freddie Mercury of Queen (AIDS, age 45, London) and Johnny Thunders, formerly of New York Dolls and The Heartbreakers (methadone and alcohol overdose, age 38, New Orleans)

1992

Neil Young reunites musicians who played on his 1972 *Harvest* to create *Harvest Moon.*

Bob Dylan's 30th anniversary concert takes place in Madison Square Garden, with performances by Eric Clapton, Lou Reed, and Neil Young.

Paul Schimmel curates *Helter Skelter: L.A. Art in the 1990s* at the Museum of Contemporary Art, Los Angeles, featuring the work of Mike Kelley, Raymond Pettibon, Charles Ray, and Jim Shaw.

Chicago's Thrill Jockey label is founded.

After performing Bob Marley's "War" on *Saturday Night Live,* Sinead O'Connor rips apart an image of Pope John Paul II, inspiring media furor.

Will Oldham's shifting project, Palace, is formed.

Albums released: The Melvins' *Lysol,* Pavement's *Slanted and Enchanted,* Rage Against the Machine's *Rage Against the Machine* (debut), and Sonic Youth's *Dirty* (cover art by Mike Kelley)

Death: Jerry Nolan, former New York Dolls drummer (stroke, age 45, New York)

1993

Table of the Elements, a label devoted to re-released and specially recorded experimental music, is founded.

A major survey of Mike Kelley's work is presented at the Whitney Museum of American Art in New York.

Kurt Cobain overdoses on heroin in a hotel bathroom in New York, but wife Courtney Love supposedly revives him with an illegal drug.

Following an anonymous request, Scotland Yard reopens the investigation into Jimi Hendrix's death.

Albums released: Nirvana's *In Utero,* Palace Brothers' *There Is No-One What Will Take Care of You,* Radiohead's *Pablo Honey* (debut), The Smashing Pumpkins' *Siamese Dream,* and Ned Sublette, Lawrence Weiner, and the Persuasions' *Ships at Sea, Sailors and Shoes*

Band formed: Modest Mouse (Issaquah, Washington)

Deaths: Frank Zappa (cancer, age 52, LA) and transgressive punk phenomenon GG Allin (heroin overdose, age 36, New York)

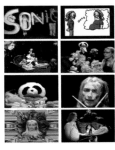

Tony Oursler
Video for Sonic Youth's, "Tunic (Song for Karen)," 1990

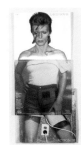

Christian Marclay
David Bowie from the series *Body Mix,* 1991

Richard Kern
Anna with Cigarette, 1993

1994

Quentin Tarantino's film *Pulp Fiction* is released, inspiring a revival of surf music.

The Fillmore Club reopens in San Francisco.

Woodstock '94, a 3-day festival, takes place at Winston Farm in Saugerties, New York. Performers include Blind Melon; Bob Dylan, who shunned the original event; and The Violent Femmes. Between 235,000 and 350,000 people attend the event, which ends in a mud fight.

Multimedia company Thinking Pictures broadcasts the first live concert online: The Rolling Stones performing from the Cotton Bowl in Fair Park, Dallas, Texas.

Critic Simon Reynolds coins the term "post-rock" in relation to bands such as Disco Inferno and Stereolab.

Kurt Cobain commits suicide at age 27 by shooting himself with a 20-gauge shotgun; his body is found after three days. Nirvana fan Daniel Kaspar kills himself in response, at a Seattle memorial service.

Johnny Cash signs with Rick Rubin's American Records and cuts *American Recordings,* featuring folk-style covers of songs by Glenn Danzig and Tom Waits.

Artist Dave Muller organizes the first *Three Day Weekend,* a nomadic artist-curated temporary project.

Albums released: Beck's *Mellow Gold,* Gastr del Sol's *Crookt, Crackd, and Fly,* Hole's *Live Through This,* Manic Street Preachers' *The Holy Bible* (cover art by Jenny Saville), Melt Banana's *Speak-Squeak-Creak,* Palace Brothers' *Days In The Wake,* Pavement's *Crooked Rain Crooked Rain,* The Red Krayola's *The Red Krayola,* Shellac's *At Action Park,* Silver Jews' *Starlite Walker,* and Unwound's *New Plastic Ideas*

Bands formed: Godspeed You! Black Emperor, Sigur Rós, and Sleater-Kinney

Death: Kurt Cobain of Nirvana (suicide by shooting, age 27, Seattle)

1995

The Fraunhofer Institute for Integrated Circuits in Germany applies for a US patent for MPEG-3 (mp3) technology.

The Rock and Roll Hall of Fame and Museum opens in Cleveland with a 7-hour concert; the 10-part documentary *Rock 'n' Roll* airs on PBS; *History of Rock 'n' Roll* is produced by Time Life.

Fort Thunder, a collaborative art space in Providence, Rhode Island, is established to provide exhibition and performance space for artists and musicians.

The Grateful Dead disbands.

It's Only Rock and Roll: Rock and Roll Currents In Contemporary Art is organized by David Rubin for Exhibition Management, Inc., and travels to various venues in the US.

Albums released: The Beatles' *Anthology Volume I,* PJ Harvey's *To Bring You My Love,* Palace's *Viva Last Blues,* Pulp's *Different Class,* The Red Krayola's *Amor and Language,* Sleater-Kinney's *Sleater-Kinney,* and Scott Walker's *Tilt*

Bands formed: Mogwai and Wilco (Chicago)

Deaths: Jerry Garcia of the Grateful Dead (heart attack, age 54, Forest Knolls, California), Sterling Morrison, founding member of The Velvet Underground (non-Hodgkin's lymphoma, age 53, Poughkeepsie, New York), and Robert Smith aka Wolfman Jack (heart attack, age 56, Belvidere, North Carolina)

1996

The surviving Sex Pistols reunite with original bassist Glen Matlock for the Filthy Lucre tour. Steve Jones of the Sex Pistols plays with John Taylor of Duran Duran and Duff McKagan of Guns N' Roses as The Neurotic Boy Outsiders at the Off Ramp, Seattle.

At the Grammys, Kiss announces a reunion tour.

The first Tibetan Freedom Concert, organized by the Beastie Boys, occurs at the Polo Fields in Golden Gate Park, San Francisco. Beck, Yoko Ono, Pavement, and Sonic Youth are among the performers.

The Ramones plays its final live show, in Los Angeles.

The art collaborative assume vivid astro focus is formed.

R.E.M. signs a deal with Warner Brothers for $80 million, the largest contract to date.

Jonathan Melvoin, The Smashing Pumpkins' touring keyboard player, dies from a heroin overdose in a New York hotel room. Drummer Jimmy Chamberlin, who was with him at the time, pleads not guilty to heroin possession.

Pulp's Jarvis Cocker invades the stage at the 1996 BRIT Awards to protest Michael Jackson's performance.

Artist Aleksandra Mir stages *New Rock Feminism* to lobby for more female artists at Denmark's Roskilde Festival.

Twenty artists and musicians form Akademie Isotrop in Hamburg, Germany.

Albums released: Beck's *Odelay,* Destroy All Monsters' *Silver Wedding Anniversary,* Gastr del Sol's *Upgrade and Afterlife* (cover art by Roman Signer), Jailhouse's *Jailhouse* (featuring Rüdiger Carl, Albert Oehlen, and Markus Oehlen), Palace's *Arise Therefore,* The Red Krayola's *Hazel,* and Wilco's *Being There*

Death: Jonathan Melvoin of The Smashing Pumpkins (heroin overdose, age 34, New York)

Douglas Gordon
Bootleg (Cramped), 1995

Aleksandra Mir
New Rock Feminism, 1996

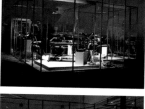

Rirkrit Tiravanija
Untitled 1996 (Rehearsal Studio No. 6 Silent Version), 1996

1997

Mike Kelley and Tony Oursler re-form the Poetics to create a project for Documenta X and release the CD *Critical Inquiry in Green.*

Bob Dylan releases *Time Out Of Mind,* produced by Daniel Lanois.

Sarah McLachlan organizes the first Lilith Fair tour.

Black Dice forms at the Rhode Island School of Design.

Jeremy Deller creates the artist's book, *The Uses of Literacy,* employing writings and drawings from fans of Manic Street Preachers.

The Flaming Lips releases *Zaireeka,* an innovative recording requiring 4 stereo systems for playback.

James Karnbach and Carol Bernson's comprehensive history *It's Only Rock-n-Roll: The Ultimate Guide to The Rolling Stones* is published.

Albums released: Björk's *Homogenic,* The Chemical Brothers' *Dig Your Own Hole,* Daft Punk's *Homework,* Eleventh Dream Day's *Eighth* (cover art by Wesley Kimler), The Melvins' *Honky,* Poetics' *Critical Inquiry in Green,* Radiohead's *OK Computer,* The Sea and Cake's *The Fawn,* Sleater-Kinney's *Dig Me Out,* Stereolab's *Dots and Loops,* and Workshop's *Meiguiweisheng Xiang*

Bands formed: The Shins and The White Stripes

Deaths: Jeff Buckley (drowning, age 30, Memphis), Michael Hutchence of INXS (suicide by hanging, age 37, Sydney, Australia), and Ronnie Lane of The Small Faces (multiple sclerosis, age 51, Trinidad, Colorado)

1998

Michael Portnoy, a self-described "multigenre mastermind artist," runs on stage with the words "Soy Bomb" written on his chest during Bob Dylan's performance at the Grammys.

Pearl Jam and Tom Waits play the Not in Our Name: The Dead Man Walking concert, aimed at raising funds to lobby for the repeal of the death penalty.

Lollapalooza goes on hiatus for six years.

Bauhaus reunites.

Albums released: Rita Ackermann and Jutta Koether's *Diadal,* Beck's *Mutations,* Fatboy Slim's *You've Come a Long Way, Baby,* Jon Spencer Blues Explosion's *Acme,* and Royal Trux's *Accelerator*

Band formed: SunnO))) (drone, Seattle)

Death: Wendy O. Williams of The Plasmatics (suicide by shooting, age 47, Storrs, Connecticut)

1999

The Jesus and Mary Chain, Pavement, and The Verve disband.

Shawn Fanning creates the online file-sharing program Napster.

The No WTO Combo, with former Dead Kennedys' singer Jello Biafra and former Nirvana bassist Krist Novoselic, attempts to play at the 1999 World Trade Organization meeting in Seattle but is unable due to conflicts with the police.

Jem Cohen's film *Instrument,* featuring Fugazi, is released.

The Recording Industry Association of America introduces the diamond award for ten million sales of an album. Guns N' Roses and Led Zeppelin are among the recipients.

Woodstock '99 is attended by 200,000 people, near Rome, New York. It's a disaster resulting in multiple fires, alleged mosh-pit rapes, a torn-down broadcast tower, and a shut-down emergency medical station. Helmeted riot police clear attendees from the site.

Netaid, a series of concerts held in Geneva, London, and New Jersey featuring David Bowie, Michael Kamen, and Jimmy Page, is broadcast online. Plagued by technical errors, it does not raise many funds.

Band and performance art group Angelblood forms, with painter Rita Ackermann on vocals.

Albums released: Bonnie "Prince" Billy's *I See A Darkness,* Destroy All Monsters' *Bored,* Eminem's *The Slim Shady LP,* The Flaming Lips' *The Soft Bulletin,* Fugazi's *Instrument Soundtrack,* Godspeed You! Black Emperor's *Slow Riot for New Zerø Kanada,* Sam Prekop's *Sam Prekop,* Stephen Prina's *Push Comes to Love* (cover by Barbara Bloom), The Red Krayola's *Fingerpainting,* and Tom Waits's *Mule Variations*

Bands formed: Broken Social Scene and The Strokes

Mark Leckey
Fiorucci Made Me Hardcore, 1999

2000

Metallica sues Napster, demanding that 300,000 Napster users found to be trading Metallica songs be banned from the network.

Rage Against the Machine, The Smashing Pumpkins, and Soul Coughing disband.

The Experience Music Project, funded by Microsoft's Paul Allen, opens in Seattle.

Nine fans are trampled to death while Pearl Jam performs at the Roskilde Festival, near Copenhagen.

Brothers Albert and Markus Oehlen release their first album, *We Are Eggsperienced,* as the band Van Oehlen.

The Filth and the Fury, a documentary film about the Sex Pistols, is released.

Albums released: The Fall's *The Unutterable,* Godspeed You! Black Emperor's *Lift Your Skinny Fists Like Antennas to Heaven,* Rodney Graham's *Getting It Together in the Country,* PJ Harvey's *Stories from the City, Stories from the Sea,* Outkast's *Stankonia,* Peaches' *The Teaches of Peaches,* Radiohead's *Kid A,* Shellac's *1000 Hurts,* Sleater-Kinney's *All Hands on the Bad One,* Sonic Youth's *NYC Ghosts & Flowers,* Van Oehlen's *We Are Eggsperienced,* and The White Stripes' *De Stijl*

Band formed: donAteller (artists' band featuring Bonnie Camplin, Enrico David, Ed Laliq, and Mark Leckey)

Deaths: Dennis Danell of Social Distortion (brain aneurysm, age 38, Newport Beach, California) and Ian Dury of The Blockheads (cancer, age 57, London)

2001

Manic Street Preachers plays for 5,000 people, including Fidel Castro, at the Teatro Karl Marx in Havana, the first Western act to perform in Cuba in more than 20 years.

David Bowie opens The Concert for New York City at Madison Square Garden. It includes performances by Bono and The Edge, Eric Clapton, Mick Jagger, Paul McCartney, and The Who.

Bus Station Loonies, a UK punk band, sets a world record by playing 25 concerts in 12 hours.

A fake Reuters e-mail prompts the media, including Chicago's WXRT-FM, to announce Lou Reed's death from a painkiller overdose even though he is alive and working in Amsterdam.

Kunsthalle Düsseldorf presents *Zuruck Zum Beton,* addressing the origins of punk and new wave in Germany.

ExitArt in New York organizes *The LP Show,* a display of more than 2,500 album covers.

Albums released: Bonnie "Prince" Billy's *Ease Down the Road,* Fischerspooner's *#1,* Gorillaz' *Gorillaz,* Liars' *They Threw Us All In a Trench and Stuck a Monument on Top,* The Melvins' *Colossus of Destiny,* N*E*R*D's *In Search Of . . . ,* Unwound's *Leaves Turn Inside You,* The White Stripes' *White Blood Cells,* and Yeah Yeah Yeahs' *Yeah Yeah Yeahs*

Band formed: Gang Gang Dance (featuring artists Lizzie Bougatsos and Brian DeGraw)

Death: Joey Ramone (lymphoma, age 49, New York)

2002

Wilco's *Yankee Hotel Foxtrot* is released after being rejected by the band's label, Reprise Records, and later picked up by Nonesuch, another Time Warner subsidiary.

Journals, a book of Kurt Cobain's writing from 1988 to 1994, is published.

Adam Ant is placed in psychiatric care after pulling a gun on the doorman of a London pub.

Jutta Koether and Steven Parrino collaborate on Electrophilia.

MTV premieres *The Osbournes.*

Michael Winterbottom's film *24 Hour Party People,* fictionalizing the rise of Factory Records in Manchester, is released.

The Tate Liverpool organizes *Remix: Contemporary Art and Pop.* The Wattis Institute at the California College of the Arts presents *Rock My World: Recent Art and the Memory of Rock 'n' Roll.*

The Society for the Activation of Social Space through Art and Sound is founded in LA to promote experimental music and art.

The Perfect Me, featuring artists Sarah Seager, Jim Shaw, Thaddeus Strode, and Marnie Weber, release the album *The Perfect Me . . . The Very Best of The Perfect Me.*

The Ramones and Talking Heads are the first punk bands to be inducted into the Rock and Roll Hall of Fame in Cleveland.

Albums released: Devendra Banhart's *The Charles C. Leary* and *Oh Me Oh My,* Beck's *Sea Change* (cover by Jeremy Blake), Black Dice's *Beaches and Canyons,* Deerhoof's *Reveille,* The Flaming Lips' *Yoshimi Battles the Pink Robots,* Godspeed You! Black Emperor's *Yanqui U.X.O.,* Interpol's *Turn on the Bright Lights,* Sonic Youth's *Murray Street,* SunnO)))'s *Flight of the Behemoth,* The Walkmen's *Everyone Who Pretended To Like Me is Gone,* and Workshop's *Es Liebt Dich Und Deine Korperlichkeit Ein Ausgefl*

Deaths: John Entwistle of The Who (drug overdose, age 58, Las Vegas, Nevada), Dee Dee Ramone (heroin overdose, age 49, LA), and Joe Strummer of the Clash (heart attack, age 50, Somerset, UK)

The Destroy All Monsters Collective
Greetings from Detroit, 2000

The Destroy All Monsters Collective
The Heart of Detroit by Moonlight, 2000

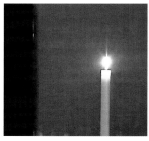
Jay Heikes
Daydream Nation, 2000

The Destroy All Monsters Collective
Mall Culture, 2000

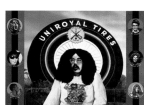
The Destroy All Monsters Collective
Amazing Freaks of the Motor City, 2000

Yoshitomo Nara
How Could I do For You!, 2000

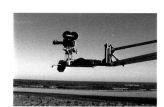
Aïda Ruilova
Untitled, 2002

2003

The Rolling Stones headline SARSstock in Toronto, an 11-hour concert attended by 500,000 people, to provide relief for the SARS outbreak there.

David Bowie previews his new album, *Reality,* with a live performance and Q&A broadcast to movie theaters around the world.

Apple introduces iTunes.

Jutta Koether collaborates with Kim Gordon on the installation *Club in the Shadow.*

Artists Lucy McKenzie and Paulina Olowska stage *Bar Nova Popularna,* creating a temporary bar and performance space in Warsaw.

Albums released: Bonnie "Prince" Billy's *Master and Everyone,* The Darkness's *Permission to Land,* Japanther's *Dump the Body in Rikki Lake,* Outkast's *Speakerboxxx / The Love Below,* Radiohead's *Hail to the Thief,* Ween's *Quebec,* The White Stripes' *Elephant,* Wire's *Send,* and Yeah Yeah Yeahs' *Fever to Tell*

Bands formed: Arcade Fire and Babyshambles

Deaths: Johnny Cash (complications from diabetes, age 71, Nashville), Adam Cox, Matt Fitzgerald, and Jeremy Gage of the Exploding Hearts (car crash, ages 22, 21, 20 respectively, near Eugene, Oregon), Noel Redding of The Jimi Hendrix Experience (natural causes, age 57, County Cork, Ireland), and Elliott Smith (suicide by stabbing, age 34, LA)

2004

The Pixies launch a reunion tour.

Mick Jagger is knighted.

Albums released: Arcade Fire's *Funeral,* Devendra Banhart's *Rejoicing in the Hands* and *Nino Rojo,* Beastie Boys' *To The Five Boroughs,* Blonde Redhead's *Misery is a Butterfly,* Chromeo's *She's In Control,* Deerhoof's *Milk Man,* Destroy All Monsters' *The Detroit Oratorio* and *Backyard Monster Tube and Pig,* Franz Ferdinand's *Franz Ferdinand,* Rodney Graham's *Rock is Hard,* Morrissey's *You Are The Quarry,* Scissor Sisters' *Scissor Sisters,* Sonic Youth's *Sonic Nurse* (cover by Richard Prince), and Workshop's *Yog Sogoth*

Deaths: Ray Charles (liver disease, age 73, Beverly Hills, California), British DJ John Peel (heart attack, age 65, Cusco, Peru), Robert Quine, guitarist for Richard Hell and The Voidoids (suicide by heroin overdose, age 61, New York), and Johnny Ramone (prostate cancer, age 55, LA)

2005

Cream reunites for 4 nights at Royal Albert Hall, where its final concert was held in 1968.

Vinyl: Records and Covers by Artists presents more than 800 record covers at the Neues Museum Weserbug Bremen in Germany. The Tate Liverpool mounts *Summer of Love,* exploring the intersection of art, politics, and music in the late '60s. *Her Noise,* at South London Gallery, presents 5 female artists working with sound.

Don't Trust Anyone Over Thirty: Entertainment by Dan Graham with Tony Oursler and Other Collaborators, featuring Japanther and Huber Marionettes, debuts at Art Basel Miami Beach.

Albums released: Bonnie "Prince" Billy and Matt Sweeney's *Superwolf,* Black Dice's *Broken Ear Record,* Bloc Party's *Silent Alarm,* Bright Eyes' *I'm Wide Awake It's Morning,* Franz Ferdinand's *You Could Have It So Much Better,* Gorillaz' *Demon Days,* SunnO)))'s *Black One,* and The White Stripes' *Get Behind Me Satan*

Band formed: Jack Too Jack (featuring artists Steven Claydon and Mark Leckey)

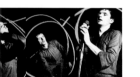

Scott King (with Kevin Cummins)
Futurama, 2004

Josh Mannis
The Wipe (Extreme Blackend Grind Version w/ Thorne Brandt, Vanessa Harris and Helen Hicks), 2005

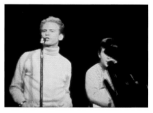

Cory Arcangel
Sans Simon, 2004

Rita Ackermann
We will skate on shiny shit . . . , 2004

Phyllis Baldino
19 Universes / my brother, 2004

Mark Flores
I Need More, 2005

Daniel Guzman
Solicito Chicas from the *Thieves Like Us Series,* 2004

Jim Drain
Sergio, 2004

Yoshitomo Nara
One, Two , Three, Four!, 2004

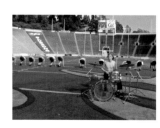

Slater Bradley
The Year of the Doppelganger, 2004

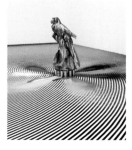

Jim Lambie
The Byrds (Love in a Void), 2005

Mungo Thomson
Drum Kit Drawing (John Bonham), 2005

2006

Influential indie-rock group Sleater-Kinney disbands.

CBGB shuts down.

Spruth Magers Lee in London presents the exhibition *Thank You For the Music: Interfaces Between Visual Art and Music.*

The first Pitchfork Music Festival is held in Chicago, featuring experimental and independent rock acts such as the Liars, Mission of Burma, and Os Mutantes.

P.S.1 mounts the exhibition *Music is a Better Noise,* exposing the crossover work of artists in music and musicians in the visual arts. The Institute of Contemporary Art at the University of Pennsylvania in Philadelphia presents *Make Your Own Life: Artists In and Out of Cologne.* The Palazzo delle Papesse / Centro Arte Contemporanea in Siena, Italy, organizes *Good Vibrations: Visual Arts and Rock Music.*

Albums released: The Flaming Lips' *At War with the Mystics,* Morrissey's *Ringleader of the Tormentors,* Sonic Youth's *Rather Ripped,* SunnO))) and Boris's *Altar,* Throbbing Gristle's *Part Two,* and Scott Walker's *The Drift*

Deaths: Ska and reggae performer Desmond Dekker (heart attack, age 64, Surrey, UK) and legendary soul performer Wilson Pickett (heart attack, age 64, Ashburn, Virginia)

2007

Jarvis Cocker curates London's South Bank Centre's Meltdown festival, featuring performances by DEVO, Melanie, Motörhead, and SunnO))), among others.

Sonic Youth performs its classic album *Daydream Nation* in its entirety at Pitchfork Music Festival in Chicago.

Rock and Roll Hall of Fame inductees include Grandmaster Flash and the Furious Five, R.E.M., the Ronettes, Patti Smith, and Van Halen.

Albums released: Jarvis Cocker's *Jarvis,* Githead's *Art Pop,* Iggy & The Stooges' *The Weirdness,* Japanther's *Skuffed Up My Huffy* and *Yer Living Grave,* Klaxons' *Myths of the Near Future,* Shellac's *Excellent Italian Greyhound,* Von Südenfed's *Tromatic Reflexxions,* Wilco's *Sky Blue Sky,* and The White Stripes' *Icky Thump*

Melanie Schiff and Tony Tasset
Hard Rain, 2006

Thaddeus Strode
In the Wild with the Ox (Herding the Bodhi Mind), 2006

Thomas Zipp
Uranlicht, 2006

Melanie Schiff
Emergency, 2006

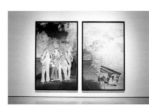

Rodney Graham
Awakening, 2006

Bjorn Copeland
Money shot, 2006

Jeremy Deller
What Would Neil Young Do?, 2006

Sources

Black, Johnny, Andy Basire, and Hugh Gregory. *Rock and Pop Timeline: How Music Changed the World through Four Decades.* San Diego, Calif.: Thunder Bay Press, 2003.

Crampton, Luke, and Dafydd Rees. *Rock & Roll: Year by Year.* New York: Dorling Kindersley, 2003; repr., 2005.

Crimlis, Roger, and Alwyn W. Turner. *Cult Rock Posters: Ten Years of Classic Posters from the Glam, Punk, and New Wave Era.* London: Aurum Press, 2006.

Digital Dream Door, "Rock 'n' Roll Timeline," www.digitaldreamdoor.com/pages/best_timeline-r1.html (accessed August 2, 2007).

Morrison, Craig. *American Popular Music: Rock & Roll.* Edited by Richard Carlin with foreword by Kevin Holm-Hudson. New York: Facts on File, 2006.

Wikipedia, "Timeline of alternative rock," en.wikipedia.org/wiki/Timeline_of_alternative_rock (accessed August 2, 2007).

Wikipedia, "Timeline of punk rock," en.wikipedia.org/wiki/Timeline_of_punk_rock (accessed August 2, 2007).

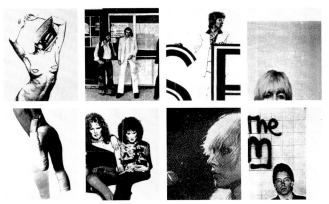

Adam Pendleton
Sympathy for the Devil, 2007

assume vivid astro focus
A very anxious feeling, 2007

Jim Lambie
Untitled, 2007

Marnie Weber
A Western Song, 2007

Bjorn Copeland
Vertical exchange, 2007

New Humans
Disassociate, 2007

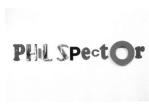

Jack Pierson
Phil Spector, 2007

Jim Lambie
Untitled, 2007

SELECTED BIBLIOGRAPHIES, DISCOGRAPHIES, AND EXHIBITIONS

RITA ACKERMANN

Born 1968 in Budapest
Hungarian Academy of Fine Arts, Budapest, 1989–92
The New York Studio School of Painting, Drawing and Sculpture, 1992–93

Solo exhibitions
2006
Court Toujours, Galerie Peter Kilchmann, Zurich, Switzerland

2005
Andrea Rosen Gallery, New York
Jump On Me, Bonner Kunstverein, Bonn, Germany

2003
Rita Ackermann—Ordogok, Galerie Almine Rech, Paris

Group exhibitions
2007
zwischen zwei toden / between two deaths, ZKM, Karlsruhe, Germany

2006
DARK, Museum Boijmans Van Beuningen, Rotterdam, Netherlands
While Interwoven Echoes Drip into a Hybrid Body, Migros Museum für Gegenwartskunst, Zurich, Switzerland

2004
Next Generation: Heavenly Creatures, Galerie Thaddaeus Ropac, Salzburg, Austria
Strategies of Desire, Kunsthaus Baselland, Muttenz / Basel, Switzerland

2003
Anti Pure, Neue Kunsthalle St. Gallen, Switzerland

2000
Presumed Innocent, Musee d'art contemporain de Bordeaux, France

Selected bibliography
Ackermann, Rita. "Interview of Rita Ackermann by Aaron Rose with Special Guest Questions from Susan Cianciolo" By Aaron Rose. *Dune,* no. 18 (fall 1999), 45–51.

Gordon, Kim. "Rita Ackermann." *Purple* (France), no. 10 (winter 2001), 158–59.

Schjeldahl, Peter. "The Young One." *Village Voice,* January 27, 1998, 89.

Schwendener, Martha. "Rita Ackermann and Ana Axpe and the Swiss Institute." *Time Out New York,* March 18–25, 1999, 64.

Smith, Roberta. Art in Review. "Rita Ackermann, Francis Upritchard." *New York Times,* October 7, 2005, E40

CORY ARCANGEL

Born 1978 in Buffalo, New York
BM, Oberlin Conservatory of Music, Ohio

Solo exhibitions
2006
Max Wigram Gallery, London

2005
Nerdzone Version 1, Migros Museum für Gegenwartskunst, Zurich, Switzerland
Team, New York

Group exhibitions
2007
AMERICAN VIDEO-ART, LAZNIA—Centre for Contemporary Art, Gdansk, Poland

2006
New York, Interrupted, PKM Gallery, Beijing
Time Frame, P.S.1 Contemporary Art Center, Long Island, New York

2005
Greater New York, P.S.1 Contemporary Art Center, Long Island, New York
Mixed Doubles, Carnegie Museum of Art, Pittsburgh, Pennsylvania

2004
The Pattern Playback, The Moore Space, Miami, Florida
Whitney Biennial, Whitney Museum of American Art, New York

Selected bibliography
Chaffee, Cathleen. "Cory Arcangel." *Contemporary* (UK), no. 84 (2006), 26–29.

Hill, Joe. "New York: 2004 Biennial Exhibition." *Contemporary* (UK), no. 62 (2004), 60–62.

Mendelsohn, Adam E. "Cory Arcangel." *Art Review,* no. 8 (February 2007), 84–85.

Sholis, Brian. "Cory Arcangel: Team Gallery / Cory Arcangel / Paper Rad: Deitch Projects." *Artforum* 43, no. 8 (April 2005), 190–91.

Stillman, Nick. "Cory Arcangel." *Flash Art* 38, no. 242 (May–June 2005), 116–17.

ART & LANGUAGE AND THE RED KRAYOLA

The Red Krayola
Formed 1966

Selected discography
2006
Introduction, Drag City
Red Gold, Drag City

2005
Live in Paris, Sordide Sentimental

2004
Japan in Paris in L.A., Drag City
Singles, Drag City

1999
Fingerpainting, Drag City

1998
Live 1967, Drag City

1996
Hazel, Drag City

1995
Coconut Hotel, Drag City

1994
The Red Krayola, Drag City

1989
Malefactor, Ade, Glass Records

1983
Black Snakes (with Art & Language), RecRec Music

1981
Kangaroo? (with Art & Language), Rough Trade

1979
Soldier-Talk, Radar Recordings

1976
Corrected Slogans (with Art & Language), Music-Language

1968
God Bless the Red Krayola and All Who Sail With It, International Artists

1967
The Parable of Arable Land, International Artists

Selected bibliography
"Kangaroomerang." *Everything* (UK) 2, no. 1 (July 1997), 28–29

Art & Language and The Red Krayola. "Kangaroo? (Some Songs by Art & Language and The Red Krayola)." *Art Journal* 42, no. 2, (summer 1982), 101–03.

Curran, Susan, and Andrea Feldman "Red Krayola." *Warped Reality,* no. 3 (summer–fall 1995), 6–8.

Gill, Andy. "The Ideological Features of Any Work as a Function." *New Musical Express* (UK), no. 21 (July 1979), 27–28.

Holert, Tom. "Flaming Feature." *Artforum* 38, no. 9 (May 2000), 148–53.

Kenny, Glenn. "Held by the Mayo." *Village Voice,* September 21, 2004, 102.

McDowell, Mike. "Radar." *Blitz!,* no. 29 (November–December 1978), 10–14.

Thompson, Mayo. "Company Man: Diedrich Diederichsen Talks with Mayo Thompson." By Diedrich Diederichsen. *Artforum* 36, no. 5 (January 1998), 82–85.

ASSUME VIVID ASTRO FOCUS

Formed 1996

Solo exhibitions
2007
assume vivid astro focus XVIII, John Connelly Presents, New York
assume vivid astro focus XIX, HOTEL, London

2006
butch queen realness with a twist in pastel colors, John Connelly Presents, New York
Kunsthalle Wien, Vienna

2005
assume vivid astro focus XII: butch queen realness with a twist in pastel colors (featuring Dick Jewell), Tate Liverpool, UK

2004
assume vivid astro focus IX, public art project for Central Park sponsored by the Public Art Fund, New York
Make It With You: A Slow Dance Club (collaboration with Los Super Elegantes), Frieze Art Fair, London

2003
assume vivid astro focus VII, Deitch Projects, New York

Group exhibitions
2006
Infinite Painting: Contemporary Painting and Global Realism, Villa Manin Centro d'Arte Contemporanea, Codroipo, Italy

2005
Ecstasy: In and About Altered States, The Geffen Contemporary, Museum of Contemporary Art, Los Angeles
Tropicália: A Revolution in Brazilian Culture, Museum of Contemporary Art, Chicago; Barbican Centre, London; Haus der Kulteren der Welt, Berlin; Bronx Museum of Art, New York; Museu de Arte Moderna do Rio de Janeiro, Brazil

2004
Whitney Biennial, Whitney Museum of American Art, New York

Selected bibliography
Bonami, Francesco, and Sarah Cosulich Canarutto, eds. *Infinite Painting,* exh. cat., Codroipo, Italy: Villa Manin Centro d'Arte Contemporanea, 2006, 32.

Cobb, Chris. "assume vivid astro focus." *Flash Art* (Italy) 36, no. 228 (January–February 2003), 112.

Leventis, Andreas. Emerging Artists. "Man or Multitude? The bootlegged beauty of assume vivid astro focus." *Modern Painters* (UK) (April 2005), 48–49.

Matt, Gerald. *assume vivid astro focus: Open Call,* exh. cat., Nuremberg, Germany: Verlag für Modern Kunst Nürnberg, 2006.

Schimmel, Paul, and Lisa Gabrielle Mark, eds. *Ecstasy: In and About Altered States,* exh. cat., Cambridge, Mass.: MIT Press, 2005, 54–57.

Wilson, Michael. "Assume Vivid Astro Focus." *Artforum* 42, no. 2 (October 2003), 172.

PHYLLIS BALDINO
Born 1956 in New Haven, Connecticut
BFA, Hartford Art School, Connecticut, 1978

Solo exhibitions
2005
Baldino-Neutrino, ThreeWalls, Chicago

1996
In the Present, Lauren Wittels Gallery, New York

Group exhibitions
2006
Brighton Photo Biennial, UK
Voodoo Macbeth, De La Warr Pavilion, Bexhill-on-Sea, UK

2005
Hunch & Flail, Artists Space, New York
Mix, Temple Gallery, Philadelphia, Pennsylvania

2004
Multiplex, Smack Mellon Gallery, Brooklyn, New York

2001
Brooklyn!, Palm Beach Institute of Contemporary Art, Lake Worth, Florida
Video Jam, Palm Beach Institute of Contemporary Art, Lake Worth, Florida

1999
Zapping Zone, Galerie Hubert Winter, Vienna

Selected bibliography
Higgie, Jennifer. "Zones of Disturbance." *frieze* (UK), no. 38 (January–February 1998), 87–88.

Smith, Roberta. "Hendrik Hakasson and Phyllis Baldino." *New York Times,* October 18, 1996, C2.

———. "The Resurging Video, Reclaimed and Reoriented." *New York Times,* February 21, 1997, C28.

Williams, Gregory. "Phyllis Baldino." *Artforum* 39, no. 9 (May 2001), 179.

Wissing, Douglas. "Phyllis Baldino, Contemporary Art Center, Cincinnati." *New Art Examiner* 21, no. 1 (September–October 2001), 101.

PEDRO BELL
Born 1950s
Self-taught

Group exhibitions
2006
Interstellar Low Ways, Hyde Park Art Center, Chicago

2005
Drunk vs. Stoned, Gavin Brown's enterprise, New York

2001
The LP Show, Exit Art, New York

Selected bibliography
Bell, Pedro. "Pedro Bell: Drawnamic Maestro of Optical Infotainment." Interview by Rob Michaels. *Motorbooty* (1989).

———. "Return of the Crazoid: Roctober Brings Artist Extraordinaire Pedro Bell Back to the Scene of the Crime Where He First Met Funkadelic." Interview by Jake Austen, Randy Lancelot, and James Porter. *Roctober,* no. 11 (fall 2004). roctober.com/roctober/greatness/pfunk.html (accessed August 3, 2007).

Corbett, John. *Extended Play: Sounding Off from John Cage to Dr. Frankenstein.* Durham, N.C., and London: Duke University Press, 1994, 18.

Saltz, Jerry. "Cover Me." *Village Voice,* June 18, 2001. http://www.villagevoice.com/art/0125,saltz,25684,13. (accessed August 3, 2007).

SLATER BRADLEY
Born 1975 in San Francisco, California
BA, University of California, Los Angeles, 1998

Solo exhibitions
2007
Galeria Helga de Alvear, Madrid
Slater Bradley: The Year of the Doppelganger and My Conclusion / My Necessity, The Contemporary Art Museum St. Louis, Missouri

2005
The Doppelganger Trilogy, Blum & Poe, New York
Slater Bradley: Lifetime Achievement Award, Red Gallery, Savannah College of Art and Design, Georgia
Slater Bradley / Matrix 216: The Year of The Doppelganger, Berkeley Art Museum and Pacific Film Archive, California
Slater Bradley: Uncharted Settlements, Taka Ishii Gallery, Tokyo

2004
Slater Bradley's Doppelganger Trilogy, Solomon R. Guggenheim Museum, New York
Stoned & Dethroned, Team, New York

2003
Slater Bradley: Don't let me disappear, Bard College Center for Curatorial Studies Museum, Annandale-on-Hudson, New York

Group exhibitions
2005
Bridge Freezes Before Road, Barbara Gladstone Gallery, New York

2004
Playlist, Palais de Tokyo, Paris
Whitney Biennial, Whitney Museum of American Art, New York

2001
CASINO 2001: 1st Quadrennial, Stedelijk Museum voor Actuele Kunst, Ghent, Belguim
Dear Dead Person, Momenta Art, Brooklyn, New York

Selected bibliography
Bradley, Slater. *Slater Bradley: Lifetime Achievement Award,* exh. cat., Savannah, Ga.: Savannah College of Art and Design, 2006.

Cotter, Holland. Art in Review. "Slater Bradley 'Unknown Pleasures.'" *New York Times,* May 17, 2002, E35.

Cruz, Amada. *Slater Bradley: Don't let me disappear* exh. cat., Annandale-on-Hudson, N.Y.: Bard College Center for Curatorial Studies Museum, 2003.

Kunitz, Daniel. "Cinephile: Slater Bradley." *Art Review,* no. 5 (November 2006), 46.

Lo, Melissa. "Slater Bradley." *Flash Art* 138, no. 241 (March–April 2005), 117–18.

Valdez, Sarah. "The Observer." *Paper Magazine* (August 2003), 48.

Weiner, Clay. "The Importance of Being Slater Bradley." *Dazed and Confused* (UK) 2, no. 107 (November 2003),100–104.

CAPTAIN BEEFHEART AND THE MAGIC BAND
Formed 1964

Selected discography
1982
Ice Cream for Crow, Virgin Records

1980
Doc at the Radar Station, Virgin Records

1978
Shiny Beast (Bat Chain Puller), Warner Bros.

1975
Bongo Fury, DiscReet Records

1974
Bluejeans and Moonbeams, Mercury Records
Unconditionally Guaranteed, Mercury Records

1972
Clear Spot, Reprise Records
The Spotlight Kid, Reprise Records

1971
Mirror Man, Buddah Records

1970
Lick My Decals Off, Baby, Straight Records

1969
Trout Mask Replica, Straight Records

1968
Strictly Personal, Blue Thumb Records

1967
Safe as Milk, Buddah (Red) Records

Selected bibliography
Barnes, Mike. *Captain Beefheart.* Cambridge, UK: Quartet Books, 2000.

Delville, Michel, and Andrew Norris. *Frank Zappa, Captain Beefheart and the Secret History of Maximalism.* Cambridge, UK: Salt Publishing, 2005.

McKenna, Kristine. "A Crossover of a Different Color. Once known as avant-garde musician Captain Beefheart, Dan Van Vliet has quickly won the art world's attention as a painter." *Los Angeles Times,* July 29, 1990, 9.

Pareles, Jon. "Already Boxed. Just Add a Little Wrapping; Captain Beefheart and His Magic Band: 'The Dust Blows Forward (An Anthology).'" *New York Times,* December 12, 1999, 44.

Watson, Ben. "Don Van Vliet: Natural Born Painter—The Artist Behind the Trout Mask." *Modern Painters* (UK) 13, no. 4 (winter 2000), 40–43.

STEVEN CLAYDON
Born 1969 in London
BFA, Chelsea School of Art and Design, London, 1991
MFA, Central St. Martins School of Art and Design, London, 1997

Solo exhibitions
2007
New Valconia, David Kordansky Gallery, Los Angeles
Old School, Hauser & Wirth at Colnaghi, London; Zwirner & Wirth, New York

2006
Statements, Art Basel 36, Switzerland
White Columns, New York

2005
All Across The Thready Eye, Galerie Dennis Kimmerich, Düsseldorf, Germany
Fear of a Planet, HOTEL, London

2004
The Third of the Third, Hoxton Distillery, London

Group exhibitions
2006
Dereconstruction, Barbara Gladstone Gallery, New York
Rings of Saturn, Tate Modern, London

2005
Even a Stopped Clock Tells the Right Time Twice a Day, Institute for Contemporary Arts, London

Selected bibliography

Coomer, Martin. "Introducing: Steven Claydon," *Modern Painters* (UK) (December 2006–January 2007), 92–94.

Day, Charlotte. "Rings of Saturn—Tate Modern," *Art & Australia* 44, no. 3 (fall 2007), 448.

Jian-Xing Too. "Le Voyage Intérieur at Espace EDF Electra, Paris." *Art Review* (UK) 10 (February 2006), 109.

Lack, Jessica. "Preview: Fear of a Planet at Hotel." *Guardian Guide*, March 19–25, 2005.

Morton, Tom. "Even a Stopped Clock Tells the Right Time Twice a Day," exh. publication, London: Institute of Contemporary Arts, 2006.

Wood, Catherine. "Fear of a Planet at Hotel." *frieze* (UK), no. 93 (September 2005), 147.

BJORN COPELAND

Born 1975 in Malone, New York
BFA, Rhode Island School of Design, Providence, 1998
Skowhegan School of Painting and Sculpture, Maine, 2001

Solo exhibitions
2007
Archival K.O., China Art Objects, Los Angeles

2005
Daniel Reich Gallery, New York

2004
Galerie Daniel Buchholz, Cologne, Germany

Group exhibitions
2006
Music is a Better Noise, P.S.1 Contemporary Art Center, Long Island, New York

2005
Cut, Susanne Vielmetter Los Angeles Projects

2004
California Earthquakes, Daniel Reich Gallery, New York
Curious Crystals of Unusual Purity, P.S.1 Contemporary Art Center, Long Island, New York
The Pattern Playback, with Jean Moreno, Mike Kelley, and Sarah Morris, among others, The Moore Space, Miami, Florida

2003
The Birdman Returns, D'Amelio Terras, New York
Karaoke Death Machine, Daniel Reich Gallery, New York

2002
The Kids Are Alright, ATM Gallery, New York

Selected bibliography

Kerry, Merrily. "Satellite Spin-off: Standouts from the Alternative Art Fair Scene." *Flash Art* (Italy) 36, no. 232 (October 2003), 52.

Saltz, Jerry. "Termite Theory." *Village Voice,* June 29, 2004, 89.

Wilson, Michael. "Curious Crystals of Unusual Purity." *Artforum* 43, no. 3 (November 2004), 222.

Yablonsky, Linda. "Rock 'n' Roll Hall of Fame." *Art Review* (UK) 54 (June 2003), 27–29.

JEREMY DELLER

Born 1966 in London
BA, Courtauld Institute of Art, London, 1987
MA, University of Sussex, UK, 1992

Solo exhibitions
2006
De La Warr Pavilion, Bexhill-on-Sea, UK
Mercer Union—A Centre for Contemporary Art, Toronto, Canada

2005
Folk Archive: Contemporary Popular Art from the UK, Kunsthalle Basel, Switzerland
Jeremy Deller: An injury to one is an injury to all, Bawag Foundation, Vienna
Kunstverein München, Munich, Germany

2004
Turner Prize, Tate Britain, London

2003
New Works: 03.3, ArtPace, San Antonio, Texas

2002
After the Goldrush, guidebook and treasure hunt, CCA Wattis Institute for Contemporary Arts, San Francisco, California

2001
The Battle of Orgreave, with Mike Figgis, Orgreave, UK, coproduction between Artangel and Tate Britain, London

2000
Tate Britain, London

Group exhibitions
2007
Skulptur Projekte Münster, Skulptur Biennale Münsterland, Muenster, Germany

2006
Making History: Art and Documentary in Britain from 1929 to Now, Tate Liverpool, UK

2004
Manifesta 5: San Sebastian, Amsterdam

2003
Dreams and Conflicts: The Dictatorship of the Viewer, 50th Venice Biennale, Italy

Selected bibliography

Bush, Kate. "Jeremy Deller, The Battle of Orgreave." In "Best of 2001." Special issue, *Artforum* 40, no. 4 (December 2001), 94–95.

Campany, David, Lynda Morris, Mark Nash, and Tanya Barson. *Making History: Art and Documentary in Britain from 1929 to Now,* exh. cat., Liverpool, UK: Tate Publishing, 2006.

Deller, Jeremy. *After the Goldrush.* San Francisco, Calif.: CCA Wattis Institute for Contemporary Arts, 2002.

———. *The English Civil War Part II: Personal Accounts of the 1984–85 Miner's Strike.* London: Artangel, 2002.

———. *Life Is to Blame for Everything.* London: Salon 3, 1999.

Deller, Jeremy, and Glen Helfand. "Jeremy Deller Talks about *After the Gold Rush,* 2002." *Artforum* 41, no. 3 (November 2002), 170–71.

Farquharson, Alex. "Jeremy Deller, The Battle of Orgreave." *frieze* (UK), no. 61 (September 2001), 108.

Firth, Hannah, Matthew Fuller, and Simon Pope. *Art for Networks,* exh. cat., Cardiff, UK: Chapter Arts Centre, 2002.

THE DESTROY ALL MONSTERS COLLECTIVE (MIKE KELLEY, CARY LOREN, AND JIM SHAW)

Formed 1973

Solo exhibitions
2006
Strange Früt, MAGASIN—Centre National d'Art Contemporain, Grenoble, France

2000
Destroy All Monsters: Postmodern Multimedia and Musical Mutations, Center on Contemporary Art, Seattle, Washington

1996
The Deep, Tokyo

Group exhibitions
2007
Un teatro sin teatro, Museu d'Art Contemporani de Barcelona, Spain

2006
All Tomorrow's Parties, Los Angeles and London (performance)

2002
Whitney Biennial, Whitney Museum of American Art, New York

Destroy All Monsters (Mike Kelley, Cary Loren, Niagara, and Jim Shaw) Selected discography
2004
The Detroit Oratorio, Compound Annex

2001
Swamp Gas, The End is Here

1999
Bored, Cherry Red

1998
Backyard Monster Tube and Pig, The End is Here / Time Stereo

1996
Silver Wedding Anniversary, Sympathy for the Record Industry

1995
Live in Detroit, Ecstatic Peace / Father Yod
Paranoid of Blondes, Sympathy for the Record Industry

1994
Destroy All Monsters, 1974–1976, Ecstatic Peace / Father Yod

Selected bibliography

Crawford, Ashley. "Monster Men." *World Art* (Australia), no. 19 (winter 1998), 28–31.

Kelley, Mike, Cary Loren, Niagara, and Jim Shaw . *Destroy All Monsters, 1975–1979: Geisha This.* New York: Barbara Gladstone Gallery, 1995.

Perez, Christophe. "Biennale du Whitney: rendez-vous manqué (Whitney Biennial: Wasted Rendezvous)." *Oeil* (France), no. 536 (May 2002), 86.

Pollack, Barbara. "Art Rocks." *ARTnews* 101, no. 11 (December 2002), 98–101.

Princenthal, Nancy. "Whither the Whitney Biennial?" *Art in America* 90, no. 6 (June 2002), 48–51, 53.

JIM DRAIN

Born 1975 in Cleveland, Ohio
BA, Rhode Island School of Design, Providence, 1998

Solo exhibitions
2005
I Wish I Had A Beak, Greene Naftali, New York
Statements, Art Basel 36, Switzerland

2004
Eldorado (1 of 5), Galerie Drantmann, Brussels
theskywasfilledwitha1000starswhilethesunkissedthemountainsblueand11moonsplayedacrosstherainbows, Peres Projects, Los Angeles

Group exhibitions
2006
An Ongoing Low-Grade Mystery, Paula Cooper Gallery, New York
Wunderground: Providence, 1995 to the Present, The Rhode Island School of Design Museum, Providence

2005
Uncertain States of America, Astrup Fearnley Museet for Moderne Kunst, Oslo

2004
Curious Crystals Of Unusual Purity, P.S.1 Contemporary Art Center, Long Island, New York
The Infinite Fill Show, Foxy Production, New York

2003
C'est arrivé demain, 7th Biennale d'art contemporain de Lyon, France
Karaoke Death Machine, Daniel Reich Gallery, New York

2002
Whitney Biennial, Whitney Museum of American Art, New York

Selected bibliography

Amy, Michael. "Jim Drain at Greene Naftali." *Art in America* 93, no. 11 (December 2005), 143.

Cotter, Holland. "Forcefield." *New York Times,* November 22, 2002, E33.

Crawford, Ashley. "Monster Men." *World Art* (Australia), no. 19 (winter 1998), 28–31.

Herbert, Martin. Emerging Artists. "Jim Drain." *Modern Painters* (UK) (May 2006), 58–60.

Kushner, Rachel. "Jim Drain." *Artforum* 43, no. 4 (December 2004), 203.

Rinder, Lawrence. "Forcefield." *Whitney Biennial 2002,* exh. cat., New York: Whitney Museum of American Art, 2002, 80.

Sheets, Hilarie M. "Where Magic Mushrooms Bloom." *ARTnews* 105, no. 2 (February 2006), 120–21.

MARK FLORES

Born 1970 in Ventura, California
BA, University of California, Los Angeles, 1999
MFA, California Institute of the Arts, Valencia, 2002

Solo exhibitions
2006
Gone West, Alison Jacques Gallery, London

2005
Angle Lovers Take A Turn, David Kordansky Gallery, Los Angeles

Group exhibitions
2004
An Arc, Another, And So On, California State University, Los Angeles
The Lateral Slip, University of California, Riverside
Paper, Patricia Faure Gallery, Santa Monica, California
Pencil Me In, Geoffrey Young Gallery, Great Barrington, Massachusetts

2003
Inaugural Exhibition, Golinko Kordansky Gallery, Los Angeles

2001
Out of the Ground Into the Sky, Out of the Sky Into the Ground, Pond Gallery, San Francisco, California

Selected bibliography

Comer, Stuart. "Looking Back: Emerging Artists." *frieze* (UK), no. 104 (January–February 2007), 136.

Cotter, Holland. "Dealers Gather at the River, Convenient to Lofts With Bare Walls." *New York Times,* March 11, 2005, E36.

Gaines, Malik. "Mark Flores." *frieze* (UK), no. 92 (June–August 2005), 172.

Herbert, Martin. "Mark Flores." *Time Out London,* July 26–August 2, 2006, 34.

Worman, Alex. "L.A. Confidential." *artnet Magazine,* December 2, 2003. http://www.artnet.com/magazine/reviews/worman/worman11=19=03.asp. (accessed August 3, 2007).

DOUGLAS GORDON

Born 1966 in Glasgow, UK
BA, Glasgow School of Art, UK, 1988
Slade School of Art in London, 1988–90

Solo exhibitions
2006
Douglas Gordon: Timeline, Museum of Modern Art, New York

2005
Deutsche Guggenheim, Berlin
Douglas Gordon: CUT / Film as Found Object, Milwaukee Art Museum, Wisconsin

2003
Play Dead; Real Time, Gagosian Gallery, New York

2001
The Geffen Contemporary, Museum of Contemporary Art, Los Angeles

2000
Tate Liverpool, UK

1998
Kunstverein Hannover, Germany

1996
Turner Prize, Tate Britain, London

Group exhibitions
2006
Tate Triennial: New British Art, Tate Britain, London

1999
APERTO Over All, 48th Venice Biennale, Italy

1998
Berlin Biennale für Zeitgenössische Kunst

Selected bibliography

Biesenbach, Klaus. *Douglas Gordon: Timeline.* New York: Museum of Modern Art, 2006.

Brown, Katrina M. *Tate Modern Artists: Douglas Gordon.* London: Tate Publishing, 2004.

Cooke, Lynne, Stan Douglas, Douglas Gordon, and Neville Wakefield. *Double Vision: Stan Douglas & Douglas Gordon.* New York: Dia Art Foundation, 2000.

Ferguson, Russell, Michael Darling, and Douglas Gordon. *Douglas Gordon.* Cambridge, Mass.: MIT Press, 2001.

McKee, Francis, Jan Debbaut, Russell Ferguson, and Thomas Lawson. *Douglas Gordon: Kidnapping.* New York: NAI Publishers, 1998.

Schneider, Eckhard, and Douglas Gordon. *Douglas Gordon: Confessions,* exh. cat., Hannover, Germany: Kunstverein Hannover, 2005.

DAN GRAHAM

Born 1942 in Urbana, Illinois

Solo exhibitions
2005
Galerie Micheline Szwajcer, Antwerp, Belgium

2004
Lisson Gallery, London

2002
Dan Graham: Works 1965–2000, Kunsthalle Düsseldorf, Germany
Films: 1969–1973, Marian Goodman Gallery, New York
My Head is on Fire but My Heart is Full of Love, Charlottenborg Udstillingsbygning, Copenhagen

2001
Dan Graham—Retrospectiva, Museu de Arte Contemporânea de Serralves, Porto, Portugal
Dan Graham: Works 1965–2000, Kröller-Müller Museum, Otterlo, Netherlands
Musée d'Art Moderne de la Ville de Paris

1999
Dan Graham, Architekturmodelle, Kunst-Werke Institute for Contemporary Art, Berlin

Group exhibitions
2007
Un teatro sin teatro, Museu d'Art Contemporani de Barcelona, Spain
zwischen zwei toden / between two deaths, ZKM, Karlsruhe, Germany

2006
27th Bienal de São Paulo, Brazil
Day for Night, Whitney Biennial, Whitney Museum of American Art, New York
Le mouvement des images, Centre Pompidou, Musée National d'Art Moderne, Paris

2005
2nd Guangzhou Triennial, China
51st Venice Biennale, Italy
Open Systems: Rethinking Art c.1970, Tate Modern, London

2003
Dreams and Conflicts: The Dictatorship of the Viewer, 50th Venice Biennale, Italy
The Last Picture Show: Artists Using Photography, 1960–1982, Walker Art Center, Minneapolis, Minnesota

2001
Flashing into the Shadows: The Artist's Film in America 1966–76, Whitney Museum of American Art, New York

Selected bibliography

Brouwer, Marianne, Benjamin H. D. Buchloh, and Rhea Anastas. *Dan Graham: Works 1965–2000.* Düsseldorf, Germany: Richter Verlag, 2001.

Graham, Dan. *Rock My Religion: Writings and Projects 1965–1990.* Cambridge, Mass.: MIT Press, 1994.

Graham, Dan, Alexander Alberro, and Jeff Wall. *Two-Way Mirror Power: Selected Writings by Dan Graham on His Art.* Cambridge, Mass.: MIT Press in association with Marian Goodman Gallery, New York, 1999.

Graham, Dan, and Chris Dercon. *Wild in the Streets: The Sixties.* Ghent, Belgium: Imschoot, 1993.

Wall, Jeff. *Dan Graham's Kammerspiel.* Toronto, Canada: Art Metropole, 1991.

RODNEY GRAHAM

Born 1949 in Vancouver, Canada
University of British Columbia, 1968–71

Solo exhibitions
2006
Donald Young Gallery, Chicago
Hauser & Wirth, Zurich, Switzerland

2005
Rodney Graham, La Coleccion Jumex, Mexico City
Rodney Graham: A Little Thought, Art Gallery of Ontario, Toronto, Canada

Group exhibitions
2006
Day for Night, Whitney Biennial, Whitney Museum of American Art, New York

2003
C'est arrivé demain, 7th Biennale d'art contemporain de Lyon, France
Dreams and Conflicts: The Dicatatorship of the Viewer, 50th Venice Biennale, Italy
fast forward: Media Art from the Goetz Collection, ZKM, Karlsruhe, Germany
Tableaux Vivants: Living Pictures and Attitudes in Photography, Film and Video, Kunsthalle Wien, Vienna

2002
(The World May Be) Fantastic, 13th Biennale of Sydney, Australia

2000
Flight Patterns, The Geffen Contemporary, Museum of Contemporary Art, Los Angeles

Selected bibliography

Balberghe, Emile van, Yves Gevaert, Rodney Graham, and Jeff Wall. *Rodney Graham: Works from 1976 to 1994.* Toronto, Canada: York University Art Gallery, 1994.

Butler, Cornelia, Grant Arnold, Jessica Bradley, Lynne Cooke, Diedrich Diederichsen, Sara Krajewski, and Shepherd Steiner. *Rodney Graham: A Little Thought,* exh. cat., Philadelphia, Penn.: Institute of Contemporary Art, University of Pennsylvania, 2005.

Dick, Terence, and Rosemary Heather. "Pop Art: Tunesmithing in the Work of Ron Terada and Rodney Graham." *MIX* 27, no. 1 (summer 2001), 34–41.

Dyment, Dave. "Long Music and the Short Now: On Rodney Graham's Music." *C Magazine,* no. 82 (summer 2004), 26–29.

Ferguson, Russell. *Rodney Graham,* exh. cat., London: Whitechapel Art Gallery, 2002.

Stern, Steven. "River Deep Mountain High: Steven Stern on Rodney Graham." *frieze* (UK), no. 71 (2002), 62–67.

DANIEL GUZMÁN

Born 1964 in Mexico City
Licenciatura Artes Visuales, la Escuela Nacional de
Artes Plásticas, Universidad Nacional Autónoma de
México, 1989–93

Solo exhibitions
2001
*Hijo de tu puta madre (ya sé quien eres, te he estado
observando),* kurimanzutto, Mexico City

2000
Golpe de suerte, Museo de las Artes, Guadalajara,
Mexico
International Studio Program, New York
Magical Mexican Beans, ART&IDEA, New York

Group exhibitions
2007
*Escultura Social: A New Generation of Art from
Mexico City,* Museum of Contemporary Art, Chicago;
Nasher Museum at Duke University, Durham, North
Carolina

2006
Local Stories, Modern Art Oxford, UK
PINK NOT DEAD!, Garash Galería, Mexico City

2005
9th International Istanbul Biennial, Turkey
Turin Triennial, Castello di Rivoli Museo d'Arte Contem-
poranea, Italy

2004
Faces in the Crowd / Volta Nella Folla, Whitechapel
Art Gallery, London; Castello di Rivoli Museo d'Arte
Contemporanea, Turin, Italy
Todo Va a Estar Bien, Museo Tamayo Arte Contem-
poráneo, Mexico City

2003
*Il Quotidiano Alterato, Dreams and Conflicts: The
Dictatorship of the Viewer,* 50th Venice Biennale, Italy

2002
Siete Dilemas: Dialgos en el Arte Mexicano, Museo de
Arte Moderno, Mexico City

Selected bibliography
Bader, Joerg. "En los Limites de Occidente (On the
Borders of the West)." *Lapiz* 24, no. 216 (October 2005),
76–79.

Heiser, Jorg, Erden Kosova, and Jan Verwoert. "Is-
tanbul." *frieze* (UK), no. 95 (November–December
2005), 122–27.

Jezik, Enrique. "Daniel Guzmán." *Art Nexus* (Colombia)
2, no. 48 (April–June 2003), 124–25.

Molon, Dominic. "Daniel Guzmán." In *Vitamin D: New
Perspectives in Drawing.* Edited by Emma Dexter.
London and New York: Phaidon Press, 2005.

Rodrigues Widholm, Julie. *Escultura Social: A New
Generation of Art from Mexico City.* Chicago: Museum
of Contemporary Art; New Haven, Conn.: Yale Univer-
sity Press, 2007, 10–12, 14, 19, 22, 26, 32, 38, 107, 109–111,
113, 138–43, 217, 221.

RICHARD HAMILTON

Born 1922 in London
Westminster Technical College, UK
St. Martin's School of Art, London
Royal Academy School, London, 1938–40
Slade School of Art, London, 1948–51

Solo exhibitions
2007
Richard Hamilton: A Host of Angels, Fondazione Bevi-
lacqua La Masa, Venice, Italy

2003
Richard Hamilton: Editions et multiple, Le Consortium,
Dijon, France
Richard Hamilton: Introspective, Museum Ludwig,
Cologne, Germany

1986
Los Angeles County Museum
National Gallery of Canada, Toronto
Philadelphia Museum of Art, Pennsylvania

1985
Yale University Art Gallery, New Haven, Connecticut

1977
Tate Britain, London

Group exhibitions
2007
The Secret Public, Institute of Contemporary Arts,
London

2006
Into me / Out of me, P.S.1 Contemporary Art Center,
Long Island, New York; Kunst-Werke Institute for
Contemporary Art, Berlin

2004
The Undiscovered Country, Hammer Museum, Los
Angeles

2002
*Richard Hamilton / Dieter Roth: Colaborações, Rela-
ções, Confrontaões,* Museu de Arte Contemporânea
de Serralves, Porto, Portugal

1999
Examining Pictures: Exhibiting Paintings, Whitechapel
Art Gallery, London; Museum of Contemporary Art,
Chicago; Hammer Museum, Los Angeles

Selected bibliography
Blazwick, Iwona, and Simon Wilson, eds. *Tate Mod-
ern: The Handbook.* Berkeley: University of California
Press, 2000.

Hamilton, Richard. *Richard Hamilton,* exh. cat., London:
Tate Publishing, 1992.

———. *Richard Hamilton: Tuppence Coloured.*
London: Hansjorg Mayer, 2001.

Hamilton, Richard, and Richard Morphet. *Richard
Hamilton,* exh. cat., London: Tate Publishing, 1970.

Mellor, David, and John Hoole. *The Sixties Art Scene
in London,* exh. cat., London: Phaidon and Barbican
Art Gallery, 1993.

Stuttgart, G. F. R. *Richard Hamilton: Prints—A Com-
plete Catalogue of Graphic Works 1939–83.* London:
Edition Hansjorg Mayer in association with Wadding-
ton Graphics, 1984.

JAY HEIKES

Born 1975 in Princeton, New Jersey
School of Art and Design, Philadelphia,
Pennsylvania, 1993
BFA, University of Michigan, Ann Arbor, 1998
MFA, Yale University, New Haven, Connecticut, 2005

Solo exhibitions
2006
The Sixth Retelling, Shane Campbell Gallery, Chicago

Group exhibitions
2007
Ordinary Culture: Heikes / Helms / McMillian, Walker
Art Center, Minneapolis, Minnesota

2006
Day for Night, Whitney Biennial, Whitney Museum of
American Art, New York
Marianne Boesky Gallery, New York

2005
All the Pretty Corpses, The Renaissance Society at the
University of Chicago

2004
Music / Video, Bronx Museum of the Arts, New York

2003
Main Space = Project Spaces, Artists Space,
New York

2002
Jay Heikes & Kirk McCall, Midway Contemporary Art,
Minneapolis, Minnesota

2001
*Camera Works: The Photographic Impulse in Contem-
porary Art,* Marianne Boesky Gallery, New York
Weak Architecture, Midway Contemporary Art,
Minneapolis, Minnesota

Selected bibliography
Barliant, Claire. Emerging Artists. "Jay Heikes." *Mod-
ern Painters* (UK) (October 2006), 58–60.

Fallon, Michael. "Review of Recent Work at Midway
Contemporary Art." *Art Papers* (August 2002).

Ferrara, Annette. "Goth, All Grown Up." *Time Out
Chicago,* December 8–15, 2005.

Grabner, Michelle. "All the Pretty Corpses." *artUS,* no.
12 (March–April 2006), 20–21.

Kalstrom, Jeffrey. "Wall to Wall: No Name Exhibitions
at the Soap Factory." *New Art Examiner* 29, no. 2
(November–December 2001), 97–98.

Martinez, Chus. "Sculpture Forever: Contemporary
Sculpture (Part II)." *Flash Art* (Italy) 36, no. 231 (July–
September 2003), 100–107.

RICHARD KERN

Born 1954 in Roanoke Rapids, North Carolina
BFA, University of North Carolina at Chapel Hill, 1977

Solo exhibitions
2006
HOTEL, London

2005
Richard Kern: Soft, Jousse Entreprise, Paris

2004
Palais de Tokyo, Paris

1997
Feature Inc., New York

Group exhibitions
2007
Bastard Creature, Palais de Tokyo, Paris
Rock 'n' Roll Vol. 1, Norrköpings Konstmuseum,
Sweden

2005
Agua sin ti no soy, 3rd Bienal de Valencia, Spain
Trade, White Columns, New York

2004
East Village USA, New Museum of Contemporary Art,
New York

2003
Educational Books, HOTEL, London
Göteborg International Biennial for Contemporary Art,
Sweden
*Phantom der Lust. Visionen des Masochismus in der
Kunst,* Neue Galerie Graz am Landesmuseum Joan-
neum, Austria

1999
Castle Gallery, College of New Rochelle, New York

Selected bibliography
Ekroth, Power. "Against All Evens: 2nd Goteborg
Biennial." *Flash Art* (Italy) 36, no. 231 (July–September
2003), 57.

Kelsey, John. "Richard Kern." *Artforum* 43, no. 5
(January 2005), 182.

Kern, Richard. *New York Girls.* London: Taschen
Books, 1995.

———. *Soft.* New York: Universe, 2004.

Kern, Richard, and Lucy McKenzie. *Model Release.*
New York: Taschen Books, 2000.

SCOTT KING

Born 1969 in Goole, UK
BA, The University of Humberside, UK, 1992

Solo exhibitions
2006
And the Pylons Stretched for Miles, Herald St, London
Information, Bortolami Dayan, New York
Galleria Sonia Rosso, Turin, Italy

2005
White Columns, New York
Statements, Art Basel 36, Switzerland

2002
Magnani, London

Group exhibitions
2005
Bridge Freezes Before Road, Barbara Gladstone
Gallery, New York
Regarding Terror: The RAF Exhibition, Kunst-Werke
Institute for Contemporary Art, Berlin
So klappt's Modelle des Gelingens, Künstlerhaus
Mousonturm, Frankfurt, Germany

2004
*Communicate: Independent British Graphic Design
Since the Sixties,* Barbican Centre, London
Inventory / Scott King / Donald Urquhart, Portikus,
Frankfurt, Germany
Per amore, Galleria Civica d'Arte Contemporanea
Montevergini, Syracuse, Italy!

Selected bibliography
Bickers, Patricia. "'Oh Politics Schmolitics!' Art in the
Postmodern Age." *Third Text* (UK) 16, no. 4 (December
2002), 335–43.

Higgs, Matthew. First Take. "Scott King." *Artforum* 40,
no. 5 (January 2002), 119–31.

Lafuente, Pablo. "Young, Free and Single." *Art Review*
56 (June 2005), 45–46.

Walters, Helen. "Anti Fashion." *Creative Review* 21,
no. 11 (November 2001), 46–50.

Wilson, Michael. "Post No Bills—White Columns."
Artforum 44, no. 2 (October 2005), 275–76.

MARTIN KIPPENBERGER
Born 1953 in Dortmund, Germany
Died 1997 in Vienna
BA, Hamburg College of Art, Germany, 1972

Solo exhibitions
2006
Museum of Contemporary Art Grand Avenue,
Los Angeles
Tate Modern, London

2005
*Martin Kippenberger: Lieber Maler, male Mir (Dear
painter, paint for me),* Gagosian Gallery, New York

2004
Museo Nacional Centro de Arte Reina Sofía, Madrid

2003
Nach Kippenberger, Museum Moderner Kunst,
Stiftung Ludwig, Vienna
Kunstverein Braunschweig, Germany

2000
*Martin Kippenberger: Hotel Drawings and The Happy
End of Franz Kafka's "Amerika,"* Smart Museum of Art,
University of Chicago

1998
Kunsthalle Basel, Switzerland

Group exhibitions
2007
Make Your Own Life: Artists In and Out of Cologne,
Institute of Contemporary Art, Philadelphia, Penn-
sylvania; The Power Plant Contemporary Art Gallery,
Toronto, Canada; Henry Art Gallery, University of
Washington, Seattle; Museum of Contemporary Art,
North Miami, Florida
Think With the Senses—Feel With the Mind, 52nd
Venice Biennale, Italy

2002
Chère Paintre, Liebe Maler, Dear Painter, Centre
Pompidou, Musée National d'Art Moderne, Paris
My Head is on Fire but My Heart is Full of Love, Char-
lottenborg Udstillingsbygning, Copenhagen

2000
Carnegie International, Carnegie Museum of Art,
Pittsburgh, Pennsylvania
Let's Entertain, Walker Art Center, Minneapolis,
Minnesota

1999
APERTO Over All, 48th Venice Biennale, Italy
Examining Pictures: Exhibiting Paintings, Whitechapel
Art Gallery, London; Museum of Contemporary Art,
Chicago; Hammer Museum, Los Angeles

1998
*Psychoarchitecture: Martin Kippenberger and Richard
Prince,* Anton Kern Gallery, New York

Selected bibliography
Caldwell, John. *Martin Kippenberger: I Had a Vision,*
exh. cat., San Francisco, Calif.: San Francisco Museum
of Modern Art, 1991.

Koether, Jutta. "Martin Kippenberger." *Flash Art* 39, no.
247 (March–April 2006), 92–96.

Krystof, Doris, and Jessica Morgan, eds. *Kippenberger,*
exh. cat., London: Tate Publishing, January 2006.

Taschen, Angelika. *Kippenberger.* New York: Taschen
Books, 2003.

Wood, Tony. "Martin Kippenberger." *Art Monthly* (UK),
no. 295 (April 2006), 29–30.

CARMEN KNOEBEL

Selected bibliography
Fricke, Harald. "Im Palast der Fantasie: Die Kestner-
Gesellschaft in Hannover begeht ihr 75-jähriges
Jubiläum mit Imi Knoebels Ausstellung 'Pure Freude.'"
Die Tageszeitung (August 2002), 14.

Knapp, Gottfried. "Pure Freude: Die Kestner-Gesell-
schaft Hannover feiert ihr 75-jähriges Bestehen."
Süddeutsche Zeitung, August 16, 2002, 13.

Rosenfelder, Andreas. "Schallplatten und Phono:
Karaoke im Ratinger Hof; Peter Heins 'Fehlfarben'
bitten auf '26 1 / 2' zum Grauschleiertanz." *Frankfurter
Allgemeine Zeitung,* March 21, 2006, 34.

Rosenfelder, Andreas. "Kuddel? Breiti? Es ist Andi, der
hochnäsige Bassist; Einmal Ratinger Hof mit viel Ge-
fühl: In Düsseldorf treffen sich Punklegenden früherer
Tage." *Frankfurter Allgemeine Zeitung,*
January 12, 2004, 27.

JUTTA KOETHER
Born 1958 in Cologne, Germany
BA, University of Cologne, Germany, 1980
MA, University of Cologne, Germany, 1983
Whitney Museum of American Art Independent Study
Program, New York, 1992–93

Solo exhibitions
2007
Kunsthalle Bern, Switzerland

2006
Fantasia Colonia, Kölnischer Kunstverein, Cologne,
Germany

2004
Fresh Aufhebung, Reena Spaulings Fine Arts, New
York

2003
The Club in the Shadow, in collaboration with Kim
Gordon, Kenny Schachter conTEMPorary, New York

2002
Galerie Daniel Buchholz, Cologne, Germany

Group exhibitions
2007
Bastard Creature, Palais de Tokyo, Paris
zwischen zwei toden / between two deaths, ZKM,
Karlsruhe, Germany

2006
Day for Night, Whitney Biennial, Whitney Museum of
American Art, New York
Make Your Own Life: Artists In and Out of Cologne,
Institute of Contemporary Art, Philadelphia, Penn-
sylvania; The Power Plant Contemporary Art Gallery,
Toronto, Canada; Henry Art Gallery, University of
Washington, Seattle; Museum of Contemporary Art,
North Miami, Florida
Music is a Better Noise, P.S.1 Contemporary Art Center,
Long Island, New York
Replay: The Aesthetics of Art and Music / Punk,
MAGASIN—Centre National d'Art Contemporain,
Grenoble, France
The Subversive Charm of the Bourgeoisie, Van Abbe-
museum, Eindhoven, Netherlands

Selected bibliography
Graw, Isabelle. "Peripheral Vision." *Artforum* 44, no. 7
(March 2006), 258–63.

Groetz, Thomas. "Jutta Koether: Unfinished Sympa-
thies—On Jutta Koether's Art." *Afterall,* no. 7 (2003),
52–55.

Kelley, Mike. "Jutta Koether." *Journal of Contempo-
rary Art* 7, no. 1 (summer 1994), 7–24.

Koether, Jutta. *Desire Is War,* copybook cat., open ed.,
Cologne, Germany; New York, 2003.

———. *Jutta Koether,* exh. cat., Cologne, Germany:
DuMont Literatur und Kunst Verlag, 2006.

Simpson, Bennett. "From Noise to Beuys." *Artforum* 42,
no. 6 (February 2004), 59–60.

JIM LAMBIE
Born 1964 in Glasgow, UK
BA, Glasgow School of Arts, UK, 1994

Solo exhibitions
2006
Anton Kern Gallery, New York
Directions: Jim Lambie, Hirschhorn Museum and
Sculpture Garden, Washington, DC

2005
The Byrds, The Modern Institute, Glasgow, UK
Shoulder Pad, Sadie Coles HQ, London
Thirteenth Floor Elevator, Concentrations 47, Dallas
Museum of Art, Texas
Turner Prize, Tate Britain, London

2004
Mental Oyster, Anton Kern Gallery, New York

2003
Male Stripper, Modern Art Oxford, UK
Moore Space, Miami, Florida

Group exhibitions
2007
Breaking Step / Uraskoraku, Museum of Contempo-
rary Art Belgrade, Serbia

2004
54th Carnegie International, Carnegie Museum of Art,
Pittsburgh, Pennsylvania

2003
Days Like These, Tate Triennial Exhibition of Contempo-
rary British Art, Tate Britain, London

2002
My Head is on Fire but My Heart is Full of Love, Char-
lottenborg Udstillingsbygning, Copenhagen

Selected bibliography
Bracewell, Michael. *Jim Lambie: Male Stripper,* exh.
cat., Oxford, UK: Modern Art Oxford, 2004.

Bradley, Will, and Rob Tufnell. *Jim Lambie: Voidoid.*
Colgne, Germany: Walter Konig; New York: Distributed
Art Publishers, 2004.

Chivaratanond, Sylvia. "Jim Lambie." *Flash Art* (Italy)
34, no. 218 (May–June 2001), 141.

Dailey, Meghan. "Jim Lambie." *Artforum* 40, no. 3
(November 2001), 144–45.

Lunenfeld, Peter. "Jim Lambie, Lucy McKenzie, Vic-
toria Morton, Simon Starling, Cathy Wilkes, Jonnie
Wilkes." *ArtUS,* no. 70 (August–October 2000), 89.

271

MARK LECKEY
Born 1964 in London
BA, Newcastle Polytechnic, UK, 1990

Solo exhibitions
2006
Museum Het Domein, Sittard, Netherlands

2005
Portikus, Frankfurt, Germany

2003
Migros Museum für Gegenwartskunst,
Zurich, Switzerland

2002
Mark Leckey: Fiorucci Made Me Hardcore,
Santa Monica Museum of Art, California

Group exhibitions
2006
Music is a Better Noise, P.S.1 Contemporary Art Center,
Long Island, New York
Strange I've Seen that Face Before, Museum Abtei-
berg, Mönchengladbach, Germany
Tate Triennial: New British Art, Tate Britain, London
Museum Het Domein, Sittard, Netherlands

2004
*The Future Has a Silver Lining: Genealogies of Glam-
our,* Migros Museum für Gegenwartskunst, Zurich,
Switzerland
Manifesta 5: San Sebastian, Amsterdam, Netherlands

2003
Fast Forward: Media Art from the Goetz Collection,
ZKM, Karlsruhe, Germany
Mixtapes, CCA Wattis Institute for Contemporary Arts,
San Francisco, California

2002
Remix: Contemporary Art & Pop, Tate Liverpool, UK

1999
CRASH! Corporatism & Complicity, Institute of Contem-
porary Arts, London

Selected bibliography
Farquharson, Alex, and Andrea Schlieker, eds. *Brit-
ish Art Show 6,* exh. cat., London: Hayward Gallery
Publishing, 2005.

Higgs, Matthew. Openings. "Mark Leckey." *Artforum*
40, no. 8 (April 2002), 128–29.

King, Emily. "This Charming Man." *frieze* (UK), no. 81
(March 2004), 56–57.

Leckey, Mark. "LondonAtella," *Flash Art* 36, no. 228
(January–February 2003), 66–69.

White, Ian. "Mark Leckey." *Art Monthly* (UK), no. 273
(February 2004), 27–28.

Wood, Catherine. "Horror Vacui: das Subjekt als Bild in
Mark Leckey's 'Parade' (Horror Vacui: The Subject As
Image in Mark Leckey's 'Parade')." *Parkett* (Switzer-
land), no. 70 (summer 2004), 157–63.

LINDER
Born 1964 in Liverpool, UK
Manchester Polytechnic, UK, 1974–77

Solo exhibitions
2006
We who are her hero, Galerie LH, Paris

2004
The Lives of Women Dreaming, British Council, Prague

Group exhibitions
2006
Audio, Cabinet des Estampes, Geneva, Switzerland
Dereconstruction, Barbara Gladstone Gallery,
New York
Replay: The Aesthetics of Art and Music / Punk,
MAGASIN—Centre National d'Art Contemporain,
Grenoble, France
Tate Triennial: New British Art, Tate Britain, London

2003
Glamour, British Council, Prague
Plunder: Culture as Material, Dundee Contemporary
Arts, UK

2001
DEAD, Roundhouse, London

Selected bibliography
Bracewell, Michael. *The Nineties: When Surface Was
Depth.* London: Flamingo, 2002.

Bracewell, Michael, and Linder. "History is for Pissing
On." *Tate: The Art Magazine* (UK), no. 29 (summer
2002), 34–39.

Jones, Peter. "Anxious Images: Linder's Fem-Punk
Photomontages." *Women: A Cultural Review* (UK) 13,
no. 1 (March 2002), 118–19.

Linder and Lionel Bovier. *Linder: Works 1976–2006,*
Zurich, Switzerland: JRP / Ringier, 2006.

McQuiston, Liz. *Suffragettes to She-Devils.* London:
Phaidon Press, 1997.

Schmitz, Edgar. "Bilderreichtum: Tate Triennial 2006
New British Art (Picturesqueness / Abundance of
images: Tate Triennial 2006 British Art)." *Kunstforum
International* (Germany), no. 180 (May–June 2006),
387–88.

ROBERT LONGO
Born 1965 in Brooklyn, New York
State University College in Buffalo, New York

Solo exhibitions
2006
Galerie Daniel Templon, Paris
Metro Pictures, New York

1997
Kunsthalle Bielefeld, Germany
Kunsthal Rotterdam, Netherlands
Metro Pictures, New York

1996
Robert Longo: Kreuze, Museum Fridericianum,
Kassel, Germany

1995
Robert Longo: A Retrospective, The Isetan Museum
of Art, Tokyo

Group exhibitions
2007
Hot Rock, Transmission Gallery, Glasgow, UK

2006
Faster! Bigger! Better!, ZKM, Karlsruhe, Germany

2004
Whitney Biennial, Whitney Museum of American Art,
New York

2003
M_ARS–Kunst und Krieg, Neue Galerie Graz am
Landesmuseum Joanneum, Austria

1997
47th Venice Biennale, Italy

Selected bibliography
Fox, Howard N., ed. *Robert Longo 1976–1989,* exh. cat.,
Los Angeles: Los Angeles County Museum of Art, 1989.

Longo, Robert. "'80s then: Robert Longo Talks to Mary
Haus." By Mary Haus. *Artforum* 41, no. 7 (March 2003),
238–39.

———. "A Universe in Climax Sonic Grandeur: Robert
Longo Talks with Glenn Branca." By Glenn Branca.
Yard (2005), 46–53.

Neil, Jonathan T. D. "Robert Longo: The Outward and
Visible Signs of an Inward and Invisible Grace." *Art
Review,* no. 8 (February 2007), 132.

Ratcliff, Carter. *Robert Longo.* New York: Rizzoli Inter-
national, 1985.

JOSH MANNIS
Born 1976 in Boston
BFA, School of Art and Design, University of
Michigan, 1999
MFA, School of the Art Institute of Chicago, 2005

Solo exhibitions
2006
Dawn of Man, 40,000, Chicago
Iron Eagle, Small A Projects, Portland, Oregon

Group exhibitions
2007
Josh Fraught, Josh Mannis and William O'Brien,
Second Gallery, Boston
Movement Research, Monkey Town, Brooklyn,
New York

2006
Champaigne, El Particular, Mexico City; New China-
town Barbershop, Los Angeles
Eric Lebofsky, Josh Mannis and William O'Brien,
Western Exhibitions, Chicago

Mariano Chavez, Josh Mannis and Chris Uphues,
Bucket Rider Gallery, Chicago
Mixart, The James Hotel, Chicago
Versus, 40,000, Chicago

2005
Coated, 40,000, Chicago

Selected bibliography
Burns, Kristen. "For Those About to Rock." *Pittsburgh
City Paper,* May 18, 2005.

Motley, John. "Josh Mannis." *Portland Mercury,*
May 3, 2006.

Orr, Joey. "Dawn of Man: Josh Mannis at 40,000."
F Newsmagazine, December 2006, fnewsmagazine.
com/2006-oct/dawn-of-man--josh-mannis-at-40000.
php (accessed August 3, 2007).

Weinberg, Lauren. "Lebofsky, Mannis and O'Brien."
Time Out Chicago, June 29, 2006.

Workman, Michael. "Opening Night." *NewCity,*
September 5, 2006.

CHRISTIAN MARCLAY
Born 1955 in San Rafael, California
BFA, Massachusetts College of Art, Boston, 1980

Solo exhibitions
2007
White Cube, London

2003
Christian Marclay: The Bell and the Glass, Philadelphia
Museum of Art, Pennsylvania
Christian Marclay: Video Quartet, Kunsthalle
Fridericianum, Kassel, Germany
Hammer Museum, Los Angeles

2001
Currents 84: Christian Marclay, Saint Louis Art Mu-
seum, Missouri
Museum of Contemporary Art, Chicago

Group exhibitions
2006
Music is a Better Noise, P.S.1 Contemporary Art Center,
Long Island, New York

2005
thank you for the music, Sprüth Magers Projekte,
Munich, Germany

2004
5th SITE Santa Fe International Biennial

2002
Whitney Biennial, Whitney Museum of American Art,
New York

1998
White Noise, Kunsthalle Bern, Switzerland

Selected bibliography
Criqui, Jean-Pierre. "Christian Marclay: la guitare, ac-
cessoire de mode." *Cahiers du Musée National d'Art
Moderne* (France), no. 85 (fall 2003), 3–23.

Eden, Xandra. "Christian Marclay: Cinema." *Parachute* (Canada), no. 103 (July–September 2001), 3.

Ferguson, Russell. *Christian Marclay,* exh. cat., Los Angeles: Hammer Museum, 2003.

Gonzalez, Jennifer, Matthew Higgs, and Kim Gordon. *Christian Marclay.* New York: Phaidon Press, 2005.

Lee, Pamela M. "Christian Marclay." *Artforum* 42, no. 2 (October 2003), 165.

Ranaldo, Lee, and Christian Marclay. "A Conversation," *Paletten* (Sweden) 245–246 (April–May 2001), 46–49. Translated into English in *BB Gun Magazine* (October 2003), 18–23.

Steiner, Rochelle. *Currents 84: Christian Marclay,* exh. brochure, St. Louis, Mo.: St. Louis Art Museum, 2001.

ALEKSANDRA MIR
Born 1967 in Lubin, Poland
BFA, School of Visual Arts, New York, 1992

Solo exhibitions
2006
Aleksandra Mir: Organized Movement—A Video Diary, The Power Plant Contemporary Art Gallery, Toronto, Canada
Kunsthaus Zurich, Switzerland

2005
Aeropuerto, Galeria Joan Prats, Barcelona, Spain
Baloise Art Prize: Aleksandra Mir—The Big Umbrella, Stedelijk Museum voor Aktuele Kunst, Ghent, Belgium
The Most Beautiful Thing Today, White Columns, New York
New Designs: Birth, Death and Abortion, Andrew Roth Inc, New York
WELCOME Sometimes, Greengrassi Gallery, London.
The World from Above, Lisboa 20 Arte Contemporanea, Lisbon, Portugal

2004
The Big Umbrella: The New York Series, in collaboration with Chris Verene, P.S.1 Contemporary Art Center, Long Island, New York

Group exhibitions
2006
Eldorado, Musée d'Art Moderne Grand-Duc Jean, Luxembourg

Selected bibliography
Beasley, Mark, ed. *Democracy!: socially engaged art practice,* exh. cat., London: Royal College of Art, 2000.

Bradley, Will. "Life and Times: Will Bradley on Aleksandra Mir." *frieze* (UK), no. 75 (May 2003), 60–65.

Griffin, Tim. "Aleksandra Mir." *Artforum* 41, no. 6 (February 2003), 130–31.

Mir, Aleksandra, and John Kelsey. *Corporate Mentality.* New York: Lukas & Sternberg, 2003.

Williams, Gilda. "Aleksandra Mir: From A to Z." *Art Monthly* (UK), no. 266 (May 2003), 22–23.

DAVE MULLER
Born 1964 in San Francisco, California
Fine Arts Graduate Program, School of Visual Arts, New York, 1990–91
MFA, California Institute of the Arts, 1993

Solo exhibitions
2006
I Want it Louder, Barbara Gladstone Gallery, New York

2005
Stars and Bars (American), Anthony Meier Fine Arts, San Francisco, California

2004
Engholm Engelhorn Galerie, Vienna
I Like Your Music, Blum & Poe, Los Angeles
San Francisco Museum of Modern Art, California
Side Street Projects 11th Annual Phantom Ball, Pasadena, California

2003
The Approach, London
Murray Guy, New York

2002
Dave Muller: Connections, Center for Curatorial Studies Museum, Bard College, Annandale-on-Hudson, New York
Dave Muller: Sprawling (and mini-sprawl), Blum & Poe, Santa Monica, California

2001
Clothes, Polaroids, Movies & Music, Blum & Poe, Santa Monica, California
Currents 85: Dave Muller, Saint Louis Art Museum, Missouri
Galleria Allesandra Bonomo, Rome

2000
How to Secede (Without Really Trying), The Approach, London
Spatial, Murray Guy, New York
Thermal, with David Hughes, Three Day Weekend, Los Angeles

1999
Chelsea, Project Wall, Rosamund Felsen Gallery, Santa Monica, California
here and there, Four Walls, San Francisco, California

1998
Apple, Curt Marcus Gallery, New York
L, L, L, L, L, L, L, A, A, A, A, A, A, A, A, Blum & Poe, Santa Monica, California

1997
Love is All Around (In Black and White and Color), Spanish Box, Santa Barbara, California

1996
Studio 246, with Alex Slade, Künstlerhaus Bethanien, Berlin

1993
D301, California Institute of the Arts, Valencia
A Number of Ladders (Borrowed), Broad Studio #2, California Institute of the Arts, Valencia
Rex Ravenelle, David A. Muller, Due North, D300 Gallery, California Institute of the Arts, Valencia

1992
Woo, Mint Gallery, California Institute of the Arts, Valencia

1990
Games, Oblong Salon, Davis, California

1989
David A. Muller, William Matthew Humphrey, Basement Gallery, University of California, Davis

Selected bibliography
Cruz, Amada, and Matthew Higgs. *Dave Muller: Connections,* exh. cat., Annandale-on-Hudson, N.Y.: Center for Curatorial Studies, 2003.

Erickson, Karl. "Dave Muller." *Flash Art* (Italy) 34, no. 219 (July–September 2001), 122.

Higgs, Matthew. "My Pop: Dave Muller." *Artforum* 43, no. 2 (October 2004), 55.

Rugoff, Ralph. "Working Weekend: The Art of Dave Muller." *Artforum* 39, no. 9 (May 2001), 162–65.

Steiner, Rochelle. *Currents 85: Dave Muller,* exh. brochure, St. Louis, Mo.: St. Louis Art Museum, 2001.

RONALD NAMETH
Born 1942 in Detroit, Michigan
BS, Institute of Design, Illinois Institute of Technology, Chicago, 1965
MS, Institute of Design, Illinois Institute of Technology, Chicago, 1967

Solo exhibitions
2001
Exploding Plastic Inevitable (EPI), Centre Pompidou, Musée National d'Art Moderne, Paris (screening)

1999
EPI, Whitney Museum of American Art, New York (screening)

1998
EPI, Walker Art Center, Minneapolis, Minnesota (screening)

1987
EPI, Institute of Contemporary Arts, London (screening)

Group exhibitions
2006
Good Vibrations: Le arti visive e il Rock, Palazzo Delle Papesse, Centro Arte Contemporanea, Siena, Italy

2005
The Expanded Eye, Kunsthaus Zurich, Switzerland
Summer of Love: Art of the Psychedelic Era, Tate Liverpool, UK; Schirn Kunsthalle Frankfurt, Germany; Kunstalle Wien, Vienna; Whitney Museum of American Art, New York

2004
Col·lecció MACBA 2004, Museu d'Art Contemporani de Barcelona, Spain
X-Screen: Film Installations and Actions in the 1960s and 1970s, Museum Moderner Kunst, Stiftung Ludwig, Vienna

1975
The Video Show, Serpentine Gallery, London

1970
New Acquisitions Show, Museum of Modern Art, New York

1968
Film Art, Museum of Contemporary Art, Chicago

1967
Film Art, San Francisco Museum of Art, California

Selected bibliography
Renan, Sheldon, and Maya Deren. *Underground Film: An Introduction to Its Development in America.* New York: E. P. Dutton & Co., 1967.

Whitehall, Richard. "Nameth / Warhol Replace Arc with Strobe." *Los Angeles Free Press,* January 5, 1968, 16.

Youngblood, Gene. *Expanded Cinema.* New York: E. P. Dutton & Co., 1970.

———. "Ronald Nameth Exploding Plastic Inevitable." *Los Angeles Free Press,* January 12, 1968.

YOSHITOMO NARA
Born 1959 in Hirosaki, Japan
BFA, Aichi Prefectural University of Fine Arts and Music, 1985
MFA, Aichi Prefectural University of Fine Arts and Music, 1987

Solo exhibitions
2006
Stephen Friedman Gallery, London
Yoshitomo Nara: Moonlight Serenade, 21st Century Museum of Contemporary Art, Kanazawa, Japan

2004
Yoshitomo Nara: Nothing Ever Happens, Institute of Contemporary Art, Philadelphia, Pennsylvania

2000
Walk On: Works by Yoshitomo Nara, Museum of Contemporary Art, Chicago
Yoshitomo Nara: Lullaby Supermarket, Santa Monica Museum of Art, California

Group exhibitions
2006
Hyper Design, 6th Shanghai Biennale, Shanghai Art Museum, China

2003
The Japanese Experience, Museum der Moderne Salzburg, Germany

2002
Drawing Now: Eight Propositions, Museum of Modern Art, New York

2001
Superflat, The Pacific Design Center, Museum of Contemporary Art, West Hollywood, California

Selected bibliography
Darling, Michael. "Plumbing the Depths of Superflatness." *Art Journal* 60, no. 3 (fall 2001), 76–89.

Hoptman, Laura. *Drawing Now: Eight Propositions.* New York: The Museum of Modern Art, 2002.

Matsui Midori. "Japanese Innovators: Fruitful transformations of the modernist aesthetic." *Flash Art* (Italy) 33, no. 210 (January–February 2000), 90–91.

————. "Yoshitomo Nara with Midori Matsui." *Index,* no. 57 (February–March 2001), 56–64.

Smith, Roberta. "Yoshitomo Nara." *New York Times,* November 5, 1999, B39.

Yoshitomo Nara, and Kristen Chambers. *Nothing Ever Happens,* exh. cat., Cleveland, Ohio: Museum of Contemporary Art, 2004.

Yoshitomo Nara, and Hideki Toyoshima. *A to Z: Nara Yoshitomo + graf = A to Z Yoshitomo Nara + graf,* exh. cat., Hirosaki, Japan: Foil Co. Ltd., 2006.

COLIN NEWMAN
Born 1954 in Salisbury, UK

Selected solo discography
1997
Bastard, Swim

1988
It Seems, Crammed

1986
Commercial Suicide, Crammed

1982
Not to, 4AD

1981
Provisionally Entitled The Singing Fish, 4AD

1980
A–Z, Beggar's Banquet

Selected bibliography
Darke, Chris. "Pop: Plugged Into the Art of Noise." *Independent* (London), February 25, 2000, 16.

Pareles, Jon. "Pop / Jazz; First-Time and Punk Pioneers." *New York Times,* June 12,1987, C14.

Rowell, Mike. "Wire: Read & Burn 01 (Pinkflag)." *SF Weekly,* September 4, 2002.

Sturges, Fiona. "Pop: High-Wire Act." *Independent* (London), April 11, 2003, 19.

Sullivan, Jim. "Colin Newman's Entrancing Swim at The Middle East." *Boston Globe,* August 19, 1999, E2.

TONY OURSLER
Born 1957 in New York
BFA, California Institute of the Arts, Valencia, 1979

Solo exhibitions
2007
Tony Oursler: Painting + Paper, Lehmann Maupin Gallery, New York

2006
Metro Pictures, New York

2005
Cincinnati Contemporary Arts Center, Ohio
Tony Oursler at the Met: "Studio" and "Climax," The Metropolitan Museum of Art, New York

2003
Lisson Gallery, London
The Poetics Project 1977–1997, in collaboration with Mike Kelley, Barbican, London

2002
Museo d'Arte Contemporanea Roma, Rome
Tony Oursler: The Influence Machine, Magasin 3 Stockholm Konsthall

2001
Mûcsarnok, Budapest

2000
The Influence Machine, Artangel, London
Tony Oursler: The Darkest Color Infinitely Amplified, Whitney Museum of American Art, New York

1999
Introjection: Tony Oursler, 1976–1999, Contemporary Arts Museum, Houston, Texas

1998
Directions: Tony Oursler: Video Dolls, in collaboration with Tracy Leipold, Hirshhorn Museum and Sculpture Garden, Washington, DC
Kunstverein Hannover, Germany

Group exhibitions
2006
Day for Night, Whitney Biennial, Whitney Museum of American Art, New York
Good Vibrations: Le arti visive e il Rock, Palazzo Delle Papesse, Centro Arte Contemporanea, Siena, Italy
Into me / Out of me, P.S.1 Contemporary Art Center, Long Island, New York; Kunst-Werke Institute for Contemporary Art, Berlin

2005
Fondazione Sandretto Re Rebaudengo, Turin, Italy

2004
5th SITE Santa Fe International Biennial

1998
Being & Time: The Emergence of Video Projection, SITE Santa Fe
Spectacular Optical, Museum of Contemporary Art, North Miami, Florida

Selected bibliography
Burnett, Craig. "Tony Oursler's The Influence Machine." *Modern Painters* (UK) 13, no. 4 (winter 2000), 103–04.

Harris, Mark. "Mike Kelley & Tony Oursler." *Art Monthly* (UK), no. 268 (July–August 2003), 37–39.

Milley, Theresa, Elizabeth Janus, Gloria Moure, and Tony Oursler. *Tony Oursler.* Barcelona, Spain: Ediciones Polígrafa; Valencia, Spain: Institut Valencia d'Art Modern, 2001.

Romney, Jonathan. "Perfect Partner: Kim Gordon / Tony Oursler / Phil Morrison." *Modern Painters* (UK) (December 2005–January 2006), 119–20.

Wright, Karen. "Close Encounters: Tony Oursler's Alien Invasion." *Modern Painters* (UK) (February 2006), 70–77.

STEVEN PARRINO
Born 1958 in New York
Died 2005 in New York
BFA, Parson's School of Design, New York, 1982

Solo exhibitions
2006
Steven Parrino: Retrospective 1977–2004, Musée d'Art Moderne et Contemporain, Geneva, Switzerland

2004
Plan 9, Team, New York

2003
Massimo DeCarlo Arte Contemporanea, Milan, Italy

2001
Grazer Kunstverein, Graz, Austria

1996
Künstlerhaus Palais Thurn & Taxis, Bregenz, Austria

Group exhibitions
2007
Painting as Fact: Fact as Fiction, de Pury & Luxembourg, Zurich, Switzerland

2006
Cosmic Wonder, Yerba Buena Center for the Arts, San Francisco, California
Day for Night, Whitney Biennial, Whitney Museum of American Art, New York

2005
The Painted World, P.S.1 Contemporary Art Center, Long Island, New York
Sweet Temptations, Kunstmuseum St. Gallen, Switzerland
What's New Pussycat?, Museum für Modern Kunst, Frankfurt, Germany

2004
Before the End: Part I, Le Consortium, Dijon, France
None of the Above, Swiss Institute, New York

2003
C'est arrivé demain, 7th Biennale d'art contemporain de Lyon, France
Vom Horror der Kunst, Grazer Kunstverein, Graz, Austria

2002
Black Bonds: Jutta Koether and Steven Parrino, Swiss Institute, New York

Selected bibliography
Birnbaum, Daniel, and Martha Rosler. "The 2006 Whitney Biennial." *Artforum* 44, no. 9 (May 2006), 283–85.

Corris, Michael. "Steven Parrino 1958–2005." *Art Monthly* (UK), no. 285 (April 2005), 15.

Nickas, Bob, and Jutta Koether. "Dark Star." *Artforum* 43, no. 7 (March 2005), 59.

Simpson, Bennett. "From Noise to Beuys." *Artforum* 42, no. 6 (February 2004), 59–60.

Violette, Banks. Top Ten. "Banks Violette." *Artforum* 42, no. 5 (January 2004), 48.

ED PASCHKE
Born 1939 in Chicago
Died 2004 in Chicago
BFA, The Art Institute of Chicago, 1961
MFA, The Art Institute of Chicago, 1970

Solo exhibitions
2006
Ed Paschke: Chicago Icon—A Retrospective, Chicago History Museum

1999
Holland Area Art Center, Michigan

1998
Ed Paschke Retrospective: 1973–1998, Galeria Darthea Speyer, Paris

1989
Ed Paschke Retrospective, The Art Institute of Chicago; Centre Pompidou, Musée National d'Art Moderne, Paris; Dallas Museum, Texas

1983
New Paintings 1983, Hewlett Gallery, Carnegie Mellon University, Pittsburgh, Pennsylvania; Kalamazoo Institute of Art, Michigan

1982
Ed Paschke: Selected Works, 1976–1981, The Renaissance Society at the University of Chicago

Group exhibitions
2006
Day for Night, Whitney Biennial, Whitney Museum of American Art, New York

2005
Big Bang: Destruction and Creation in 20th Century Art, Centre Pompidou, Musée National d'Art Moderne, Paris

2001
79th Annual Exhibition, The Arts Club of Chicago

1999
Art of the Century / Part II, Whitney Museum of American Art, New York

1996
Art in Chicago, 1945–1995, Museum of Contemporary Art, Chicago

1987
Made in the USA: An Americanization of Modern Art, the '50's and '60's, University Art Museum, The University of California at Berkeley

1985
Whitney Biennial, Whitney Museum of American Art, New York

1984
An International Survey of Recent Painting and Sculpture, Museum of Modern Art, New York

1981
Whitney Biennial, Whitney Museum of American Art, New York

1972
Chicago Imagist Art, Museum of Contemporary Art, Chicago

Selected bibliography
Bellini, Andrea. "Whitney Biennial: 'Day For Night.'" *Flash Art* (Italy) 39, no. 248 (May–June 2006), 76–79.

Benezra, Neal, Dennis Adrian, Carol Schreiber, and John Yau. *Ed Paschke.* Chicago: The Art Institute of Chicago; New York: Hudson Hills Press, 1990.

Blinderman, B. "Ed Paschke: Reflections and Digressions on 'The Body Electric.'" *Arts Magazine* 65, no. 9 (May 1982), 130–31.

Ed Paschke, exh. cat., Paris: Centre Pompidou, 1989.

Myers, Terry R. "Freezer Burn." *Modern Painters* (UK) (May 2006), 102–03.

ADAM PENDLETON
Born 1980 in Richmond, Virginia
Artspace Independent Study Program, Pietrasanta, Italy, 2000

Solo exhibitions
2006
Adam Pendleton: BAM SPLIT LAB AND THE AFRO FUTURISTIC UNDERGROUND, Perry Rubenstein Gallery, New York

2005
Adam Pendleton: Deeper down there, Yvon Lambert , New York
Gorilla, My Love, Rhona Hoffman Gallery, Chicago

2004
Being Here, Wallspace, New York

Group exhibitions
2006
Interstellar Low Ways, Hyde Park Art Center, Chicago

2005
Double Consciousness: Black Conceptual Art Since the 1970s, Contemporary Arts Museum, Houston, Texas
Frequency, Studio Museum in Harlem, New York

2004
Optimism in Contemporary Art, Ballroom Marfa, Texas

Selected bibliography
Johnson, Ken. Art in Review. "Adam Pendleton." *New York Times,* May 20, 2005, E32.

Ligon, Glenn. "Black Light." *Artforum* 43, no. 1 (September 2004), 242–49.

Neil, Jonathon. "Adam Pendleton." *Modern Painters* (UK) (February 2007), 93.

Smith, Roberta. Art in Review. "Adam Pendleton—'Being Here.'" *New York Times,* July 23, 2004, E31.

Zieher, Scott. "His 19th Manifesto." *Art Review* (UK) 4, no. 6 (2006), 23.

RAYMOND PETTIBON
Born 1957 in Tucson, Arizona
BA, University of California, Los Angeles, 1977

Solo exhibitions
2006
Centro de Arte Contemporáneo de Málaga, Spain
Raymond Pettibon: Whatever it is you're looking for you won't find it here, Kunsthalle Wien, Vienna, Austria
Regen Projects, Los Angeles

2005
Contemporary Fine Arts, Berlin
Drawing from the Modern, 1975–2005, Museum of Modern Art, New York
Museum of Contemporary Art San Diego, La Jolla, California
Whitney Museum of American Art, New York

2001
Whitechapel Art Gallery, London

1998
Contemporary Fine Arts, Berlin
Regen Projects, Los Angeles
The Renaissance Society at the University of Chicago

Group exhibitions
2007
Panic Attack!: Art in the Punk Years, Barbican Centre, London
Think With the Senses—Feel With the Mind, 52nd Venice Biennale, Italy

2004
Whitney Biennial, Whitney Museum of American Art, New York

2002
Documenta 11, Kassel, Germany

Selected bibliography
Buchloh, Benjamin H. D. "Raymond Pettibon: Return to Disorder and Disfiguration." *October* 92 (spring 2000), 36–51.

Hettig, Frank-Alexander. "'Life / Boat': Raymond Pettibon, Jason Rhoades, Hans Weigand." *Kunstforum International* (Germany), no. 147 (September–November 1999), 452–53.

Pettibon, Raymond. *Thinking of You.* Chicago: The Renaissance Society at the University of Chicago, 1998.

Storr, Robert, Dennis Cooper, and Ulrich Look. *Raymond Pettibon.* London: Phaidon Press, 2001.

Temkin, Ann, and Hamza Walker, eds. *Raymond Pettibon: A Reader.* Chicago: The Renaissance Society at the University of Chicago; Philadelphia, Penn.: Philadelphia Museum of Art, 1998.

Turner, Grady. "Raymond Pettibon." *Bomb,* no. 69 (fall 1999), 40–47.

JACK PIERSON
Born 1960 in Plymouth, Massachusetts
BFA, Massachusetts College of Art, Boston, 1984

Solo exhibitions
2007
Regen Projects, Los Angeles

2003
Cheim & Read, New York

2002
Jack Pierson: Regrets, Museum of Contemporary Art, North Miami, Florida

1995
Jack Pierson: Traveling Show, Museum of Contemporary Art, Chicago

Group exhibitions
2007
Rock 'n' Roll Vol. 1, Norrköpings Konstmuseum, Sweden

2005
Getting Emotional, Institute for Contemporary Art, Boston

2004
Whitney Biennial, Whitney Museum of American Art, New York

2000
Au-delà du spectacle, Centre Pompidou, Musée National d'Art Moderne, Paris

1993
Whitney Biennial, Whitney Museum of American Art, New York

Selected bibliography
Avgikos, Jan. "Jack Pierson." *Artforum* 42, no. 6 (February 2004), 150–51.

Marshall, Richard D., and Jack Pierson. *Desire / Despair, A Retrospective: Selected Works 1985–2005,* New York: Rizzoli, 2006.

Molon, Dominic. *Jack Pierson: Traveling Show,* exh. cat., Chicago: Museum of Contemporary Art, 1995.

Myers, Terry R. "Jack Pierson." *Art Review* (UK) 2, no. 6 (September 2004), 105.

Pierson, Jack. *All of a Sudden.* New York: Powerhouse Books / Thea Westreich, 1995.

———. *The Lonely Life.* Edited by Gerard A. Goodman. Frankfurt, Germany: Stemmle, 1997.

Rimanelli, David. "Jack Pierson, Regrets." *Artforum* 41, no. 3 (November 2002), 179.

RICHARD PRINCE
Born 1949 in the Panama Canal Zone

Solo exhibitions
2007
Astrup Fearnley Museet for Moderne Kunst, Oslo
Fugitive Artist: The Early Work of Richard Prince, 1974–1977, Neuberger Museum of Art, The State University of New York, Purchase
Solomon R. Guggenheim Museum, New York

2002
Kunsthalle Zurich, Switzerland

2001
Richard Prince: Early Photographs 1977–79, Skarstedt Fine Art, New York

Group exhibitions
2006
Defamation of Character, P.S.1 Contemporary Art Center, Long Island, New York

2005
Undiscovered Country, Hammer Museum, Los Angeles

2004
Whitney Biennial, Whitney Museum of American Art, New York

2003
Dreams and Conflicts: The Dictatorship of the Viewer, 50th Venice Biennale, Italy
The Last Picture Show: Artists Using Photography, 1960–1982, Walker Art Center, Minneapolis, Minnesota

Selected bibliography
Prince, Richard. "'80s then: Richard Prince Talks to Steve Lafreniere." By Steve Lafreniere. *Artforum* 41, no. 7 (March 2003), 70–71.

———. *Early Photographs: 1977–1979,* exh. cat., New York: Skarstedt Fine Art, 2002.

———. "Der Hausmann: ein Interview mit Richard Prince von Isabelle Graw (The house husband: an interview with Richard Prince by Isabelle Graw)." By Isabelle Graw. *Texte zur Kunst* (Germany) 12, no. 46 (June 2002), 44–59.

———. *Jokes and Cartoons*. New York: JRP / Ringier, 2006.

Prince, Richard, Bernard Mendes Burgi, Beatrix Ruf, and Gijs Van Tuyl. *Photographs–Paintings / Paintings–Photographs*. Osfildern, Germany: Hatje Cantz Verlag, 2002.

THE RESIDENTS
Formed 1972

Selected discography
2006
River of Crime, Cordless
Tweedles, Mute Records

2005
Animal Lover, Mute Records

2002
Demons Dance Alone, Ralph America

1998
Wormwood: Curious Stories from the Bible, East Side Digital

1994
The Gingerbread Man, East Side Digital

1992
Our Finest Flowers, East Side Digital / Ralph America

1991
Freak Show, The Cryptic Corporation

1989
The King & Eye, Enigma

1998
God in 3 Persons, Ryko Records

1986
Stars & Hank Forever, Ralph Records

1985
The Big Bubble, Ralph Records

1984
George & James, Ralph Records

1982
Intermission, Ralph Records
The Tunes of Two Cities, Ralph Records

1981
Mark of the Mole, Ralph Records

1980
The Commercial Album, Ralph Records

1979
Eskimo, Ralph Records

1978
Duck Stab!, Ralph Records
Not Available, Ralph Records

1977
Fingerprince, Ralph Records

1976
The Third Reich n' Roll, Ralph Records

1974
Meet the Residents, Ralph Records

Selected bibliography
Cisar, Karel, and Miroslav Wanek. *Eyeball to Eyeball.* Prague: Argo Publishing, 1995.

Gagne, Cole. *Sonic Transports.* New York: De Falco Books, 1990.

The Residents. *The Residents—An Almost Complete Collection of Lyrics, 1972–1988.* Milan, Italy: Stampa Alternativa, 1989.

Shirley, Ian. *Meet the Residents—America's Most Eccentric Band.* London: SAF Publishing, 1993.

Uncle Willie. *Uncle Willie's Highly Opinionated Guide to The Residents.* San Francisco, Calif.: The Cryptic Corporation, 1993.

JASON RHOADES
Born 1965 in Newcastle, California
Died 2006 in Los Angeles
BFA, San Francisco Art Institute, California, 1988
MFA, University of California, Los Angeles, 1993

Solo exhibitions
2006
Centro de Artes Contemporáneo Malága, Spain
Kunsthaus Bregenz, Austria

2005
Jason Rhoades: The Black Pussy . . . and the Pagan Idol Workshop, Hauser & Wirth, London
MAGASIN—Centre National d'Art Contemporain, Grenoble, France

2003
Jason Rhoades—Meccatuna, David Zwirner, New York

2002
Jason Rhoades—PeaRoeFoam, David Zwirner, New York
Jason Rhoades—Perfect World, Galeria Helga de Alvear, Madrid
Paul McCarthy / Jason Rhoades, Hauser & Wirth, Zurich, Switzerland

2001
Portikus, Frankfurt, Germany

2000
Jason Rhoades—Perfect World, David Zwirner, New York
Jorge Pardo and Jason Rhoades: Ranch (Institutional Work), 1301PE, Los Angeles

1998
Jason Rhoades—The Purple Penis and the Venus, Kunsthalle Nürnberg, Nuremberg, Germany
Van Abbemuseum, Eindhoven, Netherlands

Group exhibitions
2007
Think With the Senses—Feel With the Mind, 52nd Venice Biennale, Italy

2001
Yokohama International Triennale of Contemporary Art, Tokyo

2000
Soft White: Lighting Design by Artists, The University Gallery, The University of Massachusetts, Amherst

1999
APERTO Over All, 48th Venice Biennale, Italy
Corinne Wasmuth und Jason Rhoades, Damenwahl, Kunsthalle Bremen, Germany

Selected bibliography
Avgikos, Jan. "Jason Rhoades." *Artforum* 39, no. 6 (February 2001), 151.

Ferguson, Russell. "Jason Rhoades: Given—1. The Caprice—2. The Ferrari." *Parkett* (Switzerland), no. 58 (2000), 120–32.

Furness, Rosalind. "Jason Rhoades: The Black Pussy. . . . and the Pagan Idol Workshop." *Modern Painters* (UK) (December 2005–January 2006), 125.

Lunn, Felicity. "Jason Rhoades." *Artforum* 43, no. 3 (November 2004), 235.

Wilson, Michael. "Jason Rhoades." *Artforum* 42, no. 4 (December 2003), 145–46.

PIPILOTTI RIST
Born 1962 in Grabs, Switzerland

Solo exhibitions
2007
A la belle étoile: Pipilotti Rist, Centre Pompidou, Musée National d'Art Moderne, Paris
Pipilotti Rist: Gravity, Be My Friend, Magasin 3 Stockholm Konsthall

2006
Contemporary Arts Museum, Houston, Texas

2005
Pipilotti Rist: London, Hauser & Wirth, London

2004
Stir Heart, Rinse Heart: Pipilotti Rist, San Francisco Museum of Modern Art, California

2001
Pipilotti Rist: Apricots Along the Street, Museo Nacional Centro de Arte Reina Sofia, Madrid

2000
The Montreal Museum of Fine Arts, Canada

1999
Kunsthalle Zurich, Switzerland

1998
Pipilotti Rist / Matrix 136, Wadsworth Atheneum, Hartford
Pipilotti Rist: Remake of the Weekend, Hamburger Bahnhof Museum für Gegenwart, Berlin

1996
Museum of Contemporary Art, Chicago

Group exhibitions
2007
Global Feminisms, Brooklyn Museum of Art, New York

2005
Ecstasy: In and About Altered States, The Geffen Contemporary, Museum of Contemporary Art, Los Angeles
F. C. Flick Collection, Hamburger Bahnhof Museum für Gegenwart, Berlin

2004
State of Play, Serpentine Gallery, London

2003
Fast Forward: Media Art from the Goetz Collection, ZKM, Karlsruhe, Germany

2002
The Starting Line, Pinakothek der Moderne, Munich, Germany
Tempo, Museum of Modern Art, New York

2001
Yokohama International Triennale of Contemporary Art, Tokyo

2000
Wonderland, Saint Louis Art Museum, Missouri

1999
3rd SITE Santa Fe International Biennial
APERTO Over All, 48th Venice Biennale, Italy

1998
Berlin Biennale für Zeitgenössische Kunst

Selected bibliography
Janus, Elizabeth. "Pipilotti Rist." *Artforum* 37, no. 8 (April 1999), 130.

Phelan, Peggy, Hans-Ulrich Obrist, and Elisabeth Bronfen. *Pipilotti Rist.* London: Phaidon Press, 2001.

Ravenal, John B., ed. *Outer & Inner Space: Pipilotti Rist, Shirin Neshat, Jane & Louise Wilson, and the History of Video Art.* Richmond: Virginia Museum of Fine Arts; Seattle: University of Washington Press, 2002.

Rist, Pipilotti. *Himalaya: Pipilotti Rist, 50Kg (nicht durchtrainiert).* Cologne, Germany: Oktagon Verlag, 1999.

———. "Psychedelic, Baby: An Interview with Pipilotti Rist." By Jane Harris. *Art Journal* 59, no. 4 (fall 2000), 68–79.

AÏDA RUILOVA

Born 1974 in Wheeling, West Virginia
BFA, University of South Florida, Tampa, 1999
MFA, School of Visual Arts, New York, 2001

Solo exhibitions
2004
Lets go!: Aida Ruilova, new videos, The Moore Space,
Miami, Florida

Group exhibitions
2007
Into me / Out of me, Museo d'Arte Contemporanea
Roma, Rome
zwischen zwei toden / between two deaths, ZKM,
Karlsruhe, Germany

2006
4th Berlin Biennale für Zeitgenössische Kunst,
Good Vibrations: Le arti visive e il Rock, Palazzo delle
Papesse, Centro Arte Contemporanea, Siena, Italy

2005
Greater New York 2005, P.S.1 Contemporary Art Center,
Long Island, New York

2004
Whitney Biennial, Whitney Museum of American Art,
New York

2003
1st Prague Biennale
Dreams and Conflicts: The Dictatorship of the Viewer,
50th Venice Biennale, Italy

2001
CASINO 2001: 1st Quadrennial, Stedelijk Museum voor
Actuele Kunst, Ghent, Belgium

Selected bibliography
Chivaratanond, Sylvia. "Aïda Ruilova." *Flash Art* (Italy)
34, no. 219 (July–September 2001), 114.

Cohen, Michael. "The New Gothic: Scary Monsters
and Super Creeps." *Flash Art* (Italy) 36, no. 231 (July–
September 2003), 108–10.

Schwabsky, Barry. "Aïda Ruilova." *Artforum* 39, no. 4
(December 2000), 148.

————. "Vampire Video: Time in the Art of Aïda Ruilo-
va." *Afterall,* no. 13 (spring–summer 2006), 65–71.

Smith, Roberta. "The Art and Artists of the Year: Auspi-
cious Debuts." *New York Times,* December 28, 2003, 37.

SAVAGE PENCIL (EDWIN POUNCEY)

Born 1951 in Leeds, UK
FSIAD, Colchester School of Art, UK, 1975
MA, Royal College of Art, London, 1978

Solo exhibitions and performance
2007
Heath of the Billy Goat, Random Gallery, Paris

2001
Psychedelic Sewage, Horse Hospital, London

1999
Institute for Contemporary Arts, London (performance)
Primers, Intoxica Gallery, London

1998
Savaged, Intoxica Gallery, London

1997
Noiseville Gallery, New York

Group exhibitions
2007
Spedition, Bremen, Germany

2002
Juxtapoz, Track 16 Gallery, Santa Monica, California
Dutched!, California State Northridge Art Galleries

2000
Pere Ubu, Mayor Gallery, London

1998
Commercial Gallery, London

1992
Comic Power: Independent / Underground Comix, Exit
Art, New York

1984
Gimpel Fils Gallery, London

Selected bibliography
Bray, Glen. "Inferno Rising: Origins and influence in
the art of Savage Pencil." *Comic Art,* no. 3, 48.

Pouncey, Edwin. "Light Laboratories." *frieze* (UK), no.
46 (May 1999), 56–59.

————. "Interview: Savage Pencil." By Stewart
Voegtlin. *StylusMagazine,* May 18, 2006. http://www.
stylusmagazine.com/articles/interview/savage-pencil.
htm (accessed August 5, 2007).

PETER SAVILLE

Born 1955 in Manchester, UK
Manchester Polytechnic, UK, 1978

Solo exhibitions
2005
Peter Saville Estate, Migros Museum für Gegen-
wartskunst, Zurich, Switzerland

Selected bibliography
Carson, Paula. "Peter Saville: 'When Routine Bites
Hard.'" *Graphis,* no. 352 (July– August 2004), 28–45.

Poyner, Rick. *Designed by Peter Saville.* Manchester,
UK: Magma Books, 2005.

Prince, Mark. "Pop / art." *Art Monthly* (UK), no. 276
(May 2004), 6–9.

Smee, Sebastian. "On the Outside Looking in." *Art
Review* 2, no. 6 (June 2004), 60–63.

Vickers, Graham. "Saville." *Creative Review* 20, no. 1
(January 2000), 27–31.

MELANIE SCHIFF

Born 1977 in Chicago
Goldsmiths College, University of London, 1999
BFA, New York University, 1999
MFA, University of Illinois, Chicago, 2002

Solo exhibitions
2007
UBS 12 x 12: New Artists / New Work, Museum of
Contemporary Art, Chicago

2006
Kavi Gupta Gallery, Chicago

2004
New Photographs, Kavi Gupta Gallery, Chicago

Group exhibitions
2005
Autonomy, Foxy Production, New York
Into the Woods, Thomas McCormick Gallery, Chicago
Stilled Life, Placemaker Gallery, Miami, Florida
Sitting, Standing, Reclining II, Modern Culture, New
York

2004
Kristen + Melanie, Suitable Gallery, Chicago

2002
Here and Now, Chicago Cultural Center
Use Your Illusion, Vedanta Gallery, Chicago

Selected bibliography
Camper, Fred. "Everyday Beauty." *Chicago Reader,*
January 4, 2007.

Hannum, Terence. "Not Until Named," *Bridge Maga-
zine* (fall 2004).

McKinnon, John. "Melanie Schiff." *Time Out Chicago,*
January 4–10, 2007.

Sholis, Brian. "Melanie Schiff," *Artforum,* http://www.
artforum.com (January 4, 2007).

THADDEUS STRODE

Born 1964 in Santa Monica, California
BFA, California Institute of the Arts, Valencia, 1986

Solo exhibitions
2006
Thaddeus Strode: Between Midnight and Morningside,
Galleri K, Oslo

2005
Yellow: Thaddeus Strode, Giò Marconi Gallery,
Milan, Italy

2004
Thaddeus Strode: Folktales, Galerie Michael Janssen,
Cologne, Germany; neugerriemschneider, Berlin

2001
The Agency, London
TBA exhibition space, Chicago
Thaddeus Strode: Fresh meat for sailing ships, neuger-
riemschneider, Berlin

2000
Ghosts Adrift, Kunstverein Heilbronn, Germany
Künstlerhaus Palais Thurn & Taxis, Bregenz, Austria

1995
Galleri Nicolai Wallner, Copenhagen

1991
Luhring Augustine Hetzler, Santa Monica, California

Group exhibitions
2007
Imagination becomes Reality, ZKM, Karlsruhe, Ger-
many

2005
thank you for the music, Sprüth Magers Projekte,
Munich, Germany

2003
M_ARS—Kunst und Krieg, Neue Galerie Graz am
Landesmuseum Joanneum, Graz, Austria; neuger-
riemschneider, Berlin

2002
Out at sea: Thaddeus Strode, Giò Marconi Gallery,
Milan, Italy

Selected bibliography
Folland, Tom. Reviews. *Art Issues,* no. 35 (Novem-
ber–December 1994), 46.

Kandel, Susan. "Thaddeus Strode: A Post-Conceptual-
ist With Substance." *Los Angeles Times,* September
29, 1994, F4.

Löbke, Matthia. *Thaddeus Strode: Ghosts Adrift,* exh.
cat., Heilbronn, Germany: Kunstverein Heilbronn;
Bregenz, Austria: Künstlerhaus Palais Thurn & Taxis;
Cologne, Germany: Oktagon, 2000.

Pagel, David. Arts Reviews. *Los Angeles Times,* No-
vember 21, 1992, S8.

Purcell, Gregory. "Thaddeus Strode at TBA Exhibition
Space." *New Art Examiner* 28, no. 8 / 9 (May–June
2001), 91F.

Weissman, Benjamin. Reviews. *Artforum* 31, no. 6
(February 1993), 105.

MIKA TAJIMA / NEW HUMANS

Born 1975 in Los Angeles
BA, Bryn Mawr College, Philadelphia,
Pennsylvania, 1997
MFA, School of the Arts, Columbia University, New
York, 2003

Solo exhibitions and performance
2005
Echoplex, Swiss Institute Contemporary Art, New York
Grass Grows Forever in Every Possible Direction,
Walker Art Center, Minneapolis, Minnesota

2003
New Humans Collective, Maccarone, Inc., New York
(performance)

277

Group exhibitions
2006
Bunch, Alliance and Dissolve, Contemporary Arts Center, Cincinnati, Ohio
Interface in Your Face, Swiss Institute Contemporary Art, New York
Music is a Better Noise, P.S.1 Contemporary Art Center, Long Island, New York
Yankee Doodle Flea Market, United Bamboo, Tokyo

2005
Tonight we are Golden, Institute of Contemporary Arts, London
Uncertain States of America, Astrup Fernley Museet for Moderne Kunst, Oslo; Bard Center for Curatorial Studies, Annandale-on-Hudson, New York; Serpentine Gallery, London; Reykjavik Art Museum, Iceland; Musée d'Art Moderne de la Ville de Paris; The Herning Art Museum, Denmark

2003
Surface Tension, Fabric Workshop and Museum, Philadelphia, Pennsylvania

2002
Comfort Zone, Fabric Workshop and Museum, Philadelphia, Pennsylvania

2000
Foreign Body, White Columns, New York

Selected bibliography
Armetta, Amoreen. "Along for the Ride." *Time Out New York,* March 11–18, 2004.

Bentley, Kyle. "Associative Property." *Artforum* 45, no. 6 (February 2007), 123.

Morton, Tom. "Uncertain States of America." *frieze* (UK), no. 97 (March 2006), 159.

Ridge, Tom. "New Humans." *Wire,* no. 259 (September 2005).

Smith, Roberta. "Menace, Glitter and Rock in Visions of Dystopia." *New York Times,* December 29, 2006, E39.

MUNGO THOMSON
Born 1969 in Woodland, California
BA, University of California, Santa Cruz, 1991
Whitney Museum of American Art Independent Study Program, New York, 1994
MFA, University of California, Los Angeles, 2000

Solo exhibitions
2007
Mungo Thomson: Between Projects, Kadist Art Foundation, Paris

2006
Mungo Thomson: Negative Space Variations, Galleria d'Arte Moderna e Contemporanea di Bergamo, Italy

2005
New York, New York, New York, New York, John Connelly Presents, New York

2004
University Art Museum, California State University, Long Beach, California

Group exhibitions
2006
Prophets of Deceit, CCA Wattis Institute for Contemporary Arts, San Francisco, California

2004
California Biennial, Orange County Museum of Art, Newport Beach

2002
Rock My World, CCA Wattis Institute for Contemporary Arts, San Francisco, California

2001
Drawn from LA, Midway Contemporary Art, Minneapolis, Minnesota
Record All-Over, Musée d'Art Moderne et Contemporain, Geneva, Switzerland

Selected bibliography
Geer, Susan. "Mungo Thomson at CSU Long Beach." *Artweek* 36, no. 1 (February 2005), 17.

Miles, Christopher. "Mungo Thomson." *Artforum* 43, no. 3 (November 2004), 230.

Olsen, Erica, Ralph Rugoff, Ann Powers, and Matthew Higgs. *Rock My World: Recent Art and the Memory of Rock 'n' Roll,* exh. cat., San Francisco, Calif.: CCA Wattis Institute for Contemporary Arts, 2002.

Ratner, Megan. "Mungo Thomson." *frieze* (UK), no. 94 (October 2005), 233.

Tumlir, Jan. "California Biennial: Various Venues." *Artforum* 43, no. 6 (February 2005), 168.

Valdez, Sarah. "Mungo Thomson at Margo Leavin." *Art in America* 89, no. 2 (February 2001), 150.

THROBBING GRISTLE
(CHRIS CARTER, PETER "SLEAZY" CHRI-
STOPHERSON, GENESIS P-ORRIDGE, AND
COSEY FANNI TUTTI)
Formed 1975

Selected exhibitions and performances
2005
TG@KW: Industrial Annual Report, KW Institute for Contemporary Art, Berlin

2004
Camber Sands, Sussex, UK (performance)

2002
TG24, Cabinet Gallery, London

1981
Kezar Pavilion, San Francisco (performance)

1980
SO36 Club, Berlin (performance)

1976
Air Gallery, London (performance)
Prostitution, Institute of Contemporary Arts, London (performance)

Selected discography
2007
Part Two: The Endless Not, Industrial Records / Mute Records

2004
Live December 2004: A Souvenir of Camber Sands, Industrial Records / The Grey Area of Mute Records
Mutant TG, Industrial Records / Novamute
The Taste of TG: A Beginner's Guide to the Music of Throbbing Gristle, Industrial Records / The Grey Area of Mute Records
TG+, Novamute
TG Now, Industrial Records / The Grey Area of Mute Records

1993
In the Shadow of the Sun, Mute Records
Journey Through a Body, Mute Records
Live—Volume 1: 1976–1978, Industrial Records / The Grey Area of Mute Records
Live—Volume 2: 1977–1977, Industrial Records / The Grey Area of Mute Records
Live—Volume 3: 1978–1979, Industrial Records / The Grey Area of Mute Records
Live—Volume 4: 1979–1980, Industrial Records / Mute Records

1990
Throbbing Gristle's Greatest Hits, The Grey Area of Mute Records

1986
Sacrifice, Castle Communications
Tqcd1, Industrial Records / The Grey Area of Mute Records

1982
Thee Psychick Sacrifice, Illuminated Records

1981
Funeral in Berlin, Zensor Records
Mission of Dead Souls, Mute Records

1980
Heathen Earth, Industrial Records

1979
20 Jazz Funk Greats, Industrial Records
D.O.A. The Third and Final Report of Throbbing Gristle, Industrial Records

1977
2nd Annual Report of Throbbing Gristle, Industrial Records

Selected bibliography
Bonn, Chris. "The Masthead." *Wire,* no. 281 (July 2007), 4.

Ford, Simon. *Wreckers of Civilization: The Story of COUM Transmissions and Throbbing Gristle.* London: Black Dog Publishers, 2000.

Higgs, Matthew. "Hard Acts to Follow." *Artforum* 41, no. 9 (May 2003), 34.

Savage Pencil. "Trip or Squeek." *Wire,* no. 281 (July 2007), 9.

Stubbs, David. "Clearing the Wreckage." *Wire,* no. 281 (July 2007), 30–37.

Vale, V. *William Burroughs, Bion Gysin, Throbbing Gristle: RE / Search #4 / 5.* San Francisco, Calif.: RE / Search Publications, 1982.

Vale, V., and Andrea Juno. *Industrial Culture Handbook: RE / Search #6 / 7.* San Francisco, Calif.: RE / Search Publications, 1982.

RIRKRIT TIRAVANIJA
Born 1961 in Buenos Aires
BA, The Ontario College of Art, Toronto, Canada, 1980–84
The School of the Art Institute of Chicago, 1984–86
The Whitney Independent Studies Program, New York, 1986

Solo exhibitions
2005
The Hugo Boss Prize 2004, Solomon R. Guggenheim Museum, New York
Rirkrit Tiravanija: Une rétrospective (tomorrow is another fine day), Museum Boijmans Van Beuningen Rotterdam, Netherlands; Musee d'Art Moderne de la Ville de Paris; Serpentine Gallery, London

2004
Galerie Chantal Crousel, Paris

2002
Wiener Secession, Vienna

2001
Portikus, Frankfurt, Germany

1998
Rirkrit Tiravanija: Das soziale Kapital, Migros Museum für Gegenwartskunst, Zurich, Switzerland

Group exhibitions
2007
Gordon Matta-Clark & Rirkrit Tiravanija, David Zwirner, New York
Into me / Out of me, Museo d'Arte Contemporanea Roma, Rome

2006
Day for Night, Whitney Biennial, Whitney Museum of American Art, New York

2005
Expérience de la durée, 8th Biennale d'art contemporain de Lyon, France
Universal Experience: Art, Life, and the Tourist's Eye, Museum of Contemporary Art, Chicago; The Hayward Gallery, London; Museo d'Arte Moderna e Contemporanea di Trento e Rovereto, Italy

2004
Satellite of Love, Witte de With, Rotterdam, Netherlands

2003
2nd Bienniale Tirana, Albania

2001
Public Offerings, The Geffen Contemporary, Museum of Contemporary Art, Los Angeles

1999
APERTO Over All, 48th Venice Biennale, Italy

1998
Berlin Biennale für Zeitgenössische Kunst

1997
Performance Anxiety, Museum of Contemporary Art, Chicago

Selected bibliography
Chapuis, Yvane. "Rirkrit Tiravanija: The Space of Unconditional Action." *Parachute* (Canada), no. 101 (January 2001), 14–25.

Siegel, Katy. "Rirkrit Tiravanija." *Artforum* 38, no. 2 (October 1999), 146.

Steiner, Barbara. "Rirkrit Tiravanija: 'ON STAGE.'" *Kunstforum International,* no. 155 (June–July 2001), 212–15.

Tiravanija, Rirkrit, and Udo Kittelmann. *Rirkrit Tiravanija: Untitled, 1996 (Tomorrow is Another Day),* exh. cat., Cologne, Germany: Kolnischer Kunstverein, 1996.

Wilsher, Mark. "Rirkrit Tiravanija." *Art Monthly* (UK), no. 273 (February 2004), 24–25.

ANDY WARHOL
Born 1929 in Pittsburgh, Pennsylvania
Died 1987 in New York
Carnegie Institute of Technology, Pittsburgh, Pennsylvania, 1949

Solo exhibitions
2005
ANDY WARHOL / SUPERNOVA: Stars, Deaths, Disasters, 1962–1964, Walker Art Center, Minneapolis, Minnesota; Museum of Contemporary Art, Chicago; Art Gallery of Ontario, Toronto, Canada

2003
Andy Warhol: Screen Tests, Wexner Center for the Arts, Columbus, Ohio
Andy Warhol's Time Capsules, Museum für Modern Kunst, Frankfurt, Germany

2001
Andy Warhol: Photography, International Center of Photography, New York
Andy Warhol Retrospektive, Neue Nationalgalerie, Berlin

1999
The American Century: Art & Culture, 1900–2000 Part II, Whitney Museum of American Art, New York

1998
Andy Warhol: A Factory, Kunstmuseum Wolfsburg, Germany
Kunstmuseum Basel, Switzerland
Andy Warhol: After the Party, Works 1956–1986, Irish Museum of Modern Art, Dublin
Andy Warhol: Shadows, Dia Art Foundation, New York

Group exhibitions
2006
Into me / Out of me, P.S.1 Contemporary Art Center, Long Island, New York; Kunst-Werke Institute for Contemporary Art, Berlin
Les movement des images, Centre Pompidou, Musée National d'Art Moderne, Paris
Strange I've Seen that Face Before, Museum Abteiberg, Mönchengladbach, Germany

2005
Expérience de la durée, 8th Biennale d'art contemporain de Lyon, France
50 Jahre / Years documenta 1955–2005, Kunsthalle Fridericianum, Kassel, Germany
Open Systems: Rethinking Art c. 1970, Tate Modern, London
Summer of Love: Art of the Psychedelic Era, Tate Liverpool, UK; Schirn Kunsthalle Frankfurt, Germany; Kunsthalle Wien, Vienna; Whitney Museum of American Art, New York
Universal Experience: Art, Life, and the Tourist's Eye, Museum of Contemporary Art, Chicago; The Hayward Gallery, London; Museo d'Arte Moderna e Contemporanea di Trento e Rovereto, Italy

2003
Dreams and Conflicts: The Dictatorship of the Viewer, 50th Venice Biennale, Italy
Splat Boom Pow! The Influence of Comics in Contemporary Art, Contemporary Arts Museum, Houston, Texas

2002
My Head is on Fire but My Heart is Full of Love, Charlottenborg Udstillingsbygning, Copenhagen

Selected bibliography
Angell, Callie. *Andy Warhol Screen Tests: The Films of Andy Warhol.* New York: Harry N. Abrams, Inc., 2006.

Frei, Georg, and Neil Printz. *The Andy Warhol Catalogue Raisonné: Paintings and Sculpture 1961–1963, Vol. 1.* New York and London: Phaidon Press, 2005.

Honnef, Klaus. *Warhol.* New York: Taschen Books, 2000.

Koestenbaum, Wayne. *Andy Warhol.* New York: Viking Penguin, 2001.

McShine, Kynaston, ed. *Andy Warhol: A Retrospective (First Edition),* exh. cat., New York: Museum of Modern Art, 1989.

Michelson, Annette, and Benjamin H. D. Buchloh. *Andy Warhol.* Cambridge, Mass.: MIT Press, 2002.

MARNIE WEBER
Born 1959 in Bridgeport, Connecticut
BA, University of California, Los Angeles, 1981

Solo exhibitions
2007
Patrick Painter, Inc., Santa Monica, California

2005
Galerie Praz-Delavallade, Paris

Group exhibitions
2007
Multiple Vantage Points: Southern California Women Artists, 1980–2006, Barnsdall Art Park, Los Angeles Municipal Art Gallery

2006
All we ever wanted was everything, Centre d'Art Contemporain de la Synagogue de Delme, France

2004
100 Artists See God, Institute of Contemporary Arts, London
Certain Traces: Dialogue Los Angeles / Prague 2004, Barnsdall Art Park, Los Angeles Municipal Art Gallery

2003
LA Post Cool, Ben Maltz Gallery, Otis College of Art and Design, Los Angeles

2002
Wonderland, Aeroplastics Contemporary, Brussels

2001
Printemps de Septembre, Toulouse, France

2000
Philosophy in the Bedroom, Or Gallery, Vancouver, Canada

1999
A Girl Like You, Galerie Praz-Delavallade, Paris

Selected bibliography
Balogh, Lizzy. "Video Displayed: Marketing Mixes Forms." *PAJ* 22, no. 3 (September 2000), 58–65.

Johnson, Ken. "Art Guide: Marnie Weber." *New York Times,* April 20, 2001, 33.

Kino, Carol. "Marnie Weber at Fredericks Freiser." *Art in America* 90, no. 1 (January 2002), p. 108.

Miles, Christopher. "Marnie Weber." *Artforum* 39, no. 1 (September 2000), 182.

Pecoil, Vincent. "Marnie Weber at Galerie Praz-Delavallade." *Flash Art* (Italy) 38, no. 241 (March–April 2005), 121.

CHARLIE WHITE
Born 1972 in Philadelphia, Pennsylvania
BFA, School of the Visual Arts, New York, 1995
MFA, Art Center College of Design, Pasadena, California, 1998

Solo exhibitions
2006
Charlie White: Everything is American, Andrea Rosen Gallery, New York

2003
Andrea Rosen Gallery, New York

Group exhibitions
2007
Rock 'n' Roll Vol. 1, Norrköpings Konstmuseum, Sweden
zwischen zwei toden / between two deaths, ZKM, Karlsruhe, Germany

2004
I feel mysterious today, The Palm Beach Institute of Contemporary Art, Lake Worth, Florida

2002
California Biennial, Orange County Museum of Art, Newport Beach

2001
My Reality: Contemporary Art and the Culture of Japanese Animation, Brooklyn Museum of Art, New York

2000
(extra)super[meta], Yerba Buena Center for the Arts, San Francisco, California

Selected bibliography
Dery, Mark. "Charlie White: L.A. Creep show." *Artext,* no. 74 (August–October 2001), 48–55.

Kastner, Jeffrey. "Charlie White: Andrea Rosen Gallery." *Artforum* 44, no. 7 (March 2006), 290.

Siegel, Katy. "Charlie White." *Artforum* 37, no. 10 (summer 1999), 156.

Tatley, Roger. "Charlie White: Everything is American." *Modern Painters* (UK) (April 2006), 115.

Tumlir, Jan. *Charlie White: Everything is American,* exh. cat., Salamanca, Spain: Fundación Salamanca Ciudad de Cultura, 2006.

White, Charlie. *And Jeopardize the Integrity of the Hull.* Paris: TDM, 2003.

KARL WIRSUM
Born 1939 in Chicago
BFA, School of the Art Institute of Chicago, 1966

Solo exhibitions
2007
Winsome Works(some), Chicago Cultural Center

1997
The University of Iowa Museum of Art, Iowa City

1991
Krannert Art Museum, University of Illinois, Urbana-Champaign

1982
Southeastern Center for Contemporary Art, Winston-Salem, North Carolina

1981
Hare Toddy Kong Tamari: Selected Objects by Karl Wirsum, Museum of Contemporary Art, Chicago

Group exhibitions

2004
From Folk to Funk: Selections from the Robert A. Lewis Collection, Corcoran Gallery of Art, Washington, DC

2003
Faces, Places & Inner Spaces, The Art Institute of Chicago

1998
Making Marks, Milwaukee Art Museum, Wisconsin

1990
Word as Image / American Art 1960–1990, Milwaukee Art Museum, Wisconsin

1987
Made in the U.S.A.: An Americanization in Modern Art, the 50's and 60's, University of California, Berkeley

1980
Who Chicago? An Exhibition of Contemporary Imagists, Sunderland Arts Centre, London

1972
Chicago Imagist Art, Museum of Contemporary Art, Chicago

Selected bibliography

Adrian, Dennis. *Karl Wirsum: A Retrospective Exhibition,* exh. cat., Urbana-Champaign, Ill.: Krannert Art Museum, University of Illinois, 1991.

Vine, Richard. "Where the Wild Things Were." *Art in America* 85, no. 5 (May 1997).

Warren, Lynne. *Art in Chicago: 1945–1995,* exh. cat., Chicago: Museum of Contemporary Art, 1996.

Wirsum, Karl, Larry Silverman, and John Neff. *Karl Wirsum: Winsome Works(some),* exh. cat., Chicago: Department of Cultural Affairs, 2007.

Yood, James. "Karl Wirsum." *Artforum* 39, no. 5 (January 2001), 142–43

WORKSHOP
Formed 1990

Selected discography

2004
Yog Sothoth, Sonig Records

2001
Es liebt Dich und Deine Körperlichkeit ein Ausgeflippter (A flipped-out person loves and your physicality), Sonig Records

1997
DJ Enrique & Subtle Tease On Workshop's Meiguiweisheng Xiang, Ladomat 2000
Meiguiweisheng Xiang, Ladomat 2000

1995
Talent, L'age d'Or
The Talent E.P. by DJ Enrique, Ladomat 2000
Talent, Meiguiweisheng Xiang & previously unreleased Mundwinkelplage, Ladomat 2000

1992
Welcome Back the Workshop, Finlayson Tonträger

1990
People Take Action to Receive Certain Results, like the Workshop now Deliberately Giving in to an Urge to Make Music, Finlayson Tonträger

THOMAS ZIPP
Born 1965 in Heppenheim, Germany
Slade School, London, 1996
Leaving Certificate, Freien Kunst Städelschule Frankfurt, Germany, 1992–98

Solo exhibition

2006
Uranlicht, Harris Lieberman Gallery, New York

Group exhibitions

2007
Gallery Swap, Hotel Gallery, London
Kommando Friedrich Hölderlin Berlin, Galerie Max Hetzler, Berlin

2006
4th Berlin Biennale für Zeitgenössische Kunst
Faster! Bigger! Better!, ZKM, Karlsruhe, Germany
Rattus Norvegicus, Leopold Hoesch Museum, Düren, Germany
Rings of Saturn, Tate Modern, London

2005
When Humor Becomes Painful, Migros Museum für Gegenwartskunst, Zurich, Switzerland

2004
Kommando Pfanenkuchen, Daniel Hug Gallery, Los Angeles

2003
actionbutton, Hamburger Bahnhof Museum für Gegenwart, Berlin

2002
Friede Freiheit Freude, Galerie Guido Baudach, Berlin

2000
Landscape, Galerie Giti Nourbakhsch, Berlin

Selected bibliography

Lieberman, Harris. Art in Review. "Thomas Zipp." *New York Times,* June 2, 2006, 31.

Rosenberg, Angela. "Thomas Zipp." *Flash Art* (Italy) 33, no. 215 (November–December 2000), 110–11.

Scholis, Brian. "Thomas Zipp." *Artforum* 45, no. 1 (September 2006), 378–79.

Zipp, Thomas. *Thomas Zipp: Neroin & The New Breed.* Berlin: Guido W. Baudach, 2004.

Zipp, Thomas, and Veit Loers. *Thomas Zipp: Achtung! Vision.* Ostfildern, Germany: Hatje Cantz Publishers, 2006.

ACKNOWLEDGMENTS

This exhibition has been living in my head since the day in the mid 1980s in Chicago when as a high-school student I saw a mid-career Anselm Kiefer survey exhibition at the Art Institute followed by a screening of Jonathan Demme's concert film of the Talking Heads, *Stop Making Sense* down Michigan Avenue at the now-defunct Fine Arts Theater. Both experiences left me spellbound and convinced that something in between the two was where I wanted my life to go. I am indebted to the MCA for allowing me to realize this prospect in the form of an exhibition—*Sympathy for the Devil: Art and Rock and Roll Since 1967*—that fulfills the ambition I've had for many years to celebrate the inspired relationship between rock music and the avant-garde, which has now lasted four decades. It is perhaps the height of all ironies that a museum director inclined toward *bel canto* opera should find himself providing enthusiastic support for an exhibition focusing on music that is, at its best, more of a tumultuous caterwaul than a "beautiful song." I am therefore most grateful to Robert Fitzpatrick, Pritzker Director, for being that museum director. Elizabeth Smith, James W. Alsdorf Chief Curator and Deputy Director for Programs, has also been steadfast in her guidance and patience with an obstreperous show and its curator, and I thank her warmly for her calm insights and rationality.

An exhibition covering forty years of a cultural history demands the near-impossible from a museum's staff, and I wish to thank all of the MCA for their efforts and support in the realization of this vision. In particular, I wish to recognize Greg Cameron as well as Kaitlin Allen, Julie Havel, and Rob Sherer in the Development Department for their efforts in securing funding for the show; Jennifer Draffen, Michael Green, Amy Louvier, Amy Lukas, and Michael David Rose for managing artist contracts, shipping and crating, and rights and reproduction matters; Scott Short and the installation crew for their magnificent installation of this incredibly challenging show; and Dennis O'Shea for his brilliant handling of all the technical demands of the exhibition. Peter Taub and Yolanda Cesta Cursach and the staff of the Performance Department deserve thanks for their development of a complementary program of performance events. Angelique Power, Chaz Olajide, and Michelle Zis in the Marketing Department created effective promotional materials for the show as well as the festival of local music performance in tandem with Intonation, Chicago; Karla Loring and Erin Baldwin coordinated all press and publicity for the exhibition; Erika Hanner, Sarah Jesse, Kristin Kaniewski, and Susan Musich developed and executed an array of educational programs to complement the show; and Caitlin Martell and the Visitor Services staff dealt with the challenges presented by this exhibition with patience and aplomb.

There is no way this exhibition could have been accomplished without the phenomenal efforts of Kate Kraczon, who coordinated loan agreements, artists' travel, and myriad other details in addition to providing useful new bits of rock knowledge. Joe Madura, our 2007 Marjorie Susman Curatorial Fellow, was nothing short of a miracle worker in his intrepid dedication to the timeline, biographies, and bibliographies of the catalogue and so many other aspects of the show. I also wish to thank the curatorial interns who worked so hard on the exhibition, including Leslie Cozzi, Tijana Jovanovic, Alexis Klein, John McKinnon, and Lauren Whitney.

Special thanks go to my colleague Julie Rodrigues Widholm for offering occasional feedback and sympathy for her office mate.

This book was guided by the always-brilliant Hal Kugeler and designed by Jonathan Krohn, whose visual sensibilities and instincts were spot-on and who was an incredible conspirator in this effort. Alfredo Ruiz did a killer job on the design of the timeline. I also wish to recognize the excellent editorial work of MCA editor Kamilah Foreman as well as her Herculean efforts in combing through the back matter of the book and dealing with many other details. I thank Sarah Kramer for her sharp copyediting and indexing as well as editorial interns Nicole Huiras and Lauren Payne. My old friend and former colleague Amy Teschner performed heroically in her masterful editing of the texts in the book and provided incredibly valuable insights throughout the process. Thanks, too, to Tawney Becker for her careful translation of Diedrich Diederichsen's essay and Kathy Willhoite for her careful proofreading. Amanda Freymann kept us all on track, and I am grateful for her contribution to the success of the publication. It is wonderful to work with Yale University Press; I thank Patricia Fidler, Michelle Komie, and Carmel Lyons at Yale for their enthusiasm, counsel, and support.

The coordination of bringing over 130 works of art to the MCA required the tireless efforts of the numerous individuals at galleries, museums, and artist's studios who are recognized in the list that follows. I also heartily thank the lenders to the exhibition who are identified on page 6.

I am grateful to many people who were generous with their time, critical perspectives, and advice or in providing contact information to track down this artist or video or book, etc. Matt Aberle,

Rachel Adams, Duncan Anderson, Jacob Austen, Cindy Bernard, Barry Blinderman, Danielle Bond, Michael Bracewell, Blake Bradford, Glenn Branca, Kerry Brougher, Keith Couser, Amada Cruz, Jim DeRogatis, Lina Dzuverovic, Anne Ellegood, Russell Ferguson, Douglas Fogle, Ellen Haddigan, Terence Hannum, Matthew Higgs, Heather Hubbs, Henriette Huldisch, Marianne Hultmann, Cameron Jamie, Stefan Kalmar, Shamim M. Momin, Markus Mueller, John Phillips, Andrew Rafacz, Tom Recchion, Noellie Roussel, Kerry Schuss, Joe Shanahan, Jim Shaw, Bennett Simpson, Paul Smith, Mayo Thompson, Pete Toalson, Sarah Thornton, Scott Treleaven, Hamza Walker, and Allison Wilbur all receive my sincerest thanks in that regard.

I am especially grateful to Bonnie Clearwater, Director of the Museum of Contemporary Art, North Miami, for bravely committing to presenting the exhibition in summer of 2008 and to Kevin Arrow for his early assistance with that museum's presentation of the show.

The heart of this book exists in the insights of the essayists who contributed new texts or either refurbished or gave permission to use existing texts. I therefore owe Diedrich Diederichsen, Anthony Elms, Dan Graham, Richard Hell, Mike Kelley, Bob Nickas, Simon Reynolds, and Jan Tumlir a profound debt of gratitude. All of the above also provided much-appreciated critical guidance as well.

My sincere thanks are extended to the musicians and artists whose work appears in the exhibition in one form or another, and many of whom provided valuable insights (and criticism at times) over the course of the exhibition's development. They include Rita Ackermann, Cory Arcangel, Art & Language and The Red Krayola, assume vivid astro focus, Phyllis Baldino, Pedro Bell, Slater Bradley, Steven Claydon, Bjorn Copeland, Jeremy Deller, The Destroy All Monsters Collective (Mike Kelley, Cary Loren, and Jim Shaw), Jim Drain, Douglas Gordon, Dan Graham, Rodney Graham, Daniel Guzmán, Richard Hamilton, Jay Heikes, Richard Kern, Scott King, Jutta Koether, Jim Lambie, Mark Leckey, Linder, Robert Longo, Christian Marclay, Aleksandra Mir, Dave Muller, Ronald Nameth, Yoshitomo Nara, Colin Newman, Tony Oursler, Steven Parrino, Adam Pendleton, Raymond Pettibon, Jack Pierson, Richard Prince, Pipilotti Rist, Aïda Ruilova, Savage Pencil, Peter Saville, Jim Shaw, Thaddeus Strode, Mika Tajima / New Humans, Tony Tasset, Mungo Thomson, Throbbing Gristle (Chris Carter, Peter "Sleazy" Christopherson, Genesis P-Orridge, and Cosey Fanni Tutti), Rirkrit Tiravanija, Andy Warhol, Marnie Weber, Karl Wirsum, Workshop, and Thomas Zipp.

I finally wish to thank any friend who's ever turned me on to brilliant new music (especially my sister Carrie); my parents (particularly my mom) for teaching me just how much music means to me, by occasionally depriving me of my records, cassettes, and CDs when I was an adolescent; and to all the artists, bands, and performers whose work provides a constant reminder of the importance of contradiction, risk taking, and dissonance.

Dominic Molon
Curator
Museum of Contemporary Art, Chicago

GALLERIES, MUSEUMS, ARTISTS' STUDIOS, AND OTHER INDIVIDUALS

303 Gallery: Simone Montemunro, Lisa Spellman, and Mari Spirito

Aaron Poirier

Andrea Rosen Gallery, New York: Branwen Jones and Jeremy Lawson

The Andy Warhol Museum: Geralyn Huxley

Anton Kern Gallery, New York: Anton Kern and Michael Clifton

The Art Institute of Chicago: Lisa Dorin

Blum & Poe, Los Angeles: Tim Blum, Bridget Carron, and Jeff Poe

Cabinet, London: Andrew Wheatley

China Art Objects, Los Angeles: Steven Hanson

Christian Marclay Studio: Janelle Iglesias

The Cryptic Corporation: Hardy Fox

David Kordansky Gallery, Los Angeles: Natasha Garcia-Lomas and David Kordansky

David Zwirner Gallery, New York: Jessica Eckert

Donald Young Gallery, Chicago: Emily LeTourneau, Tiffany Stover Tummala, and Donald Young

Douglas Gordon Studio: Bert Ross

Drag City Records, Chicago: Dan Koretsky and Dan Osborn

Electronic Arts Intermix: Josh Kline

Elizabeth Dee Gallery, New York: Elizabeth Dee, Jennifer Moore, and Tim Saltarelli

Gagosian Gallery: Ian Cooke, Kara Vander Weg, and Sarah Watson

Galerie Christian Nagel, Cologne: Florian Baron

Galerie Daniel Buchholz, Cologne: Matthias Mayr

Galerie Gisela Capitain, Cologne; Estate Martin Kippenberger: Gisela Capitain and Margarete Jakschik

Galerie Neu, Berlin: Sasha Rossman, Alexander Schroeder, and Scott Weaver

Galleria Sonia Rosso, Turin: Arianna

Gavin Brown's enterprise, New York: Gavin Brown, Laura Mitterand, and Kelly Taylor

Gavlak Projects, West Palm Beach: Sarah Gavlak

Gladstone Gallery, New York: Rosalie Benitez, Bridget Donahue, and Jessie Green

Greene Naftali, New York: Carol Greene and Alexandra Tuttle

Harris Lieberman Gallery: Michael Lieberman, Allison Kave, and Jessie Washburne-Harris

Herald St, London: Nicky Verber

HOTEL, London: Darren Flook and Margherita Hohenlohe

Interpol

Jean Albano Gallery, Chicago: Jean Albano

John Connelly Presents, New York: John Connelly, Joanne Kim, and Thea McKenzie

Kavi Gupta Gallery, Chicago: Julia Fischbach, Kavi Gupta, and Kristen van Deventer

kurimanzutto, Mexico City: Jose Kuri and Monica Manzutto

Luhring Augustine, New York: Natalia Mager

Marian Goodman Gallery, New York: Karina Daskalov and Rose Lord

Marianne Boesky Gallery, New York: Adrian Turner

Matador Records

Metro Pictures, New York: Allie Card, Tom Heman, Manuela Mozo, and James Woodward

Mike Kelley Studio: Mary Clare Stevens

The Modern Institute, Glasgow: Andrew Hamilton and Toby Webster

Patrick Painter Gallery, Santa Monica: Heather Harmon

Paula Cooper Gallery, New York: Anthony Allen, Sarah Baron, and Steven Henry

Peter Saville Studio: Samuel Rooker-Robert

Reena Spaulings Fine Art, New York: John Kelsey

Regen Projects, Los Angeles: Yasmine Rahimzadeh and Shaun Regen

Rhona Hoffman Gallery, Chicago: Rhona Hoffman

Robert Longo Studio: Paolo Arao

Shane Campbell Gallery, Chicago: Shane Campbell and John Schmid

Stuart Shave / Modern Art, London: Kirk McInroy and Stuart Shave

Team, New York: Miriam Katzeff

Tony Oursler Studio: Dan Walsh

Yvon Lambert, New York: Bruce Hackney

Zwirner & Wirth, Zurich: Sylvia Bandi

INDEX TO ARTISTS AND BANDS